ARTS OF INDIA KRISHNA CHAITANYA

To

JOSEPH ALLEN STEIN

(Joe, I do hope you don't have to summarise this
book too to get the hang of it!)

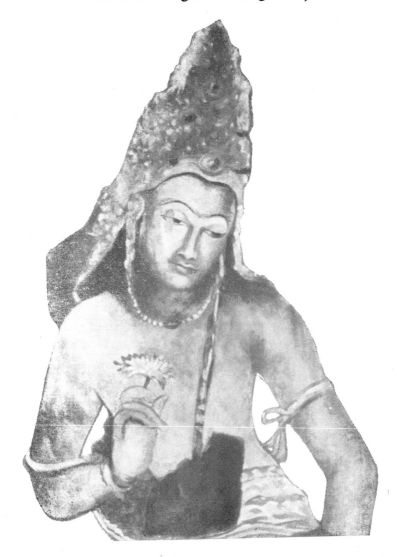

KRISHNA CHAITANYA

ARTS OF INDIA

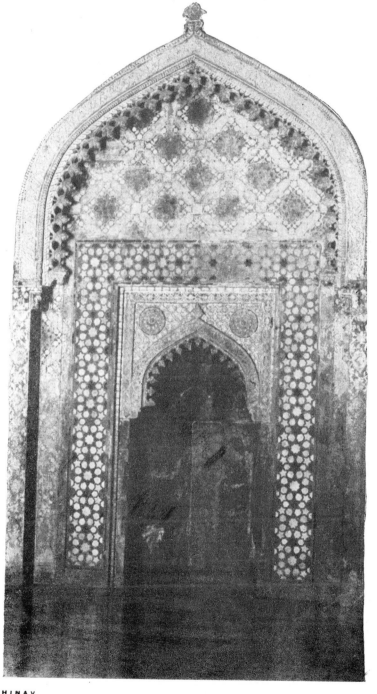

 abhinav publications

First published in India 1987

© K.K. Nair

Publishers

Shakti Malik
Abhinav Publications
E-37, Hauz Khas, New Delhi-110 016

ISBN 81-7017-209-8

Printers

Hans Raj Gupta & Sons
Anand Parbat, New Delhi-110 005

Preface

To the world's heritage of the arts, India has made a substantial contribution. Artistic impulses originating here have travelled far, reaching the sea-girt lands of south-east Asia, penetrating deep into the heartlands of the continent, with fine modulations as they flowed over the slow centuries through the ancient silk route to China, then to Korea and to Japan. India has accepted impulses as readily as she has offered. In the days when she was a Kushan empire, the outposts of the realm had schools of sculpture where Indian spiritual ideals were incarnated in a Greco-Roman plastic sensibility. When the Moghuls no longer felt homesick for Ferghana or Kabul and India had become their home, they gave this country an architectural legacy whose masterpieces can rank with the best seen anywhere in Muslim lands.

This then is a great heritage; and it is a world heritage, for the beautiful things created by man in the past, anywhere, are available for the delectation of man everywhere, today. One thing that has prevented the layman from fully coming into his legacy has been the fact that art has till very recently been the preserve of archaeologists. The idiom of the erudite alienates the layman. The present-day popularisation of the cultural legacy which has developed as a spin-off from the expansion of tourism, on the other hand, often goes to the other extreme by steam-rollering the infinite and delicate variations of beauty as it has incarnated in numerous objects of art under cliches and idioms that have the garish glitter of sales promotion copy. The ideal approach would be the one where serious research and scholarship are not neglected but are nevertheless melted down into the flow of a maximally communicative narration, the major images

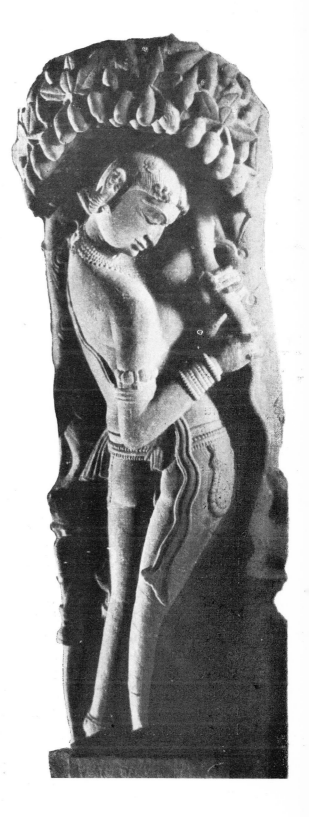

reflected in it being always the great visions of beauty in the cultural heritage. Art is created by a welling up of delight and, this way, its narration would also share and communicate that delight. This is the ideal that the author has kept in mind.

Books that have appeared on the art of India seem to have confined themselves to architecture, sculpture and painting. But there are weighty reasons for including music and dance and handicrafts, as has been done here. Temple architecture generally provided halls for the performance of music and dance, for these too were ways of worship. Some of the finest sculptures of the past have dances as their themes. Siva, deity and dancer, has been represented in the attitudes and gestures of classical dance in reliefs which are veritable manuals of dance illustrated through sculpture. Music parties and dances have figured repeatedly in painting. As for crafts, it is not elitist art that makes gracious the daily living of the masses but the art of the artisan who transforms the humble articles of daily use into objects that are beautiful too. Indian crafts enjoyed the pride of place in the trade of the ancient world and they still retain unflawed the old vision of a timelessly enduring beauty.

By trying to make the textual outlines integral and by selecting the typical best for illustrations, this book tries, in spite of the limitations of space, to introduce the reader to the best in the legacy. The author hopes that it will stimulate further exploration and hopes further that nothing encountered there will seem totally unfamiliar to those who have read this book.

Krishna Chaitanya

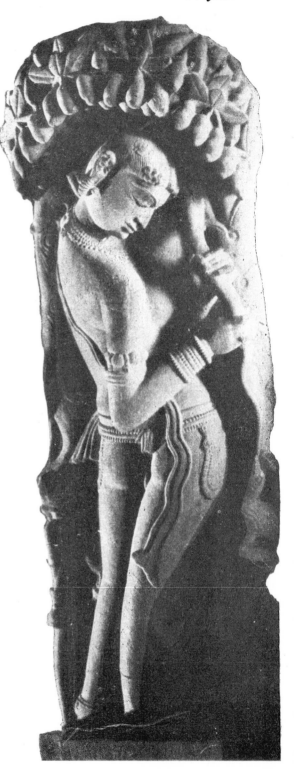

Colour Plates

Monochrome Plates

Architecture

Sculpture

Painting

149. The Hidden Admirer. Bundi, c. 1775. Prince of Wales Museum, Bombay.
150. Hunting the wild boar. Kotah, c. 1780. Vijayavargiya collection.
151. Boat of Love. Kishangarh, 1735-57. National Museum, New Delhi.
152. Nayika. Basohli, c. 1670. Boston Museum.
153. Krishna and Balarama camping. Guler, 1760-65. National Museum, New Delhi.
154. Toilet. Guler, c. 1770. Indian Museum, Calcutta.
155. Nala and the swan. Kangra, 1800-10. Dr. Karan Singh collection.
156. Rama, Sita and Lakshmana in their hermitage. Chamba, c. 1850. Bhuri Singh Museum, Chamba.
157. Usha's Dream. Chamba, 1775-1800. National Museum, New Delhi.
158. Toilet. Kulu, 1800-25. National Museum, New Delhi.
159. Krishna's Flute. Nalagarh, c. 1820. Chandigarh Museum.
160. Krishna bidden to escort Radha home. Garhwal, c. 1800. National Museum, New Delhi.
161. Rama and Sita in the forests in the rainy season. Nalagarh, early nineteenth century. N.C. Mehta collection.
162. Snug shelter in imminent rain. Kangra, late eighteenth century. Allahabad Museum.
163. For the lover who failed to come. Guler, c. 1765. Kasturbhai Lalbhai collection.
164. Krishna and Radha in a grove. Kangra, c. 1780. Victoria and Albert Museum.
165. Fire at night. Kangra, c. 1800. Kasturbhai Lalbhai collection.

Music and Dance

166. Musician and dancer. Nagarjunaconda, second-third century. Courtesy Archaeological Survey of India.
167. Dancer. Markanda, twelfth century. Courtesy Archaeological Survey of India.
168. Dancer with string drone. Kumbhakonam, sixteenth century. Courtesy Archaeological Survey of India.
169. Yamini Krishnamurti in Bharata Natya.
170. Hema Malini in Bharata Natya.
171. Santa Rao in Bharata Natya.
172. Cymbalist. Sun Temple, Konarak, thirteenth century. Courtesy Archaeological Survey of India.
173. Vijayalakshmi Shivaji in Bharata Natya.
174. Alka Nupur closing a spin in Kathak.
175. Mayurbhanj Chau. Courtesy Sangeet Natak Akademi, New Delhi.
176. Khamba Thoibi of Manipur.
177. Veethi Bhagavatam. Courtesy Sangeet Natak Akademi, New Delhi.
178. Therukkoothu. Courtesy Sangeet Natak Akademi, New Delhi.
179. Radha awaiting Krishna, Kathak.
180. Singhajit and Charu Mathur in Manipuri.
181. Mohini Attam.
182. Protima Bedi in Odissi.
183. Sutapa Dutta Gupta in Odissi.
184. Yamini Krishnamurti in Odissi.
185. Kumkum Das in Odissi. Photo, Avinash Pasricha.
186. Sanjukta Panigrahi in Odissi. Photo, Avinash Pasricha.
187. Episode from a Kathakali dance-drama.
188. A Yakshagana dancer in the role of Rama.
189. A stage in wrapping the head-dress of a Yakshagana dancer.
190. The dancer-raconteur of a Thullal play.
191. Folk dancer, Maharashtra.
192. Bhangra dance of Punjab.

Architectural Heritage

Wares created by the crafts of man have the value of utility, meeting survival needs in the contexts of daily living. Art creates values of a higher type, but they too yield utility, meeting the being-needs of man. However, it is difficult to separate the two categories absolutely. Primitive or poor craft may at times lack any higher value except barely adequate utility; and some kind of art, especially in ages of alienation, may speak only to the deeply introvert temperament that has become isolated from the concerns of human and humane living in communion with fellow beings. But these are the extremes of the spectrum. Over most of its range, mercifully, both crafts and arts have reflected the many dimensions of the human personality, craft acquiring adornment too, and art meeting the needs of living and thereby transforming existence from mere survival to aesthetically gracious living.

Architecture is a great tradition which reveals this integration. Its primary purpose is to ensure that man's life is a sheltered living, sheltered from the inclemencies of weather, the attacks of predators. But it has always sought to ensure that the convenient ambience is a beautiful one too. Mass and volume, size and proportion of components, are matters where decisions are primarily made in the light of the layout of living space that would be the most convenient. But their articulation is designed to generate beauty too, in relating the building to the landscape, in creating a rhythm in the way masses advance and recede, in etching silhouettes against the blue or cloud-dark sky. Interior space may deliberately withdraw from exterior for intimacy and privacy, or let the bright outer world flow in without break to maintain continuity and communion with nature. The surface ceases to be neutral. Its pattern can be used to accentuate height, width or depth. The colour of the material can be used to modify the light, to make it warm or cool. It is on these halations or auras of beauty which the mansions of men and of their kings and their gods wear that the layman of some sensitivity should concentrate, for he will not go wrong in assuming that the merely utilitarian purposes were more or less satisfactorily met by the creations of traditional architecture.

From this point of view, it becomes unnecessary to dwell too long on the epoch of the Indus valley civilization which flourished between about 3000 and 1500 B.C., since no standing edifices have survived. But a piquantly amusing and yet understandable aspect justifies a brief notice. Indian historians had a traumatic shock when the

partition made the main sites of this civilization—Mohenjo Daro and Harappa—part of another country; it was almost like being told that one's cherished ancestors were really somebody else's forbears. But explorations since partition have been able to cure this anxiety neurosis. The extent of the civilization now stands revealed as reaching in the north to Akhnoor in Jammu, in the east to Alamgirpur and Hulas in the Yamuna-Ganga doab and in the south to Daimabad in the Ahmadnagar district of Maharashtra. During this epoch, Lothal in Gujarat had well-built dockyards attesting to flourishing maritime trade. Mohenjo Daro and Harappa had walled citadels and were carefully planned on a grid system with main boulevards running across the townships. Kalibangan in Rajasthan too had a fortified city with a citadel and excellent streets. But we do not know what skyline the urbanised settlement created, what forms their facades presented.

About the early architecture of the Aryans who displaced the people of the Indus valley civilization, we have only indirect evidence: references in Vedic literature, representations in relief carvings. The characteristic method of construction seems to have been by vertical posts and horizontal beams, with walls of reeds or wattle and plaster. Relatively large areas were roofed with a type of barrel vault constructed out of a series of curved wooden members springing from a wooden architrave supported on rows of columns. We should remember this basic design, for it will musically echo down the centuries, even when materials of construction changed radically. Of the big cities and royal mansions, we have only tantalising rumours. Pataliputra (Patna) of the fourth century B.C. has been described by the Greek ambassador Megasthenes as a city with sixty-four gates, stupendous palisades and a deep moat around it and a spacious palace with a series of hypostyle halls.

Buddhist Architecture

But when another two centuries go by, the screen that was totally dark or only faintly lit becomes filled with images of startling clarity and beauty. In a summative account like this, we can say that the contribution of Buddhist architecture to the Indian legacy consists of three major forms: the Stupa or the memorial structure; the Vihara or residential complexes for the monastic orders; the Chaitya or the hall for religious worship.

The Stupa evolved from the simple burial tumulus into a domed structure with a small chamber a few feet below the top where the relics of the Buddha or Buddhist preceptors were reverently enshrined (Pl. 1). As time went by, the surface of the hemispherical structure got a facing of stone and it was crowned by a stone umbrella, symbol of both secular kingship and divine fiat over creation. For circumambulation by the devout, a raised terrace with railings was added along with staircases to reach it. The Stupa then became enclosed in a larger railing at ground level which had one to four ornamental gateways. Stupas built from late second century B.C. to late first century A.D. have survived in varying states of preservation at Bharhut, Sanchi and Bodh-Gaya. Of these, the Great Stupa at Sanchi is the most well-preserved. The

gateways here consist of three separate carved architraves, carried high on solid pillars. They were in all probability of wood originally, for the rich carvings show the detailed execution of wood carving. The railing posts were also carved with relief figures illustrating Buddhist legends and with decoratively stylised motifs of leaf, flower and creeper. The hemispherical form of the Stupa does not remain unchanging, rigid. Though the Great Stupa at Amaravati of the second century has not survived, we have a detailed and perfectly preserved representation of the form in a relief (Pl. 61) and we see the hemisphere changing into the cylindrical tower. The sixth century Dhamekh Stupa at Sarnath has become a domed brick pillar or tower faced with stone and with a decorated and lightly moulded base.

The early Viharas and Chaityas are rock-cut caves. The Vihara began as a court-yard surrounded by small single rooms opening from it. One can see this basic design in the small cave (No. XIII) at Ajanta. As the monastic communities expanded, upper storeys were added and to bear the weight of rock, rows of columns were carved out and left as standing supports. In the seventh century Vihara at Ellora, the cells of the monks are arranged on three storeys. One of the cells in the centre of the back wall of the Vihara was transformed as a shrine with a large image which too was cut from the rock. Later, this cell got completely detached from the back wall to allow circumambulation by the devout. A large front verandah also emerged, for formal and informal gatherings. This feature can be seen in the seventh century Vihara at Elephanta. Side chapels for private devotional purposes, of the same type as in European churches, were also occasionally provided, as in Cave XXIII at Ajanta. The facades, balconies and pillars were increasingly ornamented with relief sculpture with a variety of motifs, figurative and foliar. As early as in the second century B.C.— in Cave XII of Ajanta—we see doors and windows surmounted by horse-shoe motifs. This decorative feature will linger with delightful tenacity down the centuries. For we see it in the twelfth-century temple at Alampur though the simple horse-shoe form becomes here a richly ornamented and tiered miniature pyramid decorating the tops of windows and doors.

The Chaitya was a deep excavation - in the form of a basilica with a nave, two aisles and, at the apsidal end, a Stupa, also rock-cut and standing free of the rear wall so as to allow circumambulation (Pl. 1). Far more prominent than in the Viharas is the great horse-shoe opening on the facade, which may frame the entrance completely as in the second century B.C. shrine at Bhaja or appear above the door, separated from it by the lintel, as in the first century B.C. shrine at Karle and in Cave XIX of the first century A.D. at Ajanta. It is in the last that the facade, with pillars flanking the approach to the entry, deep relief figure sculptures on either side of the entry and the great horse-shoe window above, acquires the maximum stateliness and controlled richness (Pl. 2). Within the Chaityas, many features recall the origin from the wood construction of earlier epochs. At Bhaja, the rock above seems to have been intended to be supported by an actual wooden construction of roof ribs. At Karle and Ajanta, the wooden supports were eliminated but have been reproduced entirely in carved stone. These ribs sprang from architraves supported by rock-hewn pillars separating

the nave from the aisles. The decorations of the pillars too recall the origins in timber construction. For the carved bands on the pillars clearly simulate the decorated metal bands used to strengthen the wooden columns in the earlier days.

If the term 'cave architecture' suggests gloomy interiors, pleasantly upsetting will be a visit. The interior is spacious, the space rhythmically ordered by the marching of the columns down the nave. The flow and ebb of light coming in through the door and the horse-shoe window magically change the luminosity within the hall as the sun outside gains in strength towards noon and mellows towards the evening. With strong light, the relief sculptures seem to advance from their ground plane and they recede when the light ebbs away. Ancient Greece and Rome knew only three types of pillars: Doric, Ionian and Corinthian. The treatment of columns and capitals in the Chaityas and Viharas will tax the taxonomer with their splendid variety. The Bhaja columns are plain prismatic shafts with no capital or base, rising directly from the floor and moving directly into the vault. The Karle columns have vase-shaped bases and bell-shaped capitals (Pl. 1). Mouldings and decorations at Ajanta show endless variety. We shall see the Indian sensibility returning to the spell of this rock-cut architecture even after resurgent Hinduism had replaced Buddhism and had stabilised the structural shrine.

Hindu Structural Temple

The basilica design of the Buddhist Chaitya perhaps inhibited complex articulation of interior space by bringing the worshippers and the symbol worshipped—the miniature Stupa with sometimes the image of the Buddha carved in deep relief—together in the same enclosure. This type of design had its logic, for the Buddha, although he became deified later, had been a historical personality, a revered elder who moved among men and sought to make them finer beings through his discourses. The Hindu temple, on the other hand, arose from man's sense of the numinous, the holy, and as Rudolf Otto has shown, this sense of the sacred renders sacramental the place and things associated with adoration and worship. The temple thus began as a single cell, the sanctum, into whose consecrated space nobody except the officiating priest could enter. And all through the evolution which later created mountains of masonry, the sanctum remained small.

To get a frame into which the phases of the evolving architecture can be assimilated, we may briefly note here the social, cultural, symbolic and artistic significance of the Hindu temple. It grew up as a centre of varied support to the community. In temple records we read of communities who lived as tenants on the lands donated to the temple by rulers and rich people. Cattle donated to the temple were looked after by cowherd communities and the levy of milk and butter they had to supply to the temple looks moderate in the records. Craftsmen received their major patronage from the temple and traders flourished by servicing the temple and the floating population of pilgrims. Rest houses were provided by many temples, feeding of the poor was practised by several. The temple became a centre of education and even if the instruc-

tion was primarily religious, it should be recalled that the great texts of the Hindu religion, like the epics and the sacred legends (*Puranas*), were literature too of the highest quality. Sculpture and painting visually illustrated these texts, prolonging the Buddhist tradition. Music developed with the singing of hymns, dance emerged as ritual worship.

Symbolically, the sanctum with its tower was a representation of the Cosmic Person and the tower itself was the world mountain peopled by gods, men and the fauna and flora of the earth. This symbolic representation of the macrocosm in a microcosm, of the world in the shrine, was repeated by an architectural detail. The exterior of the tower came to be decorated with myriad miniature shrines that decoratively repeated the form of the temple (Pl. 19).

The expansion of interior space followed the rhythm of this growth in the multiple relevance of the shrine to society. A single cell originally with occasionally a small portico supported by one or two pairs of pillars, the Hindu temple in its earliest phase was not unlike the temple of the ancient Greeks. But the subsequent development was different. The Greek temple remained a simple basilica. In the Hindu temple, an open and, later, an enclosed ambulatory was added around the sanctum. A pillared hall, for sacred recitals and dances, was added in front (Pls. 14, 18), the old porch becoming a vestibule or antechamber. Still later, in many temples, a refectory hall was added in front of the dance hall. These two could be separate structures but were more often integrated with the sanctum through vestibules. The whole edifice began to be raised on a plinth of varying height with mouldings of varying richness (Pl. 13). Likewise, the roof of the sanctum also began to rise skyward in the form of the barrel-vault pyramid, stepped pyramid or cylindrical tower (Pls. 3, 4, 5, 8, 11, 12).

Geometry developed in ancient India in connection with the construction of the altars of the Vedic age with bricks of precise shape and dimensions. Deriving from this, the square is the module of construction of the Indian temple. But grids of squares can be arranged in many forms. Thus we have the extended basilica, the cruciform layout and star-like and even circular overall forms.

No early example of the simplest type of temple consisting only of a single cell has survived, but we can see the design surviving in the Khichingswara temple of the eleventh or twelfth century at Khiching in old Mayurbhanj, now part of Orissa. It does not have a portico. But an open portico had been added to the cell as early as in the fifth century Gupta temple at Sanchi and in course of time it becomes a closed or semi-closed chamber (Pl. 3). By the end of the fifth century, the roof of the cell acquired a solid superstructure of stone in the form of a pyramid with either straight or curvilinear sides (Pl. 3). We see this feature in the Deogarh temple of the fifth century. Here, the temple is raised on a square plinth with four flights of steps for access and the central shrine is surrounded by four porticos. Ambulatories also develop by the late fifth century. The Durga temple at Aihole in the Deccan, built by the Chalukyas, has an open verandah-like ambulatory (Pl. 4). It is in an elongated plan, curving round behind the sanctum. Sophisticated structural articulation also begins to be seen here. The edifice is set on a high, moulded platform. In front of the sanctum,

and surrounded by the verandah, is a hall with a nave and aisles. The roof of the hall is flat, but in two tiers, the one over the nave being higher. Finely carved perforated stone trellises admit light to the hall and these lattices alternate with niches bearing images of gods and goddesses. The other temple at Aihole, the Ladh Khan, has an enclosed slab-roofed ambulatory of square plan around the cell.

Return of Rock-Cut Architecture

We should pause here to note the extraordinary fact that even after the structural temple had evolved to this level of sophistication, there was a startling resurgence of the fascination of the old rock-cut architecture and the achievement in simulating the structural temple was a near-miracle.

In the copperplate inscription of Krishna II, the eighth century ruler of the Rashtrakuta dynasty, we overhear his incredulous wonder when the project he launched was finally completed. "How is it possible that I built this other than by magic?" His wonderment is fully justified. His architects had cut a great hill of rock at Ellora from its top to a drop of over 36 metres leaving a central block which they proceeded to carve in perfect and detailed imitation of a temple built by laying stone on stone. Perhaps the Kailasa Natha temple cannot be called unique in the world, for the thirteenth century Church of St. George at Lalibela in the Ethiopian highlands was also built in the same way. But there the first trench that had to be cut is only about 11 metres deep and the church is much smaller and simpler in design. More sculpture than architecture, the Kailasa Natha, with its central tower reaching a height of 30 metres, stands in a spacious court and is about 90 metres long and 35 metres wide. Its area is twice that of the Parthenon in Athens and height one and a half times.

The physical achievement here has tended to obscure the aesthetic. But, in very subtle ways, the Kailasa Natha (Pl. 5) has retained in its form and details the actual transformation of massive matter into great art, at once dramatic and delicate. The brilliant sunlight of the Deccan plateau floods the court and deepens by contrast the blue shadows cast by the high surrounding mountainside on the vertical faces of the temple where, at the base, giant sculptures of elephants and lions are engaged in mighty combat, hallucinogenically retaining the vibrations that coursed through the rock when workmen first cut it up with mighty blows of hammer and chisel. But in the upper storey where the structure emerges more fully from encasing shadows, the giant elephants of the thickened base stand, strong and calm, symbolising the stability that has been achieved (Pl. 6). On the walls are carved celestial beings like Gandharvas floating with effortless grace. The dead inertia of rock has been completely conquered. And the carvings on the two towers flanking the entrance and the tower on the upper floor have the delicacy of wrought gold jewellery or lace embroidery.

The Siva temple of the seventh or eighth century at Elephanta, a beautiful little island about ten kilometres off Bombay, has been cut out from the rock on a cruciform plan with the centre occupied by a free-standing shrine. The pillars have fluted shafts and circular, fluted cushion capitals.

The eighth century seems to have been remarkably productive in respect of the proliferation of regional styles. Moving from the Deccan to the far north, we find in Kashmir the great Sun Temple at Martand built by Lalitaditya, today unhappily in ruins. Buildings of the earlier Buddhist period in Kashmir have not survived. But Martand shows the transition to the Hindu style for, instead of the Buddhist assembly hall where congregational worship was held, we have here a central shrine which stands within an immense courtyard surrounded by a pillared arcade and a series of cells. The columns and the colonnades recall Greek features transmitted via Gandhara but assimilated smoothly into the style of the Hindu temple. In the Avantipur temple built by Avantivarman in the ninth century, the Martand style is prolonged but shows great refinement in the graceful colonnades. Unlike these two, the twelfth century Pandrethan temple (Pl. 7) is still well-preserved. The small shrine stands in a tank of water. Small porticos supported on pilasters, with high triangular hood-moulded pediments, adorn the four faces, one framing a door, the others having relief panels. The high-pitched stone roofs are stepped, recalling the tiers of originally wooden gables. The small shrine has a crystalline clarity and beauty of form.

We return to the eighth century, this time to the coast of peninsular India where the blue waves of the Bay of Bengal break in white surf which blends with the sun-flooded white sands of Mahabalipuram and Kanchipuram where the Pallavas, with catholic taste, carried on the traditions of both the rock-cut and the structural temple. The rock-cut shrines are at Mahabalipuram and consist of ten Mandapas or excavated halls and seven monolithic Rathas (chariots), so called because they resemble the big temple cars in which images of deities are taken out in procession. Tradition is fondly remembered and promises further evolution in some of the Rathas like the Bhima, Ganesh and Sahadeva, for they are based on the architecture of the Buddhist Chaitya hall. They are two or three storeys high and are surmounted by a barrel roof with the Chaitya gable at the ends. In this multi-storeyed structure with its barrel roof we see the beginning of the stupendous Gopurams or gateway towers which came into vogue in South India several centuries later.

Evolution of the Temple

The structural temples are the shore temple at Mahabalipuram and the Kailasa Natha temple at Kanchipuram. So solid has been the construction of the shore temple that it has withstood drifting sands, battering waves and the corroding salty air for twelve centuries. The light, elegant and well-proportioned tower over the sanctum is echoed and demurely balanced by the smaller tower over one of the two additional shrines attached to the sanctum. In the Kailasa Natha, the ground plan of sanctum and portico has been extended by the addition of a large pillared hall used as a dance pavilion. The tower over the sanctum is an elaborate, tiered pyramid. But its form shows that it has developed from the many-tiered umbrella crowning the Buddhist Stupa.

During the period from the tenth to the twelfth centuries, a veritable forest of

temples came up under the patronage of the Chandella dynasty at Khajuraho in Madhya Pradesh. Out of the original eighty temples, twenty-five have survived and the Visvanatha can be studied as typical (Pl. 8). The temple stands on a high plinth with highly developed and varied horizontal mouldings. The sanctum and its porch, together with an assembly hall aligned on the axis of the cella door, are enclosed in a broad, pillared, verandah-like ambulatory. But, from the outside, the visual impression is that of the simpler basic form of a sanctum with portico. The roof is an intricate complex of pyramids, the height rising from those over the portico and the three projecting verandahs at the cardinal points to that over the assembly hall and then considerably to that over the sanctum. The tower, square in plan, curvilinear in out-line, is crowned with cushion (*amalaka*) and pot (*kalasa*) finial and is massively buttressed, each buttress repeating the form of the tower complete with finial. Both the exterior and the interior of Khajuraho temples have profuse sculptural decoration and the pillars and ceiling are often richly carved (Pls. 9, 10). The Udayesvara temple at Udaipur in Madhya Pradesh (not to be confused with Udaipur in Rajasthan) was built about 1059 and follows the Khajuraho style. It has a very elegant tower orna-mented with four flat bands running from base to summit and separating the surfaces decorated by the buttresses shaped like miniature spires (Pl. 11).

The eighth century, again, was the period when the Eastern Ganga dynasty stabilised itself in old Kalinga, modern Orissa, and initiated a prolific program of temple-building which adorns the shore of the Bhuvaneshvar lake with about thirty temples even today though the original number must have been considerably larger. Rather like the spire buttresses repeating in miniature the overall form of the tower, the regional evolution here repeats the historic evolution of the Hindu temple. The Parashurameshvara temple, built about 750, is rather archaic, for the sanctum and hall have not been integrated but stand separate. The Vaital Deuil, built about 850, though equally small, is beautifully proportioned and the top of the tower, in its barrel-vault form and gable ends, recalls the Buddhist Chaitya like the Rathas at Mahabalipuram. With a sanctum tower of only about ten and a half metres, the Mukteshvara, built around 900, is small. But with its integrated shrine and porch, its exquisite gateway arch (*torana*), tank and low railing round the whole enclosure, this dainty temple is a jewel of the Indian architectural tradition (Pl. 12).

The search for clarity of line, which fumbled a little in the stocky contours of the Parashurameshvara, succeeds with a quiet grace in the Mukteshvara and the achieve-ment is repeated in ambitious dimensions in the Lingaraja, built around 1000. Originally it consisted only of an integrated sanctum and porch like the Mukteshvara. Later, a dance hall and also a hall of offerings or refectory were added, but as extensions on the same axis and in harmony. The three halls in front are roofed with characteristic towers leading the eye to the nearly thirty-nine metre high tower over the sanctum. While the towers of the Khajuraho temples are curved for their whole lengths, in the Lingaraja and the Orissan temple generally, the towers begin to curve inwards only at about one third of their height from the base. The profile of the Lingaraja is classic

in the rhythm of the roof line that rises in waves. The interior in Orissan temples has no sculptural decoration, but the exterior has rich sculptural ornamentation.

When it was built in the thirteenth century, the Sun Temple of Konarak must have been the supreme achievement of Orissa's architectural tradition, though today it is [in ruins. Like the Rathas at Mahabalipuram, this temple too has been designed in the form of a chariot, though in vastly larger proportions, and equipped with twelve giant wheels, each about three metres high, on either side of the base, and drawn by seven magnificent horses. The base is an immense terrace and on this raised platform (Pl. 13) stood the sanctum and vestibule with the dance pavilion (Pl. 14) and the refectory hall as detached structures, all enclosed within a courtyard. The terrace bears colossal free-standing sculptures of musicians (Pls. 85, 172).

From eighth century Rajasthan we have the Ekalinga temple built by Bappa Rawal about twenty kilometres from Udaipur. Though relatively large, it is simple in design with sanctum, vestibule, closed assembly hall with latticed windows in the transepts and a balustraded porch. Though not much adorned, the form has become attractive because the hall has an octagonal plan with a niche containing a goddess projecting from each angle. The same basic design is seen in the tenth century Ambikamata temple at Jagat, also in the Udaipur district. But it has a beautiful roof line descending in rhythmic flow from the not too high sanctum tower to the gabled and stepped roof of the vestibule and the pyramidal roof in diminishing tiers of the hall. Equally beautiful though much simpler in design is the eleventh century Someshvara temple at Kiradu in the Barmer district. Though interior space has sanctum, vestibule and assembly hall, externally the temple has the ideal simplicity of just a cella with a porch. In spite of being really rich, the ornamentation manages to retain the feeling of classic restraint because the sculptured bands demand no additive space but run along the structural contours to enlace the form like a jewelled waistband enlacing a sensuous waist. The tower is typical of the style of the Solankis. While, elsewhere, the miniature tower motifs look like carvings on the surface of the tower over the sanctum, here they are distinguished by their emphasised shaping as almost separate elements that surround a central spire.

Jain Contribution

We may pause here to note the Jain contribution to the Indian architectural heritage, for it is in Rajasthan (Pls. 15, 16) that we have quite a few of its most precious gifts. In general characteristics, the Jain shrine is not distinguishable from the Hindu. But this affluent community, which specialised in economic pursuits like trade and banking, could afford to build great complexes of shrines, some of which have become veritable temple cities.

The beginning goes back, again, to the eighth century, in Chittorgarh though construction of new shrines continued up to the sixteenth century and later. Architecturally more important than the shrines here is the Adinatha (or Vimala Vasahi) temple built at Dilwara in Mount Abu in the eleventh century by Vimala Shah,

minister of the Solanki ruler, Bhimadeva. Built entirely of Makrana marble, the temple consists of sanctum, vestibule and open portico, the last two elements being formed by a simple grouping of pillars. The temple is surrounded by a lofty wall containing 52 cells, each of which contains the image of a Jain preceptor. The cells are screened off by a double arcade. Ornamentation is profuse, with extremely ornate pillars connected by arches (*toranas*) that simulate organic forms as in the Art Nouveau architecture of Antonio Gaudi of our own century. The most spectacular feature is the octagonal dome formed by eleven concentric rings, containing carved designs of endless variety and upheld by eight carved columns. A series of sixteen brackets, each bearing an image of Sarasvati, the goddess of learning, supports the ring of the dome (Pl. 16).

Two hundred years later, Vastupala and his brother Tejapala, ministers of Vivadhavala, built another temple at Mount Abu. The Tejapala temple closely follows the style of the Vimala Vasahi; but a striking feature is the pendant of the dome which hangs from the centre more like a jewel fashioned out of crystal drops than a solid mass of marble. The Chaumukh Temple of Ranakpur, built by Depaka at the request of the devout Dharanaki in 1439, has a four-faced image of Rishaba Deva and, as a consequence, four doors to the sanctum and a cruciform layout. The pillars and their arches follow the style of the Mount Abu temples. But the temple has become enormously complex. The entire complex with its twenty-nine halls, set in a rectangular courtyard, is surrounded by four subsidiary shrines and its eighty domes are supported by a veritable forest of four hundred and twenty-six pillars.

We may follow up the Jain contribution into Gujarat. On Girnar hill in the Junagadh district, over 900 metres above sea level, we find today fifteen groups of temples, the original dates of construction of the oldest being uncertain as they have been rebuilt. The temple of Neminatha was restored in the thirteenth century according to an inscription, but the style in all probability did not deviate from that of the original which follows the layout we have studied. Another important Jain temple-city is the one built on the summit of the Satrunjaya hill near the town of Palitana in Bhavnagar. There is a forest here of 863 temples occupying the twin summits of the over 600 metre high hill with a connecting group forming a loop on the saddle in between. Most of the original temples were often destroyed and the present ones date from the sixteenth century onwards.

Gujarat under the Solankis produced a magnificent Hindu temple in the eleventh century, the Sun Temple of Modhera, today in ruins (Pls. 17, 18). It consisted of the cella, an assembly hall and a pillared hall, all axially aligned to form a rectangle. There is a decorative arch in front and this feature is repeated over the axial pillars of the front hall. There is a profusion of decorative carving on the pillars.

The Southern Legacy

Karnataka during the twelfth and thirteenth centuries created under the patronage of the Hoysala rulers a style comparable to European rococo in its very lavish

decoration. The most important temples of this style are the Kesava temple at Somnathpur, the Hoysalesvara at Halebid and the Chenna Kesava (Pl. 20) at Belur. There is a vast multiplicity of mouldings extended even under the eaves. The soft chloritic schist has proved an irresistible temptation for rich and detailed carving in very deep relief. We see here a basically cruciform layout given a stellate shaping. For instance, the Kesava temple comprises three shrines on a stellate plan, each with its own vestibule and tower. But the three shrines are arranged on the three sides of a large pillared hall, the plan thus being basically cruciform. The ceiling of the pillared hall consists of domes of concentric diminishing circles, connected by radiating ribs and bearing pendentives in the form of the banana inflorescence. In the Chenna Kesava, the over-rich effect is tempered by stone lattices.

Forlorn and deserted today is Hampi, for history was very unkind to this capital of the Vijayanagar empire (1350-1565). But the Vittala Temple of the early sixteenth century enables us to study the distinctive stylistic features. For the symbolic celebration of the wedding of the deity with his consort, a detached hall, the Kalyana Mandapa (Marriage Pavilion) has come up, in front of the hypostyle hall that serves as the porch of the temple. The pillars of Vijayanagar temples are unique. The porch in the Vittala has 56 pillars, each over three and a half metres high, all hewn out of solid blocks of granite. Each pier is really a cluster of delicately carved pillars or bundles of shafts, or of complex groups of figure sculpture cut in the round. Over these piers are bracket-supports of immense size combined with heavily carved entablatures, on which rests the ceiling ornamented with an enormous lotus flower flattened and sunk into its surface.

Farther south, in the Tamil plains, the Cholas erected a large number of temples of which the Brihadisvara of Tanjore built by Rajaraja Chola about 1000 is the most magnificent (Pls. 21, 22). The most striking feature is the towered sanctuary which rises perpendicularly from a 15 metre high square base and then tapers off to a total height of about 58 metres. The verticality is tempered by thirteen diminishing tiers with accented horizontal lines. On the top is a beautifully shaped monolithic cupola, estimated to weigh 80 tons, ornamented on the four sides with winged niches. The gateway on the east is surmounted by a tower (Gopuram) and a pillared corridor runs along the inner side of the enclosing wall. These two features become very important in the subsequent evolution (Pls. 23, 24).

In the Meenakshi temple at Madurai built during the Nayak period, in the seventeenth century, the outer wall has four large gateway towers and the inner enclosure too has four such towers (Pl. 23). The temple has become a veritable temple-city. In the Rameshvaram temple, also of the seventeenth century, there are pillared corridors which not only surround it on all sides but form avenues leading up to it. Each pillar is a huge block of granite, intricately carved with ornate capital and brackets, and over three and a half metres in height. There is a tremendous expansion of the feeling of space here, with these serried pillars marching down uninterruptedly for more than 210 metres at a stretch and the total length being about 1220 metres

(Pl. 24). In the 'Horse Court' of the Srirangam temple, added in the seventeenth century, the monolithic pillars have been carved to represent riders on rearing horses.

Variant Designs

Kerala, the stripe of green between the blue of the hills of the Western Ghats and the deeper blue of the Arabian Sea, shows some unique features in its temple architecture. With water plentifully available all over the land, every temple had a pond and the traditional habit of beginning the day with a bath and worship made shrines come up in every neighbourhood. Thus there arose many temples, but very few of them grew to ostentatious size.

Though the sanctum was mostly rectangular, the temple itself could be rectangular or circular (Pls. 25, 26). In the former case, the roof is pyramidal with gable ends, occasionally being ridged and double. The ridge of the roof shows a tendency to relax its linear rigour and produce a slightly concave skyline, giving the whole structure a buoyant lift, a light-winged aeriality. While the gabled roof goes with the square or rectangular layout and develops a clear bilateral axis, a radial symmetry may be achieved in the skyline sometimes, as in the Perumannam temple, with portico-like projections pointing in the four cardinal directions and the pyramidal roof of the central space rising above the roofs of the former.

But unique to Kerala is the abundance of circular temples, a fine example being the fourteenth century temple at Neeramankara. A conical roof is the most satisfying solution for the enclosure built on a circular layout. The sixteenth-century Ettumanoor temple has a single conical roof, while the tenth century temple at Thrikkotithanam has a double conical roof. Sometimes, as in the seventeenth-century temple at Tiruvannur, the circle is extended with a supple, sensuously languorous rhythm into an oval.

Bengal is another region with piquantly unique features in its temple architecture, which seems to be derived from the thatched bamboo hut so common in the region. The curved cornice and eave of the temples are directly descended from the bamboo framework of the huts of the common people, originally bent in this shape to throw off the frequent and heavy rains. Though made of brick, the eighteenth-century Jor Bangla temple at Bishnupur (Pl. 27) looks like two huts with thatched roofs joined together and topped by a single tower. The roof and the cornice are parabolic like those of thatched huts. Often, the facades of the temples are convexly curved and have three arched entrances which may be repeated on all four sides. Another unique feature of these temples is that the brick walls are richly decorated with terracotta reliefs which narrate, besides religious legends, secular episodes too and are therefore of great historical and sociological interest.

Civic Structures

We have made a long pilgrimage of temples, because religious architecture is undoubtedly the richest component of the legacy of the past. But, along with the

shrines of the deities erected by the rulers, the mansions they built for themselves also deserve some notice, as civic architecture too is important. The Rajput rulers have left us the best preserved specimens of this tradition which, further, present a variety of achievement. The fifteenth century palace of Kumbha Rana at Chitor is in ruins, but the palace of Man Singh Tomar (ruled 1486-1516) at Gwalior remains untarnished by time (Pl. 38). Within, the living rooms open on courtyards and are laid out to gain the maximum coolness, and the south facade is very beautiful. About 50 metres long and 30 metres high, segmented and framed by its round towers, this facade shows a fine feeling for balance between the perpendicular emphasis of the towers and the horizontal effect of ornamental friezes whose decorative motifs vary from band to band. Udaipur has a beautiful palace on lake Pichola built by Udai Singh after the fall of Chitor in 1567 and enlarged by his successors.

Massive, formidable fortifications crown many hills in Rajasthan, silent symbols today of the tumultuous history of the land in the early days. But we should remember the great seventeenth century citadel at Amber, not primarily because it was, in its time, a formidable mountain-pass fortress, but because a lovely palace has been built here on a height above an artificial lake with a garden laid out in such a way that it yields the best view when seen from the palace above.

Amber receded into the storied and romantic past when the new capital, Jaipur, was built in 1728. The Hawai Mahal or Hall of Winds here is a great tourist attraction. It consists of little more than its five-storeyed facade, but is a striking structure with its projecting alcoves to catch the breeze, its ample segmentation with both real and sham domes, window-grilles and multiple cornices. However, it has distracted attention from the fact that this early eighteenth-century city has a very modern layout with great clarity of line. Broad streets cross each other at right angles and subdivide the residential area into squares, the central one containing the palace. The main streets terminate at the eight tall, spacious gateways in the city wall. Their design, with clear and orderly articulation, broad and almost liwan-like pointed arches, arabesque ornamentation and floral decoration in blind niches, clearly suggests the influence of Islamic architecture. And that reminds us that it is time we moved on to the Muslim contribution to the Indian architectural legacy, a contribution which has made this country the proud possessor of buildings as beautiful as any that can be found in any Muslim land in the world.

Sultanate Architecture

Mosque, mausoleum, fort and palace: these are the four major components of the Islamic architectural tradition. The mosque is fundamentally an enclosure where the faithful assemble for the communal prayer whose discipline, simplicity and devout absorption are a moving experience that transcends the frontiers of creeds. The tombs guard the mortal remains and cherish the memory of the secular and religious leaders of the faith, the kings and the saints. Within a century of its founding, Islam was able to stabilise an empire that stretched east to include the

Central Asian republics of today's Soviet Union and extended west along the north African coast and into Spain. This could not have been managed without military campaigns, and forts came up in the regions assimilated. But in the aftermath of calm achieved after the campaigns, elegant ways of living evolved and these are reflected in the very architecture of the fine palaces.

Though the fact of the great contribution made by the Muslims to the Indian architectural tradition is universally known, many people tend to identify it exclusively with the Moghul legacy and as a consequence remember in this connection only the Delhi-Agra stretch, the axial region of the empire. But we should recall with gratitude the precious gifts of the sultanates that preceded the empire and also the beautiful edifices exemplifying regional modulations of the generic style that have been left for us all over the land, from Kashmir to the Deccan, from Gujarat to Bengal.

A decisive victory in 1192 made Qutbuddin Aibak the first sultan and founder of a Muslim dynasty—the Mamluk or Slave dynasty—in the Delhi region. The most distinctive part of the Quwwatul-Islam mosque he built is the arched screen of Islamic pattern covering the whole front of the prayer hall. Though the arch shape is obtained through the imperfect old technique of laying successive courses of projecting stone in the corbel style, the screen is an impressive structure with a lofty central arch over sixteen metres high and six and a half metres wide and with smaller flanking arches, the entire surface beautifully textured with ornamental inscription. The Qutb Minar (Pl. 28) is really the detached tower of the mosque and consists of five stories, the top two being later additions or replacements. There are subtle variations that create overall harmony. The lowest storey has alternately round and angular flutings, the second has round flutings only and the third only angular; but the lines of the flutings are continuous over the three storeys. The tapering effect is optically enhanced by the diminishing heights of the storeys and the rhythmic punctuation of their terminals by galleries. These have elaborate stalactite corbelling of miniature arches on which boldly projecting balconies are supported. Freizes, some with ornamental and others with calligraphic motifs, further animate the surface. With this Minar, India begins her career as the possessor of Islamic architectural masterpieces as beautiful as the best of their class in the world. In 1310, Alauddin, the sultan of the next dynasty, the Khiljis, extended the mosque complex by adding the Alai Darwaza, a gateway resembling an antechamber. A square structure of red sandstone, it has acquired a stately decorativeness through the economic use of marble for framing the arches which are made up of wedge-shaped stones, a technique new to the region. The dome is shallow and the overall proportions modest; but the symmetry, the harmonised contrast of rounded arches and rectangular niches and the surface decoration in geometric patterns and calligraphy, in red and white, make it a beautiful structure.

This trend towards refined elegance receives a tonic infusion of martial vigour with the accession to power of the Tughlak dynasty early in the fourteenth century. The Tughlakabad fort built by Ghiyasuddin Tughlak is today in ruins. But its sharply

sloping walls made of huge irregular stones, with colossal circular bastions at close intervals and heavy battlements, make a profound impact in spite of the ravage of the centuries. Still well-preserved is Ghiyasuddin's tomb, a powerful presence in the landscape with the sharp batter or slope of its walls (Pl. 29). The Alai Darwaza, with its shallow dome and decorated surface, now seems demure in retrospect. With Ghiyasuddin's tomb, the design with a highly vaulted dome over a cuboid building on a square ground plan becomes the model for later tombs. The lotus-and-vase finial of the tomb, recalling the Hindu prototype, is a first step in synthesis and it too becomes a model faithfully followed subsequently. Kotla Firuz Shah, the new capital at Delhi built by Firuz Shah Tughlak, is today in ruins, but still conveys the feeling of massive architecture.

The short-lived Sayyid dynasty (1414-51) did not have the time to make important contributions to architecture, but the Lodi dynasty (1451-1526) made some significant contribution to the general evolution. The Lodi tombs are situated within a spacious walled enclosure with an ornamental gateway. Markedly different thus from the siting of the Tughlak tomb, this layout became the model for the extensive tomb-gardens of the Moghuls.

In 1526, Babur, who hailed from the small Central Asian principality of Farghana, "watered by the Gir, with its beautiful gardens of Usk gay with violets, tulips and roses in their seasons", convinced Sultan Ibrahim Lodi at Panipat that the latter's hundred thousand soldiers made a far less forceful argument for retaining Delhi than his own twelve thousand men. But we have to postpone for a little while the notice of the Moghul contribution, for one thing because historic vicissitudes delayed its commencement and secondly because impulses from the pre-Moghul sultanates had already seeded considerable architectural development in the various regions of India.

Regional Styles

Timber was for centuries the traditional material of construction in Kashmir and continued to be used after the establishment of Muslim rule there in 1339. The tombs, square in plan, consist of a cubical hall with a pyramidal roof rising in tiers of diminishing size and crowned by a slender spire. The mosque is very similar, consisting of a hall or a group of halls joined together by a row of columns. But the mosque usually has an open pavilion, between the apex of the roof and the base of the spire, from where the faithful are called to prayer. The mosque of Shah Hamadan in Srinagar is two-storeyed but has this pavilion. The Jami mosque in Srinagar, founded by Sultan Sikandar (1389-1413) but burnt down and restored several times, is a more ambitious construction. It consists of a rectangular court surrounded by colonnades on four sides, each side having an arched front and a spacious hall. The pillars, each made of a single log, vary from seven to fifteen metres in height.

Bengal came under Muslim rule immediately after the close of the twelfth century. Here too, the rulers adopted the indigenous tradition of construction with bricks, though stone too was used wherever possible, terracotta decoration of surface

and above all the curvilinear roof derived from the earlier bamboo construction. This last feature was so enthusiastically assimilated that we find it used for its value as a decorative design in Moghul buildings much later. The most important legacy here is the Adina mosque constructed by Sikandar Shah (1359-83) at his new capital of Pandua. The building is of considerable size, with a large courtyard surrounded on all sides by cloisters formed by eighty-eight archways each leading into a cluster of bays and covered by 378 small domes. The structure perhaps suffers from the lack of a portal matching its magnitude. But it has an exquisite Mihrab. Here we see already the cusped or scalloped arch which will later become a characteristic feature of Shah Jahan period architecture.

In Gujarat, the Muslim rulers extensively used the indigenous trabeate style in preference to the arch, vault and dome, especially in memorial buildings. Characteristic too are the structural devices and elements for the controlled and gracious lighting of interiors. The Jami mosque of Ahmedabad built in 1424 by Ahmed, second sultan of Gujarat, is one of the largest and most beautiful moques of India (Pl. 30). Impressive and yet elegantly sensuous is the facade, with richly carved mouldings and string-courses of the buttresses of the central entrance. The decorative motifs here are varied from band to band. In one, miniatures of the bastion are repeated as motifs in a way that recalls the surface decoration of the sanctum tower of Hindu temples. The hall of prayer has 260 columns. The elegant solution for the problem of lighting the hall is the raising of the central compartment to three storeys with pillar-supported galleries enclosed by perforated stone panels. The grille designs are geometric but varied. Though smaller and simpler, the mosque attached to the tomb of Sayyid Alam in Ahmedabad, built around 1500, is perhaps still more elegant (Pl. 31). The hall consists of three vaulted aisles. The distances between the columns are deliberately varied as are the proportions of the three deeper and eighteen shallower domes that roof the hall. Smaller still and even more beautiful is Rani Sabrai's mosque (1514), with its tall and slender minarets, delicate traceries and jewel-like carvings (Pl. 32). Another architectural gem of Ahmedabad is Sidi Said's mosque (1572) whose perforated stone windows are some of the most beautiful in the world. They are filled with floral and geometric patterns. The arborescent designs have the lushness of a tropical forest; nevertheless they preserve a great clarity of line all through their interlacing rhythms.

Malwa declared itself independent of the Delhi Sultanate early in the fifteenth century, with a capital first at Dhar and later at Mandu. Unlike Gujarat, Malwa preferred building with arches and the robust arch-and-vault construction of the large Jami mosque (Pls. 33, 34), completed in 1454, and the austere form of Hoshang Shah's tomb (Pls. 35, 36) recall the style of Tughlak architecture. The thick and sloping walls of the Hindola Mahal strengthen this impression. It is a T-shaped building, the stem being an assembly hall and the bar being a group of private apartments. But the sternness of the general mass is tempered by arches, oriel windows and perforated stone screens. In the Jahaz Mahal, which stands between two small lakes and was intended to be a pleasure palace, the rigour relaxes and the impact is more unreservedly gracious.

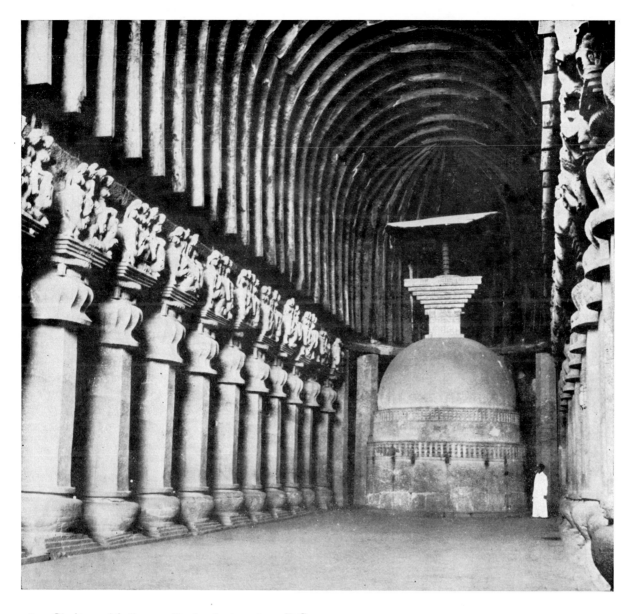

1. Chaitya with Stupa. Karle, first century B.C.

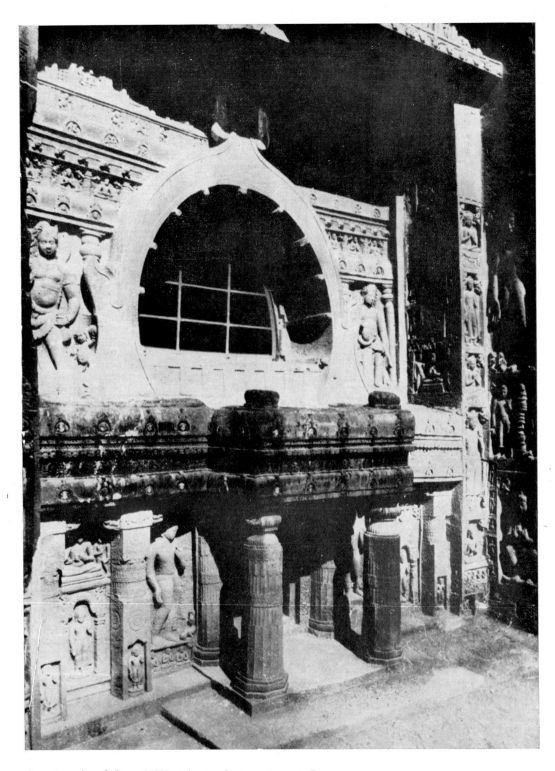

2. Facade of Cave XIX. Ajanta, first century A.D.

→ 3. Ramalingesvara Temple. Satyavolu, Andhra Pradesh, early eighth century.

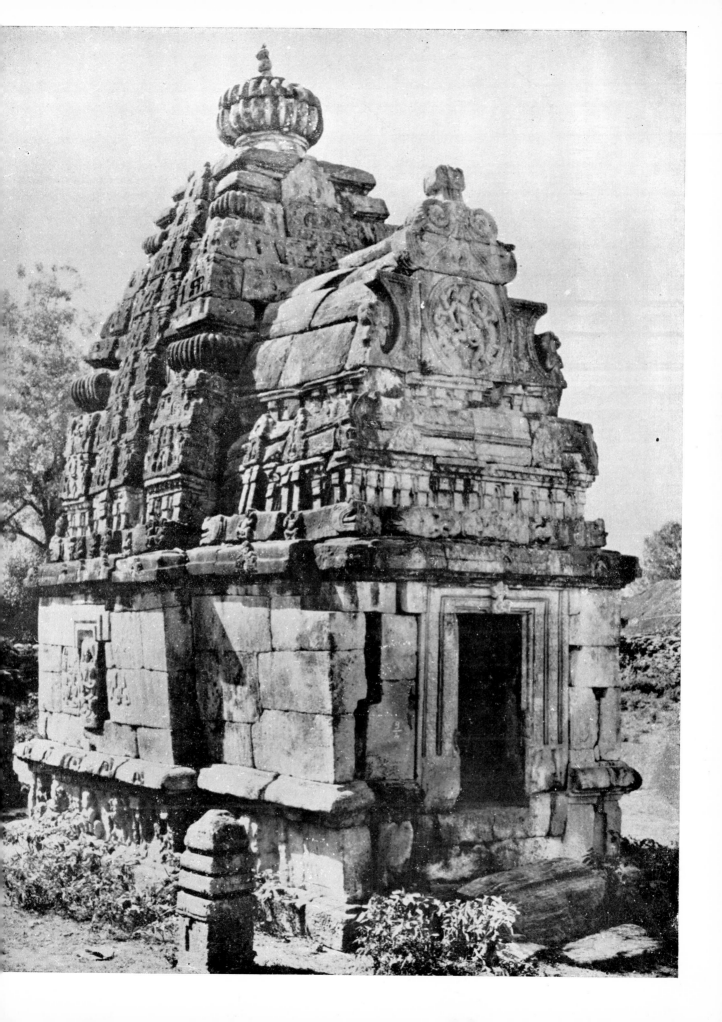

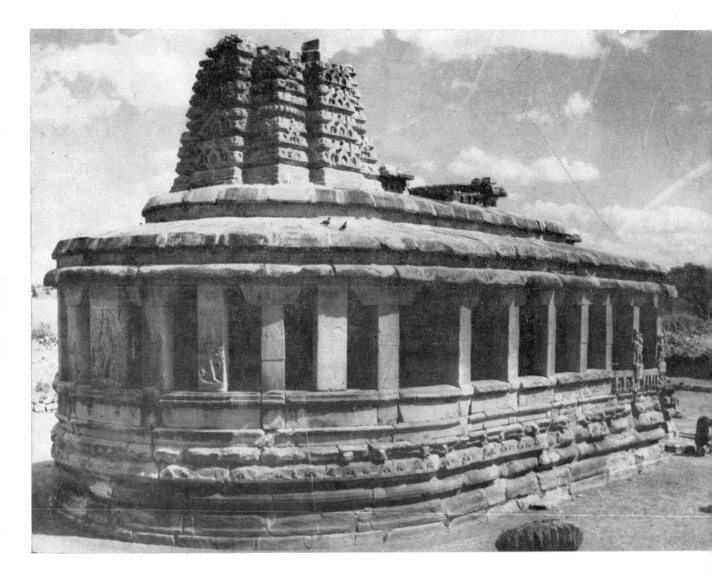

4. Durga Temple. Aihole, late fifth century.

→ 6. Kailasa Natha. Elephants represented as bearing the ten

Shrine tower, Kailasa Natha Temple. Ellora, eighth century.

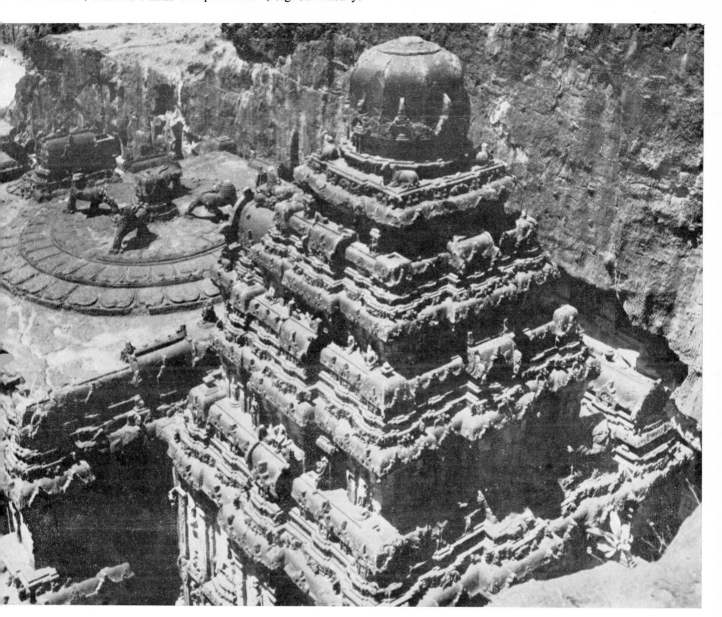

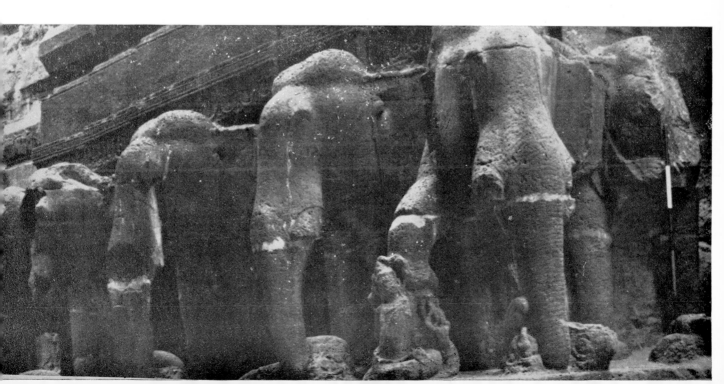

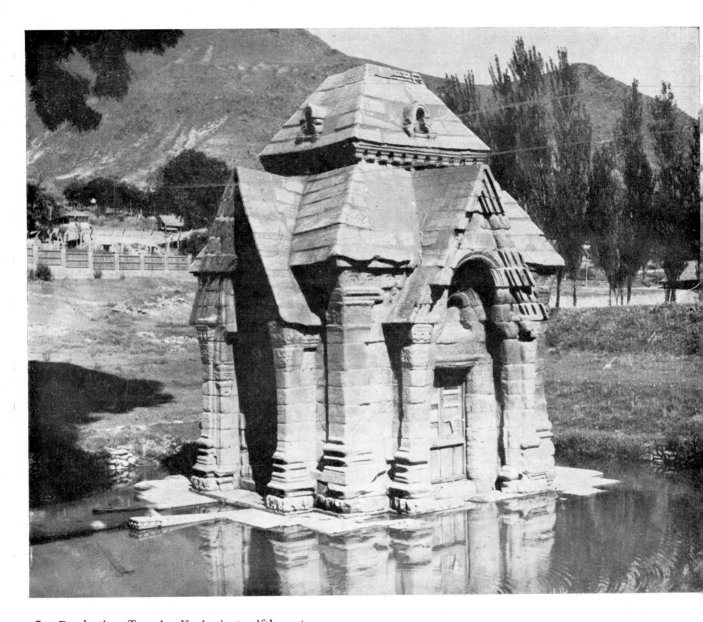

7. Pandrethan Temple. Kashmir, twelfth century.

→ 9. Sculptural cladding, Khandariya Mahadeva Temple. Khajuraho, Chandella perio

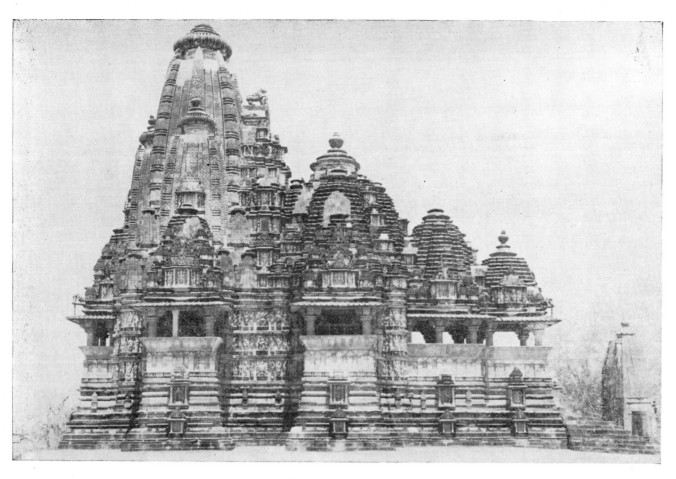

8. Visvanatha Temple. Khajuraho, Chandella period, tenth to twelfth century.

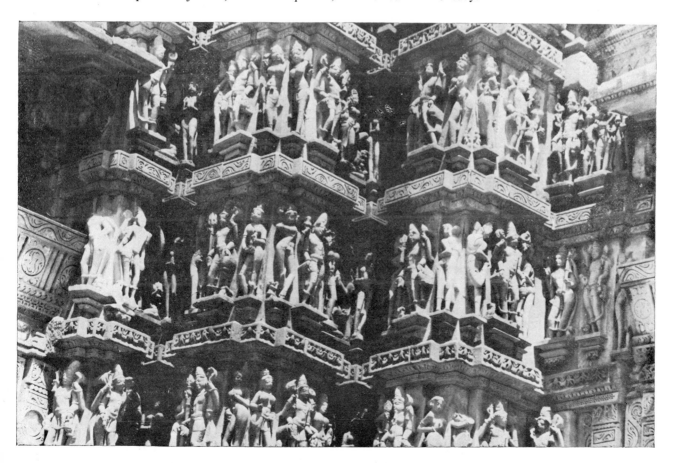

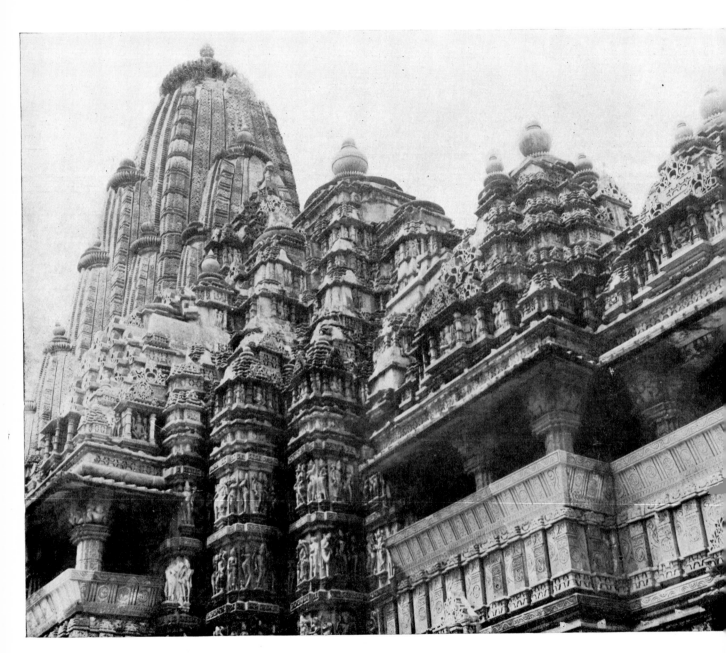

10. Detail showing architectural articulation, Khandariya Mahadeva Temple.

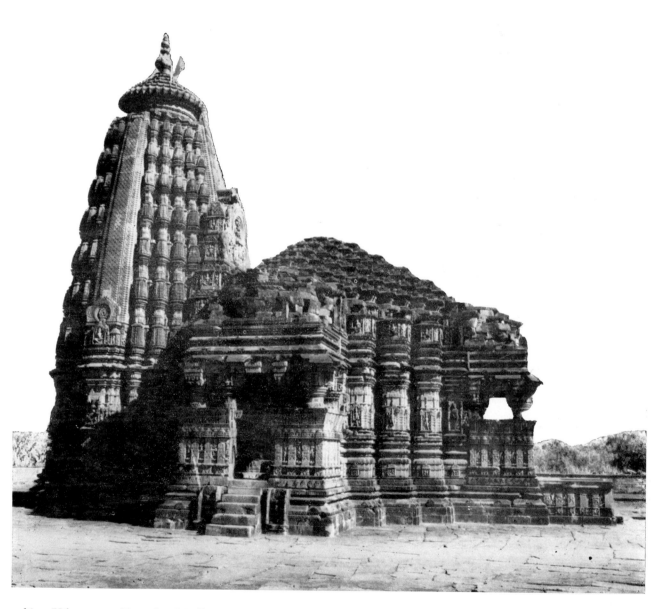

11. Udayesvara Temple. Madhya Pradesh, eleventh century.

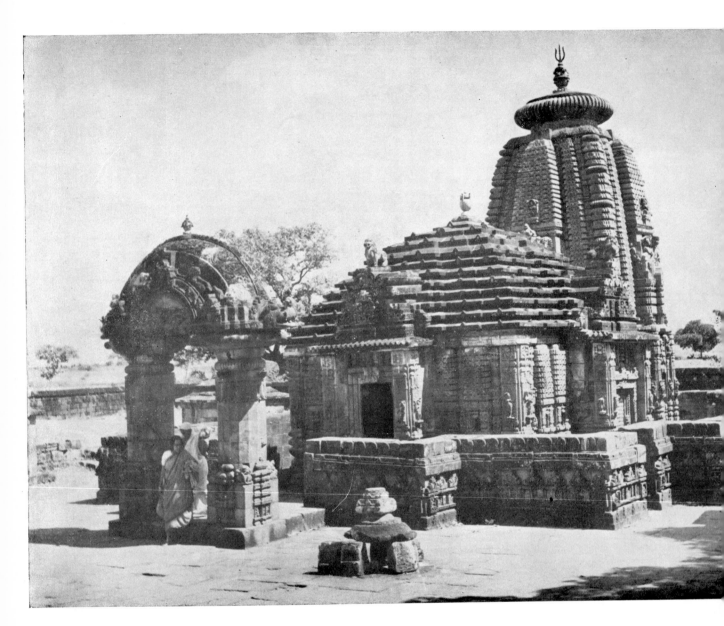

12. Mukteshvara Temple. Bhuvaneshvar, tenth century.

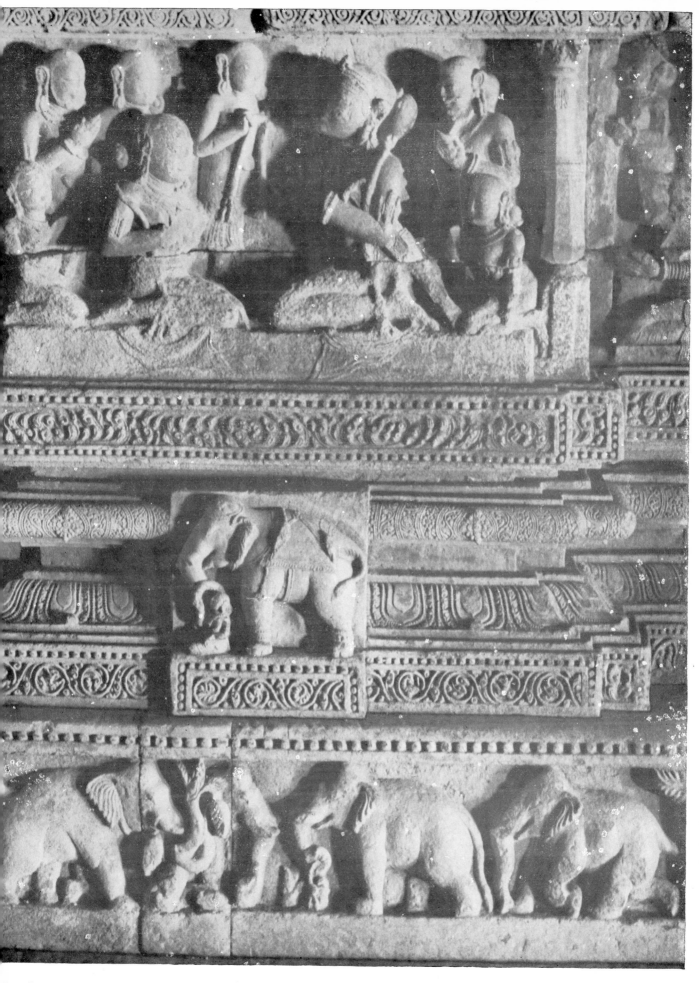

3. Sun Temple. Platform friezes and mouldings. Konarak, thirteenth century.

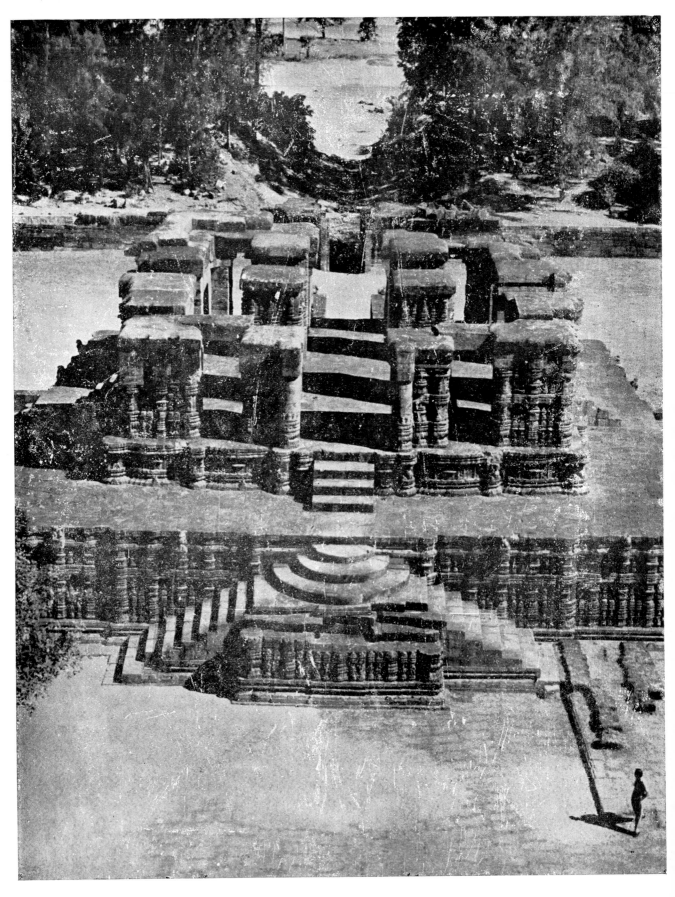

14. Dance Hall of Sun Temple.

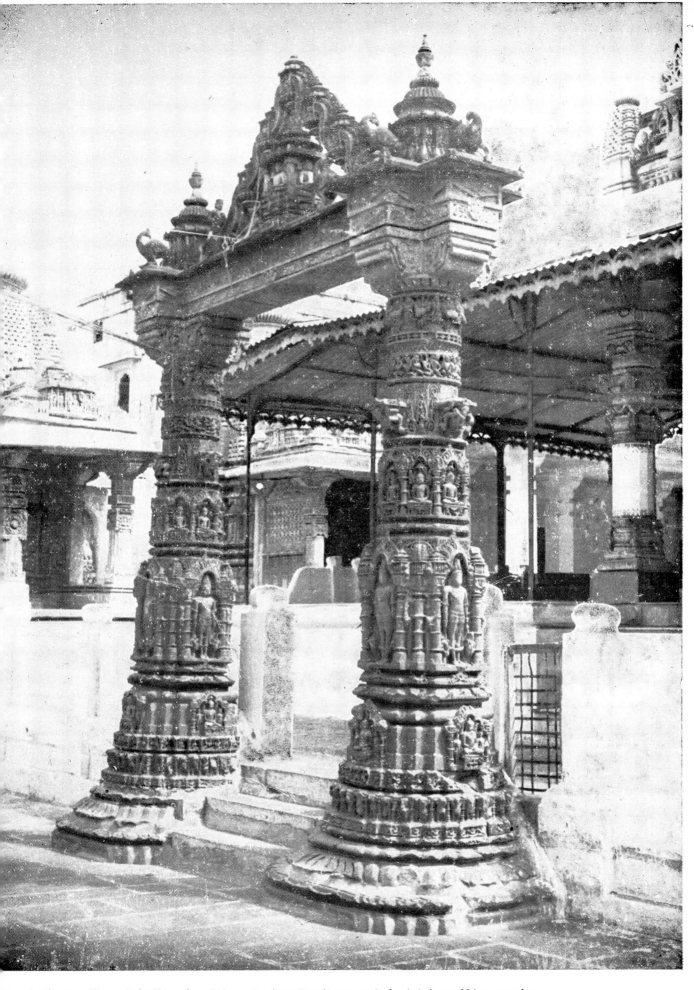

5. Archway pillars, Jain Temple. Osian, Gurjara-Pratihara period, eighth-twelfth centuries.

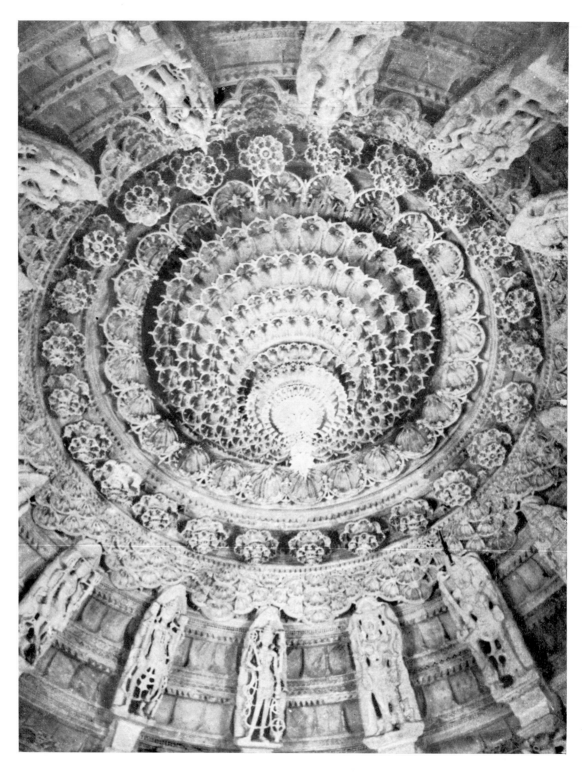

16. Ceiling, Adinatha Temple. Dilwara, eleventh century.

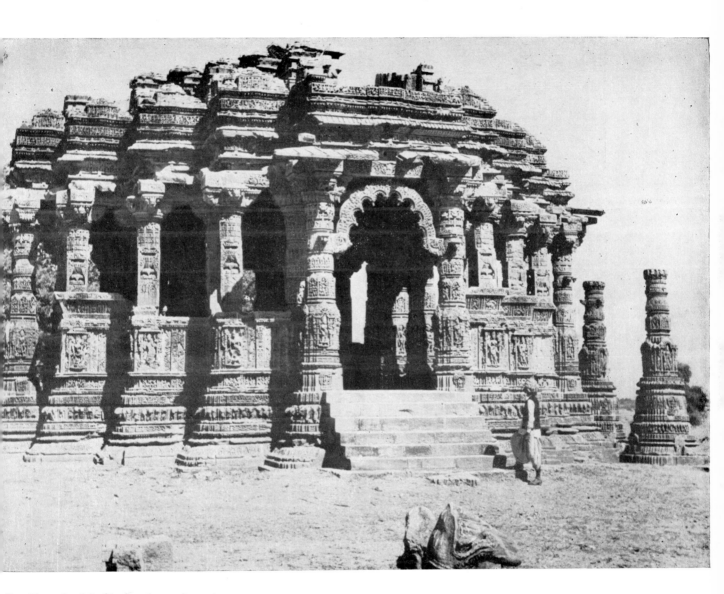

Sun Temple. Modhera, eleventh century.

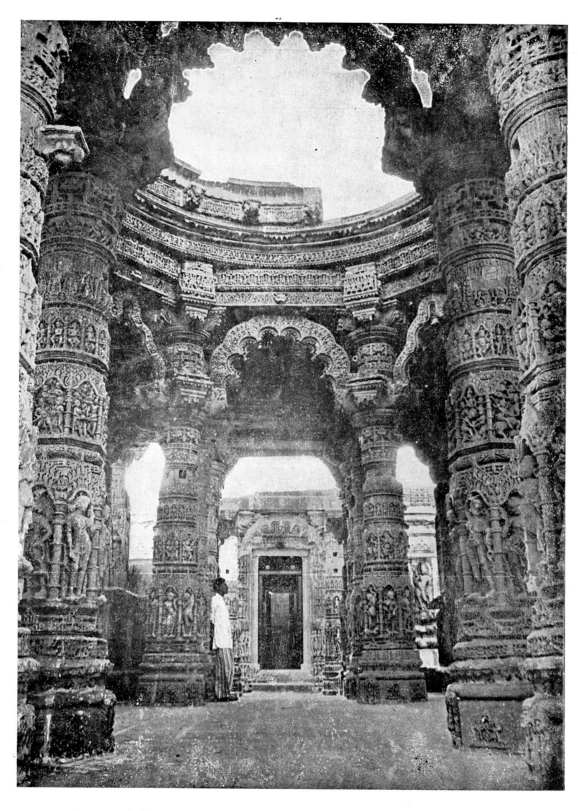

18. Dance Hall. Sun Temple of Modhera.

Trikutesvara Temple, decorative motifs of exterior. Gadag, eleventh century.

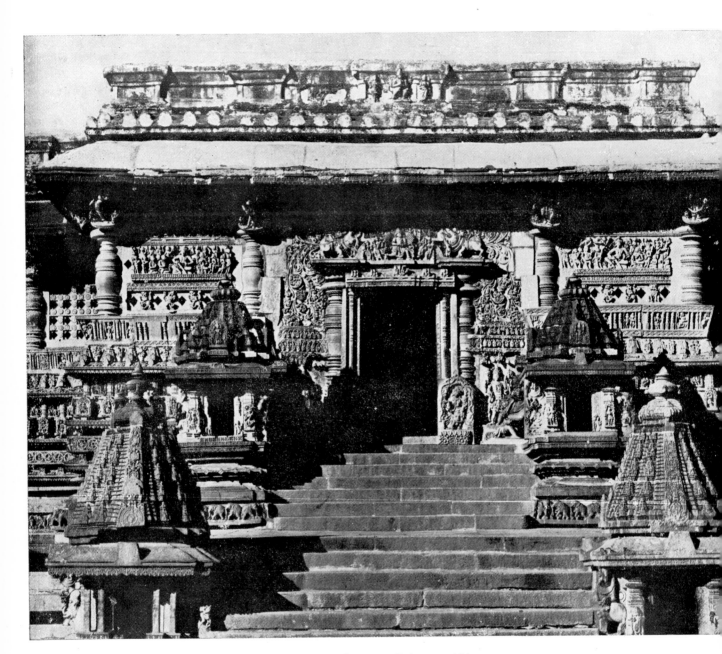

20. Chenna Kesava Temple, shrines flanking approach steps. Belur, twelfth century.

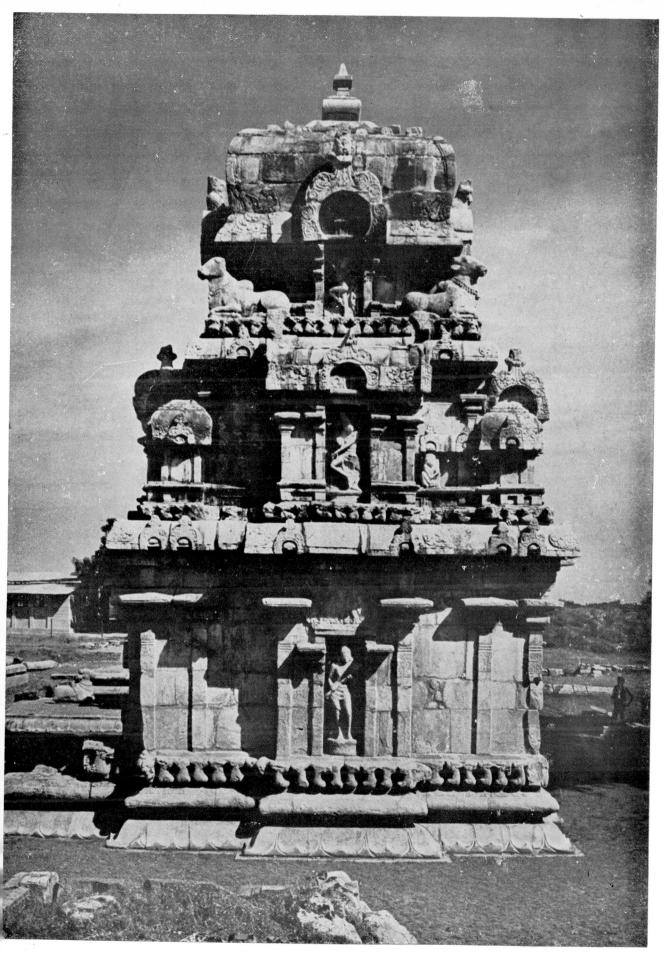

21. Muvarkoil Temple. Kedambalpur, Tamil Nadu. Chola, ninth century.

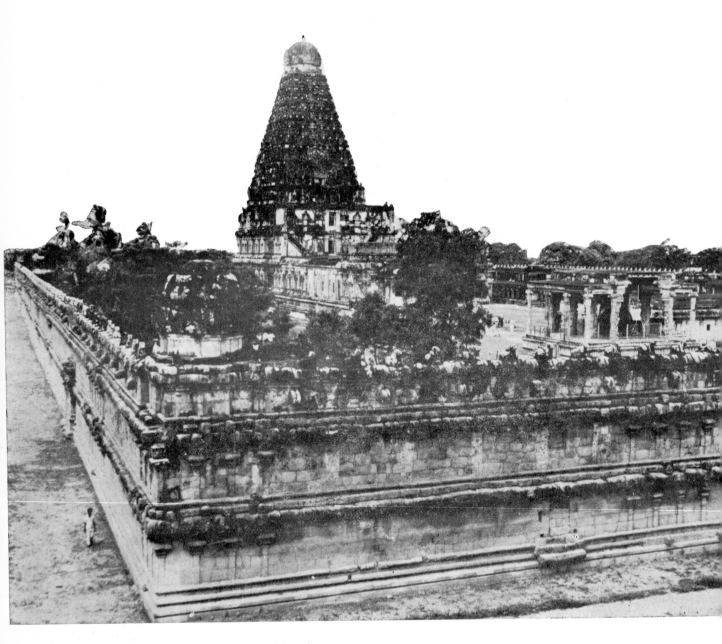

22. Brihadisvara Temple. Tanjore, Chola, eleventh century.

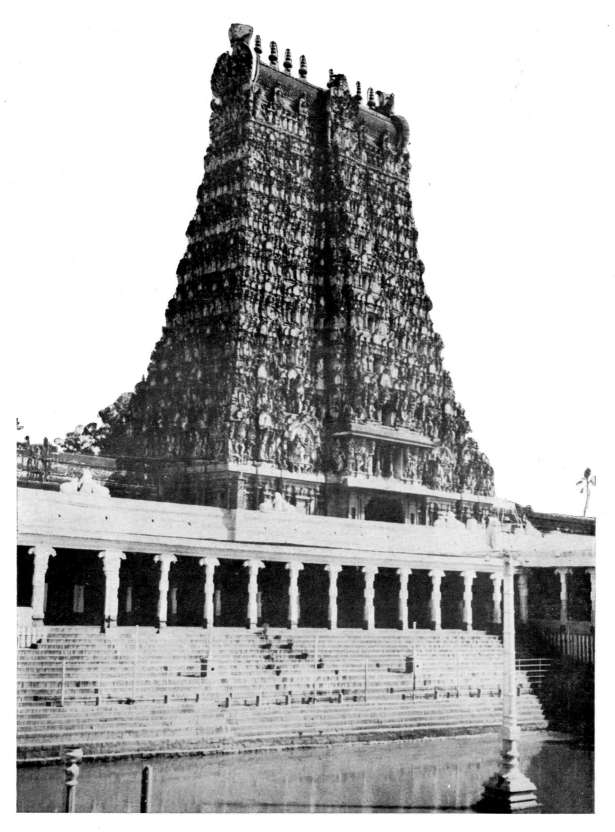

23. Gateway tower and tank, Meenakshi Temple. Madura, seventeenth century.

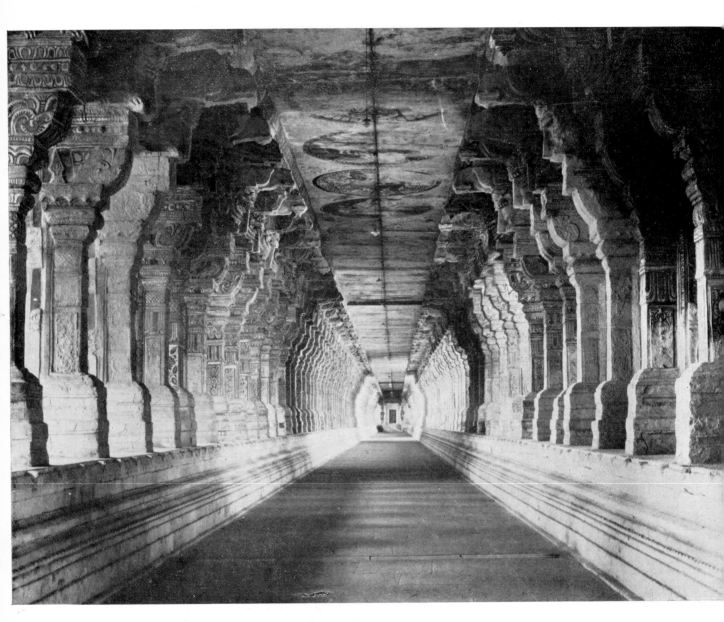

24. Pillared corridor of temple. Rameshvaram, seventeenth century.

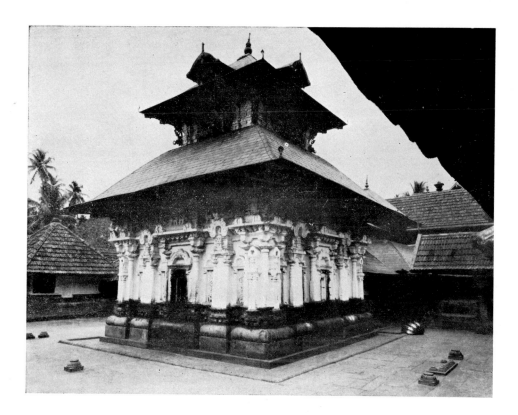

25. Tiruvanchikulam Temple. Kerala, tenth century.

26. Circular Temple. Tiruvanam, Kerala.

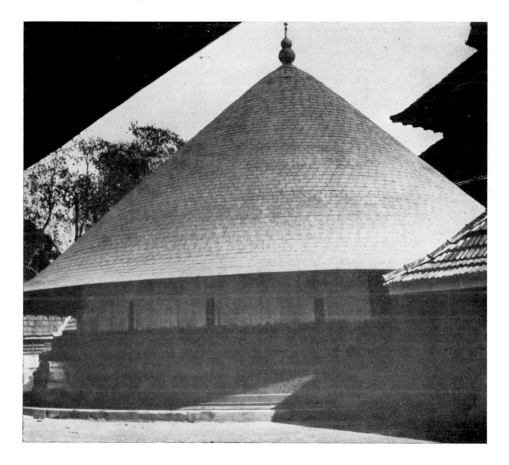

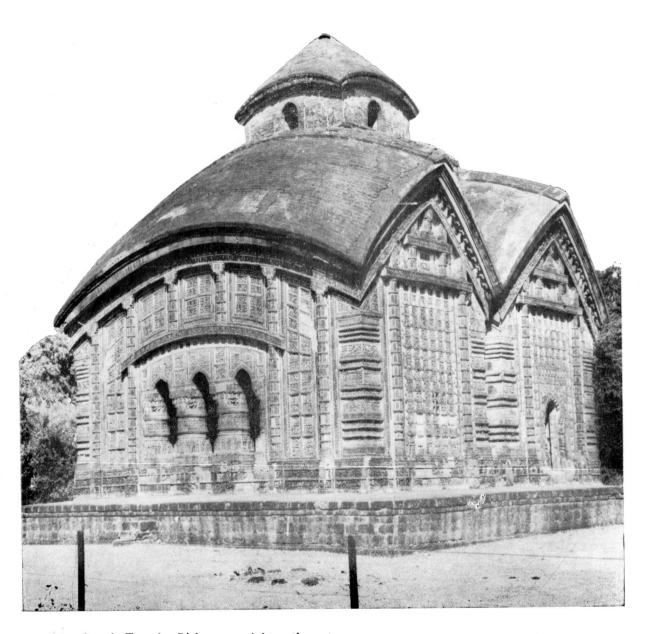

27. Jor Bangla Temple. Bishnupur, eighteenth century.

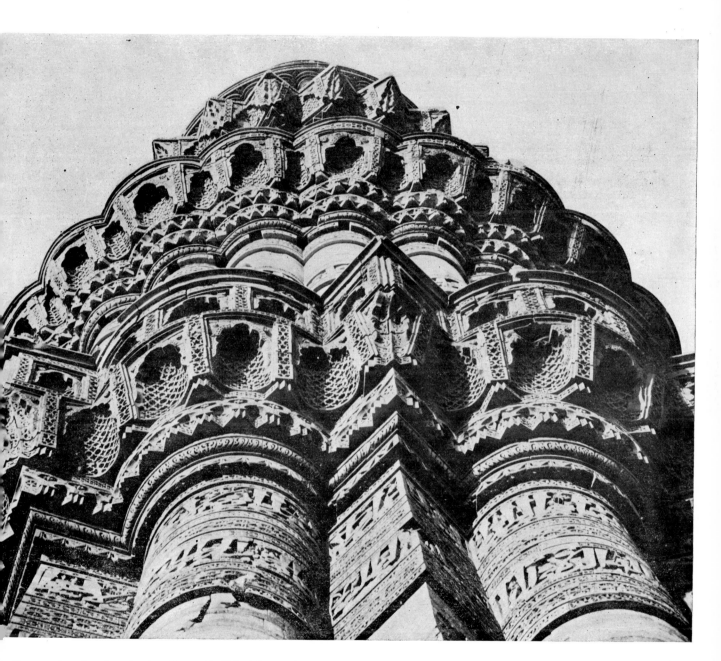

Decorative details, Qutb Minar. Delhi, thirteenth century.

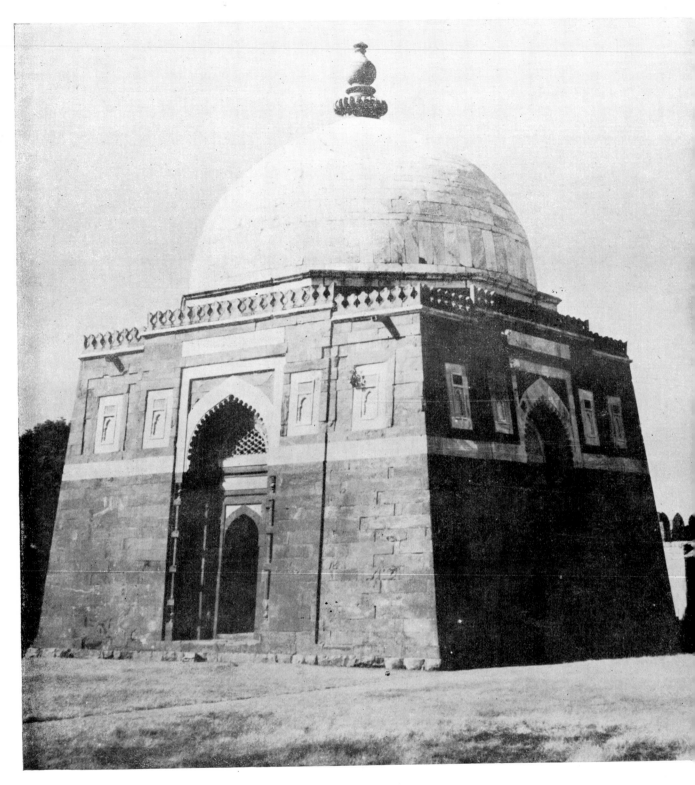

29. Ghiyasuddin Tughlak's Tomb. Delhi, fourteenth century.

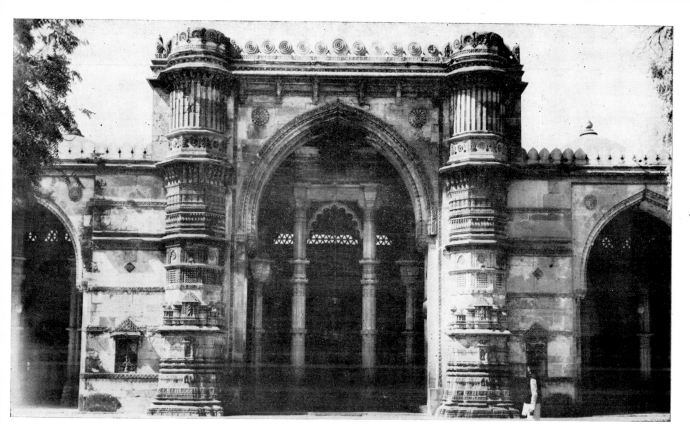

30. Facade of Jami Masjid. Ahmedabad, early fifteenth century.

31. Corridor, Sayyid Alam's Tomb. Ahmedabad, c. 1500.

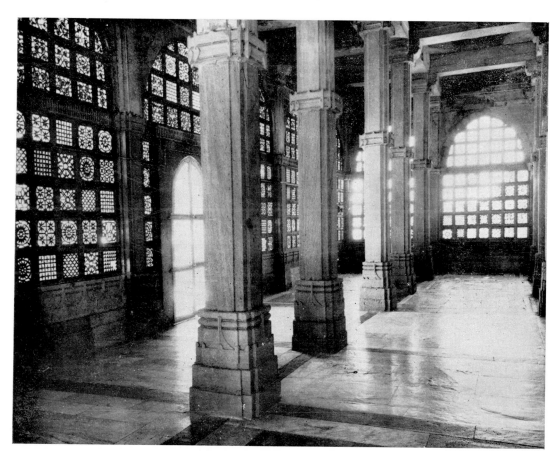

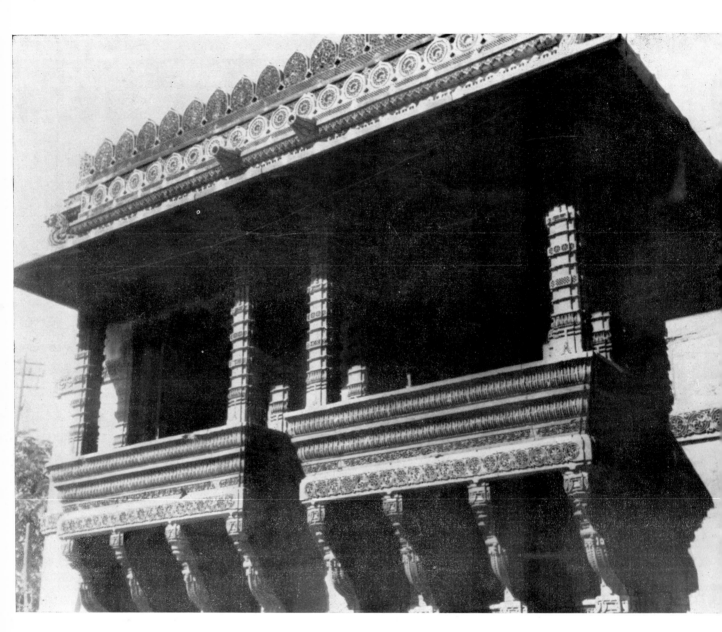

32. Rani Sabrai's Mosque. Ahmedabad, sixteenth century.

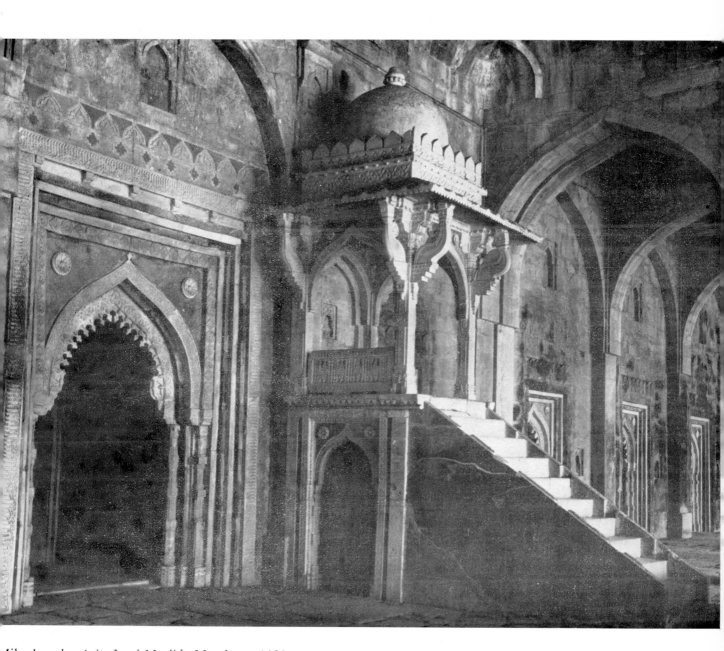

Mihrab and pulpit, Jami Masjid. Mandu, c. 1454.

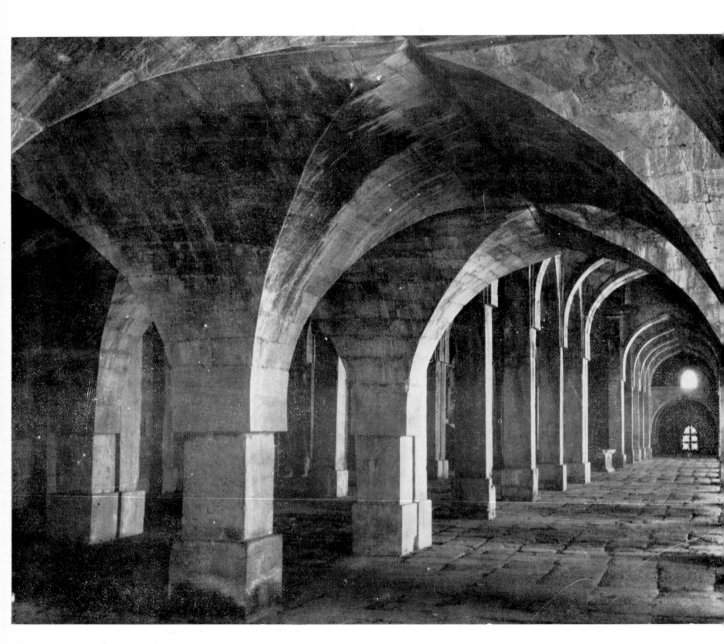

34. Arches, Jami Masjid. Mandu.

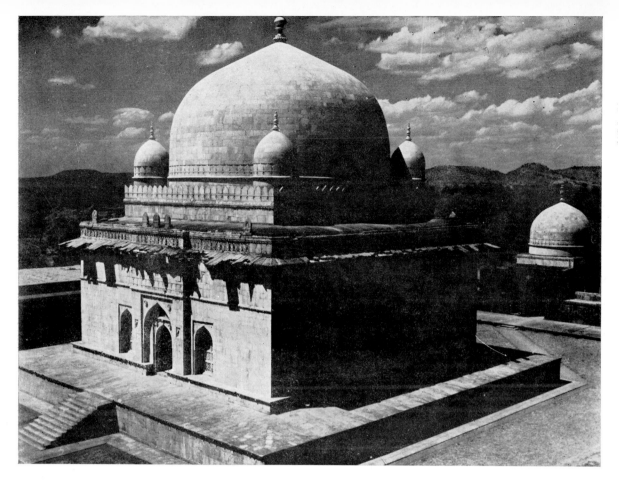

35. Hoshang Shah's Tomb. Mandu, c. 1440.

36. Hoshang Shah's Tomb, interior.

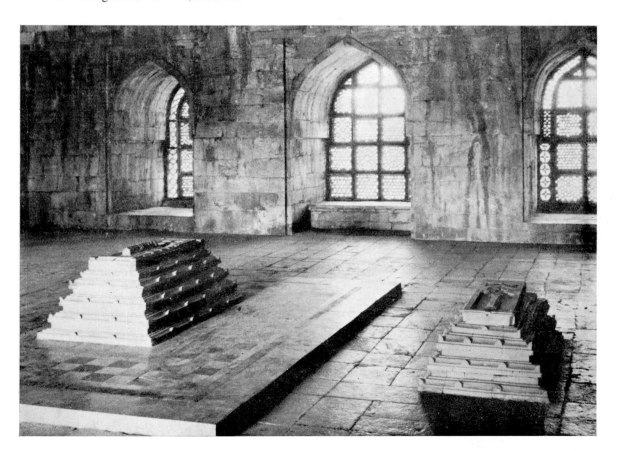

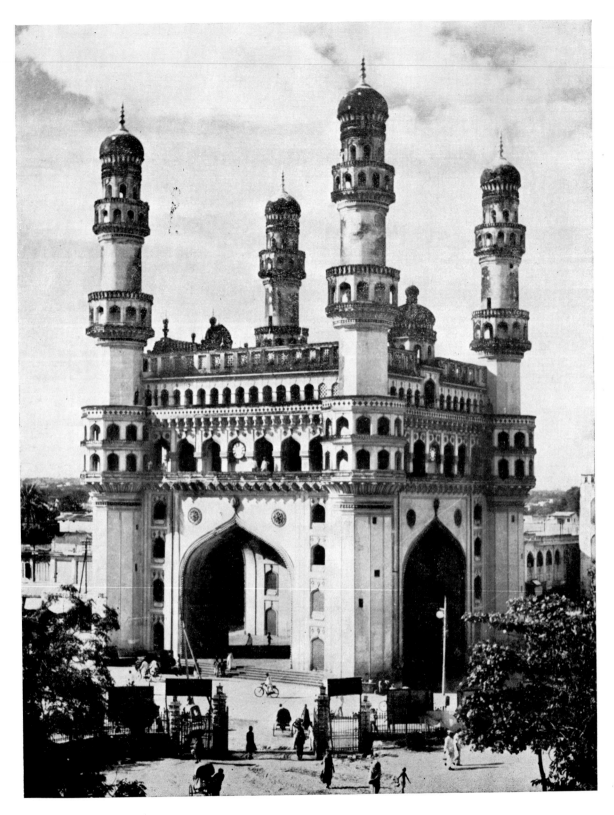

37. Char Minar. Hyderabad, c. 1591.

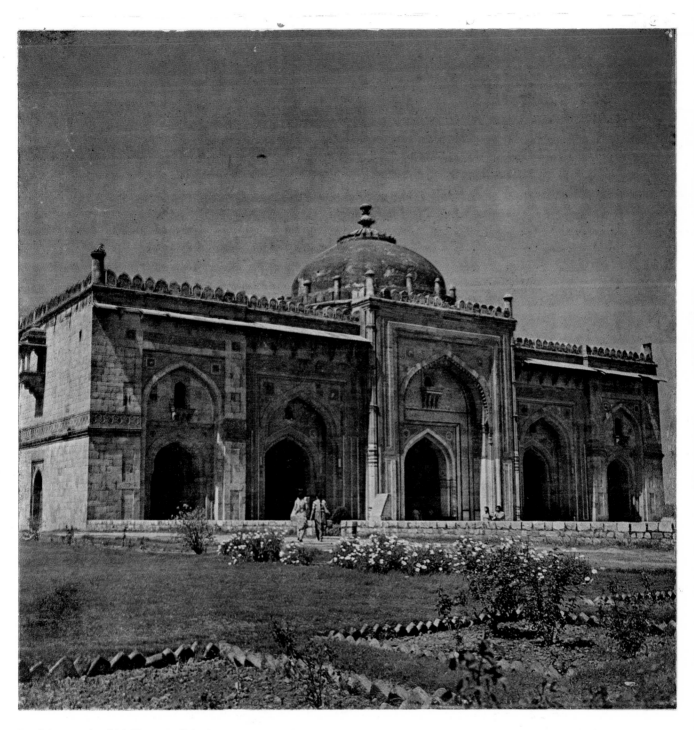

I. Mosque in Old Fort. Delhi, sixteenth century.

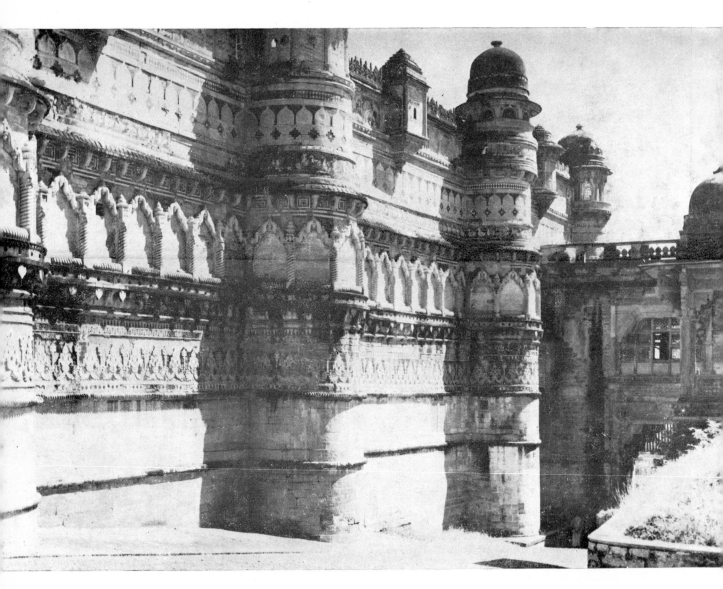

38. Man Singh's Palace. Gwalior, early sixteenth century.

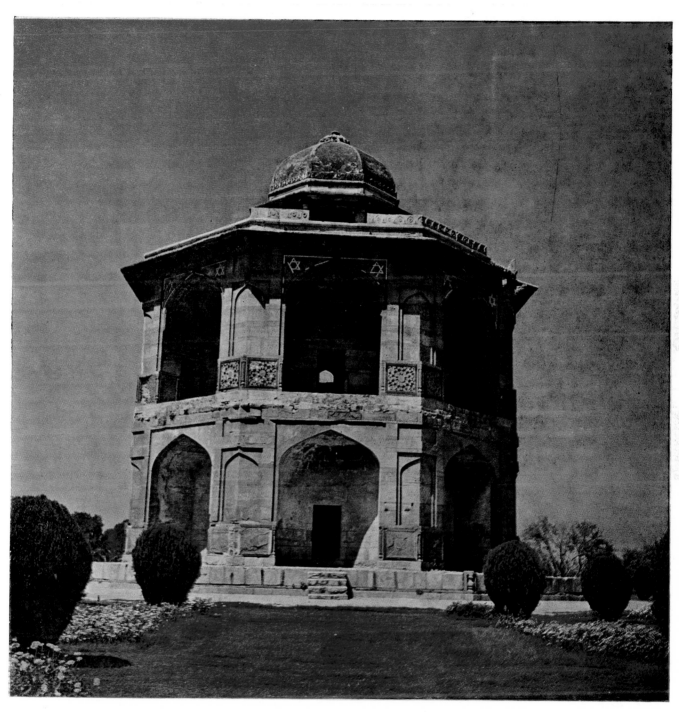

II. Sher Mandal, Old Fort. Delhi, sixteenth century.

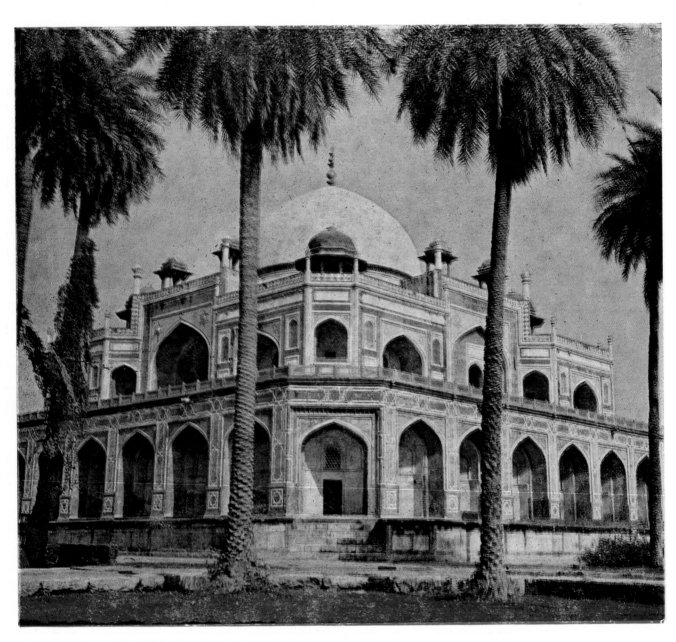

III. Humayun's Tomb. Delhi, late sixteenth century.

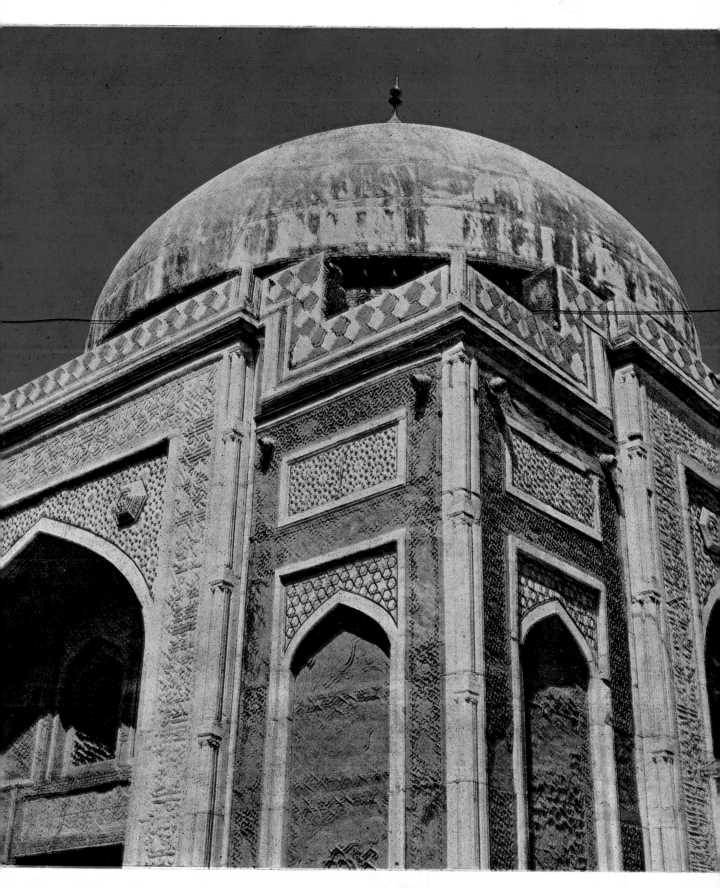

mb of Atagah Khan. Delhi, late sixteenth century.

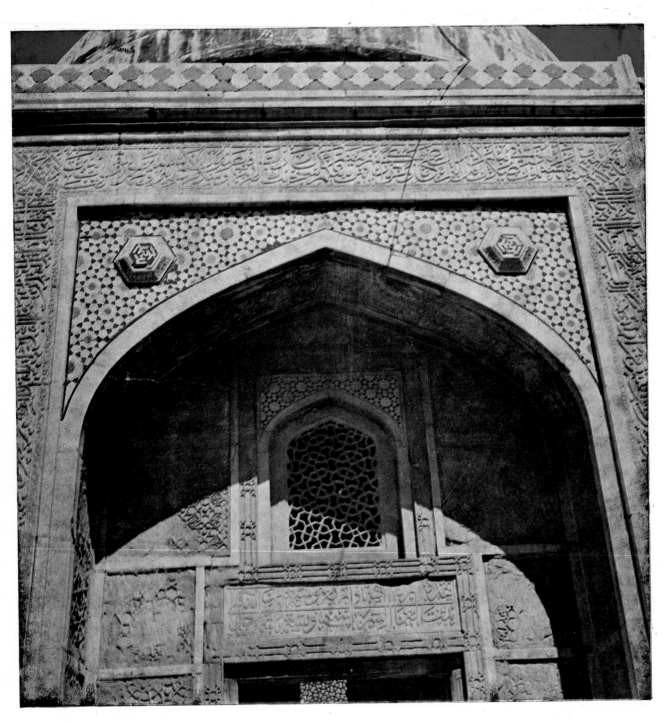

V. Tomb of Atagah Khan, detail.

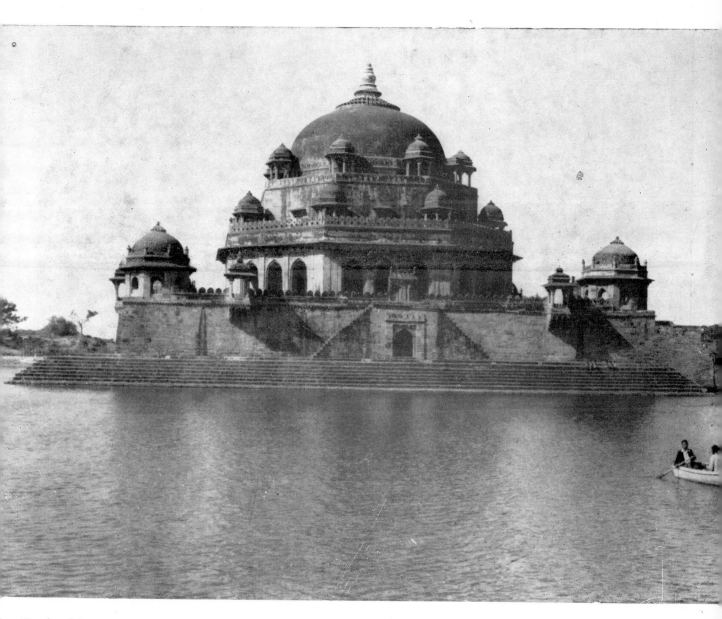

Tomb of Sher Shah Sur. Sasaram, sixteenth century.

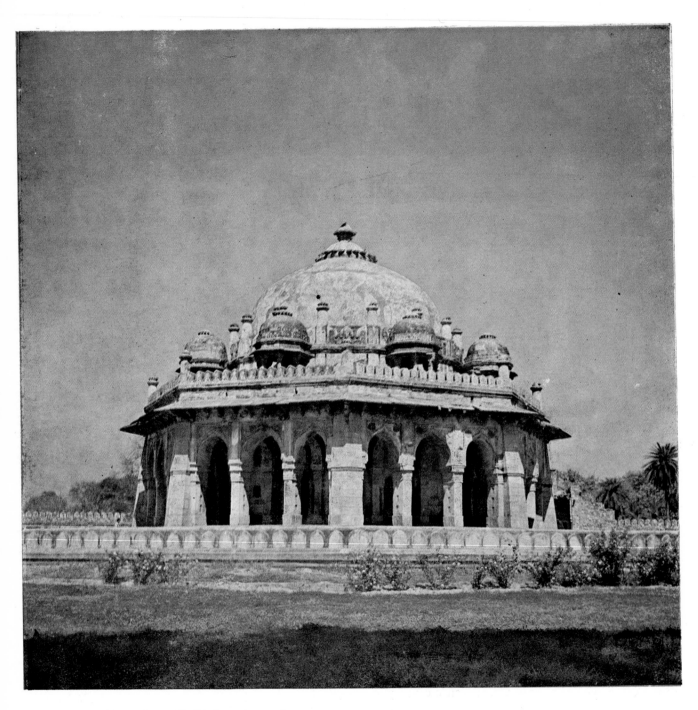

VI. Tomb of Isa Khan. Delhi, late sixteenth century.

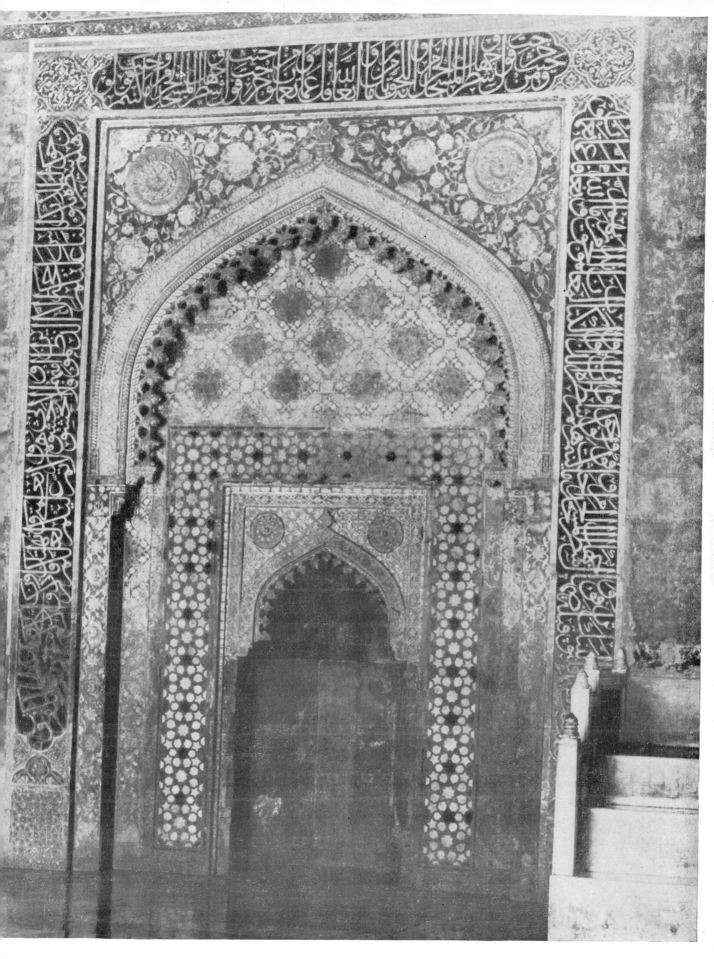

Mihrab, Darga Salim Chisti. Jami Mosque. Fatehpur Sikri, late sixteenth century.

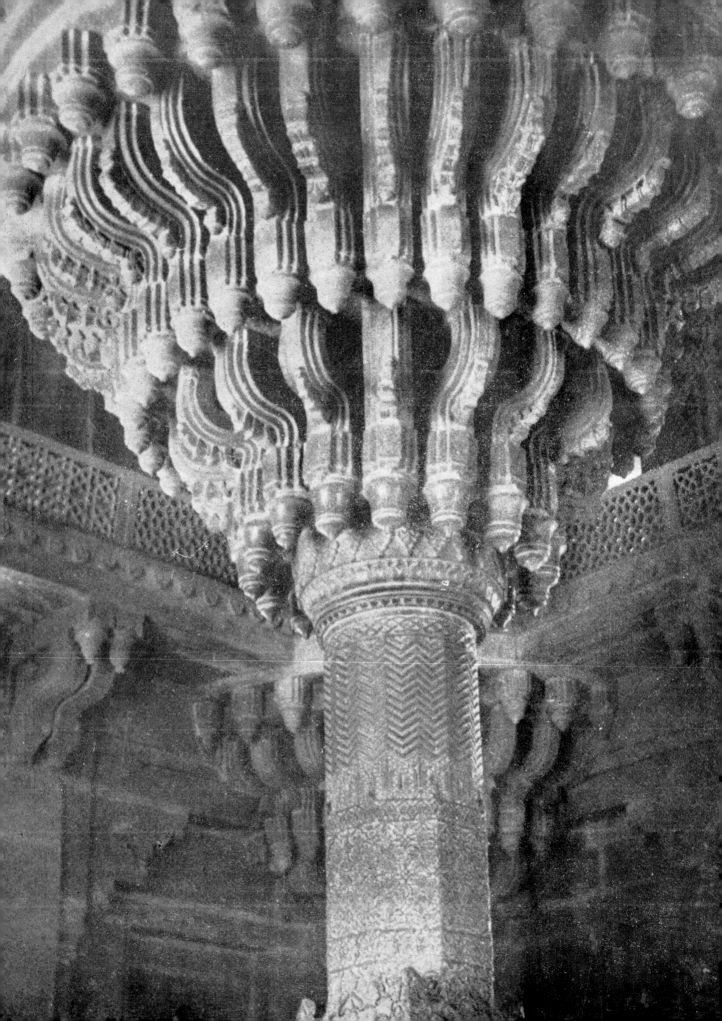

Pillar. Fatehpur Sikri, late sixteenth century. Courtesy O.P. Sharma.

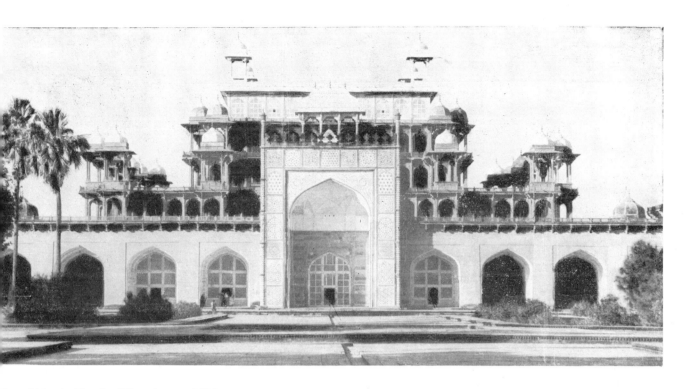

2. Akbar's Tomb. Sikandra, c. 1663.

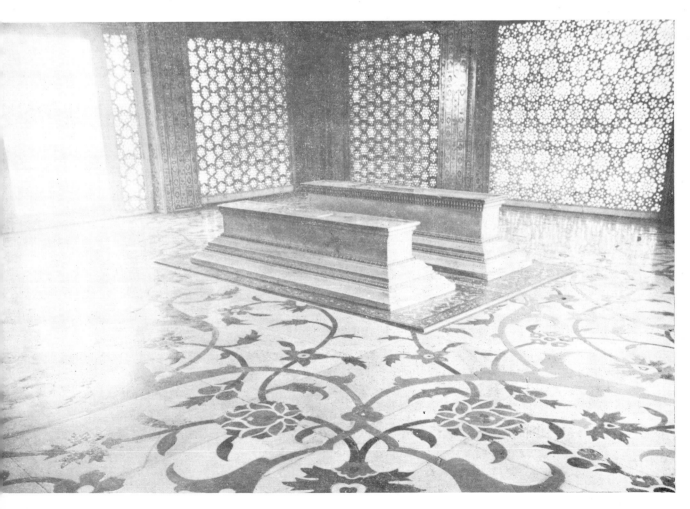

3. Screens and floor inlay. Tomb of Itimadud Daula. Agra, c. 1626.

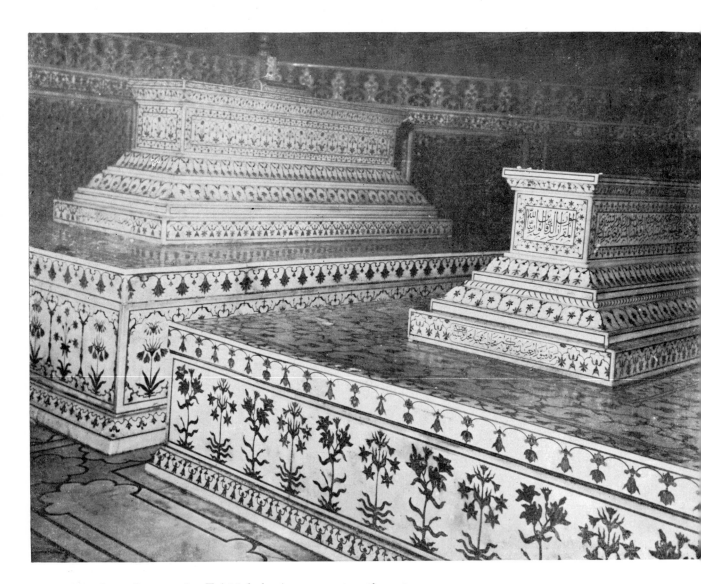

44. Chamber of cenotaphs, Taj Mahal. Agra, seventeenth century.

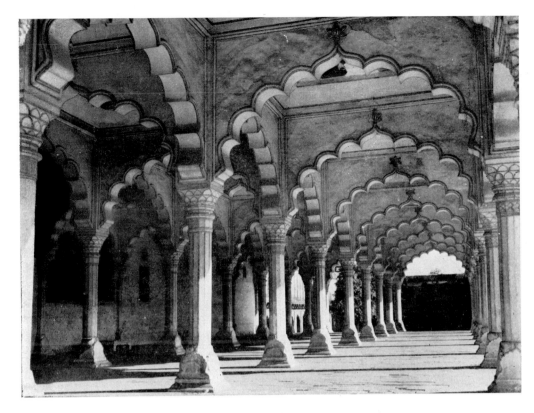

45. Public audience hall. Agra Fort, late sixteenth century.

46. Taj Mahal. Agra, seventeenth century.

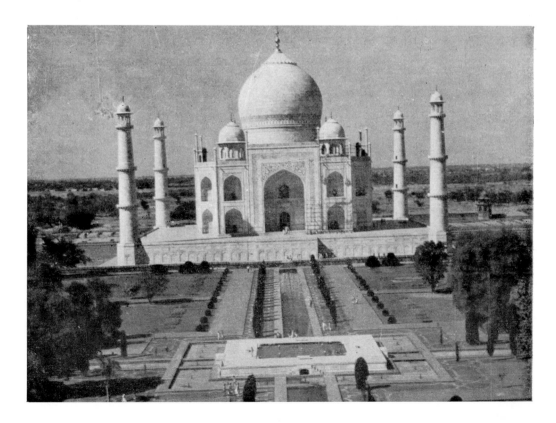

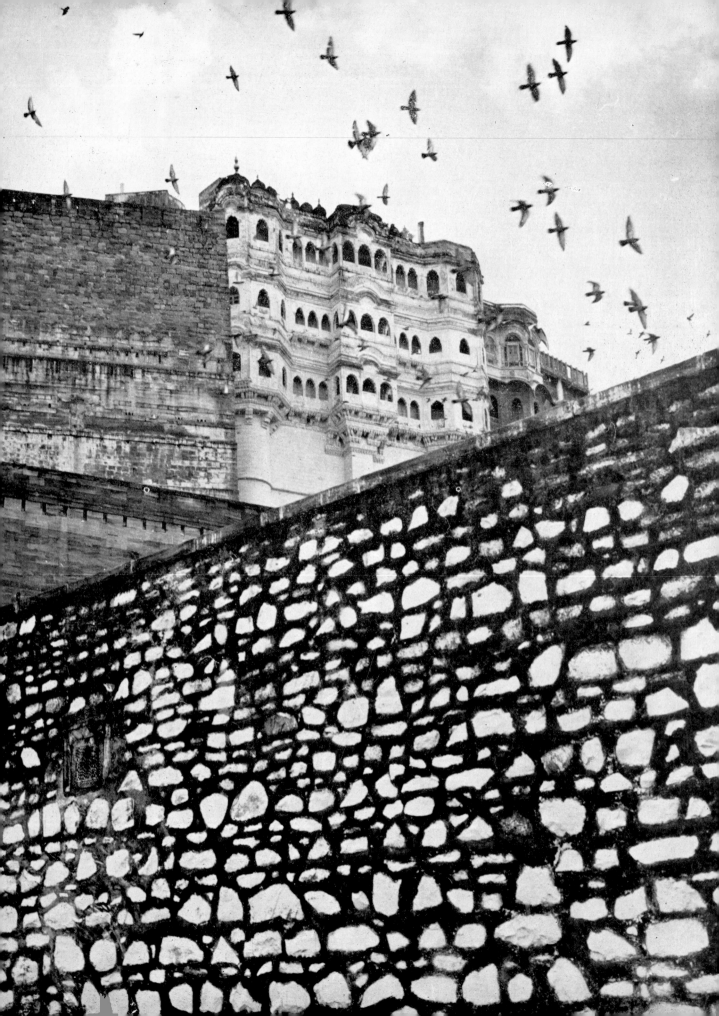

48. A balcony in a Rajput mansion.

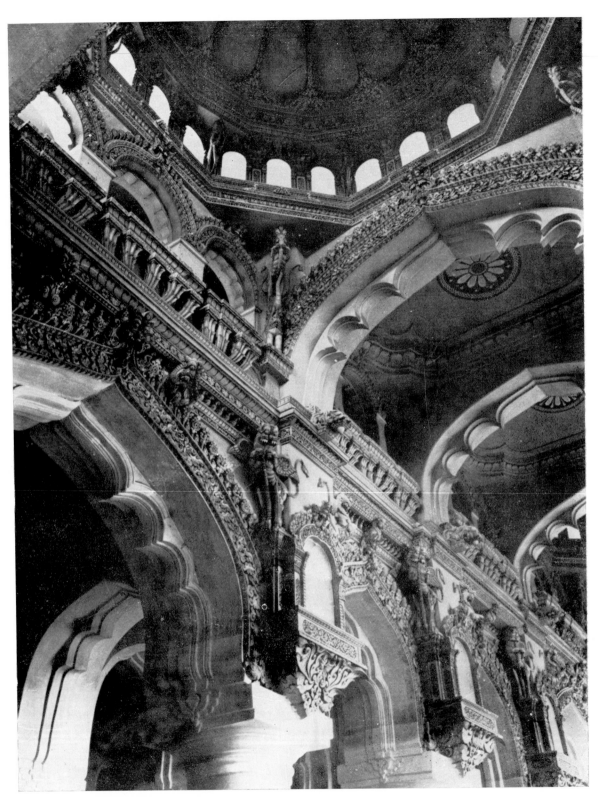

49. Interior, Nayak Palace. Madurai, seventeenth century.

The governor of the Tughlaks in Jaunpur declared his independence in 1394 and founded the Sharqi dynasty which however remained fairly loyal to the Tughlak tradition in architecture, as can be seen in the Atala mosque completed around 1408. The Sharqis introduced a new feature, further strengthening Tughlak monumentalism. This is the pylon in the facade. The Atala has three pylons, the central one being of gigantic size. It consists of a lofty recessed arch set within two square sloping towers. The heavy impact of the mass, however, is considerably lightened because it is opened up by small arched niches and stone-screened windows. The Atala served as the model for the largest legacy of Jaunpur, the Jami mosque built during the third quarter of the fifteenth century. In addition to having an impressive pylon, the Jami has been raised on a lofty plinth with impressive flights of approach steps. There are also two imposing side-wings to the central chamber that are single-vaulted, without using pillars.

History was more chequered in the Deccan. Alauddin Khalji had thrust deep into the Deccan in 1294, the Tughlaks had stabilised Delhi hegemony. But the Bahmanis declared their independence in 1347, ruling first from Gulbarga and later from Bidar. The Bahmani house itself splintered later, the most important successors being the Nizam Shahis of Ahmadnagar, the Adil Shahis of Bijapur and the Qutb Shahis of Golconda.

If Bahmani architecture in its early phase followed the Tughlak style, novel features are seen in the Jami mosque of 1367 in the Gulbarga fort. The cloisters are wide-spanned and supported on low piers. The courtyard is not open but has been covered. The main dome has been placed on a lofty square base. The broad low arches and the dome on a square base will from now on be regular features of Islamic architecture in India.

In the architecture of the Nizam Shahis at Ahmadnagar, indigenous influences are blended happily with those streaming from Gujarat and Malwa. The Damri mosque recalls Rani Sabrai's mosque in Ahmedabad in its gem-like beauty and has graceful towers with ornamental balconies. Equally distinctive is the early seventeenth century Dilawari mosque at Khed in Poona district. The central dome-on-drum has been replaced by a full-fledged tomb-like structure, with all its features of eaves, parapet, corner kiosks and circular drum supporting a shapely full dome.

Of the Adil Shahi legacy at Bijapur, the finest is the complex known as Ibrahim Rauza which consists of the mosque and tomb of Ibrahim II (1580-1627). Structurally and aesthetically, the tomb is one of the finest historical buildings of the Deccan. In the double verandah enclosing the square central chamber, the central of the seven arches on each side is wide-spanned and is flanked by a triplet on either side, a narrow arch framed by wide-spanned arches in each triplet. This makes the visual rhythm less rigorous, more relaxed, and prepares the eye for the decorative liveliness of the upper part of the building with richly executed cornices and beautiful brackets, tidy lines of perforated parapets with their decorative scansion through miniature tombs and minaret motifs, tall minarets rising from each corner, and finally the shapely dome rising out of a band of petals. If less elegantly decorative, the Gol

Gumbaz, the mid-seventeenth century mausoleum of Muhammad Adil Shah built during his own life-time, is a monumental achievement in architecture in which a dome with a diameter of about 37 metres has been supported by the pendentives of the arches.

The Qutb Shahis of Golconda built several fine mosques like the Jami (1597) with its fine facade having two rows of arches one above the other, the massive Mecca mosque of the early seventeenth century and the small but exquisite Toli mosque (1671), with its abundant decoration assimilated from Hindu architecture. More well-known than these is the Char Minar, the stately gateway in Hyderabad erected in 1591 (Pl. 37). A guardhouse at the crossing of the two main roads of the city, it is a square structure with lofty arched openings on all four sides. It is four-storeyed, the rhythmic scansion of arches and decorative motifs varying from storey to storey, and has four graceful minarets at the corners with elegantly decorated rings of balconies and shapely domes.

Babur ruled his new-won empire from horseback, always felt nostalgic about the central Asian uplands of his youth and rests today in a tomb in Kabul. He died in 1530, but his son Humayun was never secure and in 1540 he was expelled by Sher Shah Sur whose rule, though it lasted only for fifteen years, has some extraordinary achievements in administration. A fine legacy of the Sur period (some contest it as Humayun's legacy) is the mosque in Delhi's Purana Qila (Old Fort). It consists only of a main prayer hall with five arched openings, roofed by a Lodi type dome. But the structure has gained stateliness, for each of the arched entrances is placed within a larger recessed archway enclosed in its turn by a rectangular frame (Pl. I). Sur architecture left important legacies for the Moghul. The curves of the arch become less steep, more shallow, before they meet at the apex, yielding the shape which Moghul architecture will later adopt. Sher Shah also commences the use of white marble along with red sandstone for more carefully designed decorative effects than were seen in Sultanate architecture. Though basically derived from the Lodi style, Sher Shah's tomb (Pl. 39) at Sasaram in Bihar shows great refinements. It is situated on a terrace in a vast artificial lake. The square terrace has octagonal pavilions at the four corners with small kiosks between them. The elegant shape of the latter and their light-winged projection on brackets from the sides of the terrace relieve the monumentalism of the edifice with a touch of aerial buoyancy. The tomb building itself is octagonal in plan and in three storeys and its magnificent though relatively shallow Lodi-type dome is raised on a lofty eight-sided drum, also decorated with octagonal kiosks at the corners.

Moghul Legacy

Humayun was able to return after his fifteen-year exile in 1555 but he died the very next year and therefore Moghul architecture commences only with Akbar (ruled 1556-1605). The first great building he erected (1565-66) was the tomb of his father (Pl. III). It is located in the midst of a garden and here the Moghuls pay a homage

to the Lodis whom they displaced. There is a huge, well-proportioned podium on which stands the lower storey which serves as a platform for the mausoleum besides affording a fine view of the Yamuna and the plains beyond the river. The ground plan is a central octagon around which are grouped another four corner octagons. Visually, each of the four sides presents a towering recessed arch set in a rectangular surface flanked by tall octagonal volumes whose faces are opened up by arched balconies. The interior is not a single volume but a central octagonal chamber with a vaulted roof surrounded on four corners by similar but smaller compartments, all interconnected by galleries and corridors. The great dome is mounted on a high drum. Marble facing sensitively relieves the red sandstone surface.

Built about the same time as Humayun's tomb are some fine buildings like the tombs in Delhi of nobles like Isa Khan (died 1547) and Atagah Khan (died 1562) and the tomb of an unknown aristocrat known as Subz Burj or Green Tower (Pls. IV-VI). The Atagah tomb uses white marble extensively in mosaics of geometrical design that pierce the red sandstone slabs. The Subz Burj combines an octagonalised square plan and a double dome with space between the shells. The upper dome, freed of structural constraints, has risen to a high elevation and is covered with green and blue glazed tiles.

The other great building projects of Akbar were the palace-fortress at Agra (Pl. 45) and the Fatehpur Sikri complex. The fort, with its massive walls in red stone, has magnificent entrances, the Delhi Gate on the west consisting of an arched gateway between octagonal bastions with octagonal domed kiosks at the top. Noteworthy among the buildings in the interior is the Jahangiri Mahal, a palace of double-storeyed chambers enclosing an open courtyard. With its pillars, beams, brackets and flat ceilings, the palace is built in the Hindu trabeate style and the decorative carving illustrates further Akbar's open and assimilative outlook. Man Singh's palace at Gwalior was very clearly the model for the Jahangiri Mahal.

Abandoned later because of shortage of water in the locality, the complex of official, residential and religious buildings Akbar built at Fatehpur Sikri, the city of victory over which time won a swifter victory than usual, creates a redoubled nostalgia today. But within, time has tarnished little of the beauty of the designing. The interior of the Diwan-i-Khas, or private audience hall, consists of a lofty room divided by a gallery on brackets, with other narrow galleries thrown diagonally from corner to corner. At the meeting point of the diagonal galleries a circular platform has been created, the entire structure supported by a pillar rising from the lowest level and spreading into thirty-six moulded stalactite brackets (Pl. 41). The residential buildings have been attractively designed. In the one known as Birbal's House, the two rooms on the upper floor have been staggered in an inverted L-shape so that, of the open spaces in front of each, at least one enjoys shade during the day. The domes over these rooms are double-sheathed to keep the interior cool. Though small and one-storeyed, very exquisite is the house of the Turkish Sultana in its setting of paved courts and water-courses and with its profuse carved decoration. The tomb of the saintly Salim Chisti has marble screens with delicate geometrical patterns and its deep

cornice is supported by unusual brackets of serpentine design. The Jami mosque has a magnificent gateway, the Buland Darwaza. Dominating the town from the top of a high slope, the imposing structure stands on a flight of steps that serves as a layered plinth. The domed kiosks on the top, partially joined together to form a gallery, are a feature assimilated from Hindu architecture.

The most important building erected by Jahangir is the tomb of Akbar at Sikandra (1612-13). The building stands in the midst of a parkland and is a huge structure consisting of five storeys diminishing as they ascend (Pl. 42). The main gate is a free-standing structure, with marble minarets at each of the four corners. The facade is richly inlaid with coloured stones in large floral and simple geometrical patterns. Small domed pavilions of the Hindu type appear at the top as decorative features used with restraint.

The tomb of Itimadud Daula, father of Nur Jahan, Jahangir's consort, at Agra (1626) is an unusual building (Pl. 43). While the sphericity of the dome dominates other Islamic buildings, the impact here is that of a low, cuboid construction that hugs the earth with affection. The low height of the pavilion-towers at the corners and of the central chamber with its flattened dome contributes to this effect. The whole surface has exquisite decoration in stone inlay, the motifs being drawn from the repertoire of Islam's boundless art of ornamentation (Pl. 43). This elegant architecture anticipates the achievement of the epoch of Shah Jahan.

Marked changes contributing to greater elegance took place during the reign (1628-58) of Shah Jahan. Marble almost wholly replaced red sandstone as building material. Decorative carvings in low relief gave way to inlay of semi-precious and multicoloured stones. Pillars acquired foliated bases, tapering or many-sided shafts and voluted bracket capitals. The curve of the arch assumed a multifoil shape, usually of nine cusps. The dome became bulbous.

The Red Fort with its palaces, halls, pavilions and gardens was completed in 1648 when the seat of government was shifted from Agra to Delhi. The fort itself is an imposing structure of encircling massive walls broken at intervals by boldly projecting bastions topped by domed kiosks. All the palaces were provided with beautiful gardens and separate pavilions. Water was brought to the fort by a canal from the Yamuna and from there diverted into the fountains. The royal residence is the most magnificent of all. Stone inlay transforms marble into embroidered drapery lightly and elegantly enclosing interior space. There is a raised platform intended for the royal throne, a white marble canopied pavilion, set in a vaulted recess in the back wall of the Diwani-i-Am or hall of public audience. It is a masterpiece of stone inlay. The arched bamboo frame and roof of the Bengal hut shows here that its design can superbly serve imperial stateliness and elegance.

Matching the stateliness of the fort is the Jami mosque of Delhi, completed in 1658. One of the most impressive mosques in India, it is raised over a lofty basement with majestic flights of steps leading to imposing gateways on three sides and has domed kiosks at the four corners. The facade consists of eleven multifoil arches, the central one set within a rectangular frame rising above the rest. With two minarets

and three shapely domes of white marble ornamented with strips of black marble, the great mosque dominates this region of Delhi with both stateliness and grace.

In the Agra fort, Shah Jahan added the beautiful Moti Masjid or Pearl Mosque. The facade of the prayer hall has seven low-pitched arches on square pillars and the hall has three graceful domes placed on high drums, surrounded by octagonal kiosks, one at each corner, while a range of delicate kiosks is placed along the parapet front.

The finest legacy of Indo-Islamic architecture and one of the masterpieces of Islamic architecture anywhere in the world is the Taj Mahal, the tomb Shah Jahan built for his consort, Mumtaz Mahal (Pl. 46). A garden tomb on the bank of the Yamuna, it is enclosed only on three sides while the riverfront has been raised by rubble filling and masonry into a terrace. At the northern end of the enclosure is a wide terrace with the mausoleum in the centre, with a mosque on the west and its exact replica on the east to realise a fine balance and symmetry. Around the perfectly shaped dome, at the corners of the roof, are four graceful cupolas whose domes are of the traditional Hindu design. A rugged strength, not much caring for gentler accents, had characterised Ghiyasuddin Tughlak's tomb. Humayun's tomb had retained stateliness but relaxed it with controlled use of decorative elements. Structurally, the Taj is almost identical to Humayun's tomb. Nevertheless, it is gracious and feminine in its beauty like the beauty of the empress whose memory it enshrines. The miraculous sea-change has been almost wholly achieved by the use of chaste white marble and the delicate decoration of the surface with inlay. The marble screens enclosing the chamber with the cenotaphs above the actual graves are as beautifully patterned as the perforated stone windows in Sidi Said's mosque in Ahmedabad and have the further brilliance of colour due to the inlay. (Pl. 44)

Moghul architecture rapidly declined after Shah Jahan. The Pearl Mosque Aurangazeb built in the Red Fort at Delhi suffers from imbalance, with disproportionately large domes which are exaggerated decorations that do not create corresponding enhancement of interior volumes. The tomb of Aurangazeb's consort built in 1661 at Aurangabad in the Deccan was meant to excel the Taj but sorrily failed in even approaching it. The tomb of Safdar Jang at Delhi (about 1753) repeats the structural formula but does not recover the spirit of Moghul architecture in its heyday. In the Great Imambara complex in Lucknow, constructed in 1784 by Asafud Daula, the mosque is not unpleasing though the decoration is rather florid, and the large vaulted hall of the Imambara itself is a technically skilful construction. But these are the last gleams of a dying day. During the British period, European neoclassicism, already a great remove from Greek classicism, was grafted at a second remove on Indian soil and blended with Moghul minarets and Hindu pavilions to yield a hybrid architecture. Since independence, the rapid development of the country required multi-storeyed office and apartment buildings and Indian architects developed expertise in modern methods and styles of construction to meet the demand. But, like modern life, this architecture also is becoming homogenised.

New Horizons

Of late, though rather late for an awakening of perception of the fine sense of beauty in the familiar, there has been a growing interest in what has been called architecture without architects. Since their architects remain practically unknown, such structures as the great fortresses of the Rajputs with their forbidding facades (Pl. 47) masking exquisite residential buildings with sunlit balconies within (Pl. 48) and splendidly decorated later edifices like the seventeenth century Nayak palace in Madurai (Pl. 49) are also communal architecture without architects who aggressively affirmed their individuality. But, strictly, the reference is to the anonymously created domestic architecture of rural communities that was in profound harmony with the environment and the traditional ways of living. The insulating efficacy of unfired mud, against the extreme cold of winter and heat of summer in the Indo-Gangetic plain, tested by tradition over centuries in millions of peasant houses, is at last being admitted now. In Kutch and Rajasthan, the wall surface is transformed into mosaic friezes with abstract and figurative relief designs, and inset fragments of mirrors whose quiet shining reflects the surroundings in miniatures as lovely as the mirrors seen in the paintings of interiors by Flemish masters like Jan Van Ryok. Even the humbler type of house in Gujarat is scarcely ever without at least a front door in beautifully carved wood. The inner courtyard is found in the traditional type of house in almost all parts of India. Living rooms were built around the courtyard which was open to the sky, to welcome refreshing rain and invigorating light into the heart of the living space. The Tulasi, or the sacred basil plant, was also grown there, bringing in the flora and the country green right into the house, recalling too the days when woods were sacred to men, for lamps were lit in front of the Tulasi when dusk fell. Newly harvested grain dried in the courtyard, retaining for days the fragrance of the fields at harvest time. In Kerala, the courtyard-based construction proved to be a very supple modular design in the days of the joint family, for the four-wing pattern could be extended to yield double or quadruple suites in one building when the family increased in size and more living space was required. But this architecture without architects is still a virgin field for research and the future is bound to yield pleasantly surprised perceptions of the perceptive quality of traditional domestic architecture of unpretentious scale.

Sculptural Legacy

Architecture creates volume, empty and therefore habitable space, but contouring it with the shell that it structures. Sculpture seeks to occupy space, fill with matter volumes that are defined by the empty space around them. The solidity of a form, as it is clearly distinguished in perception, is already a sculptural sensation. The sculptor has to conceive his form in the full round even in the case of low-relief carvings, for what is presented to the eye has to suggest the solid reality of what is hidden from the eye, as otherwise the impact will be that of flat cut-outs.

The forms that have thus come to life over the centuries have reflected the entire range of man's concerns, both everyday and ultimate. They have disclosed his delight in the flora and fauna of his ambience as can be seen in the creepers that decorate with their rhythms a Mauryan pillar or a Bharhut rail and the gentle deer and the endearing babe elephant carved at Mahabalipuram. They have poetically recorded the mutual longing and love of young men and women as in the numerous creations of Khajuraho and Kalinga, and also the fruition of that love in motherhood. And they have created vivid symbols for man's conception of the incessantly evolving world and the intentionality behind it that drives this development to some far-off divine event, as in the great Nataraja of the Chola epoch.

Indus Epoch

Since, as we have seen, the Indus valley civilization is very much an epoch of the Indian past, even after the partition, we need have no reservation in commencing the story from that era. In fact, while historians still have not succeeded in tracing a continuity between that epoch and the subsequent ones, the linkage in art, especially in terracotta, is startlingly clear.

Sculpture creates its form through many techniques: by carving the surface of stone or wood in low or deep relief, by cutting through to create forms in the round, by pouring molten metal into moulds, by moulding wet clay and baking it in the sun or fire. A beginning in all these is made in this civilization and it is a splendid beginning, startlingly mature in many respects though the size of the objects remains small.

Terracotta is the art which is closest to the great primary realities of our world: the earth and the sun. The hand of man, who too was mothered by the earth in a

long evolution, moulds the moistened earth or clay to form and dries it to strength in the sun, or bakes it in fire whose energy ultimately derives from the sun. Terracotta art begins here an evolution which has pervaded the entire spatial span of India and has been continuous in time right up to the present (Pls. 53-59). Patna, Buxar and Mathura became important centres of terracotta long before the classical art of India gained clarity of form. And two millennia later we find a splendid resurgence of terracotta art in the decoration of the temples of Bengal (Pls. 58-59).

The Indus epoch created terracotta figurines of the mother goddess (Pls. 53-54) with a stylisation that had a monumental impact in spite of the small size, regal and stately with tall headdress, a rich series of necklaces, some around the neck and others descending to the waist in rhythmic undulations, and girdle around the opulent hip that suggests generative fertility. This archetypal form persisted with only minor modulations through Mauryan, Kushan, Gupta and later epochs and is conserved even today in the folk art of widely separated regions of India. Attractively designed terracotta toys also abound in the Indus epoch. The toy clay cart is a favourite and its wheels will roll through the centuries to provide the title and figure crucially in the plot of a romantic comedy of the first or second century—Sudraka's *Toy Clay Cart*—which has found a place in the repertory of world drama.

The small bronze figurine of a dancing girl (Pl. XX) is the first of a long tradition which will return again and again to pay homage to the female form. Kretschmer has a theory that since beauty with its attraction is nature's device for perpetuating the race, nature brings about changes of sensitivity over cyclical epochs, giving equal chance to all types. The European ideal of beauty has swung from the slender-bodied type favoured by the Middle Ages to the exuberant type loved by Rubens and again to the tall delicate type in favour with moderns like Modigliani. The dancing girl from the lost epoch of the Indus is slender, unlike the exuberant Didarganj Yakshi whom we shall meet in the Mauryan epoch. In fact, the relatively tall and slender feminine figure will reappear only rarely and much later too, though we do get it in Khajuraho carvings and Chola bronzes. The elaborate hair-do of the dancing girl also marks the commencement of the attention consistently shown to coiffure in subsequent sculpture.

A basic naturalism characterises the Indian sculptural tradition though it is modulated in various subtle ways over the whole range from vigorous realism to stately formalism. A bust in limestone has come down to us. It is the portrait of a high priest (Pl. 52). With its stylised beard, slit eyes and austere expression, it has an idealised formalism that impresses in spite of the small size. The detail shows realism. The trefoil design of the robe he is wearing is clearly shown and it is likely that it may have been finished with inlays, probably of semi-precious stones. More forthrightly and remarkably realistic is a vigorously shaped male torso in red sandstone.

The very limitations of miniature size and relief work seem to have been challenges that produced the response of startlingly finer skill in realism. One is strongly tempted to conclude that the masterpieces of the sculptural art of the Indus epoch were the steatite seals that have been found in relative abundance. The humped bull with crescent horns and heavy dewlap represented in one of these seals has a monumental

vigour (Pl. 50). Though primarily meant to convey some information, the writing in relief that also appears on this seal has been done with calligraphic elegance and gives a decorative touch to the composition.

Throughout history there have been interactions between classical and folk traditions, in art and in religion too. In a later epoch, Krishna, the dark-hued god of the Vrishni and Abhira tribes, managed to enter the Aryan pantheon, though not without a prelude of conflicts, as can be seen in the episode of Indra trying to wreck Krishna's village in a rain-storm. But we do not have as clear clues about any deities of the Indus people surviving the latter's disappearance from the stage of history and getting absorbed into the Aryan pantheon. Against this background, tantalisingly intriguing are two seals. In one we have an austere figure seated in a Yoga-like posture and the resemblance to the much later sculptures of Siva, the great Yogi, seems too striking to be fortuitous (Pl. 51). In the other we have seven female figures who too similarly call to mind later representations of the seven mother goddesses (Sapta Matrkas). In this seal, there is also another goddess-like figure shown framed by the branches of an Aswattha. This tree (*Ficus religiosa*) continues to be regarded as sacred even today and is grown in the precincts of temples, especially in south India.

Mauryas to Kushans

The curtain drops now and when it rises again, it is on a fairly well-lit stage of history. The Greek flood of Alexander had ebbed back and the third century B.C. saw India politically stabilised under the Mauryas. The stabilisation of religious faith as well, with Buddhism becoming the state religion under Asoka, created an epoch which, if it could not endure long, was able to leave enduring memories of a political leadership becoming an enlightened moral leadership too. This stabilisation produced a sculpture where both the monumentalism and realism which were definitely there in the Indus epoch, though paradoxically associated with a miniature scale, found expression in bigger dimension and gained greater conceptual depth.

In the protohistoric period, there were strong suggestions of affinities between the Indus civilization and the Sumerian, and antiquarians are still uncertain about the direction in which the cultural impulses moved, still unable to distinguish definitively donor and recipient. This is really a gratifying situation, for culture is one field of exchange where both are enriched. The trend gains clarity as time goes by. From the dawn of history, India has gratefully received cultural impulses from abroad and liberally radiated her own impulses to others. Characteristic of the Mauryan epoch are the free-standing pillars surmounted by sculptures. The stylisation of animal forms, as well as the fine polish, show that during this phase India benefited from the scattering of Persian craftsmen after the Greeks under Alexander broke up the Achaemenid empire in 330 B.C. But the Asokan pillar itself seems to be derived from the flagstaff that used to be erected in front of temples.

In the Asokan pillar from Sarnath, the beautifully polished shaft of monolithic sandstone has a bell-shaped capital surmounted by a plinth with a running frieze of four

wheel designs and four animals in relief and, mounted on it, four lions grouped back to back (Pl. 60). The wheel refers to Buddha's sermon at Banaras where he "set the Wheel of Law in motion". The lions are highly stylised and realise both vigour as well as decorative quality. Though these features may derive their immediate impulses from Achaemenid tradition, they are not necessarily novel on the Indian soil. For we have a short-muzzled terracotta bull in the full round from the Indus epoch with equally vigorous yet decorative stylisation. The horse and the bull, in the frieze, prolong the less stylised but still vigorous naturalism that characterised the figurations in the steatite seals of the Indus era.

An occupational hazard of art historians is the tendency to allocate one distinctive style to each specific period which would make art history march tidily as a progression of clearly distinguishable styles. But the actual situation is often far more complicated. If the sculptural design of the Asokan capital we just noticed has all the symbolic weight and stateliness of form that can reflect an empire stabilised in its political ordering as well as in its religious faith, we find a different temper in the capital of the Asokan column from Rampurva (Pl. 62). It is surmounted by a bull. But instead of the vigour, further accented by the stylisation, of the lions in the other capital, we find here a simplicity and gentleness which too mark the beginning of a trend—the sympathetic representation of animal life—that will keep reappearing in subsequent epochs. The legs of the lions are strong and sinewy and one can see the taut tension of the tendons and muscles. The legs of the bull are slender. The problem this would have created in supporting the weight of the body has been solved by a continuous, blocky treatment of the lower portion of the sculpture and this has helped in further toning down the monumentalism by giving it, partly, the softer impact of a relief.

The commencement of yet another trend is seen here. In the frieze of the abacus below the bull we see the beginning—and it is already a mature beginning—of the tradition of decorative design composed of repeated honeysuckle, rosette and palmette motifs. Demure and reticent at first glance, revealing exquisite insights into the life of nature when examined closer, these designs derived from vegetation will occur in thousands of temples all over the land, providing decorative bands for the moulding of plinths, for rails, door jambs and lintels, for window frames.

Since the art that grew up under imperial patronage itself thus shows stylistic differentiations, it is not surprising that the tradition that was nearer to the culture of the people shows even greater variation. The Yakshas were deities associated with mountains and the Yakshis were the deities of trees and forests. As human settlements grew by expanding into virgin land, these nature deities were propitiated by villagers and their statues were erected in villages. Two standstone sculptures have come down to us from the late Mauryan period, those of the Parkham Yaksha (Mathura Museum) and the Besnagar Yakshi (Indian Museum, Calcutta). Monumental and more than life-size, these sculptures have a frontality and rigidity of stance and it is possible that stone sculpture here was modelling itself on earlier sculptures carved from great tree trunks and thus closely hugging the original form of the material. The monumentalism

is really enhanced by the archaism of the style. But classical influences have begun to touch this tradition. The relaxation at the left knee, more pronounced in the Yaksha, softens the rigidity of the stance. Though the generative symbolism is there in the swelling torso of the Yakshi, it is not as pronounced as in the mother goddesses of the Indus epoch and with her decorative dress and jewellery, she is already beginning to represent woman as playmate and consort much more than woman as mother. The transition is clearer in the whisk-bearing Yakshi of Didarganj (Patna Museum). The care in the depiction of costume, coiffure and jewellery that characterises subsequent tradition is fully evident here. The slender waist and exuberant torso begin to fix the preferred type of feminine beauty which will be stabilised later through the sensuous poetry of Kalidasa and of many other classical poets of Sanskrit.

The carving and erection of Yaksha and Yakshi figures must have been important events in the life and growth of village settlements. More easily made, and with a rapid turnover, terracotta, though it too must have been of folk origin, responded more quickly to urban tastes. This must be the reason for the more sophisticated charm of the terracotta female figures of the type we have in the Patna Museum with pleated skirt, elaborate headdress and winsomely gay expression (Pl. 55). We shall see later that this humble tradition of terracotta shows surprisingly close contacts with sophisticated urban culture as the centuries go by.

The Sungas replaced the Mauryas in the second century B.C. The Stupa at Bharhut has been lost, but the gateway and railings have been salvaged and are preserved in the Indian Museum, Calcutta. The gate pillars continue the design of the Mauryan bell-column. Far more important is the railing. It is divided horizontally and vertically by rails and uprights. The coping at the top elaborately extends the decorative band of vegetation seen in a miniature scale in the frieze on the abacus of the Rampurva capital. The upright members of the railing often have feminine figures in deep relief, like the Sirima Devata, who is the earlier Yakshi, but in far more elaborately carved costume and jewellery, with a girdle of multiple chains and the waist-band decoratively tied and looped.

There is a stylistic simplification in Sunga art and nowhere is it more pleasantly felt than in the recurring motif of the woman and the tree. The two are naturally associated by the concept of fertility and a poetic myth emerged to strengthen the connection by claiming that a gently coaxing kick by a damsel's foot would make a tree yield flowers in greater abundance. While figurations specifically based on this myth appear in later sculpture just as references to it recur frequently in later poetry, in the Sunga and the earlier phases generally, the damsel, shown usually as clasping the stem of a tree with one hand and holding on to a flowering bough with the other, seems to be a dryad, the tree-spirit in human form. Yakshi Chandra is one of the finest of such sculptures from Bharhut (Pl. 78). She has not been carved in the full round, but in relief on an upright of the railing. But the sensuous moulding of the body is not hampered in the least by this limitation. The plaited hair contouring the torso on the left repeats the design and balances the rhythm of the leafy twig that arches above her head like a crown. The generic figuration is endlessly varied by subtle differentiation

in the stance of the figure, and in the treatment of the canopy of foliage above. The Indian tradition begins to reveal here its great inventiveness in creating variations on the same basic design.

The grille design of the railings has become richly decorative, with medallions carved on both the horizontal bars and the vertical uprights. Most of these medallions have become lotuses and their elaborate and decorative carving gradually perfects the sensitive craft skill that will yield, in the Gupta epoch later, the great aureole of the Buddha (Pls. 65-66) with its unique blending of delicacy as well as splendour.

The most memorable contribution of the Sunga epoch, however, is the development of the skill for representation of genre scenes and for extended episodic narration. Neither Buddhist nor Hindu art was ever touched by the guilt feeling found in the medieval European mentality in regard to the tender love of men and women leading to, and continuing in, wedlock. There are many representations of couples in the railings at Bodhgaya. In one we have a delightful scene of the shy, newly-wedded bride trying to slip away as her husband tries to retain her by the hem of her garment. The close interaction between the arts is seen in the fact that delicious vignettes of this kind continue to appear in later poetry, in Kalidasa and Amaru. Entertainment arts, of the masses as well as the elite, also figure in Sunga sculpture. In a Bharhut rail fragment (Allahabad Museum), we have acrobats performing their feats, no doubt for a street audience. The dance group in the Prasenajit pillar of Bharhut, on the other hand, must have been performing for a patrician audience (Pl. 74). We have here a fairly complete chamber orchestra with harp, flute and drum. The musical names of the danseuses incised in the relief—Padmavati, Misrakesi, Alambusha—show that they are celestial nymphs of Indra's court. The scene represents the commencement of the dance and the postures and gestures can be seen in the Alarippu sequence of Bharata Natyam even today.

It is in the attempt to represent scenes from the life of the historic Buddha and from his numerous legendary incarnations that the sculptor's capacity for vivid episodic narration is challenged and helped to mature. Some of the representations are very important for the reconstruction of the Buddha's life and mission in that they endorse and confirm literary references. Thus, the devout and affluent Anathapindada purchased a plot and built a monastery at Jetavana and presented it to the Buddha and the representation of this episode is one of the most important reliefs we have from Bharhut. The circular shape of the medallion is a technically dictated frame within which the sculptor has to compose his figures, and in low relief—another limitation on excavating deep volumes and creating perspectives—and if subsequent epochs will bring great refinement, imaginative designing is very much evident even in this early phase. In the representation of the dream of Queen Maya where the Buddha, in the form of a white elephant, entered her right side, to be born as Siddhartha, there is a very daring use of tilted perspective (Pl. 63). But the aesthetic effect is satisfying and the communication of the story very vivid. Later epochs handle the same theme, but with a totally different perspective (Pl. 64).

The traditions evolving through the Mauryan and Sunga epochs were further

developed by the Satavahanas, a powerful dynasty that ruled the whole of Deccan — generally the area now represented by the state of Andhra Pradesh — between the second century B.C. and the second century A.D. from their western capital at Pratishthana (Paithan) and the eastern capital at Amaravati in the valley of the Krishna river. Though the Stupa at Sanchi was built by Asoka himself, inscriptions show that the gateways were erected and carved during the reign of Satakarni, in the second century B.C. Very interesting is the further information given in the inscriptions that the carving was done by the ivory carvers of Vidisha. The detailed carving shows the successful transfer of craft skill from a soft material like ivory, in all probability to wood first, and later to stone.

The earlier motif of the dryad, or the woman and the tree, is continued in Satavahana art. The Yakshi brackets in the gateways at Sanchi make a great advance in sculptural conception over Sunga work. The dryad grasps the bough of the tree with one hand while the other is entwined around its trunk in a languorously languid way (Pl. 79). From low or deep relief, the figure has been emancipated to modelling in the round, with space and air enveloping most of its form. The earlier frontality remains, but is sensitively modulated by the elegant, graceful, sensuously inclined stance, the way the torso lifts itself above the hip with a lilt, the balance of the arms. Although carved in stone, this damsel has become a light sprite of the air, for the hold of her arms on the tree is no taut grasp for support but a sensuously relaxed attitude. Though nude, she has a pastoral, idyllic innocence.

The tradition of representing lovers and married couples (Mithuna or Dampati) was initiated in the Sunga epoch. But it is at Karle of the late Satavahana period that we have the most splendid sculpture of this type. The couple is believed to represent donors. Both the man and the woman are in the prime of youth. The figures have been splendidly shaped in deep relief, the frame of the man radiating masculine vigour through a delicate moulding which avoids exaggerated emphasis of musculature, the form of his wife exuberant but not unduly erotic. It is a pity that erotic sculpture has attracted more attention than the far more sensitive depiction of Dampatis (Pls. 88-92) who may be divine, mythological or human beings.

The episodic narration of the legends of the Buddha reaches a climactic perfection in Satavahana art. There are representations of the Jatakas (the various incarnations of the Buddha) at Sanchi. But they are surpassed by those at Amaravati. Historically they are very important because some of the representations illustrate early texts now lost, and others have not been carved anywhere else. There are many masterpieces here. One has the same theme — the dream of Maya — as in the Sunga relief we noted. But the handling of perspective is less startlingly radical and the figures have been shaped and deployed with a fine sense of rhythm. Another illustrates the nativity of the Buddha. Maya gave birth to the Buddha in the grove of Lumbini, erect, and holding on to the branch of a tree with her left hand. The posture thus recalls that of the dryads and the modelling of her form has the opulence of the woman of the Karle donor couple. Nevertheless, in some mysterious way, the sensuousness of those figurations changes here to a stateliness that elicits feelings of reverence for so august

an event. This is yet another instance of the capacity of the Indian tradition for
obtaining endlessly varied nuances from the same compositional model.

While these two sculptures are in rectangular format, the representation of the
subjugation of the wild elephant Nalagiri, let loose on the Buddha by his wicked cousin
Devadatta, is in the medallion shape. The more difficult compositional problems
created by this shape have been superbly solved by an exceptional skill in fluent,
rhythmic narration. It conserves all the tense drama of the action and reflects the
reactions of the people witnessing it with psychological insight, the women nearer to
the scene clinging to each other in fear, those looking on it safely from balconies more
relaxed. In the case of decorative motifs, the lotus design is perfected in a profusion
of carvings.

European historians, with the memory of the bitter religious conflicts in their
continent, have dramatised the vicissitudes of Indian tradition, representing the Sunga
epoch, for instance, as marking the overthrow of Buddhism by a resurgent Brahminical
faith. But the Indian tradition has been smoothly assimilative. The Bharhut Stupa
was a creation of the Sunga epoch. The Satavahanas also followed the Brahminical
faith. But they embellished Sanchi and erected Stupas at Amaravati, Nagarjunakonda
and Jaggayyapeta. Their patronage created some magnificent sculpture of Hindu
deities too, like those of Surya (sun god) in his chariot and Indra on his gigantic
elephant at Bhaja and of Siva on the Linga at Gudimallam. This last figuration,
incorporating as it does the concepts of Agni and Rudra into the iconic model of the
Yaksha, illustrates once again the way in which the Indian tradition went on creating
new forms by blending diverse currents.

From eastern India which was the seat of the Mauryas and the Sungas though
their realm covered the whole of north India, and from the Deccan of the Satavahanas,
we have now to travel far to the north-west, to regions which are no longer part of
India today. When the Macedonian phalanxes of Alexander flooded the north-west of
the subcontinent and ebbed away, it left a rich silt of European classicism fertile to
new growths. Gandhara, which was part of the Kushan empire in the second century,
bordered directly on some of the post-Alexandrian and later kingdoms and therefore
had numerous contacts with the Mediterranean world. The art that emerged in this
region was first called Greco-Buddhist by art historians, but it is now clear that the
European influence came, not from Greece or the Hellenistic world, but from Rome of
the late first and the second centuries. Gandharan sculpture was at first in stone.
This tradition declined during the third century, but the style was prolonged in clay,
stucco and terracotta by a new Indo-Afghan school during the fourth and fifth
centuries. The inspiration of the story of the Buddha and the plastic vision and
technique of Rome which inherited them from Greece commingled to create
Gandharan sculpture which has yielded some aristocratically handsome yet spiritually
sensitive figurations of the Buddha in stone (Pl. 67) and piquantly delightful creations
in clay and stucco. It could even be that while earlier art had represented the
Buddha only through symbols like his foot-prints, the first anthropomorphic representa-
tion (as a human figure) was created in Gandhara. The clay and stucco sculptures

understandably acquire fluency in episodic narration. But the grouping of the figures and their postures are closely modelled on those appearing in Roman sarcophagi of the period of Trajan and despite the theme the art feels alien in its idiom.

But our story becomes wholly Indian once again when tall stately kings of the Kushan dynasty appeared on the scene of history. The Kushan rulers, of whom Kanishka of the second century was the greatest, carved out a huge dumb-bell-shaped empire, the Peshawar-Balkh route being the grip and the terminals reaching as far north-west as the Oxus and as far south-east as Banaras. Though they had a summer capital at Kapisa in the Hindu Kush, they ruled their realm mostly from Mathura and it is at Mathura that the sculptures of a seated Vima Kadphises and a standing Kanishka—both unfortunately headless today—were found. These sculptures, especially that of Kanishka, are in an alien, Scythian idiom. And there are sculptures of Hercules and Hariti in Greco-Roman style, of Mathura provenance, in the Mathura Museum. Can we speak of a genuinely Indian style when we discuss the sculpture of the Kushan epoch?

The earlier belief of art historians was that the sculpture of Mathura of the Kushan period was derived from Gandhara. Today it is realised that the great realm of the Kushans had three major schools of sculpture: one in the Oxus region which used a white limestone; the Gandhara school which used a bluish or greenish schist; and the school of Mathura which used the mottled red sandstone of Sikri. Gandharan sculptors who had found their way to the eastern capital of the Kushan empire, or even their local apprentices, may have executed sculptures in the Gandhara style, like those of Hariti and Hercules. But, in the main, Kushan Mathura developed the traditions of Sanchi and Bharhut.

In free-standing stelae and in railing pillars, the Yakshis of the old tradition are born again as lissome nymphs, standing in attitudes of graceful and relaxed flexion. One of the Bhutesar Yakshis pleasantly converses with her pet parrot released from its cage and helped on to her sensuously rounded shoulder (Pl. 80) and a verse from Kalidasa's *Meghaduta* (*Cloud Messenger*) reads as if it was a poetic caption to this pleasing sculpture. The culture is becoming rapidly urbanised and the sensibility acquiring elegant sophistication. The dryad in the Sanchi bracket was nude. The Mathura nymphs are draped, but the cloth is so diaphanous that she appears nude and it needs a second look to realise that she is not undraped. Feminine apparel is beginning its fine adventure of ambivalence, revealing while pretending to conceal. This again is another indication of the refined eroticism of the cultured urbanite. The damsels have no longer as clear connection as in the past with trees and woods. The bough rarely appears above as a canopy. In fact, in most of the stelae, the damsel is standing in sensuously provocative attitude below a balcony on which appears a young couple in amorous dalliance. In one stele, she seems to be offering a flask of wine which the man above is lifting up with one hand while he embraces his companion with the other.

The relaxed, pleasure-loving temper of urban life is reflected not only directly thus. Scenes of the kind from literature are also selected for sculptural compositions.

In one block carved in deep relief on both sides, on one side we have a scene which seems to represent an episode from the *Toy Clay Cart,* the Sanskrit romantic comedy of Sudraka (Pl. 81). Hurrying home at dusk, the lovely Vasantasena is pursued by the ill-mannered eve-teaser, Sakara. She has pulled up her anklets so that their jingling will not betray her in the dark; likewise, she pulls up her upper garment or scarf over her head lest the fragrance of the flowers in her hair disclose her while she tries to escape. On the other side of the block, another lovely damsel, luckier than Vasantasena, has obviously found a likeable companion. Wine has apparently been flowing freely during the evening, for she is tipsy and is finding it difficult to stand up without help.

Subtle modulations are taking place in the temper of the Indian psyche. In the very early mother goddess figurines (Pls. 53-54), the symbolism of generative fertility had been so much stressed in the anatomy that it evoked little of the other aspect of woman: the companion in amorous dalliance. In the Mauryan terracotta we noted, the heavy symbolism of maternity is shed and the figure is gay, but the iconography still recalls the earlier mother goddess and she does not quite become the most desirable companion of amours (Pl. 55). The dryads have sensuous appeal, but the link with fertility through the representation of the tree is shed in the urban milieu of Kushan Mathura and she becomes wholly the mistress who can give endless sensuous pleasure. But in one sandstone relief, now in the Mathura Museum, the two concepts are beautifully integrated. It is a representation of a mother and child and the leafy bough above, replaced by the balcony with an amorous couple in other stelae of damsels, reappears here, gently recapturing the generative symbolism. But the woman, though a mother, retains all the beauty of the other damsels. The Kushan epoch creates here a fine new category on which subsequent ages will ring many lovely variations, a fine later instance being a Chandella sculpture of the eleventh century (Pl. 87).

In Buddhist sculpture, though there is some heaviness in the figuration, suppleness begins to be gained. The gliding linear contour begins to acquire fluent rhythms, the modelling becomes delicate enough to allow the play of light and shadows over the surface. The Katra Buddha is one of the best Kushan sculptures of this type. But it was the Guptas who developed this legacy to perfection.

The Sungas and the Satavahanas were Hindus but liberally patronised Buddhism. Likewise, though the Kushans were Buddhists, they extended liberal patronage to the other religions. Lakshmi and other goddesses retain the associations with the earlier deities who symbolised fertility and granted prosperity. There was a practice of making stelae, with the representation of a Stupa, as votive offerings (Pl. 61). A perfectly preserved Jain tablet of this type has come down to us. The architraves of lost buildings are fascinating: some of them have representations of the horse and bullock carriages of the period in which men and merchandise covered the long stretch of one of the greatest trade routes of antiquity, the Uttara Patha, or Northern Route, from Tamralipti in Bengal to the eastern Mediterranean. Satavahana inscriptions, we noted, state that the Sanchi gateways were carved by the ivory-carvers of Vidisha. Kushan

Mathura had much bigger guilds of ivory carvers and their creations too travelled far along the Northern Route. A hoard of these carvings was discovered at Begram near Kabul in Afghanistan and a carving of a damsel with an attendant was recovered from Pompeii in Italy. Indicating once again the elegantly sensuous culture of the Mathura of this epoch is the fact that most of the Begram ivories show maidens in seductive postures while some of them illustrate scenes of feminine toilet.

Guptas and Vakatakas

The epoch of the Guptas (320-600) has been, perhaps a shade too frequently but not undeservedly, called the Golden Age of India. As far as sculpture is concerned, the epoch saw a magnificent efflorescence, the peak being reached in Buddhist images. Gupta sculptors of Mathura worked in red sandstone and of Sarnath in the cream-coloured sandstone which the Mauryas had used for their columns and capitals. The perfection of craftsmanship enables the drapery to become transparent, revealing the softly moulded body beneath. While it is true that the Kushan sculptor was the first to create the diaphanous drapery, there is much greater artistry here. For in the case of the Kushan damsels, the drapery reveals its presence only through a rather token device when the eye notices the fringes at the ankles. But in the case of the Gupta figures of the Buddha, the robe falls in fine folds that trace flowing rhythmic patterns all over the figure. Thus, visually, it is very much a decorative presence, which is further accented by its spread on either side, free of the body. But it reveals also the body beneath and so delicate is the workmanship that one can see the waist-cord through the robe (Pl 66). The visage with its softness and delicacy of moulding acquires a rapt serenity of expression, a quality of inward musing (Pls. 65-66) which were beyond the reach of Kushan sculptors. Whether standing or seated, the sculpture sheds the feeling of heaviness from which Kushan figurations of the Buddha never entirely emancipated themselves.

The Kushans also had carved their Buddha figures with a halo or aureole. But it is in Gupta sculpture that it becomes a glory. Here too we see the integration of small but fine currents to create a new beauty. The lotus medallion had been created at Bharhut, refined at Amaravati. The overall form of the aureole is that of the lotus, further perfected (Pls. 65-66). But the overall form is further decorated with concentric bands and if the honeysuckle creeper had been used at Amaravati, we find here more motifs, like the palmettes which we found in the coping of the Bharhut railing. And in the sculpture which shows the Buddha giving his first sermon, two celestial beings float into the rim of the aureole above, one on either side. The sculpture has some touches of sensitive sophistication (Pl. 65). The drapery, between and below the crossed legs of the seated figure, spreads forward and its fluted form looks like a lotus, musically echoing the form of the aureole, but in a foreshortened perspective. Below the seat is a frieze of worshippers symmetrically ranged on either side of a wheel—the Wheel of Law—in the centre. But this wheel is seen from the front, its rim curving forwards towards the viewer, a most unusual play with perspective.

The Gupta achievement in the creation of the classical icon of the Buddha is a landmark in the art of Asia. For it spread across the seas to Indonesia and travelled through the old Central Asian silk route to China, Korea and later to Japan. Though by now we have considerable knowledge of the routes and phases of this transmission, buried under the oblivion of the centuries there may have been unsuspected direct contacts between India and distant regions. For instance, while the Buddha icon becomes increasingly sinified as it traverses China and almost all the Buddha figures in Korea have the unmistakable impress of Chinese mediation, in the eighth-century grotto on the top of a hill at Sokkuram in Korea we have a seated Buddha who is so astonishingly like the Buddha created by the Gupta epoch that it is impossible not to think in terms of some direct contact whose meandering path, lost in the leaf-drift of the centuries, has yet to be researched.

Sculpture inspired by Hindu deities and legends also had a splendid efflorescence in the Gupta period and the fifth-century Vishnu temple at Deogarh has several masterpieces that vividly visualise profound symbolic concepts (Pls. 93-95). According to the cosmogony of modern science, the universe burst into existence in a tremendous explosion of energy and after a vast stretch of time it will die down into quiescence through what is known as entropic decay. Hindu thought went further and assumed this process to be cyclically, endlessly, recurring. The great universe is ingathered when Vishnu sleeps, it begins to evolve when he wakes up again. A frieze in Deogarh shows Vishnu in calm, majestic repose (Pl. 93). Another great Hindu concept, fully elaborated in the *Gita*, is that of the partnership of man (Nara) and God (Narayana) in the piloting of history towards the divinisation of man. The Nara-Narayana panel at Deogarh (Pl. 95) is even finer than that of Vishnu in repose and has a moving inwardness in the hieratic postures and contemplative absorption of the two figures. The Puranic lore about the ten incarnations of Vishnu seems to intuit dimly the great landmarks in the earth's geological evolution. The legend of Vishnu incarnating himself in the figure of a mighty boar to raise the earth which had been submerged seems to recall some faint racial memory of the emergence of a vast region of the earth from below the armour of ice which had been clamped upon it in some forgotten glacial epoch or from a great flood which had drowned even the mountain peaks. The representation of this incarnation at Udayagiri in Madhya Pradesh, carved on a rock face, is a masterpiece of monumental strength in sculpture (Pl. 99). The figure with its massive torso strives upward with an immense strength, with the delicately carved and exquisite figure of goddess Earth resting on its shoulder.

The expressive range of Guptan sculpture is revealed when we move from the great symbolic themes to the familiar rendered endearing. In the Skandamata from Kotyarka we have one of the many variations in Indian sculpture on the mother and child theme we noted in the Kushan epoch. The mother here fondles the child who is hugely enjoying a ride on the shoulders of a smiling attendant. The terracotta tradition, perennially continuing, surfaces in this epoch with a masterpiece—a head of Parvati, consort of Siva, from Ahichhatra—where this humble art, predominantly a folk art, reaches classical status. The individuation of the visage is more striking than

in the case of Sunga dryads and Kushan city girls and has the quality of a portrait (Pl. 57).

The Vakatakas of the Deccan were the contemporaries of the Guptas and matrimonial alliances linked the two dynasties. Inscriptions in the later caves at Ajanta definitely relate them to Vakataka patronage and sculptures of their period can also be found at Ellora, Elephanta and Aurangabad. In one sense, the Vakatakas continued the tradition of the Satavahanas and they left a legacy for the Pallavas.

Indian sculpture by now had perfected the stately sculptural statement. But this had of necessity emphasised the static representation. The seizure of movement can be seen in the medallions of Bharhut and Amaravati, but it is in the Vakataka epoch that it becomes fully free. Moving and flying figures of different sizes—dwarfs, Yakshas, Yakshis—are found abundantly in the corners of the capitals in Ajanta and the interior, hewn from rock and still tending to retain in the excavated volume the static massiveness of rock, becomes alive with movement. In these representations of flying celestial beings (Pls. 71-72) and of dancing figures (Pls. 74-77, 102, 112) the technical mastery of the Indian sculptor succeeds in making heavy stone levitate and gyrate.

There are sculptural masterpieces on the Buddha (Pl. 68) and Buddhist themes at Ajanta like those depicting the temptation of the Buddha, his first sermon and his passing away. Very important is a group which represents, not any deity ranking high in the Buddhist pantheon, but a Naga king and his consort. Recalling the worship of the serpent as a chthonic deity which emerged when early man cleared virgin forests for settlement and, by association. representing the communities that continued the cult even in later times, the Naga couple symbolises the entry of the folk tradition into that of classical art. The lotus aureole is replaced here, and magnificently in its own way, by the hoods of seven cobras. This deeply curved hood creates shadows which are a fine foil for the jewelled crown with its minute carving. A whisk-bearing attendant is also placed in the shadow of a pillar and the attention thus concentrates mainly on the king and his consort who are the couples whom we have seen earlier in Bodhgaya rails and the sculptured balconies of Kushan stelae above lissome nymphs, but acquiring a new stateliness which we shall see again in the representations of Siva and his consort. The relaxed pose (*Maharajalila* posture) of the king also creates an iconic idiom which we see not only in subsequent sculpture in India but also in China and Japan.

The Vakataka epoch produced abundant sculpture inspired by the deities and lore of Hinduism. At Ajanta we may meet with only minor deities like the river goddesses, Ganga and Yamuna. But at Ellora, where there are thirty cave shrines, Buddhist, Jain and Hindu, we have many representations of Indra, Vishnu and of Siva. The representation of Indra (Pl. 103) is notable not only for the monumental stateliness of his figure but also for the splendour of the setting with its richly decorated capitals and canopy, delicately carved out of hard rock, and the lissome elegance of the attendant figures. The love of movement we noted earlier enlivened the general ambience of the cave interior. Here it is focused to fine impact in the representation of Vishnu in his incarnation as the Man-Lion (Narasimha) slaying the demon king

Hiranya Kasipu, in the Dasavatara cave. The torso of the demon, seized by Vishnu, is tautly arched towards the latter, his arms stretched back and his face not in profile but rotated towards the viewer. Though done in relief, the figuration, in the excitement of movement, begins to emancipate itself from being bonded to the ground plane. This is even more dramatically vivid in the case of the Man-Lion whose hips are seen from the side but torso and shoulders are turned towards the viewer. But no manner is made a fetish and movement is restrained, even surrendered, in the light of the aesthetic intention. Thus, it is an adagio or slow, lyrical sequence that Siva is dancing in the Rameshvara Cave; it is incidentally one of the earliest representations of the dancing Siva in any medium. The feet rest on the ground, the leg is not flung out, the frontality aligns with the ground plane. But the figure is still not bound tightly to that plane and a sinuous rhythm ripples through it from head to feet. Even this delicate movement subsides into serene stillness in the rapt mood of the composition at Elephanta where Uma (Parvati) is given in holy wedlock to Siva. The stillness becomes profound, august, with far-reaching symbolic resonances, in the massive figuration of the triune Siva at Elephanta (Pl. 104). The visage in the centre is austere yet auspicious. But to the right is carved the visage of Siva as Bhairava, with dishevelled locks of hair and menacing mien. Balancing it is the exquisite visage on the left symbolising the feminine which, according to both Hindu philosophy as well as Jung's depth psychology, is present in every man, integrally rounding off his psyche.

The dancing group had been created by the Sunga sculptors at Bharhut (Pl. 74). But with Siva now emerging as the supreme dancer, such compositions will figure more frequently in subsequent sculpture. The dancer in the Aurangabad cave (Pl. 75), in fact, echoes a little the posture of the dancing Siva in the Ellora cave. With only one figure dancing, the composition has permitted a parabolic, arc-like grouping and a symmetry that is not rigid but delicately modulated; and with the fourfold orchestra of drum, flute, lute and cymbals, it far surpasses the Bharhut relief and is, in fact, the most beautiful panel illustrating solo dance in Indian sculpture.

Central India

The Vakatakas were succeeded by the Chalukyas but the vicissitudes of their history cover many locales. It is the Western Chalukyas of Badami who make the first appearance in history and their contribution to sculpture, dating from the sixth century, can be seen at Badami, Aihole and Pattadakkal. The sculptors of this phase carved serenely poised figures of the dancing Siva, turbulent dramatic representations of the slaying of the Tripura demons and exquisite and gracious representations of the river goddess Ganga. The relief of a celestial couple flying through the clouds, from Aihole, now in the National Museum, is remarkable for the lightness and the fast, fluent movement of the figures as they speed through the clouds, their garments fluttering in the wind. There are several representations of amorous couples in the temple of Durga at Aihole. Fine bronzes of elegant women at their toilet also have come to us from the epoch of the Western Chalukyas (Pl. XXIII).

By establishing the Vengi kingdom, the brother of Pulakesi, the Western Chalukya ruler, initiated the Eastern Chalukya line and the sculptures of this phase can be seen in the temples of the Vijayawada region. There is a long frieze on music and dance, of the ninth century, in the Jamidoddi temple where numerous figures have been composed without crowding, with animation and clarity of narration.

Later, the Chalukyas established themselves in Gujarat and patronised both Hinduism and Jainism. The twelfth century Sive temple at Modhera has fine sculptures of both Siva and Vishnu and in the thirteenth century Tejapala temple at Mount Abu, deep relief sculptures on the ceiling vividly narrate incidents from the life of Neminatha, the Jain preceptor.

In the eighth century, the Rashtrakutas had for a while wrested power from the Chalukyas. We have already noted their unique achievement in creating architecture out of a giant sculpture in the Kailasa Natha at Ellora. Significant sculptural compositions in deep relief have also been carved in this temple. One masterpiece is the composition where Ravana, in order to display his great might, lifts and shakes the Kailasa mountain, the abode of Siva. The alarm of Parvati which makes her cling to her lord, the panic of her maid which makes her flee, and the unconcerned poise and pose of Siva have been expressed here with vividly dramatic power. There is far greater movement in the dancing Siva here than in the Vakataka sculpture in the Rameshvara cave. With the two arms outflung, the body twisted to present a frontal torso while the hip and visage are in profile, the contour of the figure develops shapely rhythm and the smiling face adds to the graciousness of the whole composition.

The Gurjara-Pratiharas were the contemporaries of the Rashtrakutas and their realm included Gujarat and Rajasthan, pressed upon the Rashtrakuta borders in Central India and extended east to the frontiers of Pala territory. The sculpture created under their patronage during the ninth and tenth centuries has a range of expressiveness. In the representation of Vishnu in his cosmic form from Kanauj (Pl. 96), a great many deities have been mobilised around the central figure to underscore his supreme status. The symbolism of Vishnu as the supporting pillar of the universe finds a truly aesthetic expression here, with the great differential in proportions between his figure and those of others. The iconography of the latter shows that Vishnu's figure rises from the nether world of the Nagas to the realm of Brahma above. With representations of his weapons in personified forms and of several of his incarnations, the composition could have become crowded. But the teeming figures have been organised with consummate artistry, the crowded pantheon withdrawing visually to become a decorative background and frame that serve to accent further the monumental figuration of Vishnu. In the sculpture representing the wedding of Siva and Parvati, also from Kanauj (Pl. 108), the sculptor has moved from monumentalism to lyricism. Deities, come to attend the nuptials, levitate above, but they are deployed in a relaxed placement and Siva is less austere, more gracious, than in the representation of the same theme at Elephanta. The nymph, now in the Gwalior museum, is one of the finest creations of that category (Pl. 83). The jewellery is minimal, but the undulations of the necklace bring out the swell of the torso, the slenderness of the

waist, the ample curve of the hip. The decorative border has been delicately incised on the brief waist-cloth. Fine sculptures of Kartikeya (Pl. 111) and Ganesa (Pl. 112) also have come down to us from this epoch. The Gahadvalas who succeeded the Gurjara-Pratiharas inherited their skill in the creation of beautiful feminine figurations. The twelfth-century head from Rajorgarh in Bikaner (Pl. 86) is probably the best sculpture in the Indian tradition for the most elegant and elaborate representation of flower-decked coiffure.

The sculptural style of the Gurjara-Pratiharas reaches its last phase under the Chandellas who ruled Bundelkhand from the tenth to the twelfth centuries and erected the temples of Khajuraho. The sculptures here have attracted an undue notice because of their erotic themes, some of which are extremely uninhibited in expression and may shock conventional morality though there is little here that is not normal in sexual behaviour, in any land or epoch. But they have led to the neglect of the sensitiveness seen in innumerable sculptures with less provocative themes. Woman has been observed here in all her moods, from the involvement of the heart to preparation, longing, anxious expectation. Pretending that a thorn had entered her foot and turning the face to remove it was the transparent yet tender stratagem which Kalidasa's Shakuntala adopted when she wanted to have a last longing, lingering look at Dushyanta. Damsels engaged in this pleasant pretence abound at Khajuraho. In other sculptures we see the damsel writing a love letter, applying collyrium to her eyes, studying herself in the mirror. The canopy of foliage above, in the last figuration, shows that the damsel is the dryad of the early days. But while the latter was unself-conscious in her beauty, here she is very conscious of her power to attract, an evolution towards elegant sophistication that began in Kushan times. Beautiful as these compositions are, more hauntingly evocative is the sculpture which shows a damsel lost in wistful reverie. Erotic associations are wholly dispensed with in yet another sculpture which shows a damsel playing unpremeditated melodies on a flute (Pl. 84). And finally, we have a representation of mother and child, with a flowering canopy above, refining to exquisite tenderness the integration of the concepts of woman as the beloved and woman as the mother which was initiated in Kushan sculpture (Pl. 87).

Eastern India

The Pala dynasty rose to power in northern Bengal and parts of Bihar during a time of troubles in the eighth century. In the middle of the twelfth century it was succeeded by the Senas whose rule came to an end by 1280. Culturally, the periods of the two dynasties constitute one epoch although the angularisation of the Gupta idiom, already evident in Pala times, hardens in the Sena period. The Palas were Buddhists, but along with sculptures of the Buddha, the epoch yielded figurations of Vishnu, Siva and Sarasvati (Pl. 100). Perhaps the finest stone sculpture from the Pala epoch that we have is a panel carved in black basalt showing a recumbent female figure with an infant at her breast. The posture of the mother has a flowing rhythm,

the treatment of costume and jewellery is elegantly decorative and the deities of the nine planets are ranged in a border frieze above the reclining figure. Another sculpture, also in black basalt, now in the Philadelphia Museum, presents the Naga king and his consort in a composition which is as fine as the one in Ajanta though totally different in formal conception. The figures are close together, the king with his arm around his consort. Their forms fuse in overall contour with fluent rhythms, crowned by the coalescent serpent hoods of both and the tender expression on the visages and the mutually responsive tilts of the heads make this a lyrically expressive composition. The great age of Indian bronzes is the epoch of the Cholas. But the Pala period also produced a substantial number of bronze sculptures, of Vishnu, the Buddha and the deities of Tantric Buddhism. Among the finest of these is a sculpture of Manjusri from Nalanda, now in the National Museum.

When forced to surrender to the imperial armies of Asoka, the small kingdom of Kalinga, today's Orissa, had won a big moral victory by forcing the emperor to reflect on the inhumanity of war and to abjure it for the rest of his life. In the time of Kharavela, who was a contemporary of the early Sungas, Orissa had produced a monumental sculpture in the caves of Khandagiri and Udayagiri. But they are in a bad state of preservation though the superb quality of the representation of elephants still makes impact and will irresistibly come to mind when we see the magnificent monolithic elephants in the Sun temple of Konarak built by the Eastern Ganga dynasty more than a millennium later. While the Rashtrakutas sculptured a whole hill at Ellora to simulate a structural temple, the Eastern Gangas built the temple at Konarak to simulate a giant sculpture of the sun god riding in his chariot drawn by horses. If slightly frozen in the expression of the visage, magnificently shaped still is the figure of the sun god, with the minimal jewellery, especially the beautifully carved girdle, gaining the maximum decorative effect. There are fine Dampati sculptures here (Pls. 91, 92). The composition showing a couple about to kiss each other is far less sensual but far more evocative than the uninhibited representations at Khajuraho and has a place in the world repertoire on this theme along with Rodin's masterpiece which latter is more ardently passionate. Amazonian in build and yet attractively sensuous are the figures of the female drummers (Pl. 85) and cymbalists (Pl. 172) on the vast terrace of the temple. The more sensuous type of feminine figuration is also plentifully seen here as well as in the temples of Bhuvaneshvar. Among these, the most gracious is the reticent yet provocative figure of a damsel, her body in languorous triple flexion, shown as tying the waist-band of her lower garment, in the Lingaraja temple.

South India

In the meantime, important developments had been taking place in the peninsular south. We should begin with the Pallavas for they had some connection with the tradition in the north which we have reviewed and they also left legacies for the Pandyas and Cheras of the south. The Chalukyan ruler Vikramaditya had conquered

Kanchipuram for a while and it was an architect from Pallava country who built the Chalukyan temple of Virupaksha at Pattadakkal. Likewise, the Rashtrakutas too had occupied Pallava lands for a while, making amends with matrimonial alliance. The Pallava queen Reva was the daughter of Danti of the Rashtrakuta line, her son Dantivarman was named after his grandfather, and there is some infusion of Rashtrakuta features in later Pallava sculpture.

The masterpiece among Pallava creations is the gigantic tableau carved at Mahabalipuram. It represents the descent of the Ganga and the whole rock-face has become a representation of the river and the teeming animal and human life on its banks. The rock has become alive with figures. It has also shed its gravity and weight, for the gods of the celestial space float effortlessly here. There are exquisite instances of sympathetic observation of animal life. We see a pair of gazelles, one of them gently scratching its muzzle with a hind leg. A babe elephant quietly reposes under the shelter of the vast belly of its mother. A monkey solicitously picks the lice from the head of its mate.

There are magnificent panels in the Rathas or monolithic shrines too, representing the incarnations of Vishnu. Alive with dynamic tension, with tautly inclined postures of the combatants, is the panel which represents Durga in her great fight with the Buffalo Demon (Mahisha). Very varied are the aspects of the great Siva and we have here a gracious representation of him as teacher, or Dakshinamurti. He is shown as teaching the essentials of music and dance to Bharata, the great legendary authority on these arts in the Indian tradition. Evocatively pastoral is the carving showing Krishna engaged in milking the cow which, meanwhile, is licking the coat of her calf to glossy freshness. Portrait sculpture was something of a speciality in the Pallava tradition and we have several sensitive studies of royal couples.

The Brihadisvara temple in Tanjore built around 1000 by Rajaraja Chola and the Gangaikonda Cholesvara temple built by his son Rajendra have a large number of sculptures in niches in the architectural facades. As the name itself suggests, the latter temple was built to commemorate Rajendra's thrust north to the Ganga. There is a fine group here of Siva and Parvati, with Siva shown as crowning his devotee, Chandesa. It is widely believed that the figure of Chandesa is a portrait of Rajendra himself. In the gateway towers of the temple in Chidambaram, Siva illustrates the dance poses of Bharata Natya, a unique manual in sculpture on a sister art. The lives of Saivite saints are carved on the plinth of the shrines in the temple of Darasuram which also has fine panels illustrating music and dance. A preference for the tall, slender anatomy had commenced in Pallava sculpture. It is even more noticeable in Chola figures. But where the need is felt, the figures can become titanic and turbulent, as in the Dwarapalas or guardians in the Gangaikonda Cholesvara.

But it is in bronze sculpture that the Chola epoch produced its greatest creations. Though both the Vaishnavite and Saivite traditions exist in the Tamil region, the former has fewer compositions. But there are figurations of Rama, by himself, or with Sita and Lakshmana, and a number of delightful representations of the child Krishna dancing. The Saivite tradition has been prolific in categories. The bronzes of the

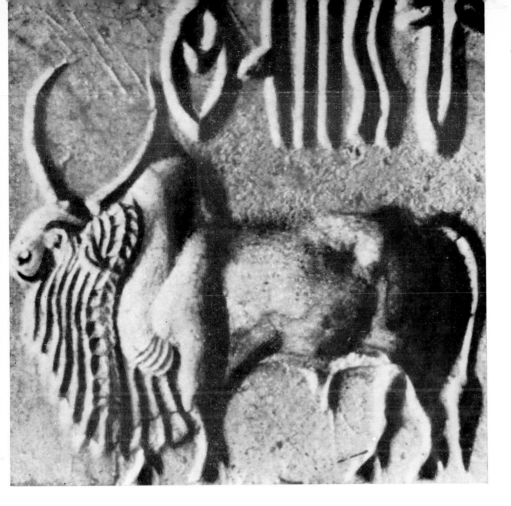

50. Bull seal. Steatite,
 Mohenjo Daro,
 2500-1700 B.C.

51. Seal with Siva-like
 figure. Steatite,
 Mohenjo Daro,
 2500-1700 B.C.

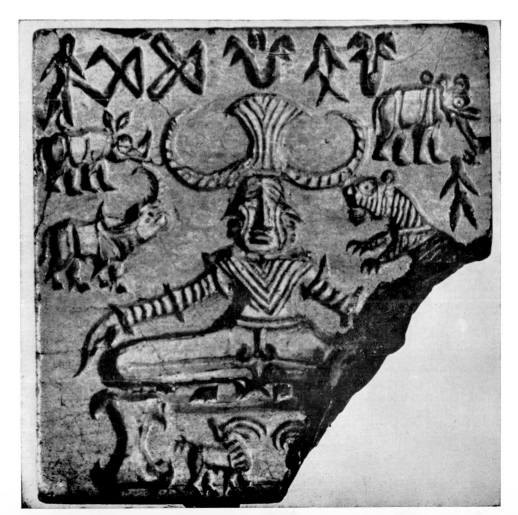

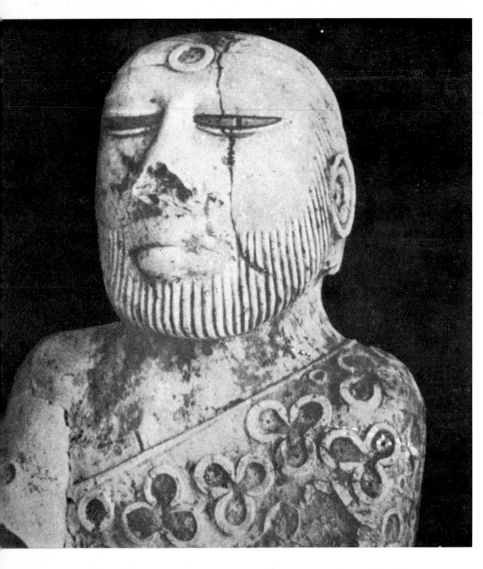

52. Portrait of a priest. Limestone, Mohenjo Daro, 2500-1700 B.C.

54. Mother goddess. Terracotta, Mohenjo Daro, 2500-1700 B.C.

53. Mother goddess. Terracotta, Mohenjo Daro, 2500-1700 B.C.

55. Female figurine. Terracotta, Mauryan, third century B.C.

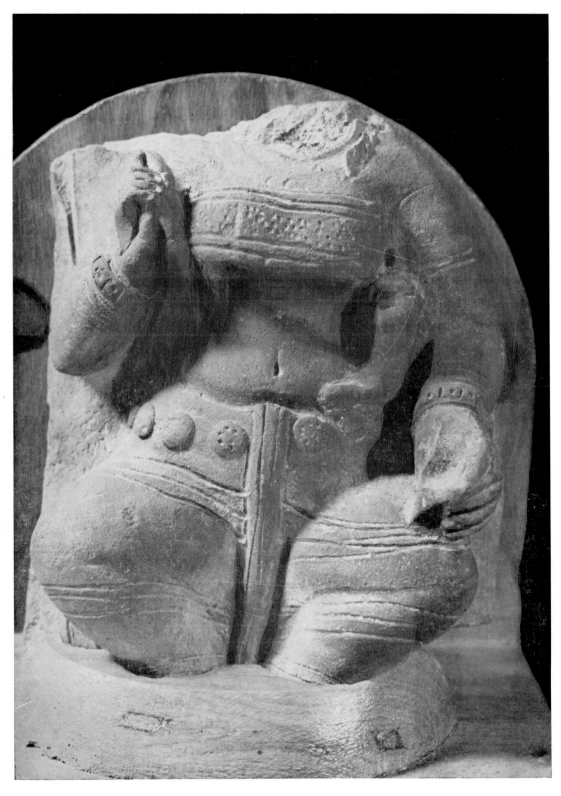

56. Mother and child (latter disfigured and without head). Terracotta from Ahichhatra, fifth century.

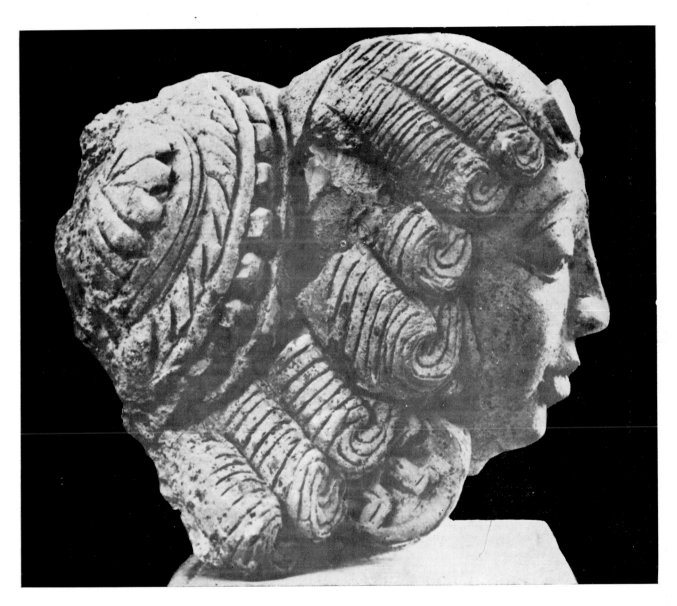

57. Head of Parvati. Terracotta from Ahichhatra, c. 500.

→ 59. Krishna steals the cloths of the maidens. Terracotta, Bengal, eighteenth century.

58. Ras Lila, Krishna's dance with the maidens. Terracotta, Bengal, eighteenth century.

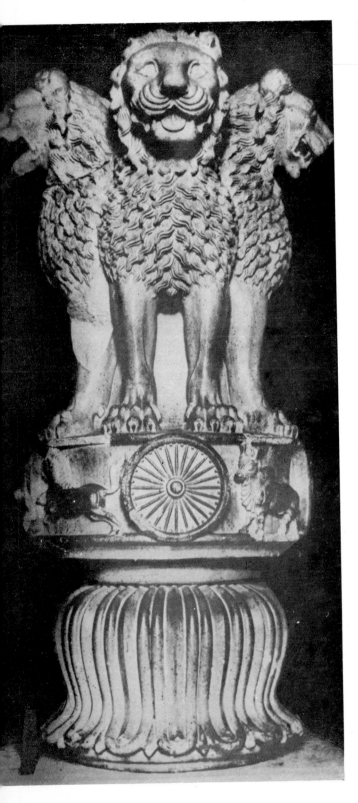

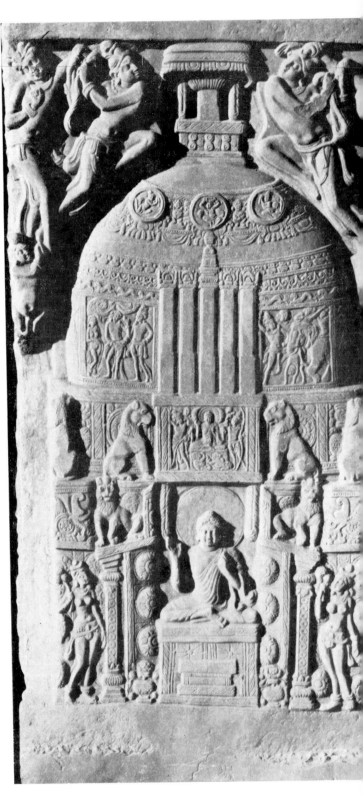

60. Lion capital. Sandstone, Sarnath, Mauryan, third century B.C.

61. Relief sculpture showing a Stupa. Nagarjunaconda, f century A.D.

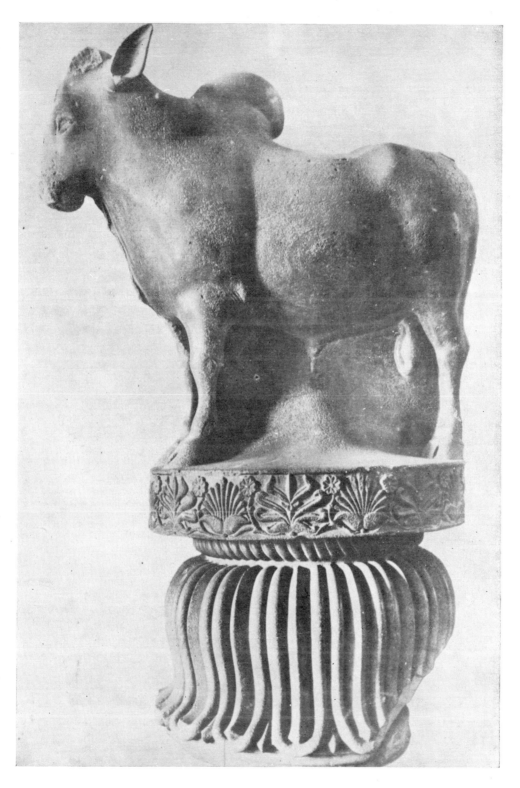

62. Bull capital. Sandstone, Rampurva, Mauryan, third century B.C.

63. Maya's dream of Annunciation. Bharhut, Sunga, second century B.C.

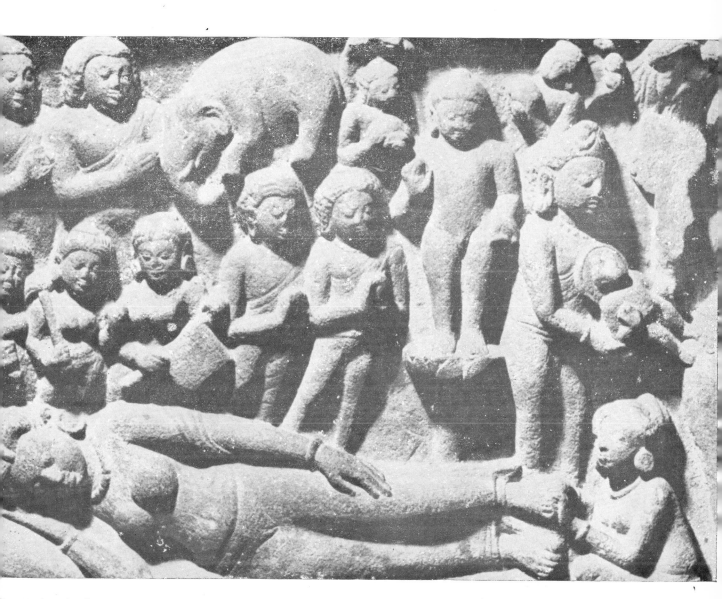

Maya's dream of Annunciation. Sarnath, Gupta, fifth century.

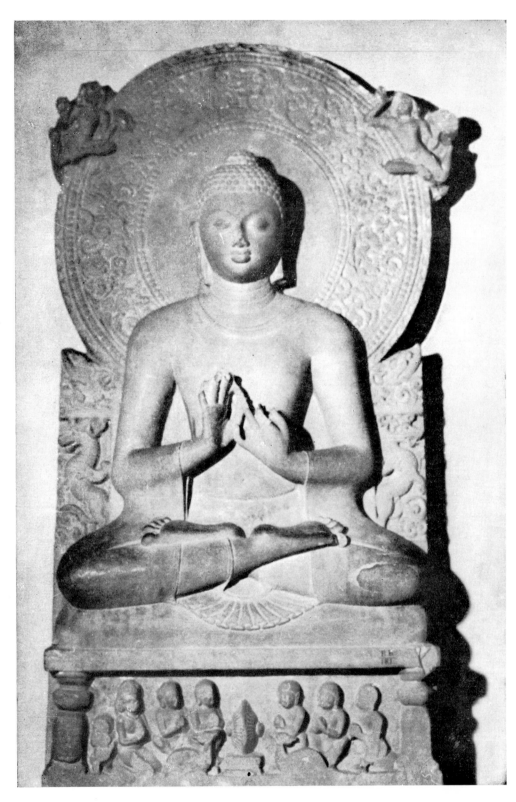

65. Seated Buddha. Sandstone, Sarnath, Gupta, fifth century.

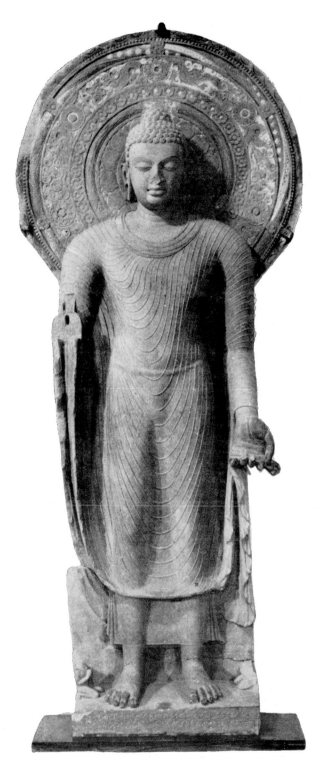

66. Standing Buddha. Sandstone, Mathura,
fifth century.

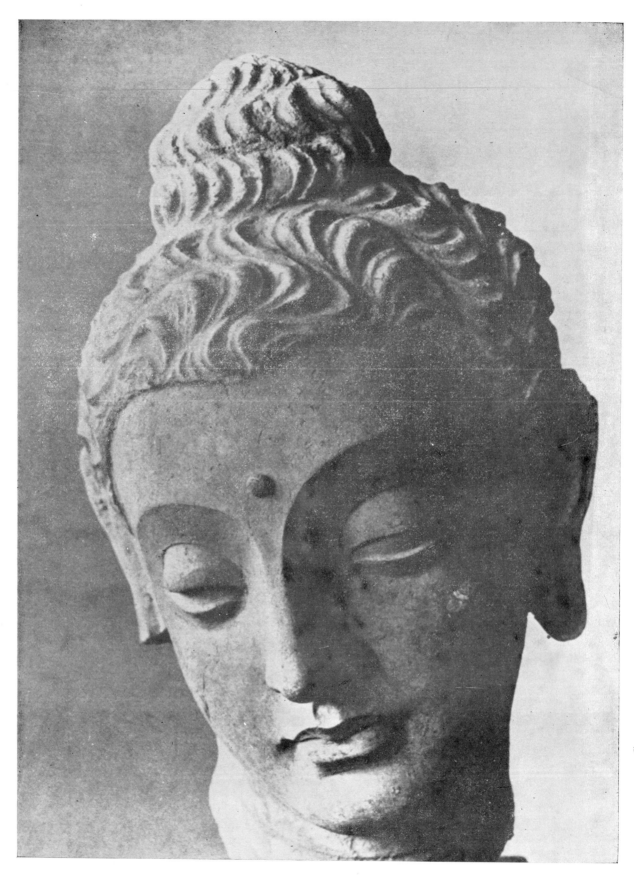

67. Bodhisattva. Gandhara, second century.

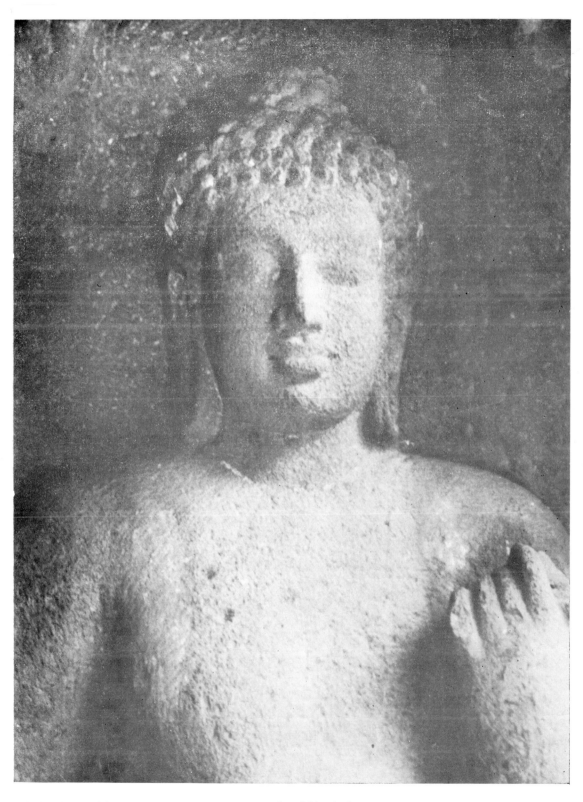

68. The Buddha. Cave IX, Ajanta. Vakataka, fifth-sixth century.

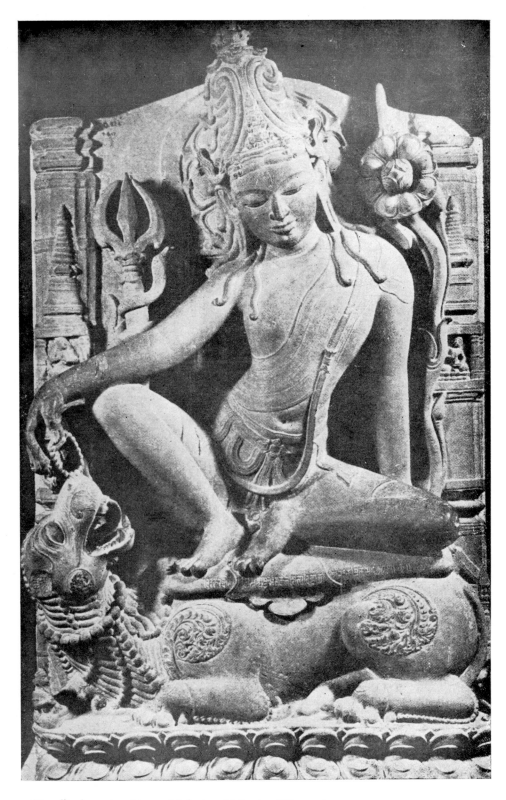

69. Simhanada. From Mahoba, U.P., twelfth century.

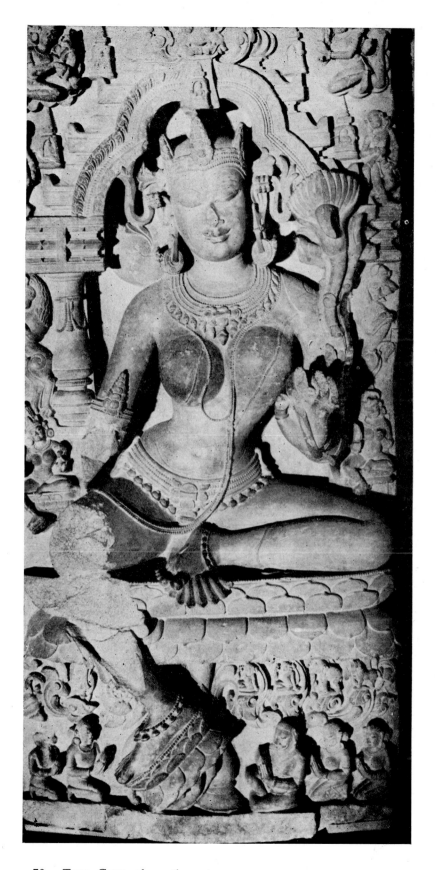

70. Tara. Gaya, eleventh century.

71. Flying Vidyadhara. Garuda Brahma temple, Alampur, sixth century.

72. Flying Vidyadhara. Garuda Brahma temple, Alampur, sixth century.

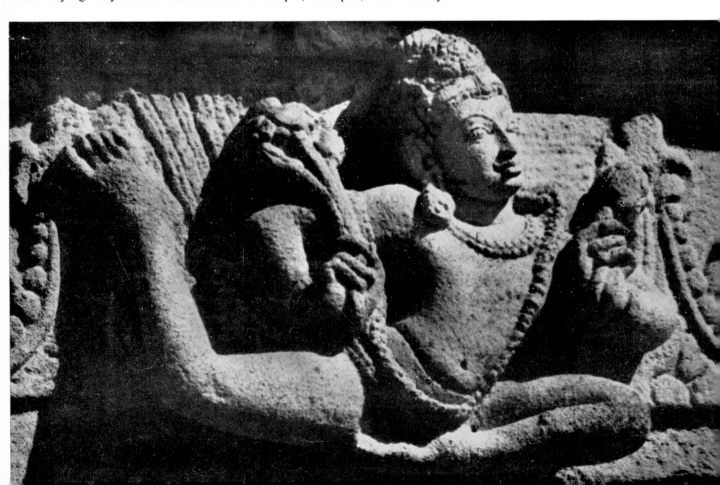

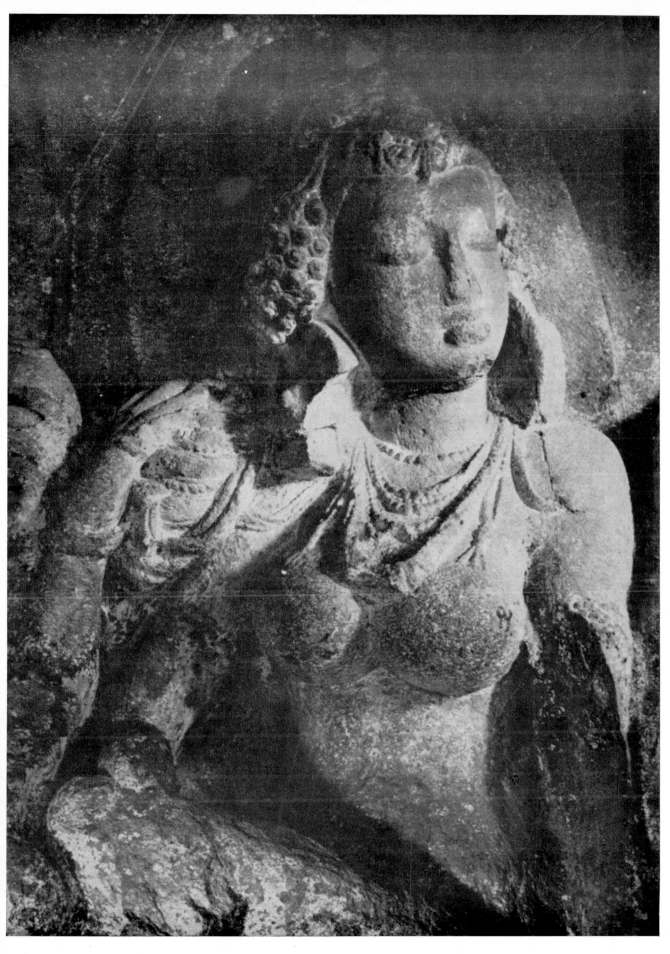

73. Matrka. Cave XXI, Ellora, eighth century.

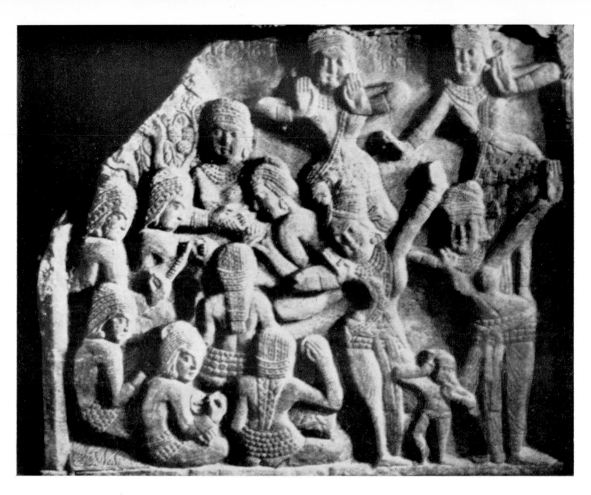

74. Dancing celestial nymphs. Prasenajit pillar, Bharhut, second century B.C.

75. Dance panel. Cave VII, Aurangabad, Vakataka, seventh century.

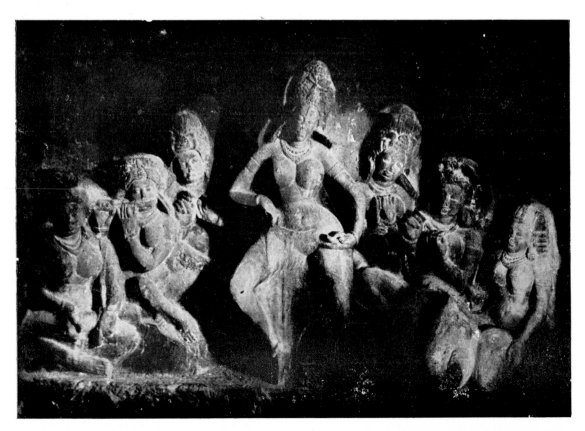

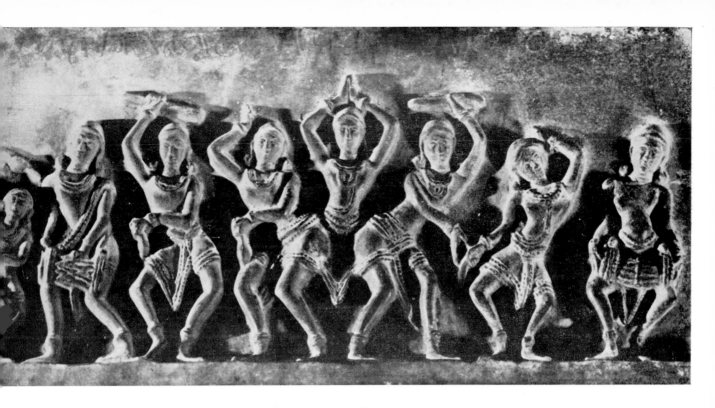

Dance panel. Ramappa temple, Palampet, Kakatiya, thirteenth century.

77. Holi dancers. Vijayanagar, fifteenth century.

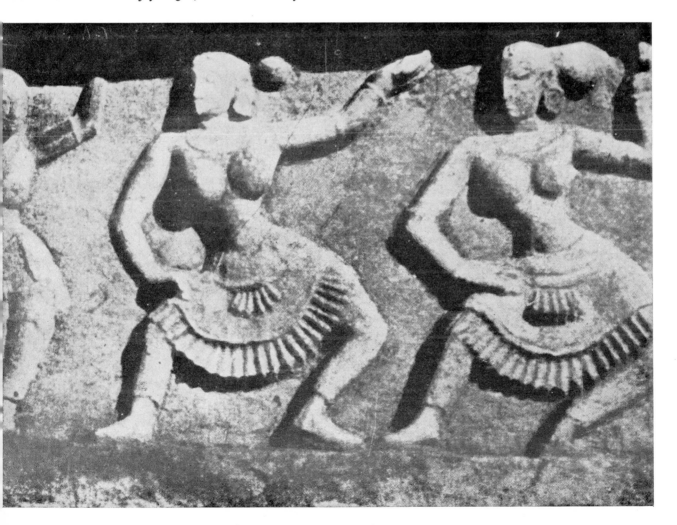

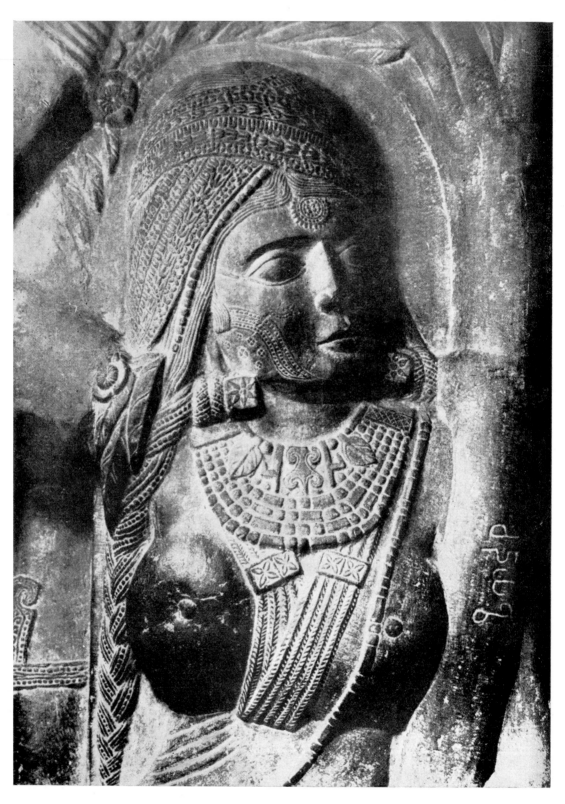

78. Yakshi Chandra. Bharhut, second century B.C.

rikshaka or dryad. East Gate, Sanchi Stupa. Satavahana,
rst century B.C.

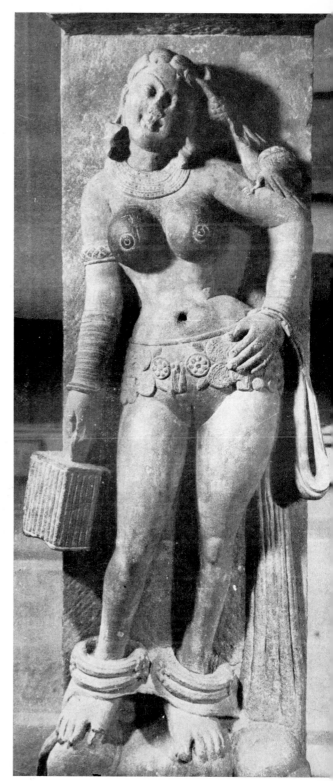

80. Damsel with pet bird. Bhutesar, Mathura,
Kushan, second century.

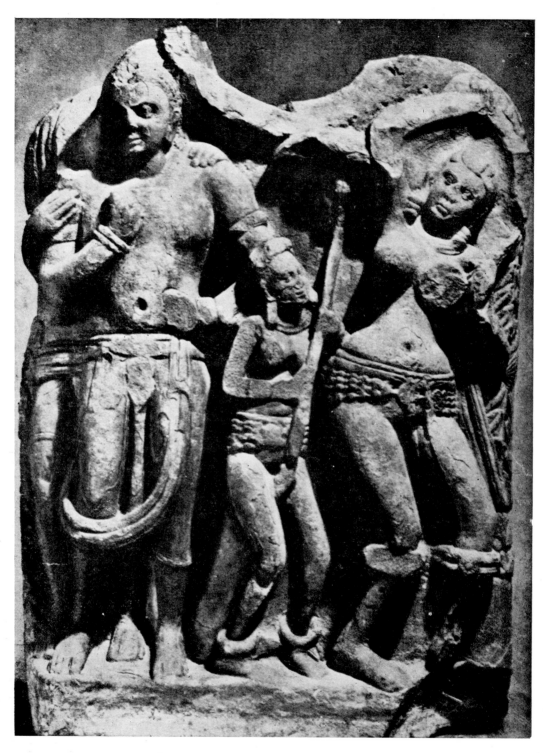

81. Vasantasena pursued by Sakaraka. Mathura, Kushan, second century.

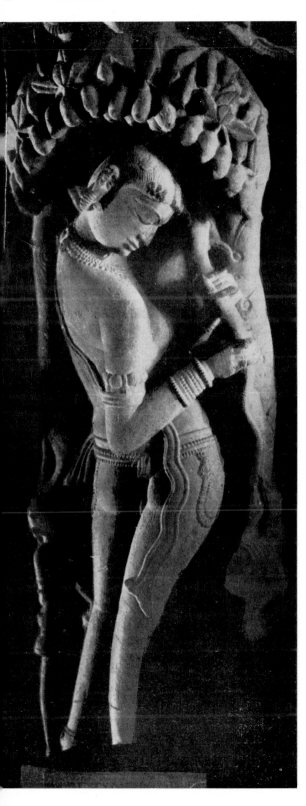

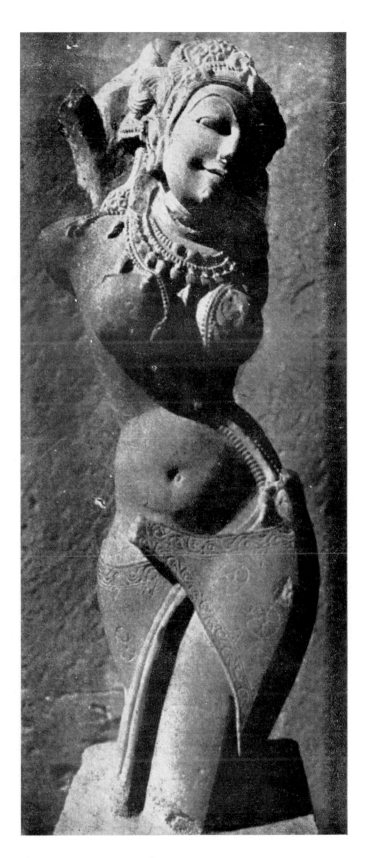

82. Bracket figure. Lakshmana temple, Khajuraho. Chandella, tenth century.

83. Celestial nymph from Gyraspur. Gurjara-Pratihara, tenth century.

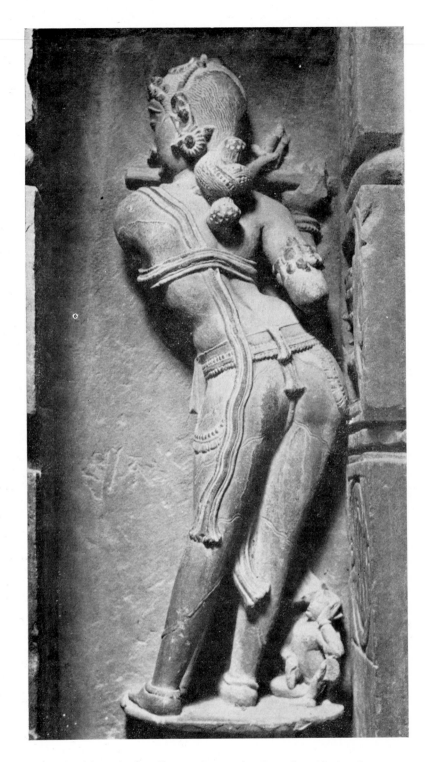

84. Maiden playing flute. Visvanatha Temple, Khajuraho.
Chandella, eleventh century.

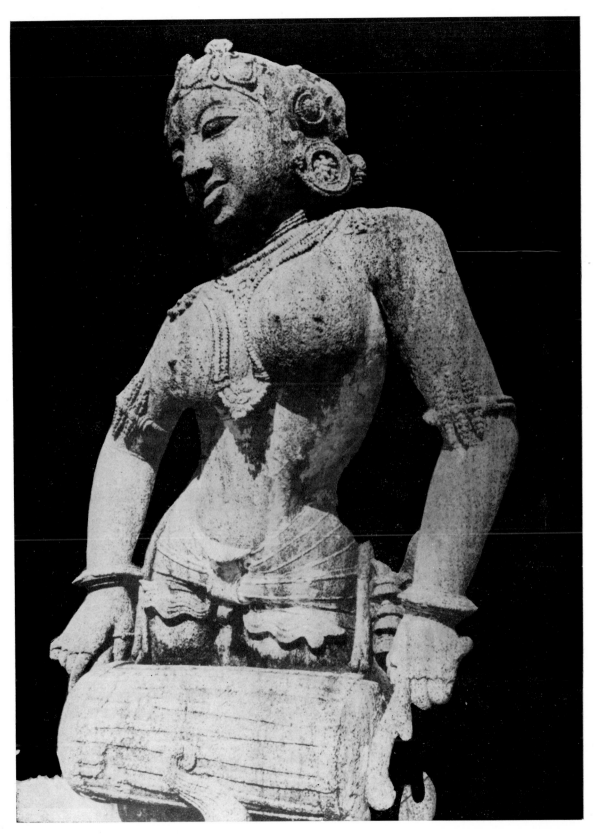

85. Damsel playing the drum. Sun Temple, Konarak. Eastern Ganga, thirteenth century.

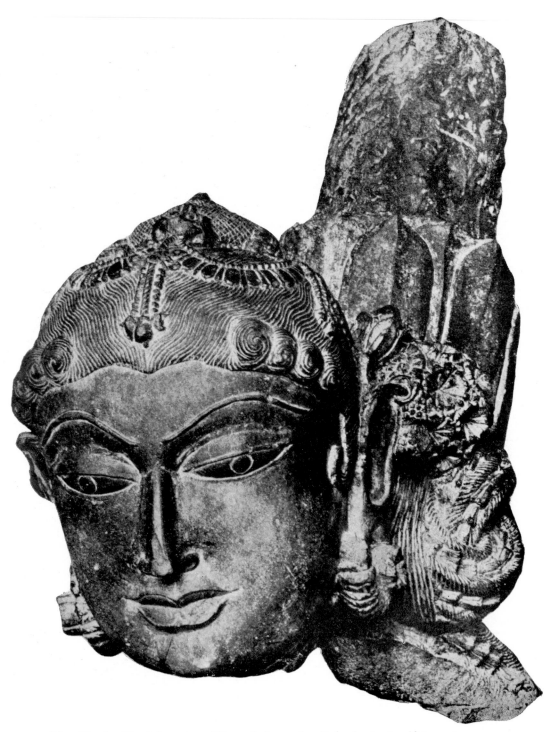

86. Head with elaborate coiffure, Rajorgarh. Gahadvala, twelfth century.

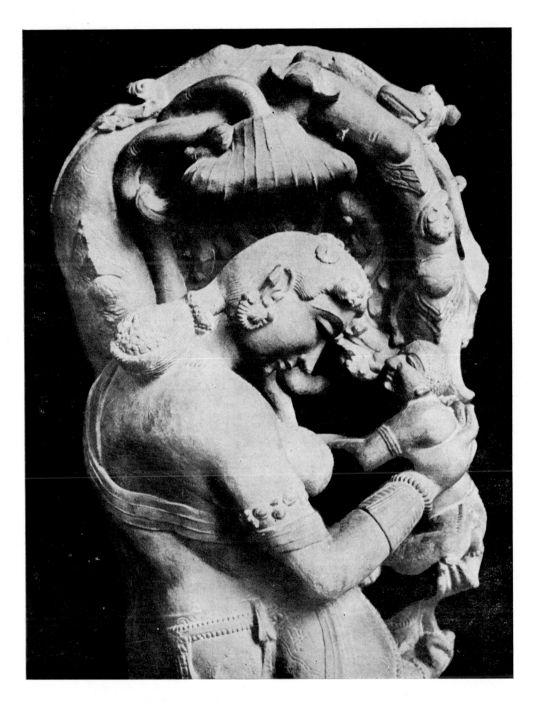

87. Mother and Child from Khajuraho. Chandella, eleventh century.

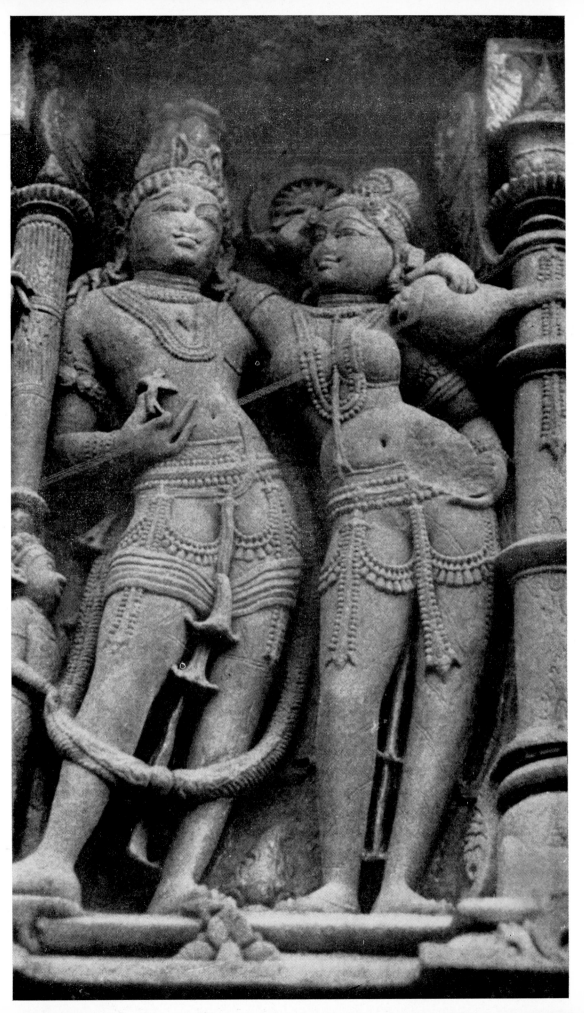

88. Vishnu and Lakshmi, Sachiya Mata Temple, Osian. Pratihara, eighth century.

89. Siva and Parvati. Uttar Pradesh, twelfth century.

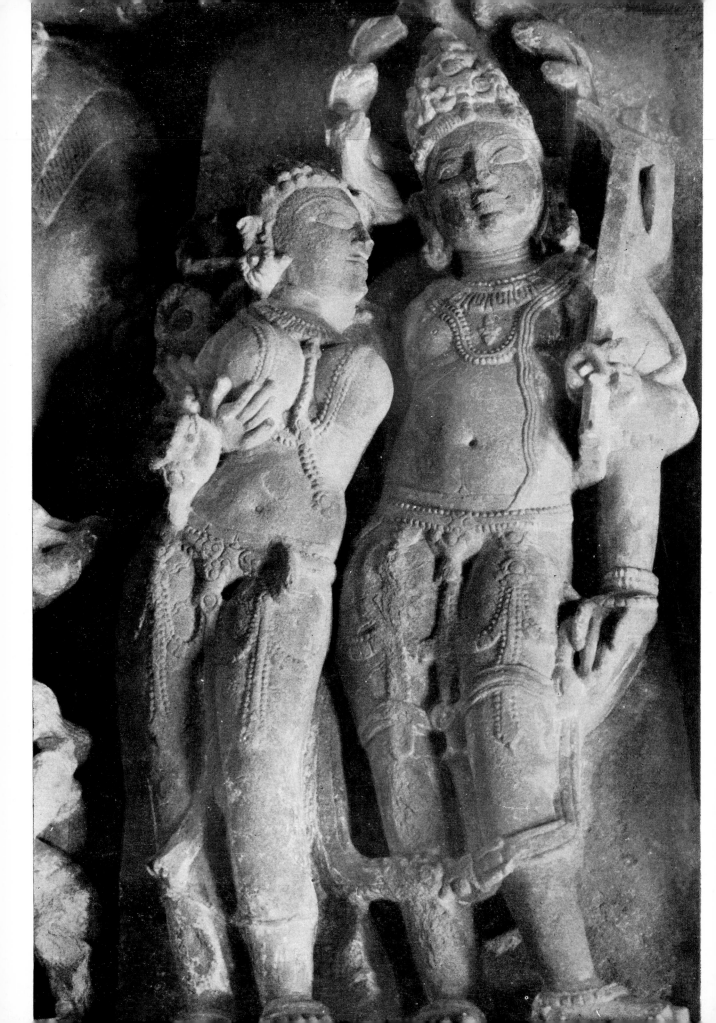

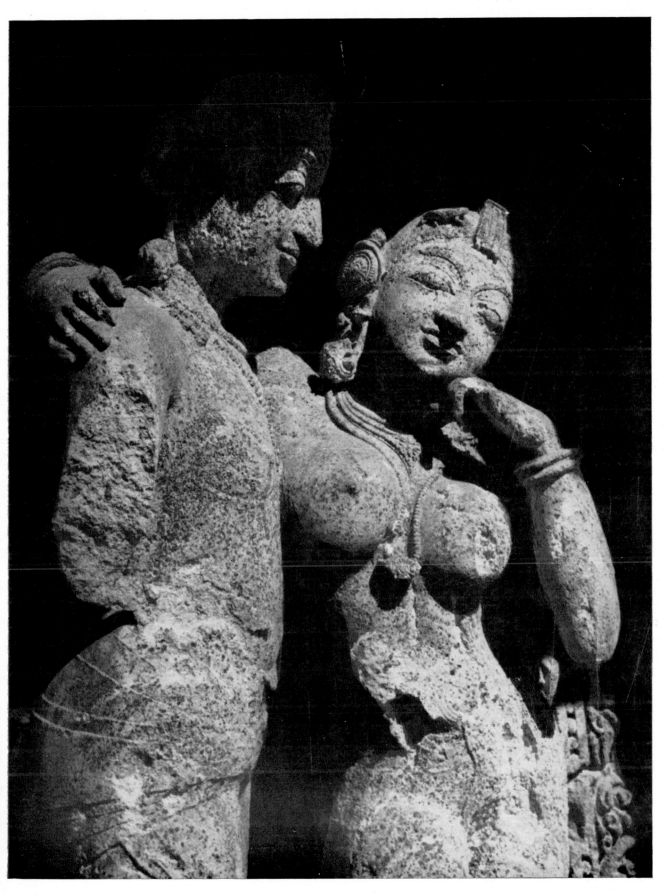

91. Couple. Sun Temple, Konarak. Eastern Ganga, thirteenth century.

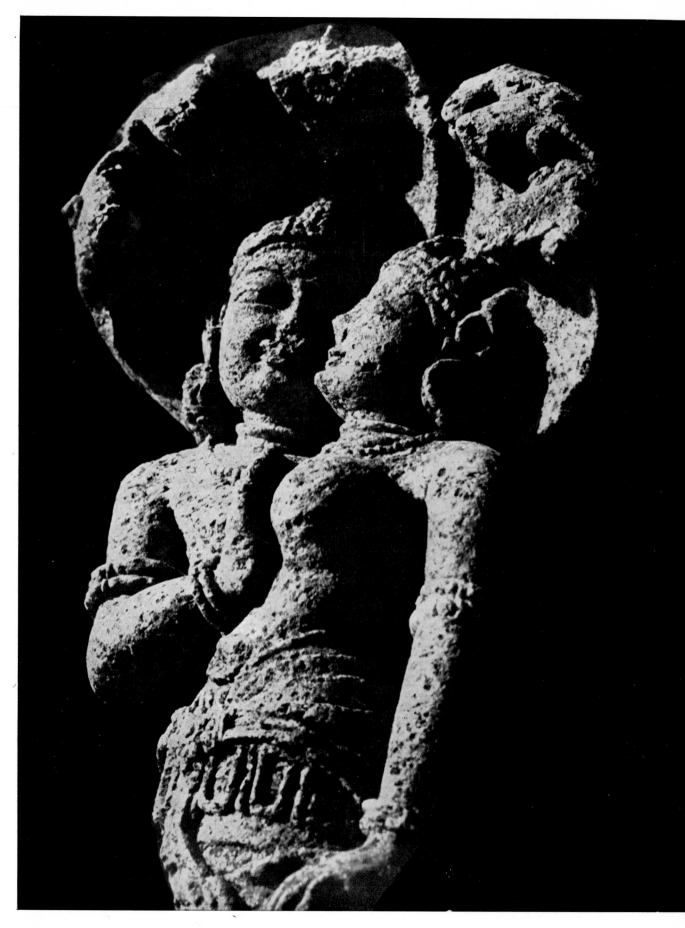

92. Naga couple. Sun Temple, Konarak. Eastern Ganga, thirteenth century.

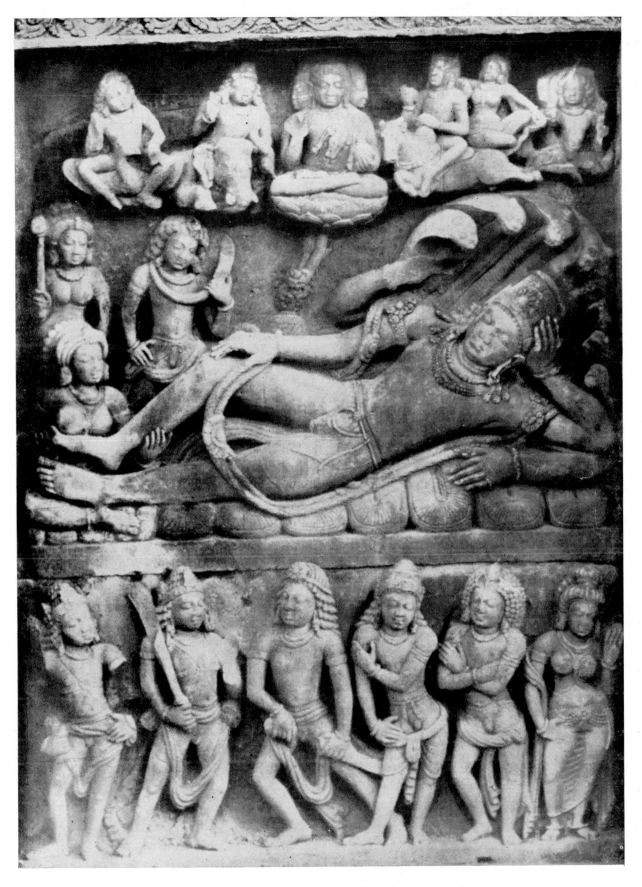

93. Vishnu asleep between cycles of creation. Deogarh Temple. Gupta, fifth century.

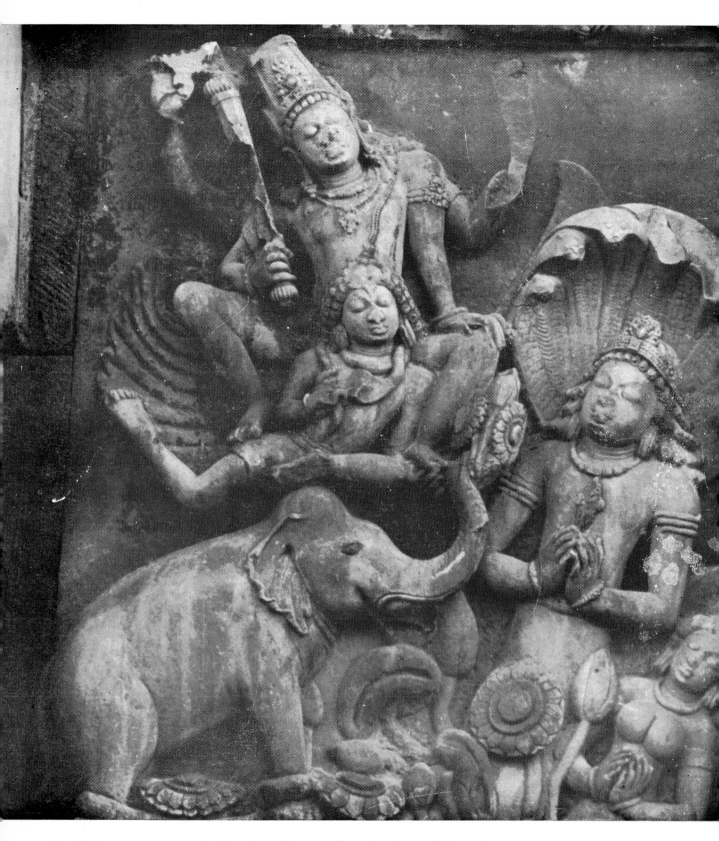

94. Vishnu rescues a devoted elephant. Deogarh Temple. Gupta, fifth century.

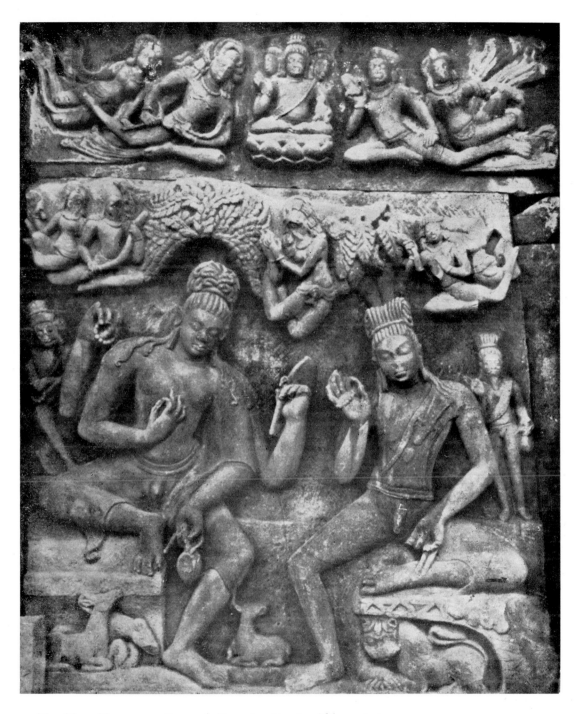

95. Nara-Narayana. Deogarh Temple. Gupta, fifth century.

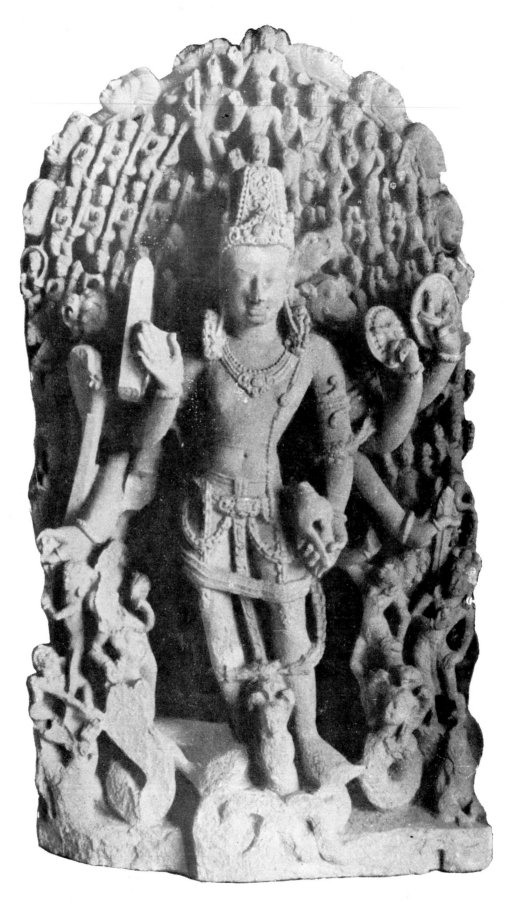

96. Cosmic Form of Vishnu. Kanauj, tenth century.

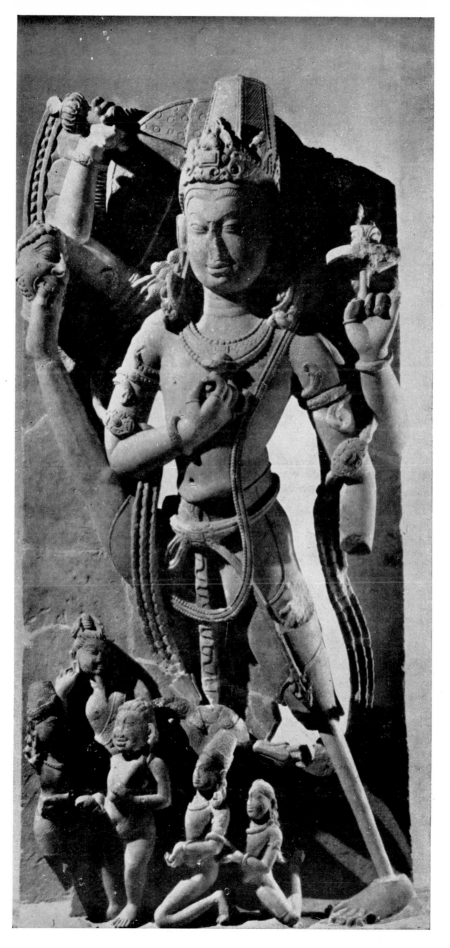

97. Vishnu Trivikrama. Kasipur, Moradabad, tenth century.

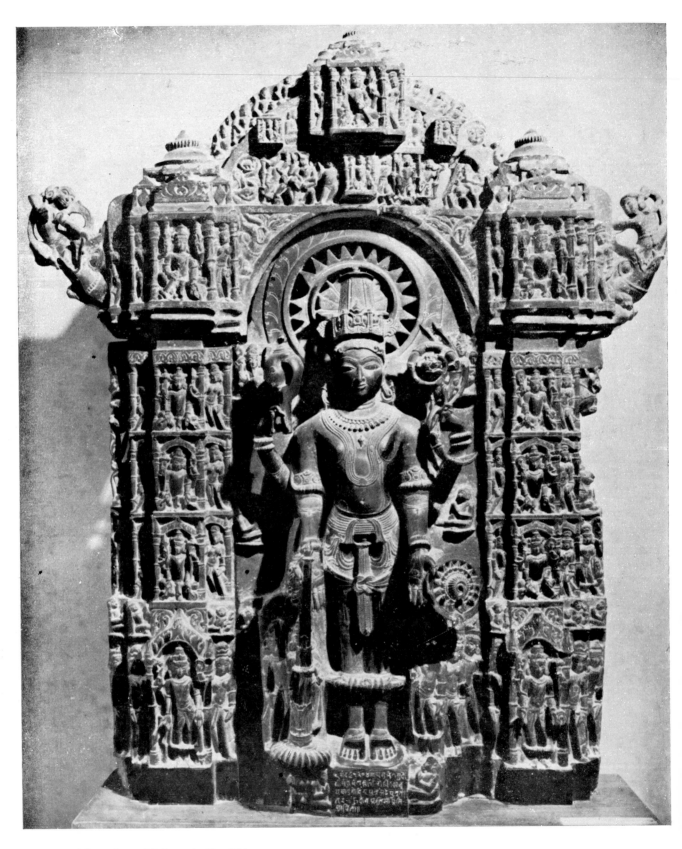

98. Vishnu from Mehrauli. Twelfth century.

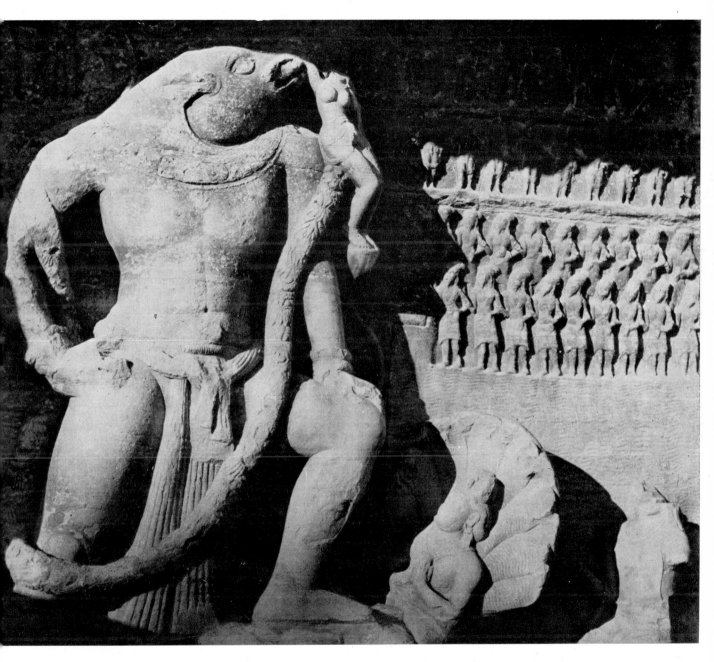

99. Boar Incarnation of Vishnu salvaging earth from deluge. Rock-cut sculpture, Udayagiri, Madhya
Pradesh. Gupta, fifth century.

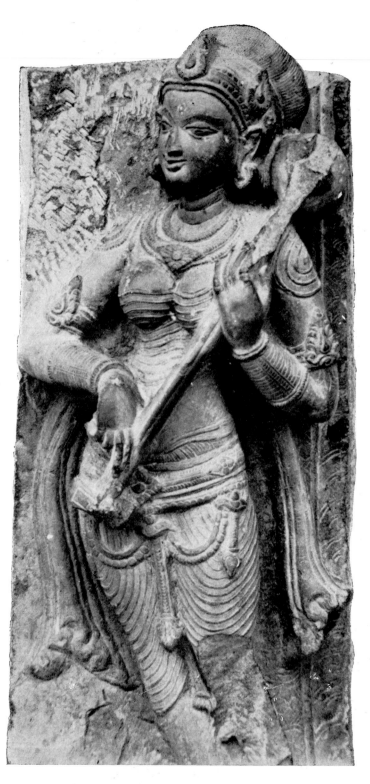

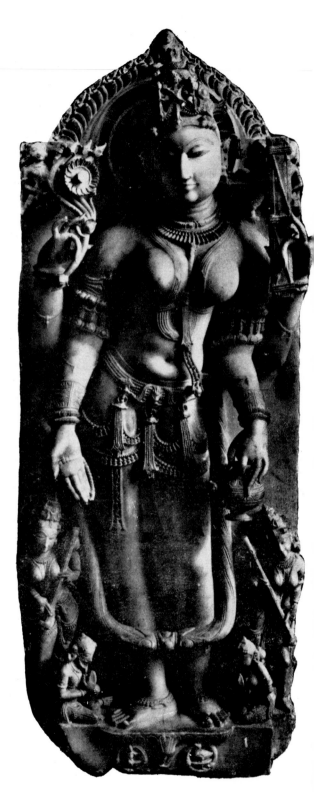

100. Sarasvati from Sunderban, West Bengal.
Pala, eleventh century.

101. Sarasvati from Bikaner. Gahadvala,
twelfth century.

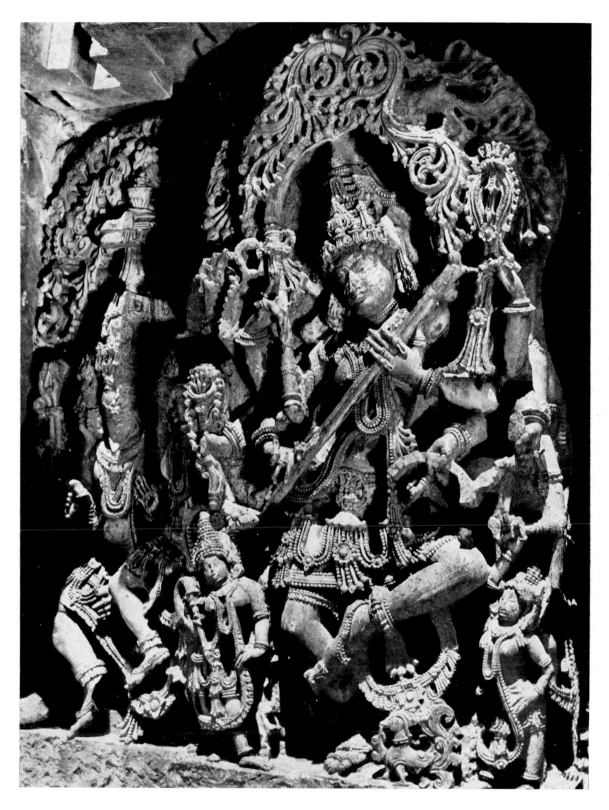

102.　Dancing Sarasvati.　Halebid Temple.　Hoysala, twelfth century.

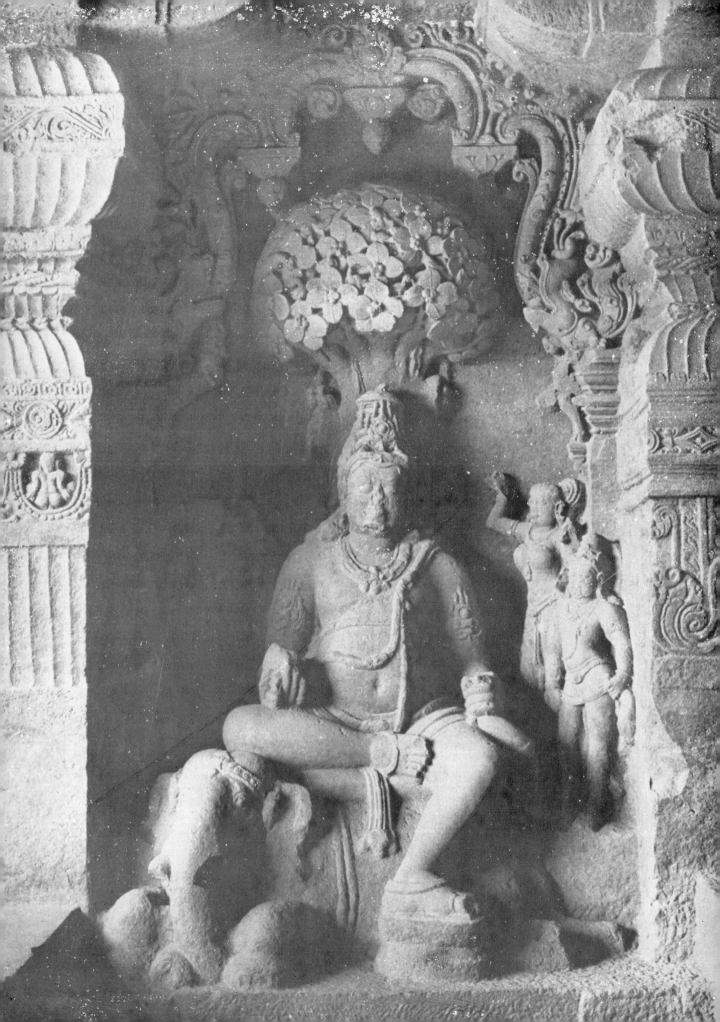

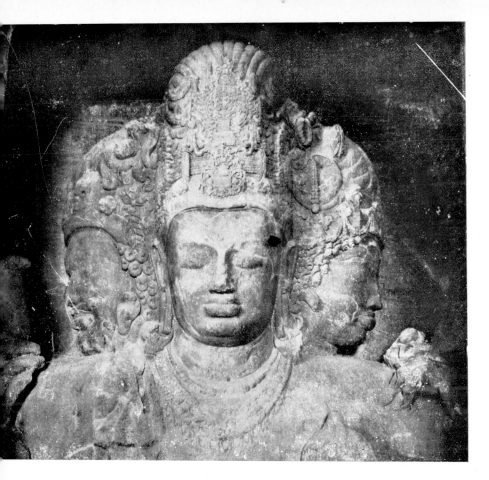

104. Mahesamurti of Elephanta. Rashtrakuta, seventh-eighth century.

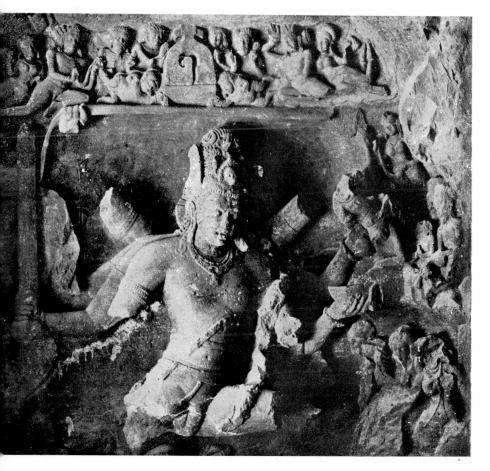

105. Siva slaying the demons Andhaka and Gaja, Elephanta. Rashtrakuta, seventh-eighth century.

103. Indra seated on the elephant Airavata. Cave 33, Ellora. Vakataka, sixth century.

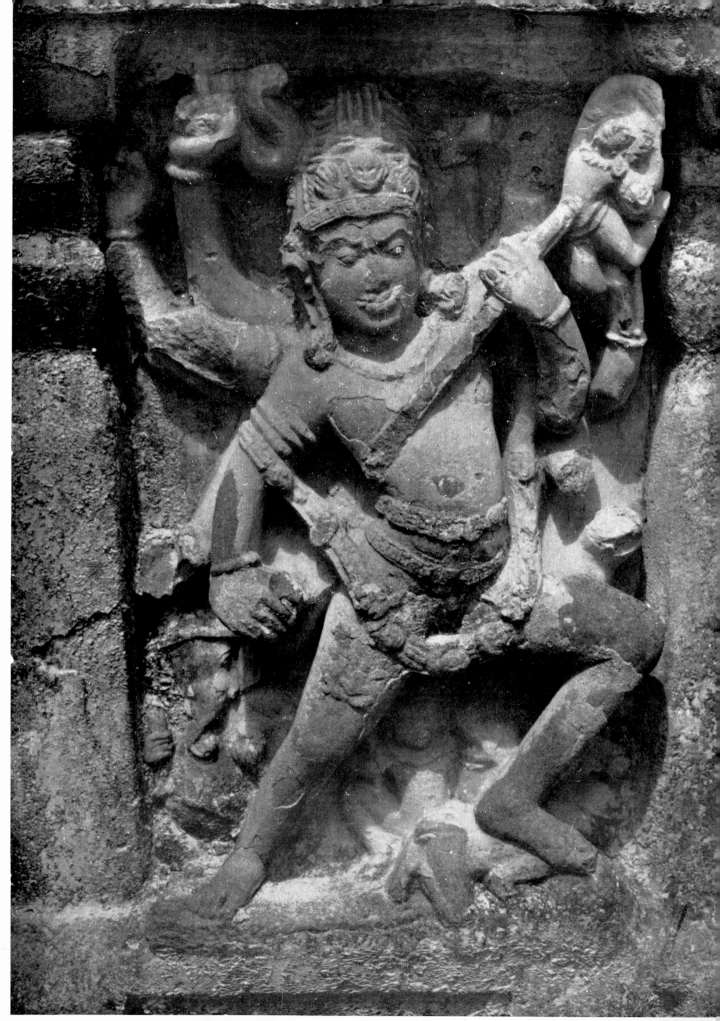

← 106. Siva as the slayer of Andhaka. Kudaveli Sangamesvara Temple, sixth century.

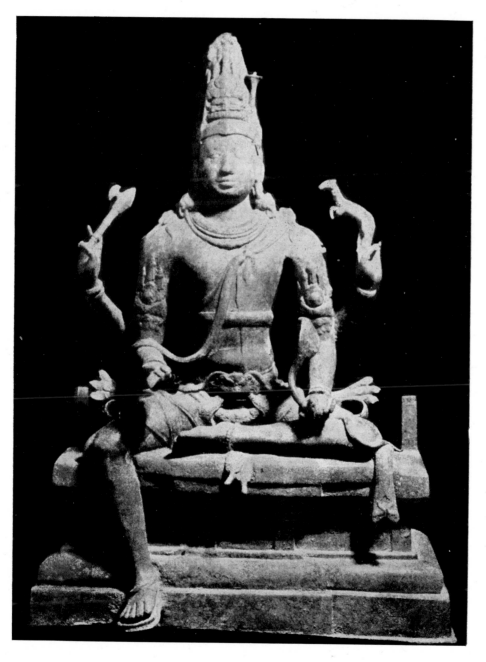

107. Siva about to drink and thus contain the poison generated by the cosmic process. Pallava, ninth century.

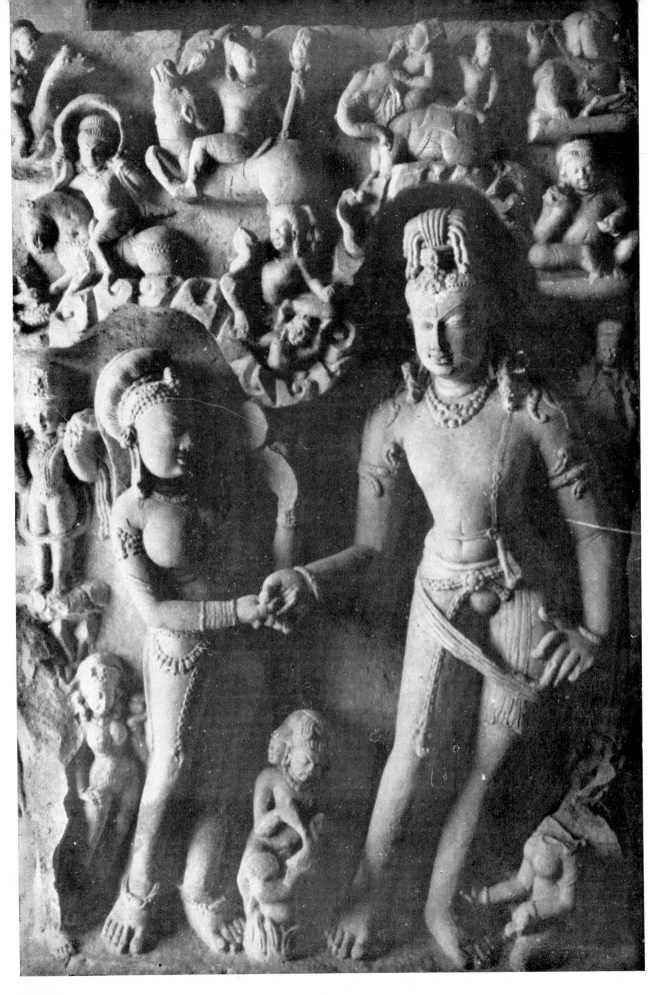

08. Marriage of Siva and Parvati. Kanauj, ninth century.

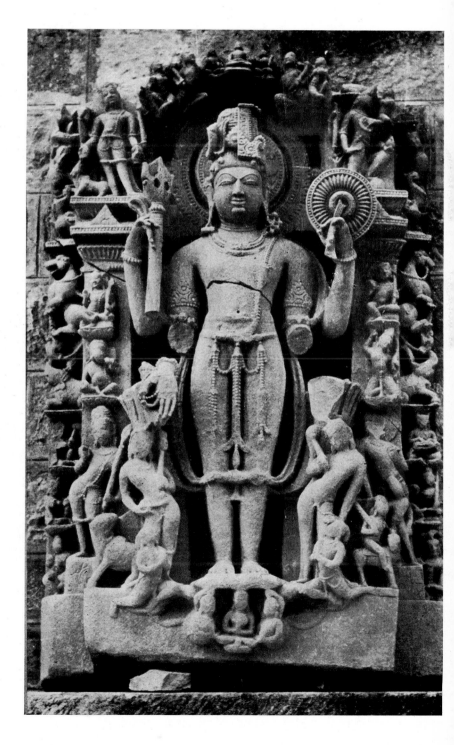

109. Veerabhadra, attendant of Siva. Pillar sculpture, Lepakshi Temple, sixteenth century.

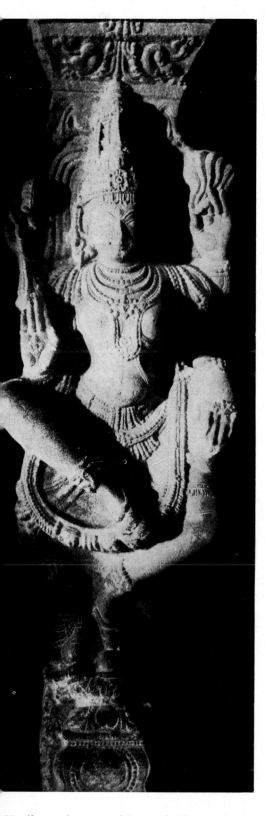

Harihara, integrated icon of Vishnu and Siva. Khajuraho, eleventh century.

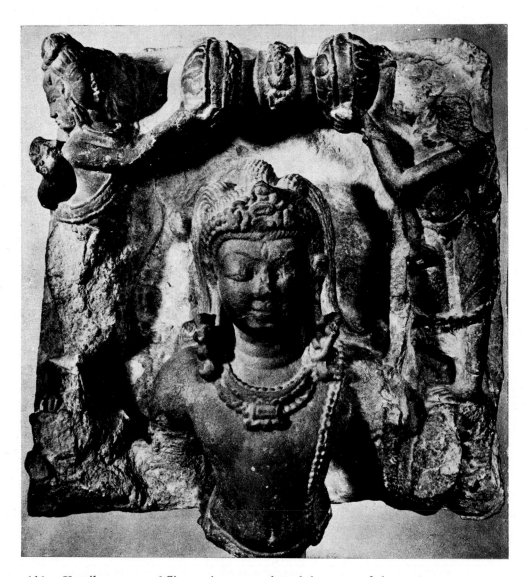

111. Kartikeya, son of Siva and commander of the army of the gods.
Gurjara-Pratihara, ninth century.

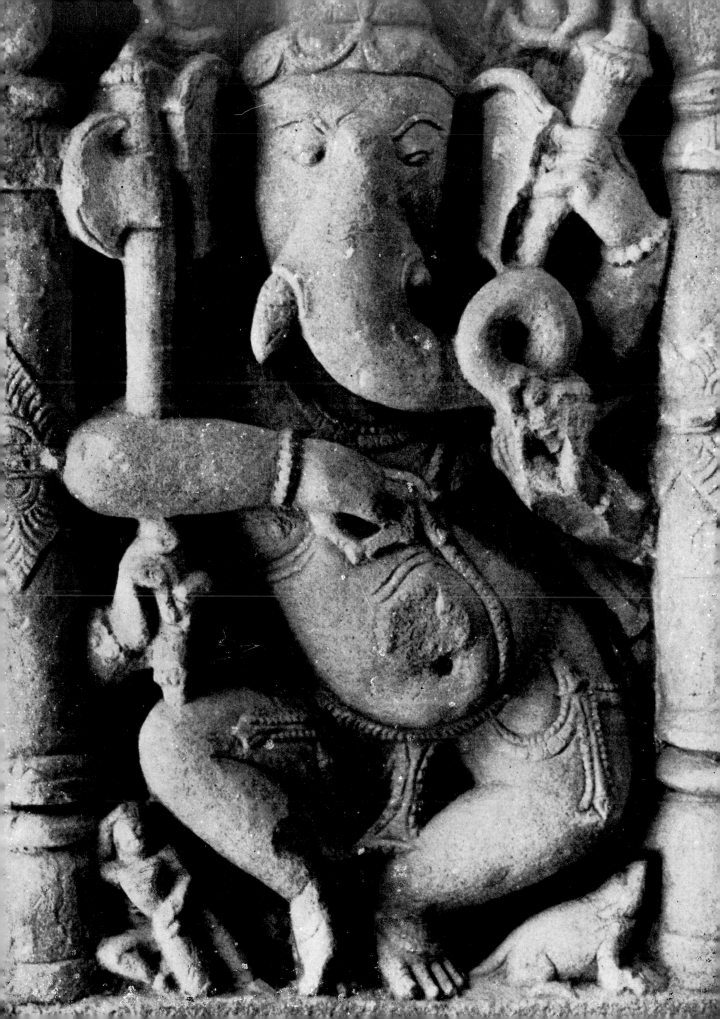

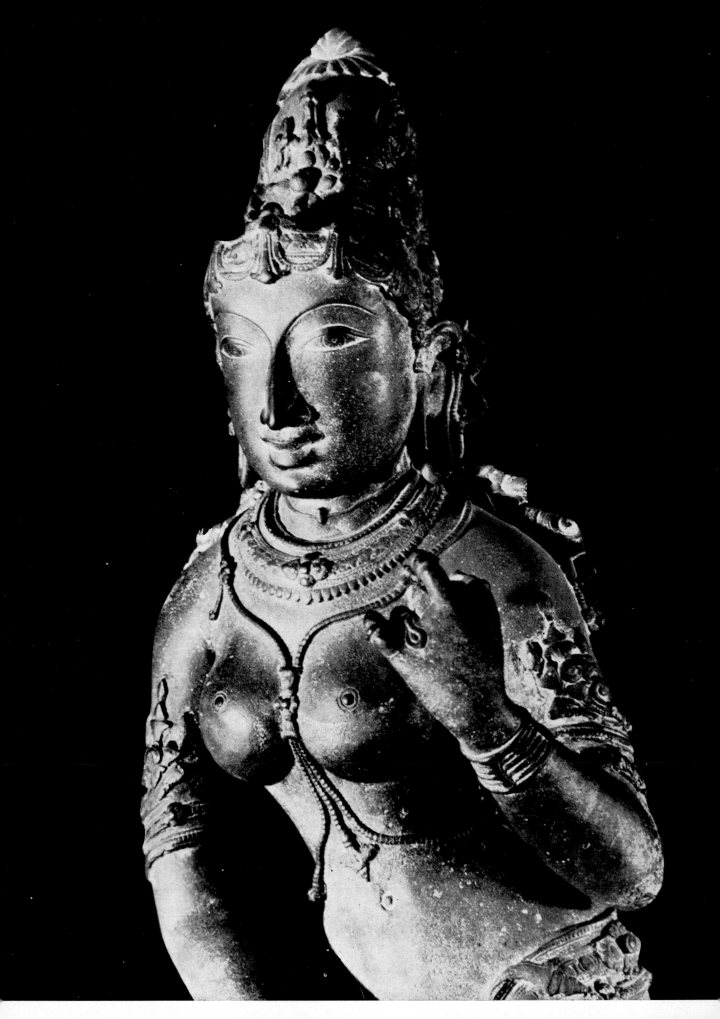

← 113. Parvati, consort of Siva. Bronze. Chola, eleventh century.

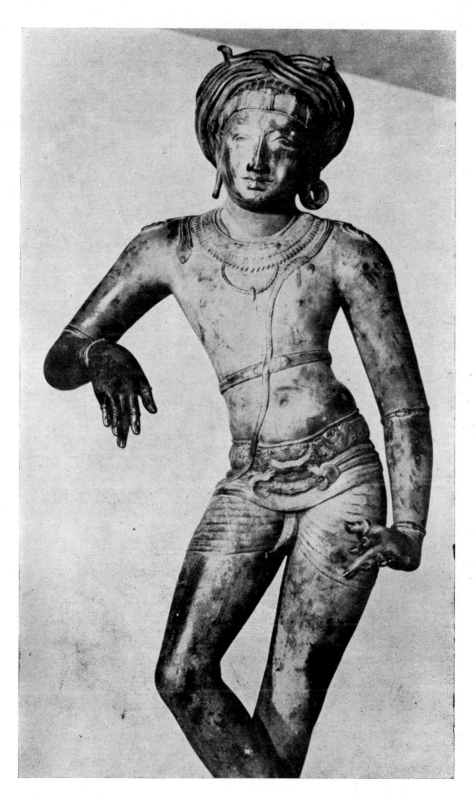

114. Siva relaxing with his hand resting on his bull (not shown).
Bronze. Chola, eleventh century.

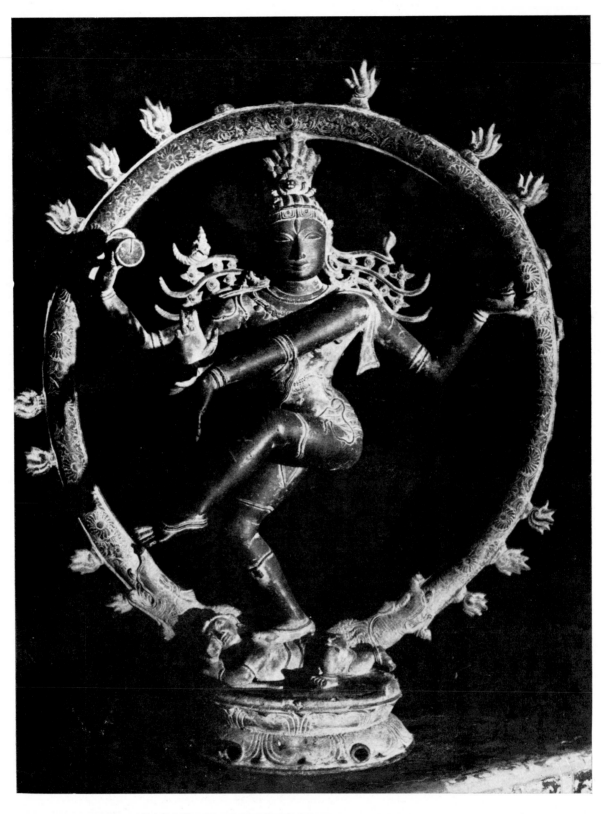

115. Siva Nataraja. Bronze. Chola, eleventh century.

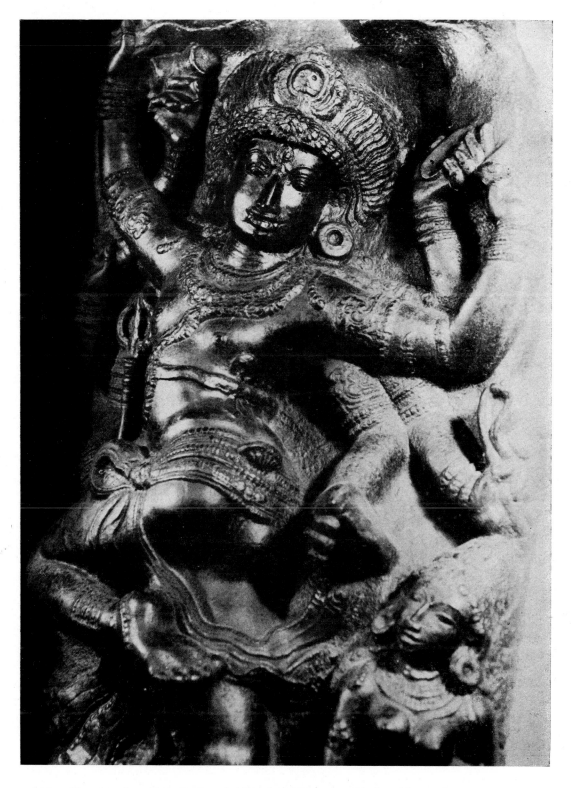

116. Siva dancing after slaying the Elephant Demon. Chola, thirteenth century.

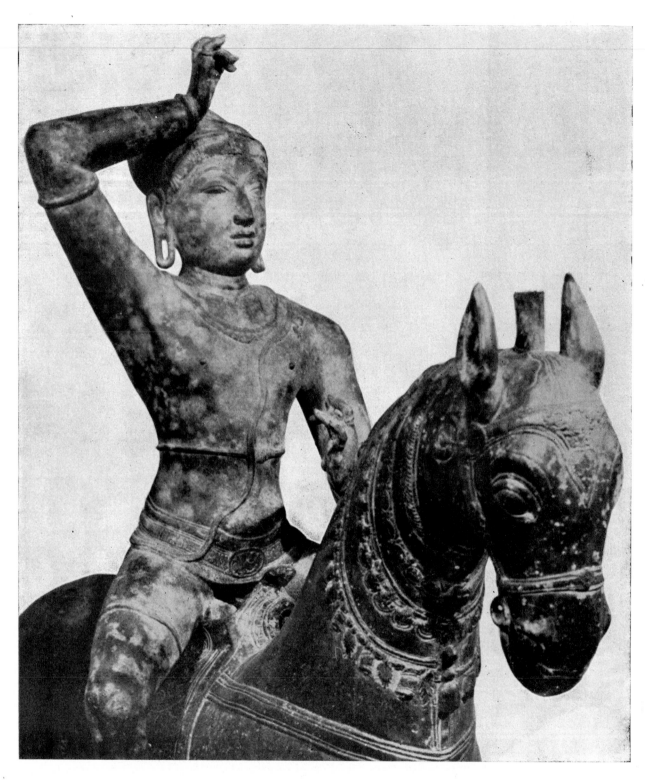

117. Siva in the guise of a horse-merchant. Bronze. Chola, thirteenth century.

saints are finer than the stone sculptures, those of Sundaramurti and Manikkavachaka having the individuality and fidelity of sensitive portraits. But Siva is the dominant deity of Chola sculpture, in stone too besides bronze. He is seen in a whole spectrum of moods from the most serenely domesticated to the most profoundly symbolical (Pls. 109, 110, 114-117). No sculptural representation has been more relaxed than that of Siva in the relaxed (*Sukhasana*) pose. In the Kalyanasundara figurations, he is the austere yet affectionate bridegroom. Numerous bronzes present him in a contentedly domestic mood, with his consort and children, Ganesa and Skanda. Wanderer, he relaxes for a while with his elbow and forearm resting on his bull-mount, Nandi (Pl. 114). The bull is not there in the composition, but the stance with all tautness allowed by the support to flow out of the frame vividly evokes its presence.

But in depth of symbolism and perfection of expressive plastic form, the Nataraja or dancing Siva (Pl. 115) is the greatest creation of the Chola epoch and it is universally accepted today as one of the masterpieces of world art. In east and west alike, men have often made the mistake of misconceiving the relation between being and becoming, transcendence and empirical reality, eternity and temporality. As things are always in flux in the world, it was thought to be unstable, even illusory. But flux is process, phases of the realisation of an intentionality. The words of a recited lyric, the notes of a melody, perish from second to second, but the poem and the song are authentic realities. That is why, in the Rigveda, God is called Kavi, poet or singer and Nartaka, dancer. Siva's dance is the dance of creation. An intense dynamism pulsates through the whole figure. Nevertheless, it is almost still in its classic balance, stable like the universe with its gyrating galaxies and the miniature solar systems of the smallest atoms with their planetary electrons.

Every detail of the splendid plastic creation is charged with symbolic meaning. In many instances an arch frames the figure. This is the arch of nature which deity has created and which frames and reveals him, as the sanctum of a shrine houses the icon. The arch is decorated with flames at intervals, all along its length. Each flame is really a cluster of three flames, and they represent the cosmic energy that manifests itself as the sun in the depth of space, as lightning in middle space and as fire on earth. One foot crushes Apasmara, the demon of ignorance and fantasies. It is this demon who stands between us and the realisation that the cosmos is the dance of deity, not the mindless gyration of matter. The protective gesture of one hand, and the uplifted foot to which the other hand points, indicate that those who seek their sanctuary at the feet of the deity will be free from fear, from the existential *angst* that always springs from the feeling that the world and existence are governed by chance and necessity.

In spite of the total saturation of the concept by rich symbolic meaning, the plastic realisation shows creative variations. This can be seen by studying the treatment of a single detail- like for instance the locks of hair. In bronzes which place the accent on the serene, still centre within the flux of the world, and thus freeze the motion, the locks fall gracefully on the back and shoulders. When the accent is on the whirling of the world, the dizzy gyration of the galaxies, and the tempo has

to increase, the locks spring up to swirl sideways, speeding away like waves, forked lightnings or clusters of arrows. At the height of the dance the locks are supposed to fill up all space and enmesh the stars.

Many profound concepts are integrated in the mythology of Siva and sculpture, especially of the south, has done full justice to them. The dynamic of evolution, and history, needs the interaction of positive and negative, good and bad, forces and therefore demons also participate along with the gods in the churning of the primeval ocean of chaos that creates order out of it. But poison is inevitably generated by the churning. Siva drinks it lest it destroy the world. A fine Pallava sculpture shows him about to drink the poison (Pl. 107). Destruction of evil is necessary for the survival of the good and legend elaborates this concept into many stories about Siva vanquishing the demons (Pls. 105-106). When Ganga, originally a river of heaven, descended on the earth, it was the matted locks of Siva that broke her fall and thus saved the earth from deluge. The locks really stand for the forests of the Himalayan uplands that break the fury of torrential rain, conserving the water as well as the topsoil. This nature myth gets transformed as romantic legend. Ganga, hidden in the locks of Siva, becomes his mistress and he has some difficulties in appeasing his consort, Parvati. As Dakshinamurti, he is the great teacher, not only of music and dance, but of spiritual truths too. While the gods dwell in the affluent and luxurious heaven of Indra, he wanders like a mendicant, mounted on his bull (Pl. 114). Folklore adores him as a god ever solicitous about his devotees. The saint, Manikya Vachaka, commanded by the Pandyan king to buy horses for his cavalry, spends all the money in the service of Siva and is imprisoned. He is rescued by Siva who comes in the guise of a horse-merchant and gives the king a hundred horses, as those supposedly bought by the saint. The story has yielded a fine equestrian sculpture of Siva (Pl. 117).

Chola sculpture has influenced other regions. A wheel-and-horse motif was added to the hall or Mandapa in the Darasuram temple to make it look like a chariot. Princess Rajasundari of the Chola house became the consort of an Eastern Ganga ruler and Narasimha who built the Konarak temple as a giant chariot of the sun god was her descendant. The style of the sculptures of Darasuram finds reflection also in the sculptures of Borobudur in Java which was regularly visited by the ships of the Chola imperial and commercial fleet.

Vishnu Vardhana of the twelfth century was the greatest ruler of the Hoysala dynasty which ruled a realm that roughly corresponds with modern Karnataka and he and his successors built fine temples at Belur, Halebid and Somnathpur. The temples are profusely decorated with sculptures and these, carved in a soft chloritic schist which can be rather too easily cut by the chisel, have very profuse ornamentation. Those who prefer the restrained classicism which harder stones insensibly lead to, may find these forms rather too lush, especially when the Hoysala damsel admiring herself in a mirror inevitably reminds one of the similar representation in Chandella sculpture with its far greater purity of line. But these goddesses, celestial damsels and danseuses have a rich, sensuous appeal with their very intricately carved jewellery and the opulent ripeness of their figure (Pl. 102). Those who find European rococo not unpleasing

may respond with delight to these figurations. In the sculpture of the same period of the Kakatiyas of Warangal, the damsels reappear with greater restraint in style and without the heavy ornamentation. Besides illustrating a dance pose, a fine bracket figure in the Ramappa temple at Palampet shows in her physique a preference for the tall, slender anatomy rare in Indian sculptural tradition although it is seen in the bronze figurine of the dancing girl that has come down to us from the Indus valley civilisation.

In the sixteenth-century sculptures created under the patronage of the Vijayanagar rulers at Hampi, Lepakshi in elsewhere, there is a recovery, after many centuries, of the skill for fluent narration that was seen first in the Sunga epoch. Episodes from the stories of Rama and Krishna are narrated in the temple at Hampi. The Vijayanagar sculptor is particularly good at conveying the impression of royal pomp and circumstance and there are lively scenes of elephant processions, cavalcades and marching soldiery, troupes of dancers (Pl. 77).

The Tamil realm was never the exclusive fiat of the Cholas. The region around Madura was ruled by the Pandyas and their tradition was continued later by the Nayaks, viceroys of Vijayanagar who became autonomous when that empire collapsed. The eighth century rock-cut shrine of Siva at Kalugumalai is a treasure-house of early Pandyan sculpture. The architectural decoration itself, with beautifully carved blind dormer windows (*kudu*), matches the delicacy of the decorative work in the Kailasa Natha temple at Ellora. In addition, there are large sculptures of Vishnu and Siva, the latter in many attitudes, of which one showing him playing the drum and another representing him in the company of Parvati are the finest. Among the numerous sculptures on minor themes are exquisite figurations like that of a damsel gracefully drying her long tresses after the bath. In Nayak sculpture of the sixteenth and seventeenth centuries, the stiffness that became pronounced in the decadence later is only very faintly seen and the figures still retain great elegance. Among the finest of them are the bejewelled lute player on a pillar in the Ramaswamy temple at Kumbakonam and Rati, consort of Kama, the god of love, on a bracket in the thousand-pillared hall of the Meenakshi temple at Madurai. The Deepa-Lakshmi, or damsel carrying small votive lamps of oil and wicks, is perhaps not a creation of the Nayak epoch but was profusely made during that period, those in bronze or brass being more decorative than the figures carved in stone.

The region corresponding to present-day Kerala was in the old days the realm of the Cheras. The representations of Siva on the facade of the cave shrine at Vizhinjam near Trivandrum show an initiating inspiration of Pallava tradition. Though stone sculpture continued to be produced in Kerala in the succeeding centuries, the more distinguished contribution of the region is in wood carving. Figural sculpture emerges at first as a component of architectural decorative work. Single figures carved in deep relief in roundels within square or rectangular panels and serially repeated, span large ceiling surfaces in many temples. In the thirteenth-century Katinamkulam temple, the ceiling is divided into nine square compartments having nine images of deities in medallions, with Brahma in the centre riding a swan. The Triprayar temple ceiling

represents the nine planets in anthropomorphic forms, in a similar way. The visual experience is one of progressive discovery, the sensory delight gaining richness as the vision, after the first general glance, focuses on detail. At first the eye notes only the stability of structure of strictly aligned parallels decoratively varied by the medallion-like inset shapes. This is an abstract architectural pattern of neat rows of circles and squares. Then the different planes and projections of this surface—the high ridges of the squares, the shallow rims of the roundels, both with incised decorative patterns— compose a web of textures with a fine play of light and shade. The visitor now moves round to view each figurative representation from the vantage point most suited to it. It is then that the delicate variations of what at first seemed to be identical figures and the fineness of the carving become startlingly real experiences to the sensitivity.

The *Ramayana* story is illustrated in friezes in many temples and palaces. The most ambitious treatment is in the sixteenth century at Ettumanoor where the whole story has been carved round the central shrine. In the eighteenth-century temple at Padmanabhapuram and in the nineteenth-century palace of Swati Tirunal in Trivandrum, the carved panels show a novel feature. No background is depicted except when it is an essential part of the scene delineated. Sky and distant background are pierced out, giving the frieze the appearance of an enormous length of fretwork. The Padmanabhapuram frieze is about half a metre high and has a total running length of over ninety metres. The pierced spaces serve a subtle aesthetic function. They bring out contours—the graceful curve of the neck of a deer, the hourglass curve of hip and torso—with the sharp clarity of silhouettes and they bring space and air into the composition.

Figures in full round also abound. In many of these there is a love of flamboyant decorative detail which recalls the Hoysala style. One figure in the Triprayar temple has a wreath of flowers hanging on either side from the head, which is a marvel of decorative carving. More restrained and stately are some of the compositions representing Rama with his consort and brother.

The Chakyar is the raconteur-actor who narrated religious legends in the temples of Kerala in the old days. But he always assimilated the characters in old legends to contemporary social types and used humour, sarcasm and caricature, an excellent stratagem for the smooth absorption of the classical heritage into folk culture. It is fascinating to note that in the temples of Triprayar, Kidangur and elsewhere, there are representations of the Chakyar in amusing roles.

Links with Past: Challenges of Future

This can be a fitting coda leading to our finale which will also curve back to recall the beginnings. We noted that terracotta, basically a product of folk culture, commenced in the Indus valley epoch and persisted right through the centuries, one current from it often getting classicised though the mainstream remained steadfastly loyal to the folk tradition. The brick temples of Bengal with their decoration of terracotta reliefs were noticed earlier. These reliefs add up to a very rich legacy, a

profusion of them being made in the seventeenth and eighteenth centuries (Pls. 58-59). The creation of humble folk artists, the tradition has evolved in distinctive regional styles. This lowly medium is escalated to monumentalism in its figurations in the terracottas of Birbhum. The artisans of Burdwan used decorative detail with extreme restraint, concentrated on forms to which they sought to give the feel of stone carving. Bishnupur terracottas organise their figures with a strong sense of rhythm. The Murshidabad style is very decorative, with a detailed moulding that reminds one of silver filigree work. The Hooghly style is a blend of Burdwan's formal clarity and Bishnupur's rhythm.

In representations of combats between warriors and hunting scenes, these terracottas develop a splendid dynamism. Genre scenes abound, with women worshipping at temples and dancing girls performing for affluent patrons. Naive yet moving are the scenes of quiet domestic happiness. A group of mothers points out the newly risen full moon to their children. There are many representations of the pranks of infant Krishna. One of the most delightful of these is the scene where the child is given a much-needed bath. He does not like it at all and it needs several hefty matrons to accomplish this Herculean enterprise. In one composition we see an old man quietly enjoying a smoke with a hookah. Portuguese ships and soldiers also figure in some of these terracottas.

Though the sculptural tradition continued in the subsequent decades, it was low-pulsed, sharing in the general decline which led to a shadowed phase of history when India had to live under alien rule. The revival, in its first phase, was very derivative. But, since independence, Indian sculptors have rapidly liberated themselves from such stylistic domination. They are facing exciting challenges. The old sculpture was integrative in many respects. Thematically, it was integrated with religion; structurally, it was integrated with architecture. If, in one sense, this limited the autonomy of sculptural art, the dissolution of these linkages has created the problem of incarnating meanings that are as profound as those of traditional sculpture. This quest started only recently and it is too early to present it as a rounded-off story. But there is great promise in the air. A most significant trend is that, even if it is done in new materials like steel and aluminium, fibre-glass or even fibre, the form is trying to recover the iconic quality, the power to stir the religious instincts of awe and adoration that are humanistically the most valuable strains of the Indian cultural heredity.

Traditions in Painting

Vision is a miracle. In spite of its curvature, the retina of the eye is a two-dimensional surface. Nevertheless, the image formed on it can re-create in miniature the great world out there, with its deep recessions like a lane meandering away into the depths of the valley, and its projections like a tree-bough loaded with flowers that stretches towards you. And from very early times, the hand of man has repeated the magic of his retina by drawing and painting the scenes of his ambience on the relatively flat surfaces of rocks and the walls of the caves which were his first shelters.

Prehistoric and Protohistoric Painting

According to the chronology of prehistory, framed mainly by anthropologists, the new stone age stretches back from about 1800 B.C. to 3000 B.C., the middle stone age goes further back to 7000 B.C. and the Magdalenian or last phase of the old stone age can range back from 7000 B.C. to 15,000 B.C. Large galleries of old and middle stone age paintings have been found at Altamira in Spain and Lascaux in France.

It is doubtful if the rock paintings found in India can be claimed to have equal antiquity. Bhimbetka in Madhya Pradesh, discovered and explored only since 1957, is one of the richest sources of primitive art in the world, with paintings that come right into the historic period. But the antiquity of ten to fifteen thousand years claimed for the older paintings here has not been unanimously accepted. However, if completely isolated, primitive communities can retain their culture mentality even when other groups have moved considerably ahead in societal evolution. This is why the paintings in Bhimbetka and the primitive rock shelters of India, most of them in Madhya Pradesh, a few in Uttar Pradesh, seem so strikingly similar in temper to those found in Lascaux or Altamira.

It is generally held by anthropologists that the painted or sculptured representation of animals in primitive art began as a magical ritual inspired by the belief that if one could seize the form of an animal in this way, its seizure in hunting would be assured. While this seems to have been a common belief held by primitive communities in many parts of the world, it would be regressive reductionism to assume that art was always tied to magical belief and practice and that the artistic impulse never gained autonomy. For ritual purposes, a notational and vestigial representation

is enough. But we find a genuinely aesthetic impulse gradually asserting itself in the progressive maturation of a strikingly vivid realism. Even when the treatment is starkly linear, the silhouette effect creates a dramatic shadow play of scenes of hunt, in the rock paintings of Hoshangabad. And the fuller treatment of bisons (Pl. 118) and boars here and in Mirzapur have a powerful realism, the open mouth of the wounded boar expressing all its agony.

Since the buildings of the Indus valley epoch have been swept away by the river of time, we do not know whether mural paintings decorated their walls. But in Greece where both murals and painted pottery have survived, we see that pottery decoration closely followed mural painting both in themes and style. And perhaps we shall not be wrong in assuming that mural painting existed in the Indus epoch since painted pottery has come down to us in abundance. The shape of pottery has to be strictly subservient to utilitarian, functional requirements. But its decoration is non-utilitarian. More positively put, it seeks beauty as a utility for the sensibility, as a value. And thus we find an astonishingly creative play with composition, style, expression. Realism is decoratively refined in the depiction of deer, peacocks; animals are grouped in a symmetric choreography; whimsical sights are noted as in the vignette of a bird perched with self-conscious pride on a quadruped. In a fragment from Lothal, the form of the deer has been streamlined into a silhouette with a calligraphic verve of line, its horns sweeping back in ripples. And in another fragment, from Navadatoli, the distilled reduction of the figure to expressive movement presents to us the vivid impression of a dancer, though it is done in simple, slender strokes.

Ajanta

If the curtains come down now and the stage remains dark for over a millennium, it is on one of the world's great treasures of art that they rise. It is hard to believe that modern India, and the modern world, have known of the existence of Ajanta only since 1819 when a British Captain, retired from the Madras army, went out hunting and blundered upon this great legacy which the jungles, that grew up when dynastic transitions affected political stability and patronage, and trade routes shifted away from the region, had screened from the remembrance of men for over a millennium. For the last time the ancient world had heard of Ajanta was in the seventh century when the Chinese pilgrim, Hiuen Tsang, had written about it. But by his time, painting in Ajanta had completed nearly a millennium of evolution and was in fact in its closing phase.

Hinayana or early Buddhism remembered only the transience of things, the pervasiveness of pain. Here it was remembering only the four great visions of Siddhartha, his encounter with the decay of the mortal frame and its drift to disease and death, the traumatic experience which made him renounce the world. If the story had ended here, there would have been no art. But Mahayana discovered that the tears at the heart of things were often tears of compassion and that this

radiant fact could redeem the world. When Siddhartha took the great decision to leave his home, he had wanted to take his son Rahula with him. But he could not bring himself to do it because the mother's hand lay protectingly over the child. After many years of inward storm, he won his reconciliation with life when he rediscovered the depth of humanity in that protecting gesture of the mother's hand even in sleep. And so he said: "As a mother protects her only son, so let every one cultivate a boundless compassion towards all that has life." It is this great and enduring compassion that shifts the emphasis from the Hinayana ideal of the Arhat, who seeks enlightenment for himself, to that of the Bodhisattva who does not cease striving till the whole world is guided by him towards enlightenment. Here the earth won back the Buddha and the great pageant of the earth was won back for art.

In the scene of the renunciation, the longing to look back on his native city before it faded in the distance came to him again and again; he controlled it and did not turn. But earth, the great mother, far more mature than young Siddhartha in her perception that humanising bonds are not bondages, turned round on her giant axis, so that he could see through his tears what he was tearing himself away from without having to turn around and look back. When Siddhartha attained enlightenment and became the Buddha, Mara, the Evil One, came to him and told him that he had no right to sit on the little square of earth where he was sitting, because the earth belonged to him. The Buddha touched the earth with his fingertip and called upon it to witness that it did not belong to Mara, because he had just attained enlightenment on it; whereupon the earth responded, 'I bear you witness', with a hundred, a thousand, and a hundred thousand thundered affirmations. In a central episode to which the Dhyan or Zen tradition goes back, instead of giving his usual sermon, the Buddha, uttering no word, just held aloft a lotus. In a sudden flood of perception, Maha Kasyapa understood the meaning of this gesture: the familiar world is a world awash with beauty.

It is absolutely essential to understand this radiant and radical transformation of outlook, for art affirms the earth and a creed which denies it could never have created the art of Ajanta, or at least the great art that it is, untouched by the distrust of the beautiful things of the world seen in early and medieval European art. While the Arhat sought to escape from the earth, the Bodhisattva rejected Nirvana and accepted rebirth again and again so that he could serve the world and redeem it. He was reborn not only as human beings in various walks of life but also as a swan, a deer, an elephant. The Jataka tales narrated these legends and produced great literature. Ajanta retold them in line and colour and produced great art.

Ajantan painting is not true fresco as the colours were not applied when the lime was wet. Pigments were vegetable and mineral dyes and bonding media were vegetable gums. Though lyrical tributes have been paid to the melodic beauty of the Ajantan line, only in the last, decadent phase does the line assert an autonomy and then it is apt to indulge in a baroque exaggeration of rhythm. In its finest phase, line and colour work together for the plastic modelling of forms. This is managed without chiaroscuro or cast shadows and solely through tonal modelling. Those parts of the

surface of a form which belong to the plane nearest to the eye are given a plastic projection through clear, bright colour and sometimes by a sparse brushing which allows the white ground to show through. Pictorial space expands not only laterally along the walls but often extends to the roof. Painting and sculpture are integrated as when the painted figure of a monk is shown as kneeling before a large figure of the standing Buddha, the latter form being a sculpture. The demands on compositional skill thus become very challenging but are brilliantly met. The artists show that they can handle linear perspective with precision of recession. But the expressive intention is paramount and allows play with perspective just as it permits a colour spectrum that is not naturalistic, in the representation of natural objects.

The locales, figures and episodes of the Jataka stories bring the entire variety of the world into the murals. Animal life is observed with accuracy and sympathy and we see not only the large forms like elephants and horses but a train of ants going up a Palasa tree in flower. Untouched by the medieval European mistrust of woman's beauty, the Ajantan artist has represented her, in undraped loveliness of form, mingling with others in worship, close to the figure of the Buddha. Every one of her expressive gestures and attitudes, every detail of her costume and jewellery, all the intricate patterns of her coiffure, have been sensitively noticed (Pl. 122). There is a great variety of human types: cowherds of the rural areas, tradesmen and entertainers in the city streets, aristocratic men and women in the palaces. And in the figurations of the Dying Princess (Pl. 119), and the Padmapani of the scene of the Great Renunciation (Pls. 120, 121), the Ajantan artist shows himself capable of depicting the most moving scenes with a classic restraint that has won them a place among the most expressive paintings of the world.

Paintings contemporary with the last phase at Ajanta, in the Bagh caves in Gwalior, have been very badly damaged by the seepage of rain water over the centuries. Faint indications of a cavalcade, a music party (Pl. 123) and of figures of Bodhisattvas have survived.

"Go unto all lands and preach this gospel", the Buddha had said. "Tell them that the poor and the lowly, the rich and the high, are all one, and that all races unite in this religion as do the rivers in the sea." The chisel and the brush accompanied the message of peace, and painting in the Ajantan idiom emerged in the sea-girt lands of the south and in many places along tne Silk Route. In the rock-face above the walled gallery that was the approach to the palace which Kasyapa, ruler of Sri Lanka, built in the fifth century on Sigiriya or Lion Rock, we have some twenty feminine figures, drawn three-quarter length, cut off by clouds a little below the waist. These gracefully posed figures, who seem to be casting down a rain of flowers, could have come directly from Ajanta. Incidentally, here the idiom is used for a secular, purely decorative intention. Lying midway on the Peshawar-Balkh route, Bamiyan in Afghanistan was a favourite halt for caravans before or after the weary climb over the Hindu Kush. The merchants endowed many monasteries and Hiuen Tsang was received here in 632 by the monks Aryasena and Aryadasa. Ajanta seems to have been miraculously transported to a central Asian highland, for there is a crescentic

cliff-face facing a valley and caves have been excavated in the cliff. A series of Buddha figures seated in the posture of turning the Wheel of Law, accompanied by attendant figures and flying celestial nymphs carrying offerings, are found here. In China, Buddhist painting in the Ajantan manner can be seen at many places on the old Silk Route like Miran, Kucha and Dandan Uiliq culminating in the caves of Tun Huang. From China, the style spread to Korea and thence to Japan. In the collegiate foundation and temple at Horiyuji in Nara, Japan, we have paintings of the eighth century and the Padmapani here comes closest to the Padmapani of the Great Renunciation in Ajanta.

Later Murals

In India, the mural tradition continued right up to the late nineteenth century. The sixth century paintings at Sitabhinji in the Keonjhar district of Orissa are not too well-preserved; but one can make out a royal procession and the Ajantan style is unmistakable. In the cave shrine of Badami completed by the Chalukyan rulers in 578, there are two panels, one representing Indra in his magnificent court enjoying dance and music, the other showing a king and queen, in all probability Kirtivarman and his consort. The deployment of figures shows high compositional skill, with dancers, musicians, nobles and their attendants grouped without crowding and represented in a variety of attitudes and moods. Kirtivarman's queen has a slender, elongated frame and is shown in a relaxed pose that attests to confident drawing. In another feminine figure, two large ear-rings frame the soft visage and a veil etches its delicate line over the smooth forehead (Pl. 124).

If there are exuberant feminine figures in Ajanta, there are slender figures too and the Pallavas show an even greater preference for them than the Chalukyas. Mahendravarman, the Pallava ruler of the seventh century, was a great patron of the arts. He wrote plays in Sanskrit, built rock-cut and structural temples and was called, or called himself, "the best of painters" (*Chitrakar puli*). The painting of the Devi in the Panamalai temple looks almost like a copy of a slender figure seen in the Ajantan painting showing the expectant Queen Maya. Both figures stand with sensuous languor, leaning against a pillar, one leg planted on the ground, the other bent back at the knee with the sole of the foot pressed against the pillar.

The cave shrine of Sittannavasal in Pudukottai was carved out of the rock by the Pallavas, but the paintings here were done in the ninth century under the patronage of the Pandyas who overran this region. The Pandyas, like the Pallavas, were at first followers of Jainism but their conversion to the Saivite faith involved very little rejection of the legends of their former faith in the assimilative tradition of this country. The mural here seems to be a representation of the faithful gathering lotuses to decorate the resting place made by the gods for a Jain saint after he had attained liberation. The figure of a dancer is better preserved than other figures. The pose indicates that she is rendering Siva's dance as Nataraja. Broad-hipped, narrow-waisted, the torso bare except for jewellery, she has been drawn with a fluency and a confident

grace which are unmistakably Ajantan in their derivation. But there are indications here of the beginning of decadence. The drawing tends to become occasionally brittle. Angularity appears in the contours of figures. The profile becomes sharp. A three-quarter visage is only schematically suggested by the farther eye. These trends harden in the Rashtrakuta paintings of the ninth century in the cave temples of Ellora where the farther eye, depicted in a front view on a profile face, gets more or less detached from the face and protrudes beyond its contour into space.

The southern passion for dance combines with the baroque idiom of the last phase of Ajanta to yield that extraordinary Chola painting of a danseuse in the Brihadisvara temple at Tanjore where the dizzy, whirling movement has twisted the figure to present the upper part of the body full front and the lower part three-quarters seen from behind. But the feeling of effortless levitation, of fluent movement through the air, has been captured without any distortion in a frieze-like panel showing a group of celestial musicians and dancers—Gandharvas and Apsaras—flying past, playing their cymbals and drums and showering lotus petals on the Chera king and the saint Sundara shown below, riding a horse and an elephant.

The episode in the *Mahabharata* in which Siva, to test Arjuna, appears as a tribal hunter (*Kirata*) and shoots at the boar that Arjuna had shot at, thus provoking a combat, has repeatedly figured in literature and art. Bharavi in the sixth century wrote an epic poem on the theme. A magnificent panel narrates the episodes of the story in the sixteenth century temple at Lepakshi and is in fact the finest legacy of Vijayanagar painting. The decadent medieval manner persists in the depiction of the farther eye. But the artists here are very good at handling movement. It develops a hurtling momentum in the turbulent episodes of the boar-hunt, becomes sedately graceful when retinues of maids attend Parvati. The grouping of these maidens is managed with flowing rhythm, with fine variations in the colouring of their figures which deviates from naturalism for achieving decorative effects (Pl. 125).

The painting of the Nayak period, usually treated casually by art historians, reveals a high narrative artistry on closer study. The contour of the body is treated with such a strong sense of rhythm that it yields hourglass figures which recall the art of the ancient Aegean, the elegant figures of Cretan painting. There is a great love of movement. Even when the scene represented is not one which involves movement as an intrinsic episodic feature, the rhythmic contouring of figures and their serial placement are so organised that currents of movement sweep through the overall composition, providing a rapid scansion of the episodic development, or billowing from either side to meet in some figure which is at once the focus of the episode, the picturisation and the organisation of rhythms. The flat treatment in one plane and the reduction of details in the background make the picturisation, serialised in panel after panel, look like a frieze filmed by a camera rapidly scanning a panoramic scene from left to right, the tempo of the scanning psychologically heightened in moments of high drama by the speed of the rhythms.

The earliest painting in the land of the Cheras is as close in style to Ajanta as Pallava painting in Panamalai. But unfortunately only vestiges of this painting, dating

back to the eighth or ninth century, have survived in the small cave-shrine at Thirunandikkara which is now in Tamil Nadu. Here and there a face emerges inclined in devotion, having all the graciousness of a Bodhisattva's countenance. There is now a gap of several centuries and in the sixteenth century paintings in the old palace at Padmanabhapuram, the manner has become baroque, the patterns of drapery and jewellery of the crowded figures covering the entire surface with minute filigree. This crowding is relaxed and air let in, in the paintings of the sixteenth century and later in the Mattancheri palace in Cochin. A notable feature here is the many sympathetic and closely observed renderings of animal life (Pl. 126). Mural painting of the traditional kind continued to the middle of the nineteenth century, for we have a large panel of this late date, illustrating the story of Vishnu rescuing an elephant which was seized by a giant crocodile, in the palace at Krishnapuram, near Quilon.

Manuscript Miniatures

But the mural had also come down from the wall to become the miniature centuries earlier.

During the tenth and eleventh centuries, Pala Bengal saw the emergence of the palm-leaf manuscripts of Buddhist treatises like the *Prajna Paramita* (Pl. 127) and of legends like the *Vessantara Jataka* whose illustrations clearly reveal themselves to be the earlier mural tradition reduced to the miniature dimension. The plastic sense of the Ajantan tradition is sought to be retained, colour treatment being guided by the requirements of modelling. The soft rounded flesh of an extended arm and the modelling of the cheeks are suggested by colour modulations, occasionally with clear highlights. But with far less space available, some compulsion is felt to use the line more and more for the clear definition of forms. It can suggest the weight and volume of modelled masses in the manner in which it sways or curves. It outlines with a sensuous, lingering precision the roundness of the breasts, narrows elegantly at the waist and enlarges into sumptuous curves at the hips to provide a support for the exuberant torso. In the earlier phase, episodic narration with all the richness of incidents is attempted on the model of Ajanta. But the constraint of limited space gradually develops a preference for the representation of single divinities or small groups and their presentation tends to be confined to one plane (Pl. VII).

The Pala tradition influenced neighbouring lands. Palm-leaf manuscripts of the *Prajna Paramita* and other texts appeared in Nepal, their illumination closely modelled on the Pala style. A fascinating development was the emergence of a second genera-tion mural from the miniature which itself was derived from the earlier mural. The banner painting in cloth, done in Nepal and transmitted to Tibet as well, was a rever-sion to the original because the priming of the surface follows the mural technique. The reversion is complete when the actual wall surface is used again. The miniature regenerated the mural in this manner not only in Nepal and Tibet, but also in Burma which was close to Bengal. The murals in Pagan date from the eleventh century

onwards. In spite of the recovery of ampler space, there is a preference in Pagan for single figures of divinities. But in the murals in the monasteries of Ladakh, Lahaul and Spiti, episodic fulness is recovered in the ampler space, rhythms again become complex, penetrating depths instead of being confined to a flat frontal plane as in the miniatures, the depiction of the larger action of turbulent deities also becomes possible again.

The Pala line became brittle and extremely angular in the twelfth century. This was due to the exhaustion of the cycle of creative surge which had yielded the great murals of Ajanta and the sensitive early miniatures. The later murals at Ellora reveal this decadence which inevitably spread to the miniatures too. The decline was, regionally, widespread. The symptoms stood out particularly starkly in Orissa. Unlike drawing with the brush, engraving encounters difficulties in obtaining lines with smooth curves. The medieval angularity is particularly pronounced in a copper plate engraving of the twelfth century discovered from Sunderban in Bengal. Orissa also took to engraving, though the surface was not metal. Orissan manuscript illustrations were engraved with a stylus on palm leaves often without colour. Dots also can be made easily with the pointed stylus and a style evolved later which used such dots in profusion, though they were used with some representational justification as decorative fringes of canopies, patterns of costumes, designs of jewellery. The painted surface became filigreed and crowded. But a recovery from this baroque style became possible when wooden manuscript covers were decorated with paintings and the tradition was later prolonged on paper. In the seventeenth-century set of drawings, now in the Asutosh Museum, showing Gopis (maidens of Krishna's pastoral village) gathering flowers on the banks of the Yamuna, there is only a slight tinting, not full colouring, and the treatment is linear. But the contour lines have recovered rhythm and the composition has regained genuine lyricism (Pl. 128). Medieval Assamese manuscripts, including a fascinating treatise on elephants, had coloured illustrations, but the treatment is flat, composition schematic and line angular.

The medieval idiom is most typically seen in Western Indian, primarily Jain, manuscript illustrations. They were at first done on plam-leaf but, after about 1400, increasingly on paper. The patronage of the affluent trading community also explains the lavish use of gold in many instances. The founding of the great Jain libraries in many centres stepped up the demand for copies of Jain religious texts, the *Kalpasutra* (Pl. 138) being the most popular, closely followed by the *Kalakacharya Charita*. Midway in the transition from the Ajantan three-quarter face to the Rajput profile, the visage in Western Indian miniatures is revealed to be a profile but for the farther eye and a portion of the forehead, by the simple test of drawing a line from the middle of the forehead to the chin of any figure. But the oddly projecting farther eye cannot be totally attributed to the loss of capacity for foreshortened drawing. The manner seems to have been stabilised by the conservatism of convention too. For we find a curious deviation. In one Jain legend, king Gardabhilla carried away a nun from a sanctuary and would not surrender her even though Kalaka, the great Jain preceptor, pleaded with him. Kalaka therefore left the country and made friendship with the

Sahis, the Saka tribe dwelling on the western bank of the Indus. With their help, he brought about the downfall of the erring king. Now, in the representation of the Sahis, we do not find the odd mannerism of the projecting eye. The medieval style characterised also the illustration of Hindu religious texts and even of secular poems.

New Modulations

We now come to a crucial phase in the history of Indian painting and an equally crucial challenge for the historian of art. Events in their sequence and causal connections create history, but the awareness of that history emerges only from the retrospective reconstruction of the sequence. When the first art historians of our times looked back on the art scene, the sixteenth century which saw the advent of the Moghuls struck them forcibly as an epoch of radical transition. Seven or eight decades before 1526—the year in which Babur founded the Moghul empire by defeating the Lodis at the battle of Panipat—we seem to have only manuscript miniatures in the medieval manner. About the same duration after 1526, we have Moghul paintings, larger in size, polished in style and execution. And the output of the Rajput principalities that were politically close to the Moghuls, also begins to show increasingly the influence of the Moghul atelier. Jumping to conclusions can be one of the most natural occupational hazards for the art historian in this situation. A reading was sought to be clamped down according to which Moghul painting was seen as nothing but a provincial school of Persian painting and Rajasthani and Pahari painting was regarded as nothing but the Moghul style applied to different themes. It was also aggressively asserted that, but for the advent of the Moghuls, miniature painting—as an independent category, distinguished from manuscript illustration— would not at all have emerged in India. But, as we shall see, lyrical stirrings can be discerned in medieval manuscript illustration before the advent of the Moghuls; these crystallise into a school with a totally different aesthetic flavour from the products of the Moghul atelier, and even before the latter starts functioning.

The medieval idiom was admittedly staccato and angular. But a strong aesthetic impulse that could overcome the pressure of hieratic conservatism, shed archaic features, modulate the staccato linearism towards suppleness and rhythm and enliven the composition with the freshness of some sort of natural background could, and ultimately did, transform it. Here and there, in the Jain manuscripts, we come across surprisingly fresh modulations. The angular awkwardness relaxes into suppleness in the scene where supporters of the winner celebrate his victory in a philosophical disputation between Vadi Devasuri and Kumuda Chandra. Parsvanatha and Indra are shown as seated under two trees whose boughs spread in undulating rhythms. Sympathetically observed antelopes and other animals are occasionally found. In the Mandu *Kalpasutra* of 1439, the figure of the reclining Trisala has been drawn with supple grace (Pl. 138). Though gold is used lavishly in the Jaunpur *Kalpasutra* of 1465, dancing figures show spontaneity in their movement. All types of movements

have been seized with both naturalism and vigour in the *Maha Purana* of the last quarter of the sixteenth century.

This evolving tradition had contacts with Persian painting even before the advent of the Moghuls because of the trade contacts between Gujarat and Persia. Jain manuscripts reproduce scenes from Persian paintings, but only in the decorative border panels, resolutely preventing the influence to percolate through that barrier into the main illustrations. Therefore we cannot talk of any Persian influence affecting the Indian style at this stage. Texts like the Mandu *Nimat Nama* of 1510 also are not relevant here because they were done deliberately in the Persian style. We have to watch for modulations in the main stream. Here, the *Vasanta Vilasa* (Dalliance in Spring) of 1451 is a landmark. A romantic poem, the theme enables the style to develop considerable lyrical expressiveness. We see the heroine lying in bed and watching the moon coming out of the clouds, waking up in the morning, arranging her ear-rings by looking into the mirror and greeting her lover with a betel-leaf roll.

As yet we have only the first fresh breezes of spring which do not wholly dispel the chill of winter. However, we now get some paintings which can be grouped together as a proto-Rajasthani Central Indian school. It has been called Central Indian because the evolution towards its very characteristic generic features began with the Mandu *Kalpasutra* of 1439. The *Aranyaka Parvan* (Forest Canto) of the *Mahabharata*, in the collection of the Asiatic Society, Bombay, is a very important text here, since it is dated 1516 in the colophon. The year antedates the Moghul advent by a decade, and the commencement of the Moghul atelier by more than half a century. Two costume features, occurring in most of these paintings, tie them up as a group. One is a long tunic (*chakdar jama*) with its lapels drawn out to terminate in four or six points or stiff corners. It is remarkably like the tunic worn by Kanishka in Kushan sculpture. The other is a small, compact cap (*kulahdar*). These items of apparel never appear in any Moghul painting. But the really significant aesthetic difference between these paintings and Moghul paintings is the passionate intensity of the romantic mood in the former.

Theme or content on the one hand and style or expression on the other are categories obtained by the vivisection of analysis. In reality they interact intimately to become a unity. It is the romantic theme that transforms the staccato and angular medieval style. The story of Laurik and Chanda was intensely romantic. Though he was already married, Laurik falls in love with Chanda who too was already married. There are at least four different sets of illustrations of the poem, showing the progressive transformation of the style towards romantic expressiveness, which culminates in a set originally in the Lahore Museum and, during the partition, was divided between the Lahore and Chandigarh Museums. The same quality of expression is seen in a Bhairavi Ragini painting originally in the collection of J.C. French, in the illustrations of the romance, *Mrigavat*, written by Qutban in 1504, in the Bharat Kala Bhavan, and in the illustrations of the *Chaura Panchasika* (Fifty Stanzas on Stolen Love), the eleventh century love poem by Bilhana, in the N.C. Mehta collection (Pl. 139).

The dating of these paintings by art historians has varied. Many consider them anterior to 1526. Others who subscribe to the view that the Moghul advent managed a discontinuous and radical transformation have argued for late datings but have found it difficult to establish datings subsequent to the starting of the Moghul atelier. In any case we have the *Aranyaka Parvan* with the secure pre-Moghul date of 1516. And practically reducing all controversies about dates to irrelevance is the fact which no one has dared to contest, the fact that, in terms of feeling and style, this school is totally unlike the Moghul.

In this phase of its evolution, the style is characterised by a farouche, passionate quality, the women being shown with great romantic eyes, proudly cut physiques and bold stances, backgrounds being of strong, uniform, unrelieved colour. In the next phase, the texts illustrated are the *Gita Govinda* (Pl. 140) and the tenth canto of the *Bhagavata Purana*. The more poetic romanticism of these texts, the refined gentleness of their sentiment, the sustained music of their mellifluous verse, all tone down the intensity of the earlier group. The proto-Rajasthani school is on the verge of modulation to the finer expression of the Rajput miniature. But since the subsequent evolution of the Rajput school was in undoubted interaction with the Moghul, we have to study the latter before resuming the story of the former.

Moghul Painting

Expelled by Sher Shah Suri in 1540, Humayun was befriended by Shah Tahmasp, ruler of Safavid Persia, and towards the end of his fifteen-year exile, he commissioned two Persian painters—Mir Sayyid Ali and Abdus Samad—with the illustration of the Persian classic, *Hamza Nama*. Though Humayun was able to return to Delhi in 1555, he died the very next year. The work on the *Hamza Nama* began only under Akbar and that too only in 1567, his twelfth regnal year.

As we have seen, by this time, a proto-Rajasthani school of miniature painting had evolved out of the medieval style in India. For establishing his atelier, Akbar recruited a large number of Indian painters, from Gujarat, Gwalior, Kashmir and elsewhere. Of the forty-eight painters whose names are found inscribed in the 183 paintings of the *Babur Nama* (Pls. 129, 130), forty are definitely indigenous painters. Persian miniatures were the work of individual artists. But in the Moghul atelier, the artists worked as a team. One man would execute the outlines, another the portraits, a third the landscape, and a fourth would add the colour. Though the atelier was headed by Persian masters, the high ratio of indigenous painters and the specialisation of functions in the corporate style of working created right from the beginning a momentum towards synthesis.

Akbar's own temperament played a decisive role in the mutation of the Persian style. Inspired by Persian poetry which was steeped in fantasy and romance, Persian painting had acquired what has been called a paradisiacal temper. In radiant but unearthly landscapes, handsome princes sought and won beautiful princesses after many curious adventures where the willing suspension of disbelief that constitutes

poetic faith often became rather difficult. Akbar was deeply interested in contemporaneity, in history in the making. Painters had to chronicle not only the life of the court but accompany him in his military expeditions and battles. This realistic outlook influenced many elements of the pictorial style. Moghul painting does not hesitate to cut its figures at the base or sides of the frame, often showing only the body from the waist upwards within the picture (Pl. 129). More formally composed, the Persian painting groups its figures well within the frame. Architectural elements form a simple background in Persian painting. The Moghul painter can organise architectural panoramas, spelling out their component elements with clarity. Moghul painting never uses colour in such a way as to reduce a picture to a coloured tapestry or mosaic as Persian painting does. Fond of dramatic action, the Moghul painting has far greater movement and the eye is guided along the phases of episodic development by a changing viewpoint and perspective, so subtly manipulated as to create no discord whatever in the visual experience (Pl. 130).

Moghul painting under Akbar very quickly ceased to be a provincial school of Persian painting and with the illustration of Persian translations of the great Indian epics—*Ramayana* (Pl. IX) and *Mahabharata*—it became a truly Indian school of painting. The assimilation of Safavid features does not impair this Indian character any more than the assimilation of Achaemenid features in the Asokan pillar affects its Indian quality.

Basically a court art, Moghul painting loved to reflect imperial pomp and circumstance and has given us magnificent pictures of royal assemblies and embassies (Pl. 131) and vivid scenes of the chase of which Akbar and Jahangir were very fond. Each of the numerous figures in the paintings of the assemblies is a meticulously finished portrait which developed also as an independent category, the drawings (Pl. 132), sometimes with light washes of colour (Pl. 134), being more perceptive in the reading of character than the fully coloured works. Jahangir, who was something of a naturalist, commissioned paintings of flowers, birds and animals, especially the exotic types like the zebra and the turkey-cock. Due to contact with European painting through gifts from Jesuit missions and British embassies to the Moghul court, later Moghul painting attempted Christian themes and also experimented, not wholly successfully, with western perspective and chiaroscuro. Some paintings had gorgeous *hashiya* or border decoration (Pl. 134).

Painting declined during the rule of Aurangazeb who had little interest in the arts. It had an insecure prolongation in the late eighteenth and early nineteenth century in Lucknow and Fyzabad (Pl. 135) under the Nawabs of Oudh. Moghul painting had recorded the sensuous beauty of woman (Pl. 133), but with a curious detachment, with no indication of any romantic excitement or deeper ardour. In Oudh painting, the sensuous degrades further to the sensual and there are rather uninhibited representations of the revelry of the pleasure-loving prince and the complaisant courtesan. The sublimation of eros is the most important humanistic feature distinguishing Rajput painting from the Moghul.

Painting in the Deccan

While studying the architectural heritage, we noted that the Islamic architecture of India cannot be considered as the exclusive donation of the Moghuls. Painting in the Muslim courts of the Deccan, likewise, cannot be derived from the influence of the Moghul atelier. There is not a single cultural tradition in India which has developed in insulated isolation without fertilising contacts with other traditions and there is no important tradition which has not evolved a distinctive style in spite of the assimilations. Deccani painting is a splendid substantiation of these truths. One can discern a variety of influences, but the Deccani identity remains unmistakable.

The *Tarif-i-Husain Shahi* is a Persian poem in homage to Husain Nizam Shah of Ahmadnagar, commissioned by his widow and illustrated during the period 1565-69. Persian influences, in all probability transmitted via the *Nimat Nama* illustrated in Mandu in 1510, can be seen here. Deccan was introduced to Persian painting directly also through Persian merchants, and Safavid features like thinly convoluted clouds, the flamboyant halo and costumes of contrasting colours can be seen in the *Nujum al-Ulum*, an encyclopedia illustrated in Bijapur about 1570. Nevertheless there are striking deviations from the Persian manner. In the first work, the beauty of Husain's bride is enhanced by representing her as assuring an ampler flowering of a tree by her touch, a conceit that goes back to very old days and has inspired poetry and sculpture. The lyrical theme has given a sparkling palette and lively movement to the composition which also recalls Western Indian painting in the landscape and in the feminine figurations.

Burhan II of Ahmadnagar was the second son of Husain who seized power from his elder brother Murtaza with Akbar's help. His sojourn in the Moghul court has left some Moghul influence in his portrait. But as it evolved further, the Deccani portrait became very different. The palette is orchestrated in a high key with delicately blended colours, glowing luminously but not loudly against the gold ground. The Deccan rulers seem to have loved the open air unlike the Moghuls. For conveying royal pomp and circumstance, Deccan preferred the procession to the Moghul court assembly and these paintings have a sense of movement not seen in Moghul durbar scenes. The Deccani tradition has also many paintings of princes and princesses relaxing in gardens (Pl. 137) or open country. Some of these compositions can organise panoramic landscapes in depth, with glistening white castles in the distance and rivers meandering through woods linking the background plane to the foreground where we see the old dryads, this time in Deccani costume, relaxing languidly under trees or sporting in water.

As the ruler of a principality, Ibrahim Adil Shah II of Bijapur (1580-1627) ranked behind his contemporary Akbar who was emperor. But he was as great an administrator and as catholic in outlook as Akbar and he had a range of creative talents not quite shared by the latter. Ibrahim wrote poetry, practised music and wrote a treatise on it, the *Kitab-i-Nauras*, where he has also included his lyrics in Deccani Hindi set to specific Ragas. He was a painter and calligrapher too. The Ragamala paintings that

emerged under his patronage are distinctive. The fans of pleats and the long arcs of drapery worn by the feminine figures seen in these paintings recall the Vijayanagar style of Lepakshi. So impressive has been the stabilisation of the Ragamala painting in Ibrahim's epoch that some art historians have felt that this category emerged first in the Deccan (Pl. X) spreading later to the north. But this does not seem to be likely. Later Deccani painting shows the assimilation of features from Rajput painting (Pl. XI) which we can now take up.

Rajasthani Schools

As we have seen, the evolution of medieval painting into a proto-Rajasthani school had commenced before the establishment of the Moghul atelier and proceeded independently of it after its establishment. It was the lyricism of the theme—the love poetry of Bilhana, the romance of *Laur-Chanda* and *Mrigavat*—that achieved the transformation. In the next phase, the developing current was nourished by the far greater reservoirs of lyricism in the Indian tradition—the *Gita-Govinda* (Pl. 140) and the *Bhagavata Purana*. Here painting was linking up again with literature that had become familiar to prince and peasant. Rajput art thus became an art of universal appeal, a status which the elitist art of the Moghul atelier never attained.

But, understandably, this is not managed without some fumblings. Traditional associations had linked the Ragas, the modes of the Indian musical system, with the seasons, spring and rain, and the moods of the heart, longing in separation, ecstasy in union; and this was another source of lyrical inspiration. But the early Ragamala paintings do show some awkwardness. However, the manner becomes fluent in the Chawand Ragamalas of 1605 and the lyricism of Raga Megh of 1680 from Narsinghgarh has the liberating freshness of rain after implacable summer. Similarly, the *Gita-Govinda*—the love, separation and reunion of Krishna and Radha narrated in one of the most musical poems of the world—was at first illustrated in Gujarat in a style that does have a naive charm but is still not refined in its lyricism. However, the arbour of the assignment bursts into flower, line becomes rhythmic, colour begins to glow, in the illustrations of the late sixteenth and early seventeenth century (Pl. 140). The *Gita-Govinda* is really a distillate of the tenth canto of the *Bhagavata* where sensuous lyricism, with allegorical overtones, reaches its peak in the story of the dalliance of Krishna with the maidens of his pastoral village which is spun out of the loveliest material that nature can furnish, moonlight on the river, the scented breath of the night breeze flowing from the heart of the woods, and the call of Krishna's flute heard by the maidens even in their sleep. After some fumbling, the *Bhagavata* illustrations mature as the most beautiful legacy which Rajput painting has left for posterity.

The *Bhagavata*, poems generated by it like the *Gita-Govinda* and the *Sursagar* of Surdas, the *Ramayana* (Pl. 143), the love-poems of Amaru, even more tender and delicate than Bilhana's poem, the texts like the *Rasikapriya* (Pl. 148) and the *Rasamanjari* (Pl. XV) that studied woman in all her moods of love (*Nayika* lore), the

texts in the visualisation of musical modes, and seasonal (*Baramasa*) songs: these were the great lyrical treasures from which Rajput art drew its themes and inspiration and during the seventeenth and eighteenth centuries, principality after principality, in the plains of Rajasthan and in the valleys of the Himalayas, yielded miniatures whose generic unity accommodated piquantly different speciation in expression. We have space only to note the salient features of the various schools.

Malwa during the Rajput period yielded illustrations of the *Ramayana* (Pl. XII) and Amaru's poems and Ragamala paintings. The design is simple but has great clarity, with figures tidily placed in decorative architectural frames and with the base of the picture representing either a flowerbed or a floral border. Episodic narration has a charming naivete and directness. In Mewar output (Pl. XIII), the background gets filled with lush vegetation producing a rich tapestry effect in the Ragamala paintings, and the illustrations of the *Rasikapriya* (a *Nayika* text) mature the capacity for more complex and convincing episodic narration. From Jodhpur have come many paintings that deal with the pleasure-loving life of the rulers and present seraglio scenes, scenes of dalliance, water-sports. The style is fussily decorative. But a rare stateliness is sometimes recaptured in paintings of royal processions and cavalcades (Pl. 144). Exceptionally fine equestrian portraits have come down to us from Bikaner where the figure of the cavalier is shown against a background of rolling clouds and mountains with their contours dissolving into mist. Jaipur shared with Jodhpur a love for representing scenes of sensual delight. But the Jaipur paintings of love-making in a pavilion or of a cavalier chancing upon a bevy of bathing beauties have far greater artistry than Jodhpur paintings, the sensuousness controlled by an admirable restraint from decaying into the sensual. And in presenting the Krishna story (Pls. 145-147), Jaipur developed the capacity for pictorial statement of great amplitude. In the Jaipur painting of Krishna lifting the Govardhan hill (Pl. 146), the background opens up to spreading plains and European influence has been well assimilated in the moulding of the hill with light and shade. Another Jaipur painting showing Krishna returning to his village from the pastures with the herds of cows (Pl. 147) is a masterpiece with its coherent mobilisation of a very large number of figures and superb decorative quality.

Bundi has yielded paintings on the whole range of Rajput themes. The varied but always decorative patterning of the leaves of the plantain and the equally decorative placement of ducks in pools are characteristic Bundi idioms. During the third quarter of the eighteenth century, Bundi evolved a very distinctive style. The pictures are executed in a high key, to borrow an expression from the art of photography. The colour orchestration is subtle. Instead of the bright spectrum of the earlier periods, we get delicate tonalities with a chaste white predominating the surface and restrained use of coloured areas. The vegetation remains a cool green and though it uses many shades of green, it does not allow the explosive intrusion of blossoms with their plangent colours. The semi-nude female form often appears here, the ivory white of the figure further accenting the overall impression of lustrous softness (Pl. 149).

Kotah (Pl. 150) was originally part of Bundi and it created a startlingly variant

style, incidentally transforming a Bundi detail to a totally different significance. In many Bundi pictures, we see, framed in an unobtrusive window, the head and shoulders of an admirer who stealthily gazes on the semi-nude figure of a maiden at her bath or toilet (Pl. 149). Similarly framed heads appear in Kotah paintings. But they represent hunters on the alert for prowling tigers. It is the branches and foliage of trees that frame them and the forests remind us of those in the paintings of European fauvist painters like Douanier Rousseau. The flora look as if they belong to a past geological epoch. Stems and leaves are boldly stylised and each leaf is picked out vividly, its contours precisely drawn. Kotah painting in this style is an astonishing anticipation of fauvist temper and even idiom about eighty years ahead.

Kishangarh is another school that created a distinctive style. Aesthete, poet, dreamer, Samant Singh (1699-1764) had no heart in ruling his principality and abdicated to go with his beautiful mistress Bani Thani to Vrindavan for re-living the love of Krishna and Radha. Something of a painter himself, Samant Singh seems to have given specific guidance about themes and visualisations, besides commission, to his painter, Nihal Chand. In the days when he had to administer his state, Samant Singh's poetry had sought solace in the memories of "Vrindavan and the sweet waters of the Yamuna". However, he had repeatedly fretted. "But life is slipping by. How greatly do I long for Vrindavan, how afraid I am that life is slipping by." Release from the burden of state came at last and life became a serenely quiet yet deeply rapt relish. The Radha of Kishangarh paintings is modelled on Bani-Thani with her large, lustrous eyes and distinctive profile. The paintings represent the lovers in quiet gardens, boating on the Yamuna in the gathering dusk while sunset red still lingered in the sky, in arbours lost in the deep woods (Pls. 151, XIV). There is a tremendous expansion of virtual space in several of these pictures which visually reflects the expansion of the heart (*chitta-vistara*) in euphoric experience, analysed by Indian aestheticians. The poetry of Radha-Krishna legend finds the finest expression in the Rajasthani miniature tradition in the school of Kishangarh.

Pahari Centres

In the Himalayan uplands, in the valleys of the Rabi, Beas and Sutlej, the intrepid Rajput warriors from the plains set up many principalities. Nearly forty small states flourished in the region from Jammu to Tehri-Garhwal and from Pathankot to Kulu, measuring only about three hundred and twenty kilometres in length and about a hundred and sixty kilometres in width. But the small strip was astonishingly productive during the late seventeenth and eighteenth centuries and has yielded over fifty thousand paintings in known collections over and above the number scattered by time and lost to us. The generic name for the output of the region is Pahari painting, 'pahar' meaning hill or mountain.

The story of Pahari painting begins in Basohli, in the Jammu region. Basohli art is a blend of many traditions. The medieval style was widespread and Kashmir too had artists practising it, some of them being recruited later into Akbar's atelier.

There was also a widespread tradition of folk painting in the hills, in a vigorous idiom. Originally hailing from the plains, the Pahari princes used to sojourn there often for family visits and pilgrimages. Some of the temples in the hills are directly modelled on famous shrines in the plains, and relief sculpture in the temples reveals the linkage even more clearly. The first impulses for Basohli painting seem to have come from the proto-Rajasthani school of the plains. It is significant that Basohli shares with the *Chaura Panchasika* plain backgrounds of glowing colour, distinctive gryphons in the architecture represented and above all the intense mood. But while, in the plains, this mood was shed by the evolving Rajasthani schools, Basohli, alone among the Pahari schools, retained it and created an art of lyrical intensity and forthright pictorial statement which has few parallels anywhere in the world.

The boldly stylised trees of Basohli, the flat planes of stark colour built up without knuckling down to perspective and the distinctive figures with their large, lustrous eyes, embody a vision of the world charged with passion and intensity and completely free from sentimentality. The figures become the dramatis personae of an intensely wrought action that develops in a strange stillness, for there is no finely modulated gesture, none of the obvious stratagems of lyrical evocation. Posture and simple gesture, grouping or isolation, all enhanced by the wash of monochrome colour enveloping the figures, seem enough to develop a high charge of feeling (Pls. XV, XVI, 152).

The Basohli-Nurpur area was a single complex in the early phase, with the result that the provenance of some of the Basohli paintings may have been Nurpur. But later work in Nurpur shows a preference for less plangent colours and an increasingly greater delicacy in the treatment of figures. Guler painting too was initially inspired by Basohli, but later the monochrome background begins to be replaced by landscape, the idiom becomes gentler (Pls. 153, 154, 163, XIX). Guler ultimately merged into Kangra, both politically and in respect of its pictorial output.

In Sansar Chand of Kangra (ruled 1775-1823) we see a man of enormous ambitions. Though ultimately he became a pitiful vassal of the Sikhs of Lahore, at the height of his power he brought many of the hill states under his rule, built many temples and fine palaces and patronised painting in a big way. The quantitative richness and qualitative excellence of Kangra output have made many equate Pahari painting with Kangra painting. Ultimately, Kangra painting is the superb lyricism of the Krishna story made visual. The landscape is assimilated to the mood of the personages through a symbolism that is very transparent in its poetic suggestion. Flowering sprays indicate that the cloistered gardens of the lovers' hearts have burst into blossom. Bare branches indicate the desolation of separation, the sadness and the loneliness and the wistful remembering. Colour in Kangra work reaches a luminous clarity. And above all there is the extremely fluid and delicate line (Pls. XVII, 155, 162, 164). Kangra has left us many sets of drawings that bring out the beauty of the line unaided by colour.

Kangra influenced the art of several other hill states. Though there are currents from Basohli and Guler also in the painting of Chamba, it stabilised itself on the

Kangra idiom as can be seen in the paintings that narrate the story of Rama and Sita (Pl. 156) or the romance of Usha and Aniruddha (Pl. 157). Prince Suleman Shikoh, fleeing from his murderous uncle Aurangazeb, had sought shelter for a while, during 1658-59, in Garhwal and Shyam Das, a painter in his small retinue, was the ancestor of Molaram of Garhwal (1740-1833). Molaram's earlier paintings are not particularly distinguished. But his sojourn in Kangra brought the Kangra idiom to Garhwal and there seem to have been many painters who practised that idiom more successfully than Molaram (Pl. 160). The landscape becomes fairly autonomous in Garhwal painting. In the lovely painting where Krishna and Radha are shown contemplating their reflections in a mirror, the balcony opens on a lake full of lotus, the trees on its banks festooned with flowers, hills in the distance and expanse of sky with lazily drifting clouds.

The Bilaspur tradition modulated the Kangra manner to satisfy its delight in a bright, intricately wrought, ornamental surface. The cows in the paintings have decorative coats, their skins having free shapes of various colours, often flecked with gold. Nalagarh was an offshoot of Bilaspur and close to it in style. But where identical compositions are attempted by both, Nalagarh work is more restrained in its decoration, more lyrical in its expression (Pls. 159, 161).

In Jammu, it was not the ruler but his younger brother who patronised art. Eccentric but likeable, Balvant Dev, who was born about 1718 and lived well past 1760, made his artists pictorially record all that he did, with the result that even his daily chores, such as the trimming of his beard, have been painted. While lyricism is not to be expected, we have here a whole collection of genre paintings, not found elsewhere in Pahari art. Kulu painting too is unique in a way, for it has maintained the closest links with the folk painting of the hills (Pls. 158, XVIII). But in its later phase Kulu refined the folk manner to a very vigorous expression that contrasts with the soft charm of most of the Pahari schools except Basohli. In the astonishingly fertile Pahari tract, painting, intrinsically attractive if stylistically not distinct, was produced at many other places too like Mandi, Mankot, Suket, Siba, Sirmur and Arki.

Unlike the elitist art of the Moghul atelier, Rajput painting became an art of the people because it nourished itself on one of the profoundest myths of the land: the Krishna story. It had such deep appeal that it inspired not only painting but many other forms like poetry, song, dance. Again and again we see the phenomenon of traditions that were tending to get elitist and precious being captured by Krishna and made movingly poetic. Painting on the Nayika lore (Pls. 163, 164, XV) and on the Ragas would have remained formulaic if Krishna had not annexed these traditions by his enchantment. Above all, in a land that is still mostly rural, Krishna stands for a pastoral tradition and today, when it is under threat, we are nostalgically reminded of a great way of living in attunement with nature by the many beautiful vignettes of a village on the Yamuna with its meadows and woods and the herds of cows returning from the pastures (Pl. 147).

Decline and Recovery

In the twilight that followed the decline of Rajput painting by the beginning of the nineteenth century, there are only faint glimmerings for a long while. The miniature was enlarged to mural size with much simpler composition in cloth hangings in Nathdwara and other shrines of Rajasthan and Gujarat. Paintings of deities, almost like Byzantine icons in their heavy incrustations of gold and semi-precious stones, came up in Tanjore. Indigenous talent was utilised by the East India Company to make pictorial records of scenes, peoples, fauna and flora. The western style was assimilated with refraction and at many levels: through casual acquaintance by artists of low calibre, through private tutorship by a prince like Ravi Varma and at last systematically: by the founding of art schools on the western model. The strong reaction of Abanindranath Tagore to this westernisation was really an affective response to the historical context of lost freedom by a compensating immersion in the past; he sought to revive the great styles of the past, Ajantan, Moghul, Rajput. But it was, unfortunately, the rather baroque style of Ajanta in its decline that was chosen as a model by the revivalists. Even in 1911, Coomaraswamy found revivalist output "too often sentimental in conception, weak in drawing and gloomy in colouring".

But during the period of the revival itself, the foundations of modernism were being firmly laid. Gaganendranath Tagore, brother of Abanindranath, experimented with all the European avantgarde movements (of that period) ignored by the staid academism of the art schools and this restless experimentalism and openness to global currents continue to characterise contemporary painting in India. Daughter of an Indian father and a Hungarian mother, Amrita Shergil tried to reflect the genetic synthesis of her heredity in her art and the more serious integrative explorations of today are heavily indebted to her outlook and practice. While Abanindranath recalled only the prestigious styles of the past and that too during the heavily mannered phases of their decline, Jamini Roy returned to the vigorous tradition of folk art, classicising it in many subtle ways. This has helped very greatly in opening up the Indian sensibility, especially that of our painters, to a great and almost inexhaustible source of inspiration, untapped for an unconscionably long time. There is increasing interest today in folk traditions like Madhubani and Warli painting, in the ritual floor and wall decorations like Alpana, Rangoli and Kolam practised in almost all regions of India (Pls. XLIV, 255, 256).

But it is to Rabindranath Tagore that modernism in Indian painting owes the most. Uncle of Abanindranath, he dissociated himself from the latter's revivalist outlook. "I strongly urge our artists to vehemently deny their obligation to produce carefully something that can be labelled Indian art by conforming to some old world mannerism." As revolutionary as this call was his artistic practice, which shows remarkable anticipations even from a global perspective. Automatism in drawing and writing was urged by Andre Breton in his *Manifesto of Surrealism* in—mark the date—1930. Calligraphic erasures start blossoming into rhythmic arabesques and expressionist forms in the manuscript of *Purabi* – poems written by Tagore during 1922-24; about

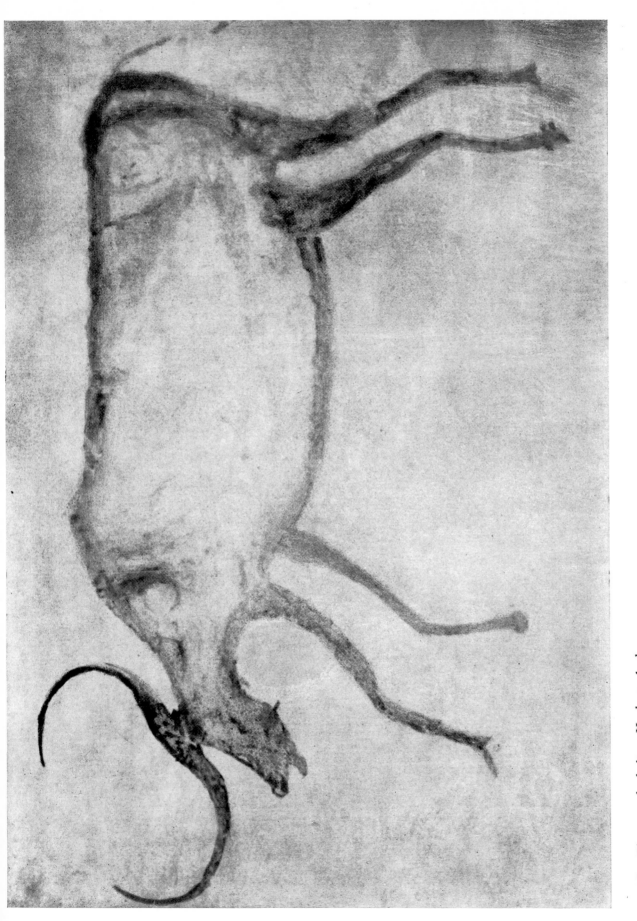

118. Bison, rock shelter, Hoshangabad.

121. Yasodhara. Detail from the Great Renunciation.

120. The Great Renunciation. Ajanta, fifth-sixth century.

123. Music Party. Bagh, sixth century.

126. Detail, Siva surprised with Ganga by Parvati. Chera, Mattancheri, sixteenth century.

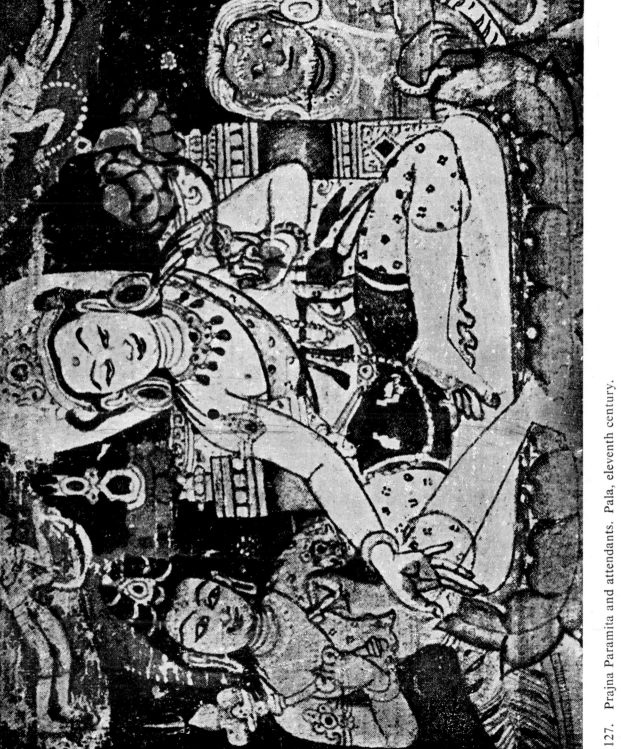

127. Prajna Paramita and attendants. Pala, eleventh century.

128. Gopis gathering flowers. Orissa, seventeenth century.

9. Babur's Fall. Babur Nama. Moghul, 1598.

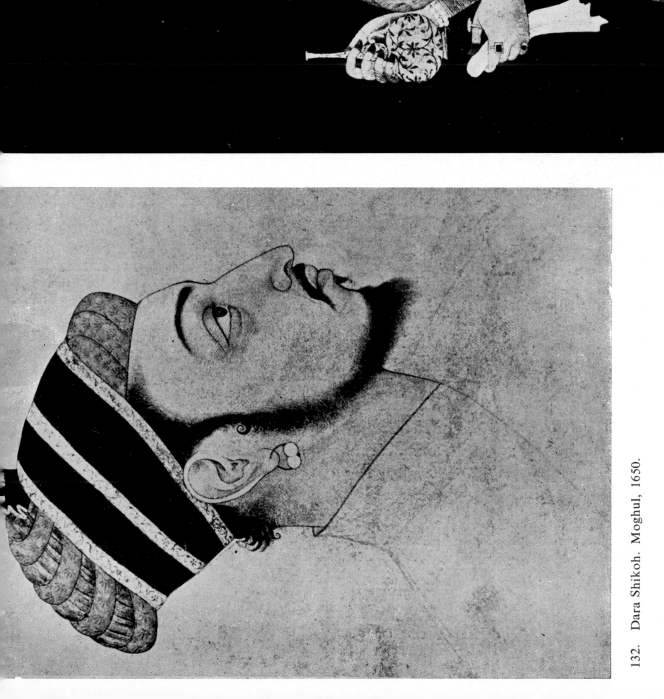

132. Dara Shikoh. Moghul, 1650.

133. Lady with a flask. Moghul, seventeenth century. →

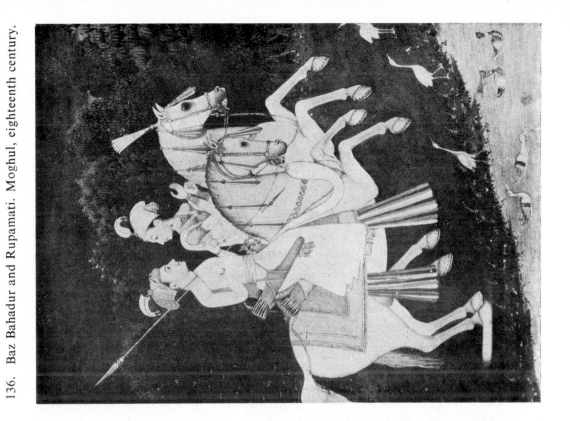

135. Lovers in a Grove. Faizabad, eighteenth century.

136. Baz Bahadur and Rupamati. Moghul, eighteenth century.

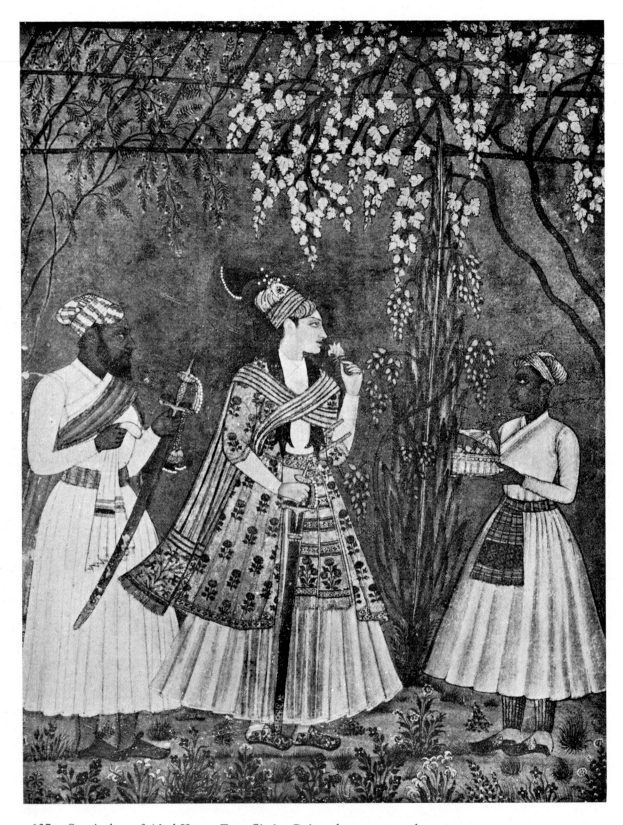

137. Son-in-law of Abul Hasan Tana Shah. Golconda, seventeenth century.

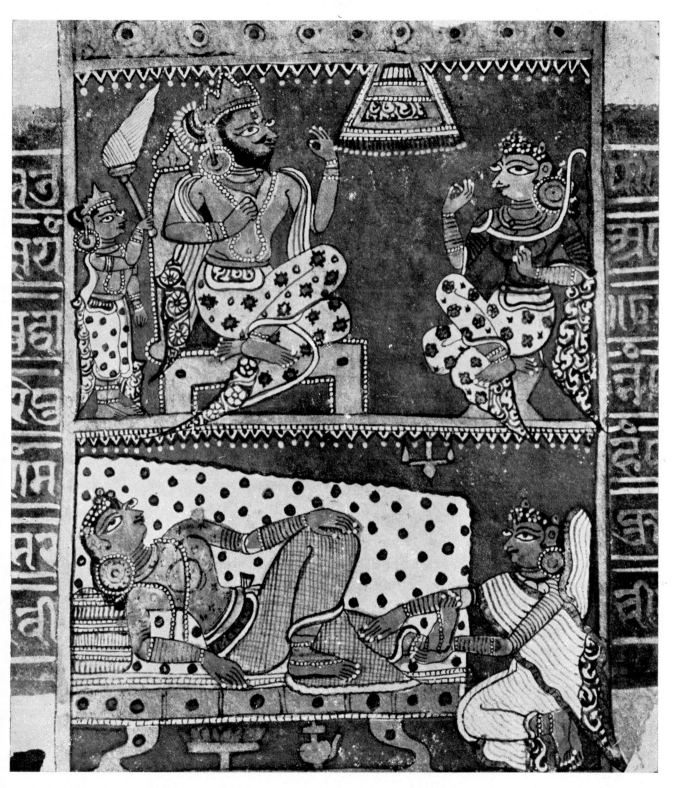

138. Siddhartha and Trisala. Trisala in bed. Kalpasutra, Mandu, 1439.

140. Gita Govinda, late sixteenth century.

142. Lady smoking a hooka. Ajmer, about 1700.

143. Janaka discovers Sita. Ramayana, Udaipur, 1651.

144. Maharaja Abhai Singh. Jodhpur, 1750.

145. Krishna steals the clothes of Gopis. Jaipur, eighteenth century.

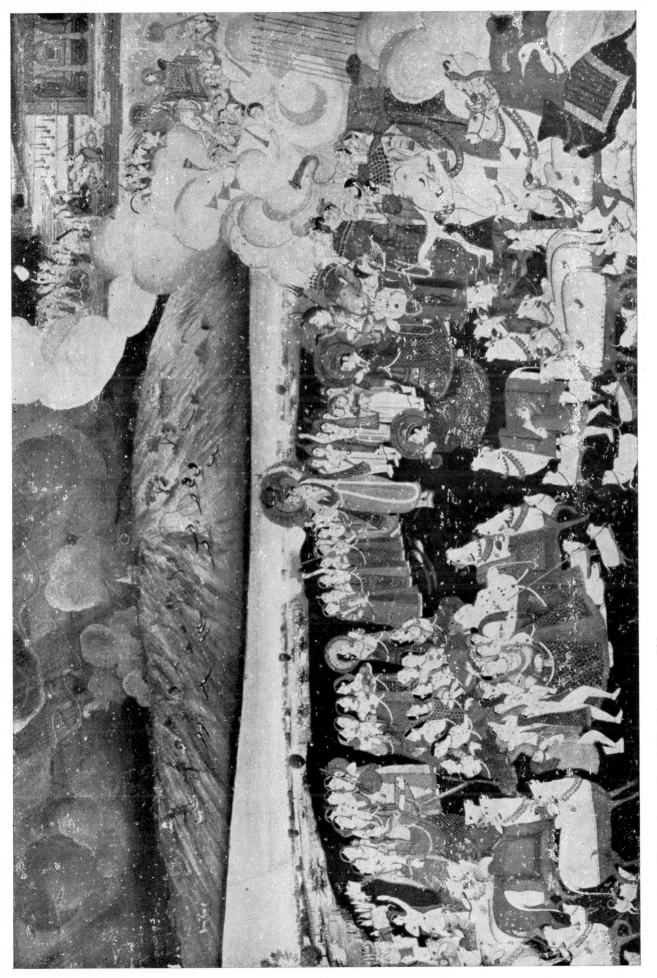

146. Krishna lifting Govardhan hill. Jaipur, c. 1800.

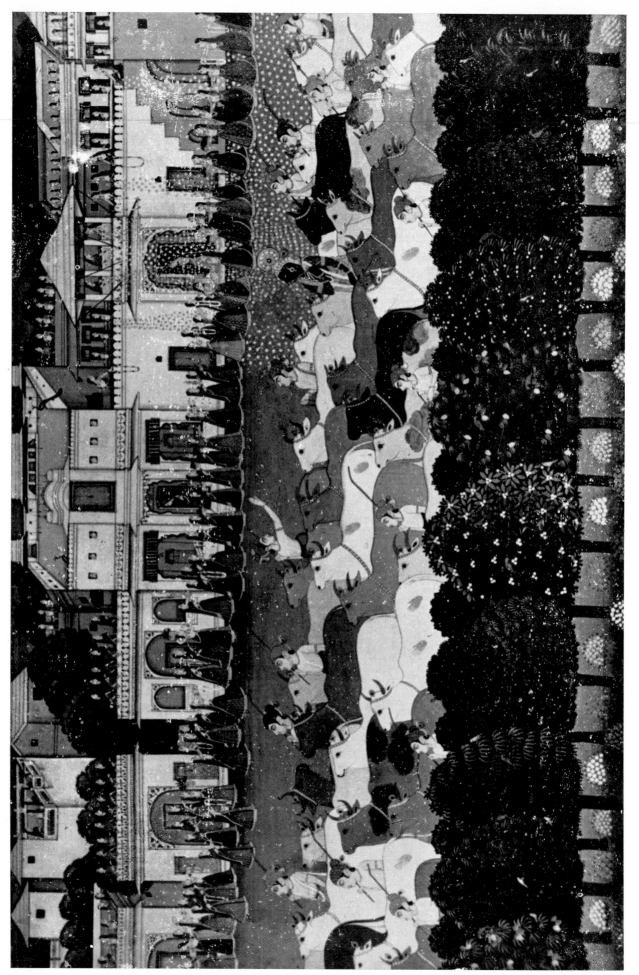

147. Krishna returns with the cows. Jaipur, c. 1800.

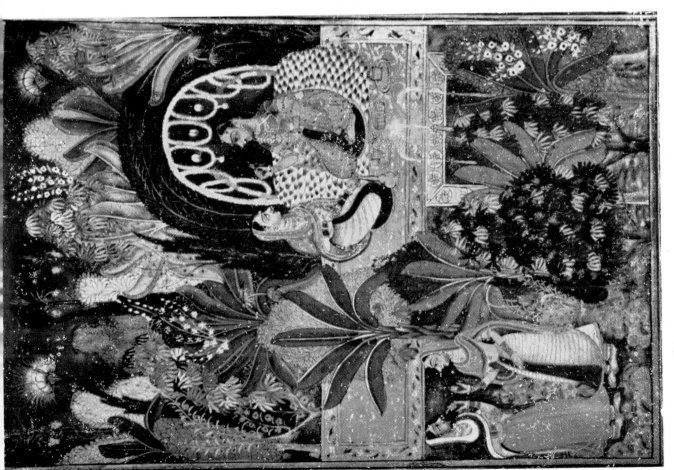

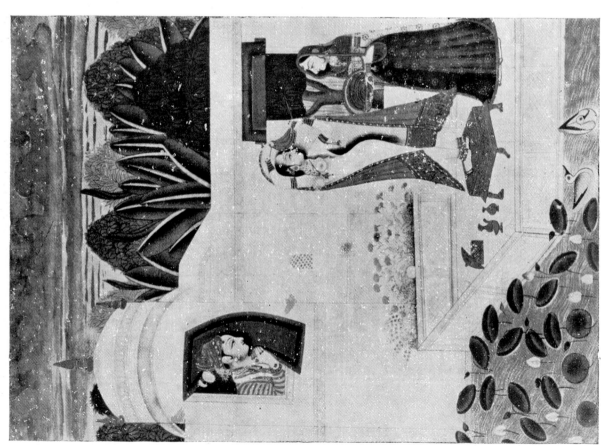

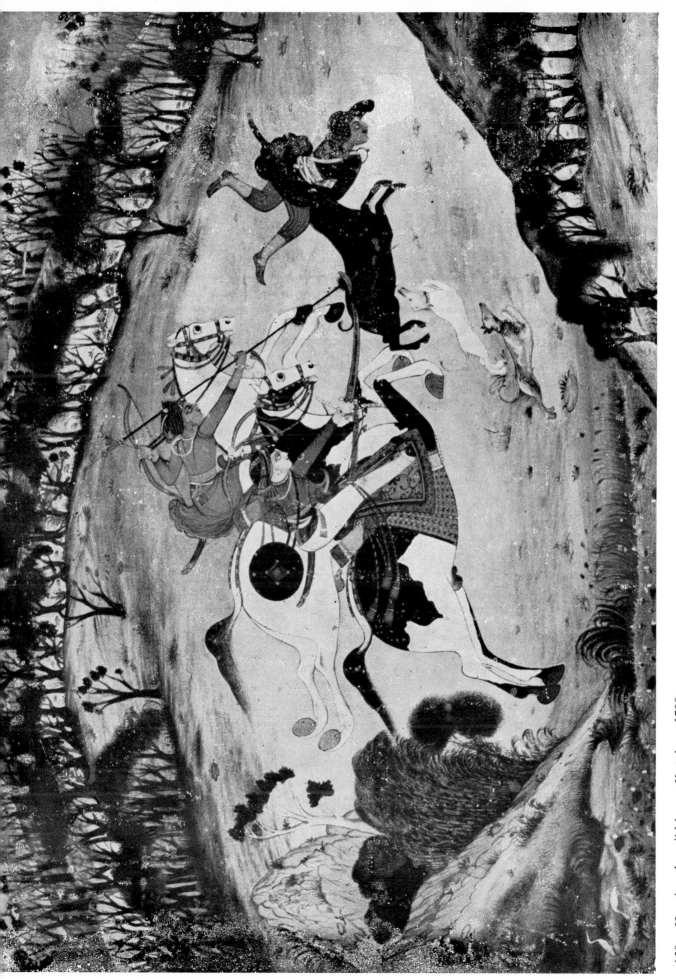

150. Hunting the wild boar. Kotah, c. 1780.

151. Boat of Love. Kishangarh, 1735-57.

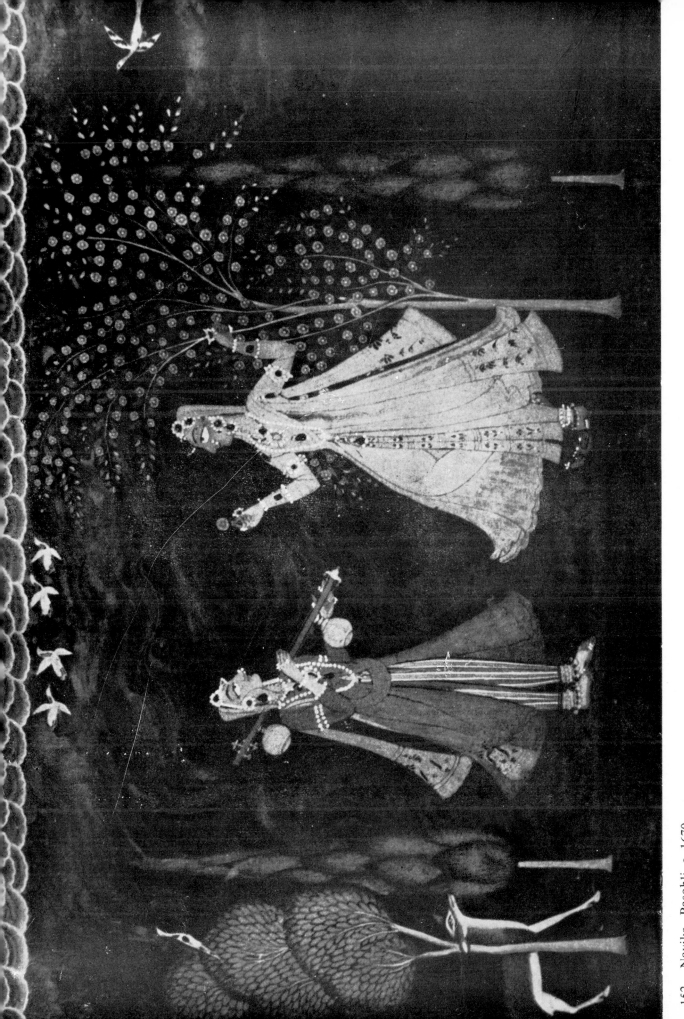

152. Nayika. Basohli, c. 1670.

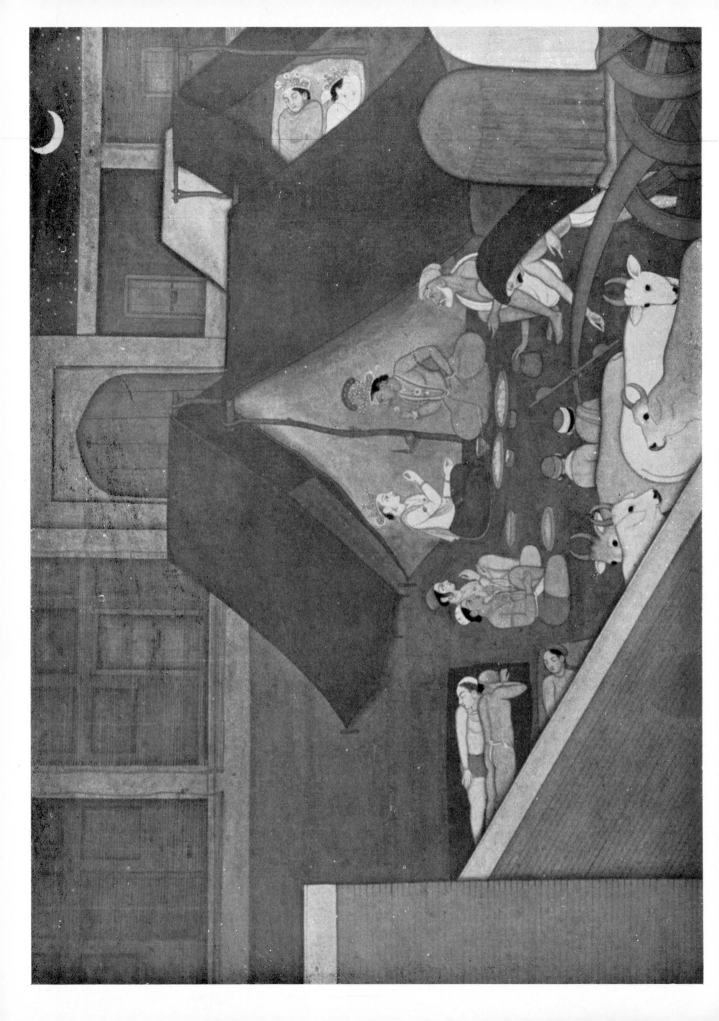

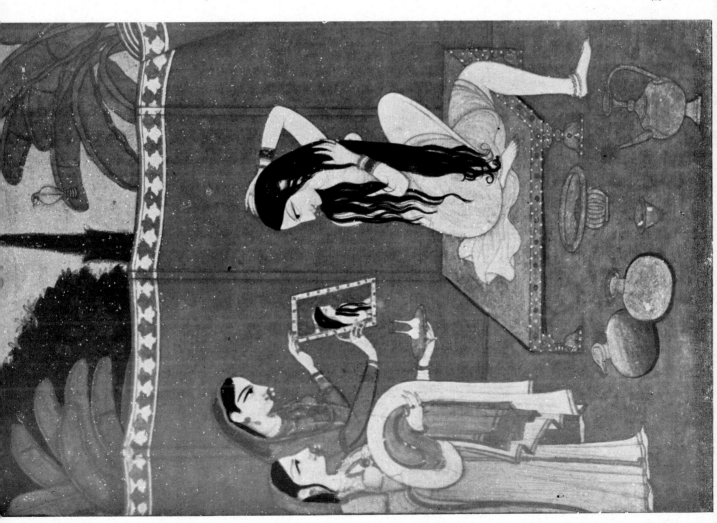

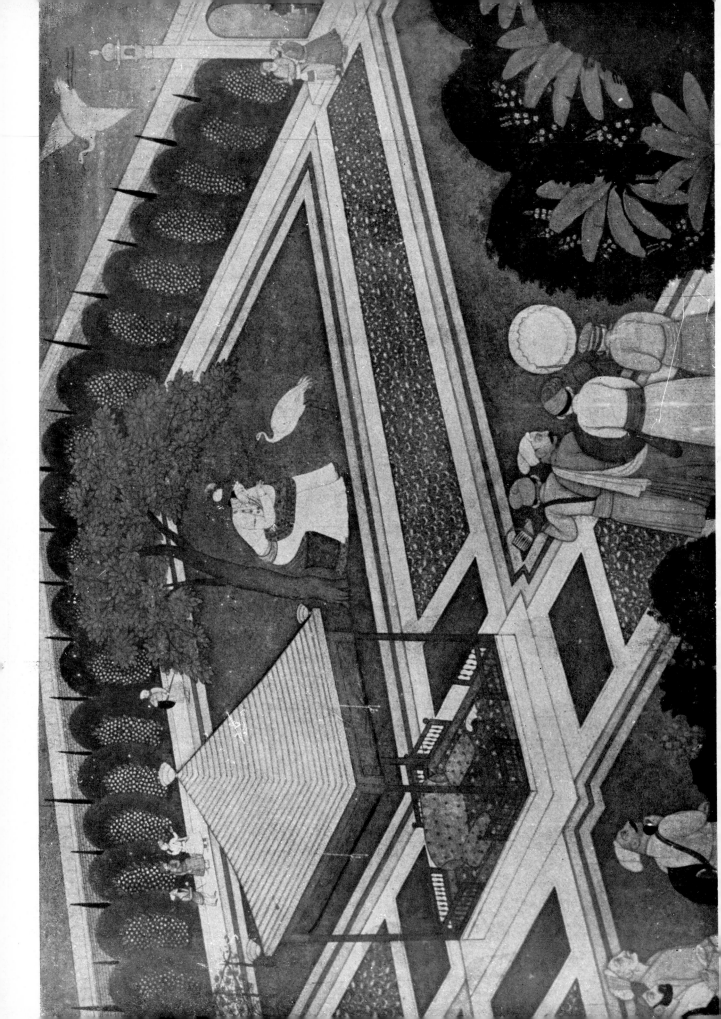

156. Rama, Sita and Lakshmana in their hermitage. Chamba. c. 1850.

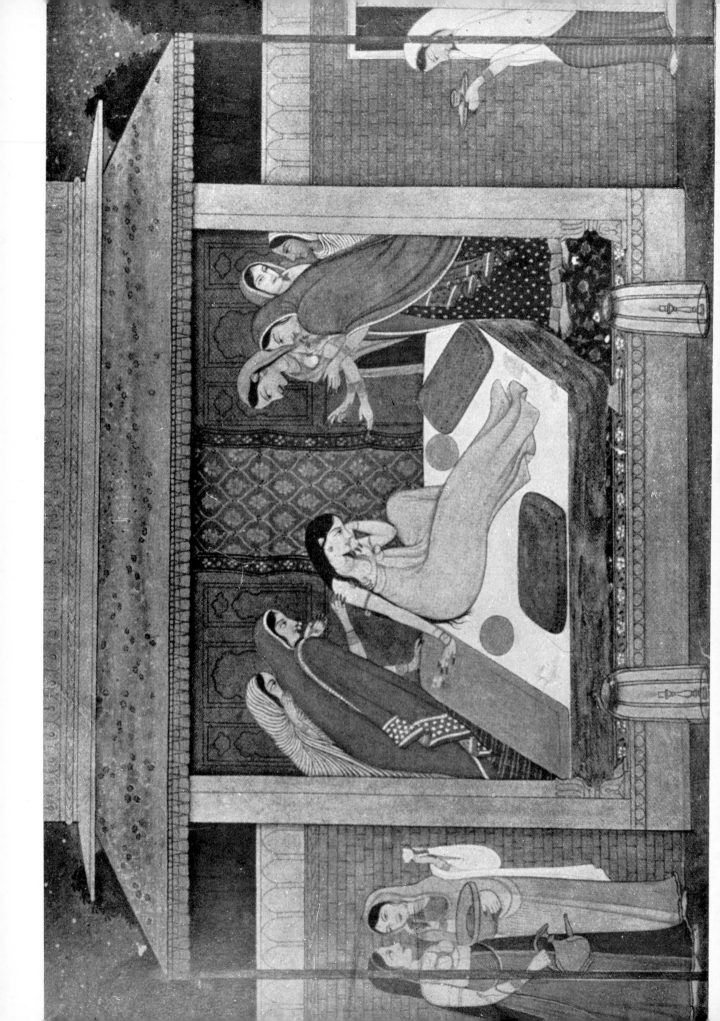

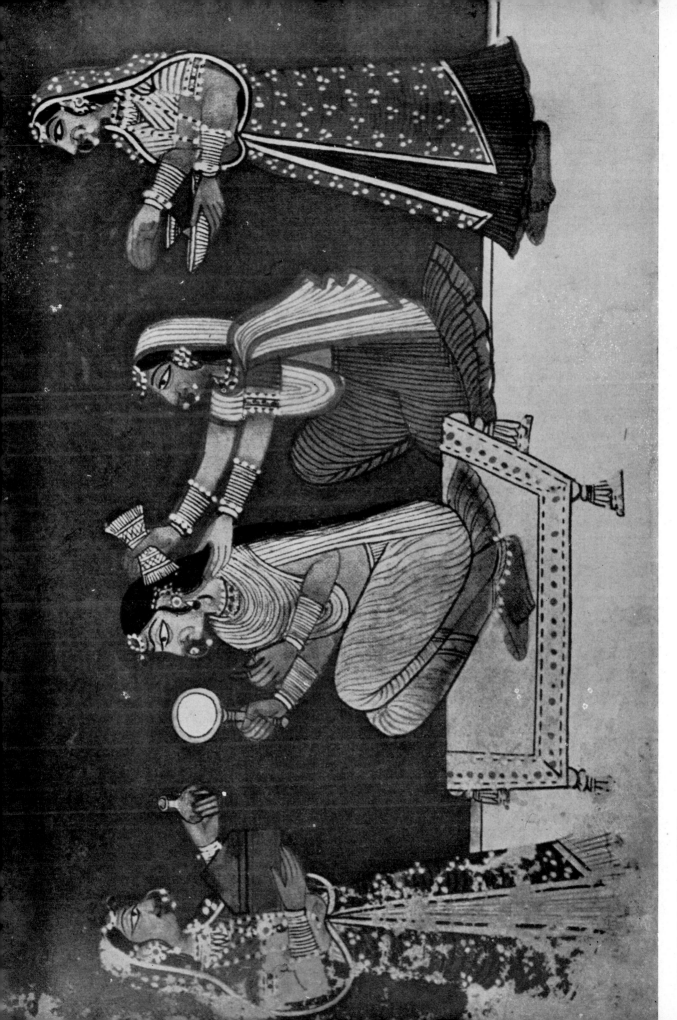

158. Toilet. Kulu, 1800-25.

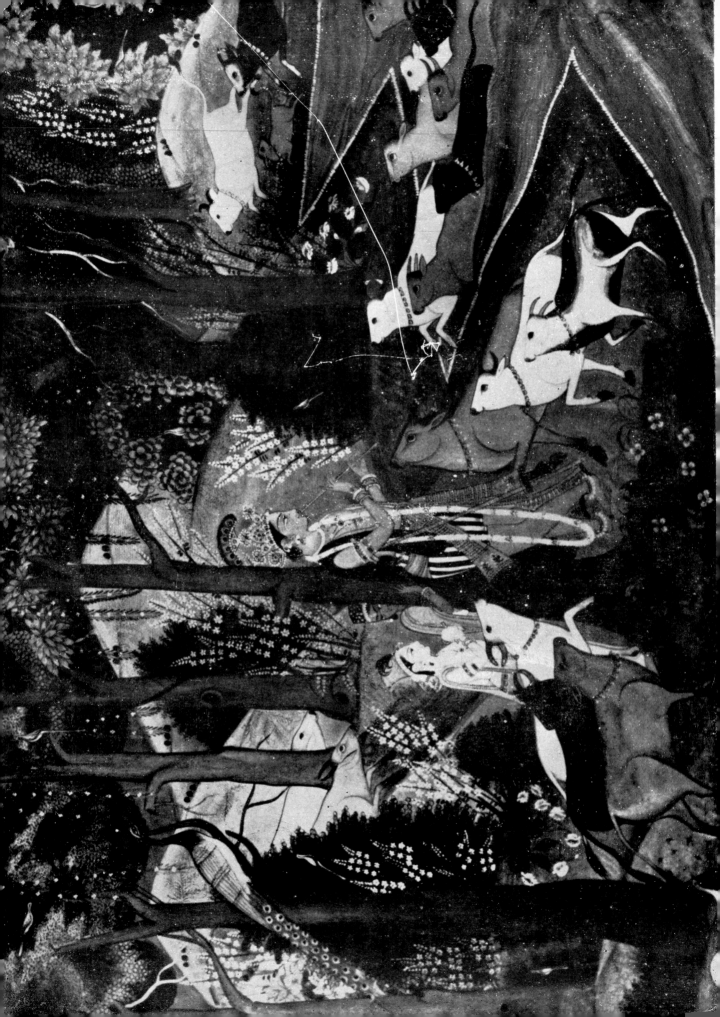

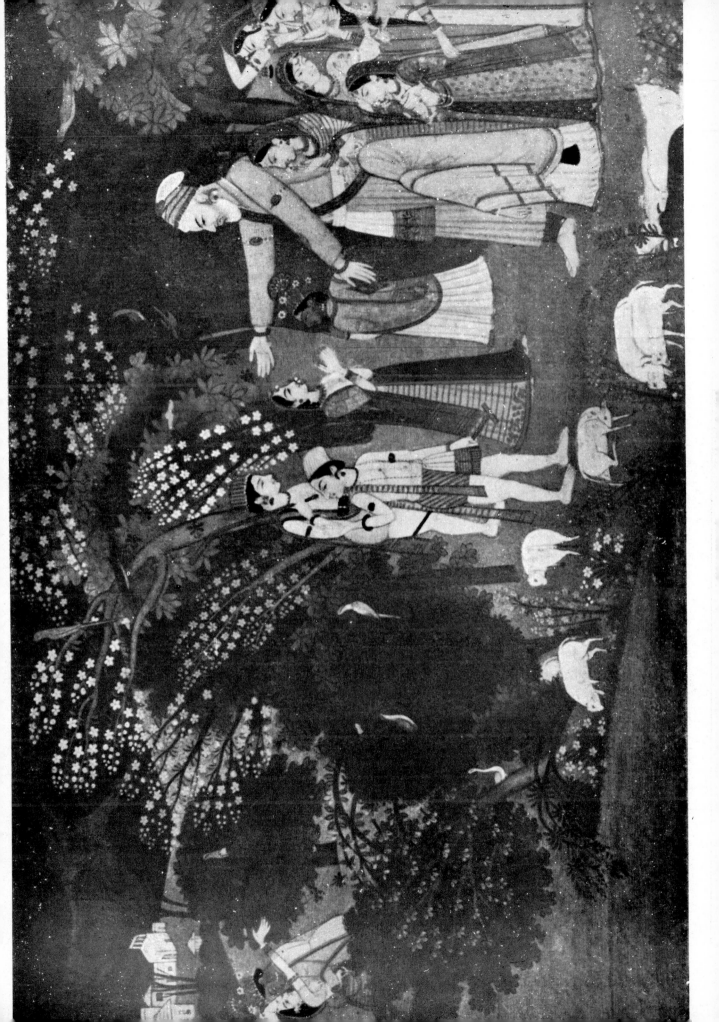

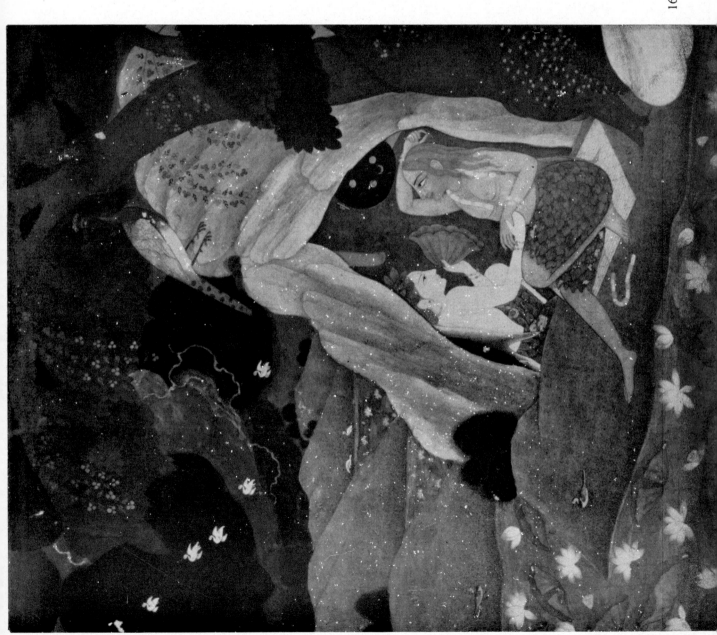

161. Rama and Sita in the forests in the rainy season. Nalagarh, early nineteenth century.

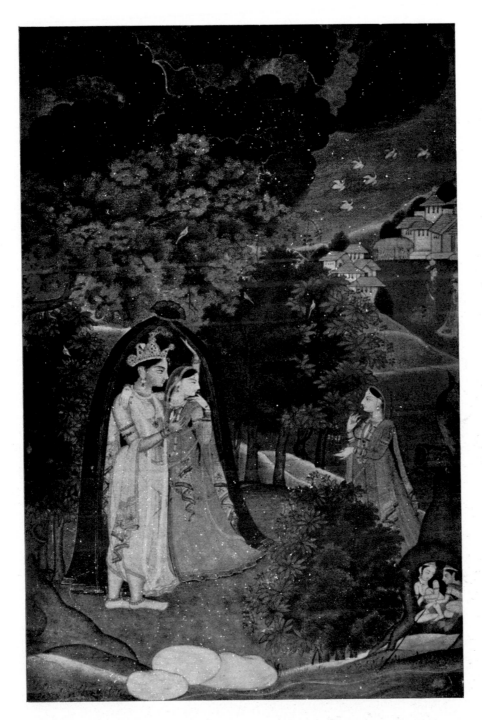

162. Snug shelter in imminent rain. Kangra, late eighteenth century.

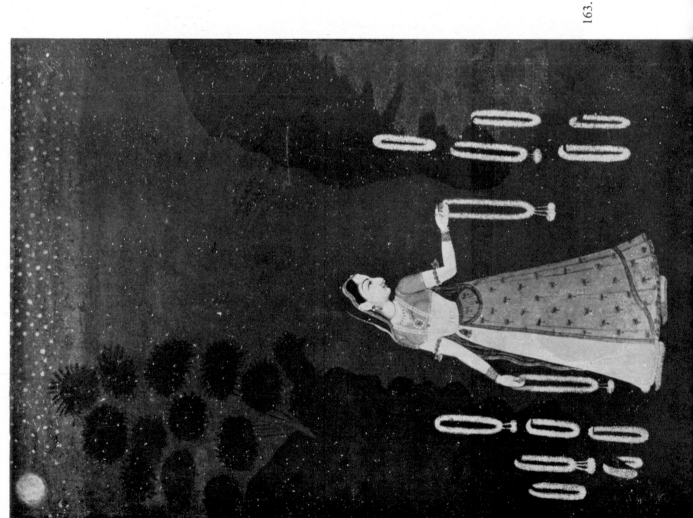

163. For the lover who failed to come. Guler, c. 1765.

164. Krishna and Radha in a grove. Kangra

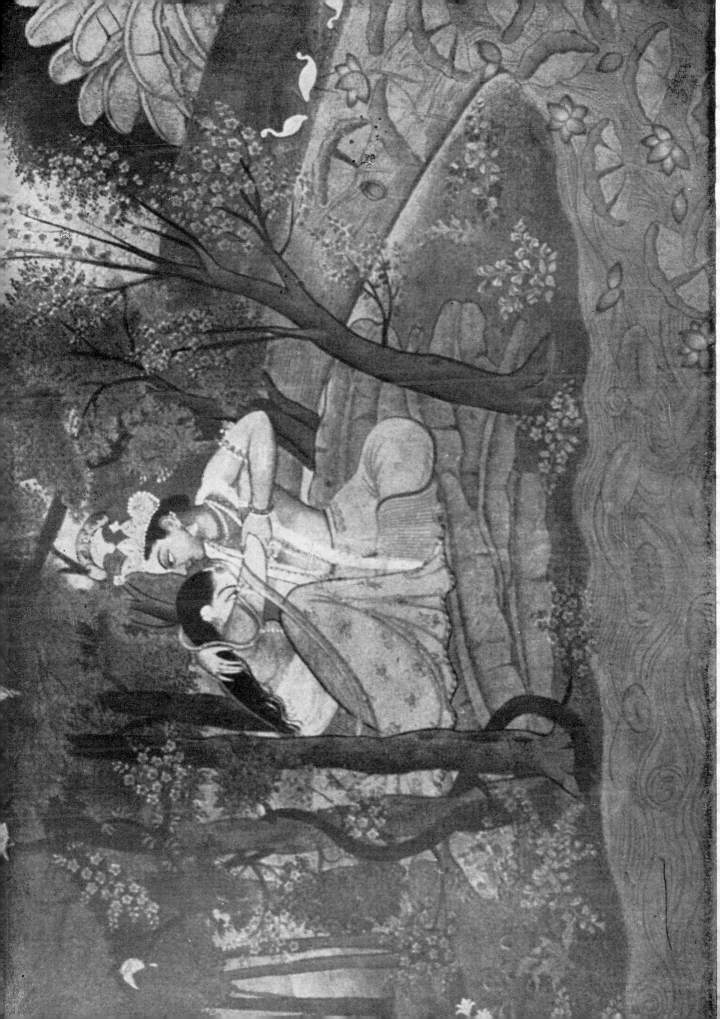

VII. Avalokitesvara. Pala, eleventh century.

VIII. A Noble Relaxing. Moghul, seventeenth century.

IX. Rama and Sita in the forests. Moghul, early seventeenth century.

X. Vasanta Raga. Ahmadnagar, 1580-90

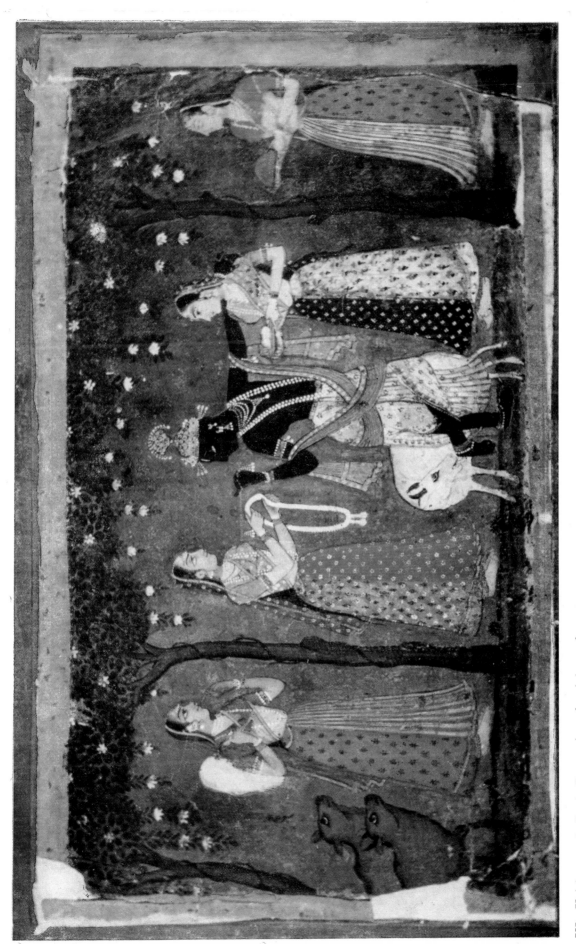

XI. Krishna and Gopis Deccani, early eighteenth century.

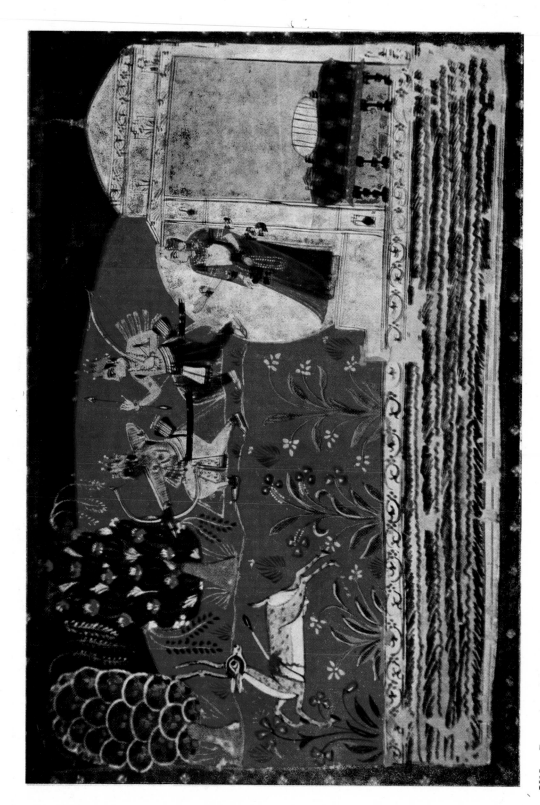

XII. Rama lured by the Golden deer. Malwa. seventeenth century.

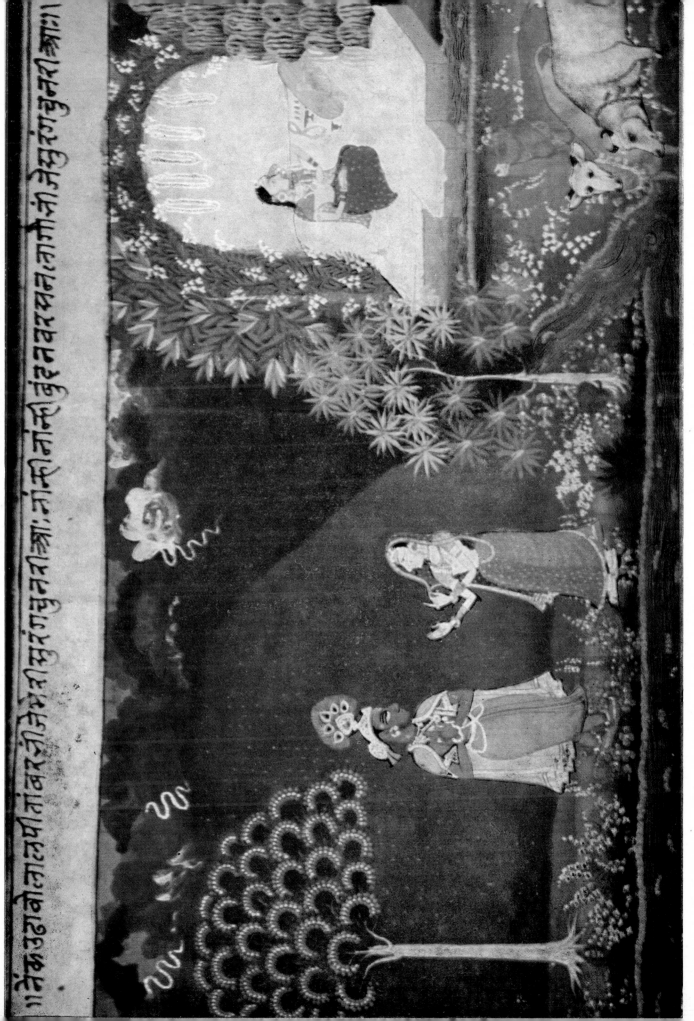

XIII. Krishna being invited to Radha's bower. Mewar, seventeenth century.

XV. Rasamanjari. Basohli, 1660-70

XVI. Gīta Govinda. Basohli. 1730→

XVII. Krishna steals the clothes of the Gopis. Kangra, 1790-1810.

XVIII. Krishna raising Govardhan hill. Kulu, late eighteenth century.

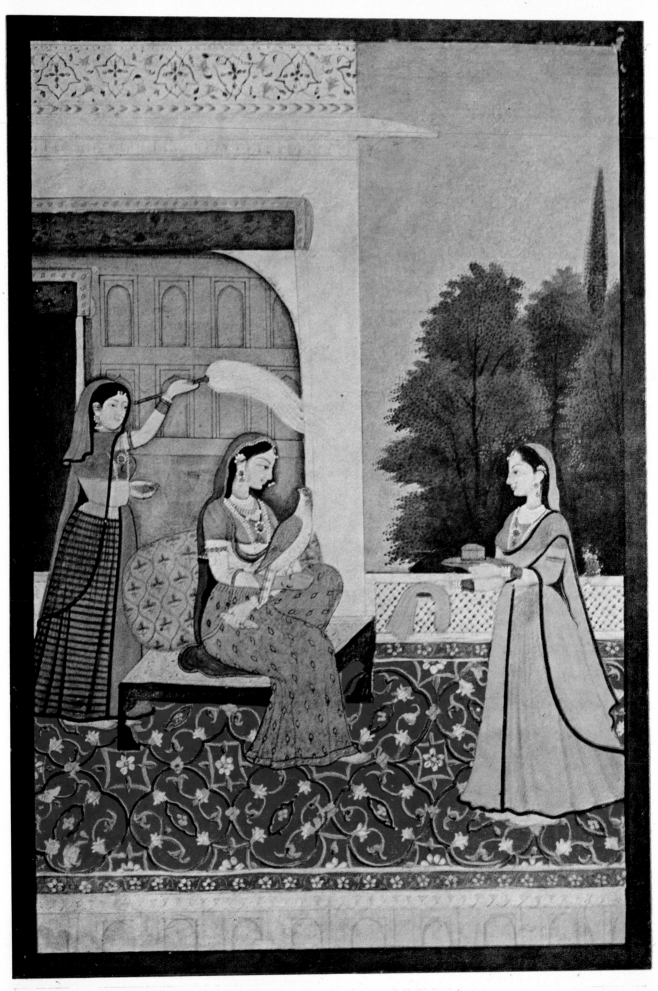

XIX. Ragini Saveri. Guler, late eighteenth century.

1928 he starts independent paintings in this manner; in his important note of 1930 he calls for a development of pictorial and plastic art on the basis of "music's declaration of independence" from the contingencies of the externally given; and a statement dated May 25, 1941 reads: "Creation is not repetition, or correspondence in every particular between the object and its presentation. There is a world of dreams and fantasies which exists only in man's imagination. If I but depict this in my pictures, I can beat the Creator at his own game . . ."

These four pioneers—Gaganendranath, Shergil, Jamini Roy, Rabindranath Tagore—gave a charter, of theory and practice, on the basis of which contemporary painters are exploring a fascinating variety of expressions.

Music, Dance, Dance Drama

Music must be as old as man. Even birds sing and there is no reason to think that a far more highly evolved species like man was incapable of similarly expressing the fulness of his heart in a spontaneous utterance that showed, incipiently at least, the shapeliness of a melody, the pulse of a rhythm.

But thought and conscious craftmanship have to refine the spontaneity if music has to start its career as a classical tradition. And a long evolution is needed before the tradition achieves maturity and yields variety. The vicissitudes of history have often hampered this kind of evolution. The music of antiquity, of the Sumerians and the Assyrians, has been engulfed, along with these races, by history. The great odes that Pindar wrote for civic celebrations were set to music, but the reconstructions of the modes of ancient Greece are at best speculative. There are other nations that have a continuous history from antiquity to today. But it has often happened that they excelled in other arts, their music not matching the greatness of their painting, sculpture and crafts.

Against this background, it is not illegitimate to claim that the Indian tradition is unique. Indian music has a longer unbroken — though continuously evolving — tradition than perhaps any other system known today.

Musical Evolution

Max Muller called the Vedas of India, which grew over a millennium from 1500 to 500 B.C., the earliest literature of Aryan man, and the evolution of classical music begins with the Vedas. The Rig Veda was the earliest and its hymns were metrical, recited. But as the religious sensibility deepened, man wanted to sing rather than merely recite or chant. Thus, the hymns of the Rig Veda begin to sprout wings as songs in the Sama Veda. But it took a long evolution to liberate the melody fully. For at first there were only three notes and they were sung rigidly in a descending order. The phases of the long growth need not be described in detail here. Briefly, the evolution unfolded in the direction of expanding the scale and transforming the sequence from mere scale-singing to fascinatingly varied progressions up and down. The notes used for building up the melody increased from three to five and then to seven. Flats or sharps of five of the seven notes raised the spectrum to twelve fairly

easily distinguishable notes. But the whole span was also more minutely divided into twenty-two microtonal steps of less than a semitone. This means that even a specific flat or sharp note can be found in actual singing and playing in delicately shaded, aesthetically flavoured variations. These demand a fine ear and repeated hearing.

While this is the scale of the Indian music system as a whole, the Ragas or melody-moulds—to one or other of which all music, vocal or instrumental, has to conform—are structured scales derived from the total repertory of notes. In fact, it is very helpful to compare the repertory to the gene-pool of an evolving genus of plant or animal forms, the notes being the individual genes. It is by the selection and recombination of genes that a wonderful variety is created. The face that launched a thousand ships, the beauty of Helen, was created thus; and in Indian music one speaks of the "shakal" or visage of the Raga.

Each Raga has an unmistakably characteristic, though very subtly moulded, visage. This distinct personality is created in many ways. A Raga should have at least five notes: the upper limit is usually seven, occasionally nine and may be even twelve in the case of some mixed Ragas. Comparative musicology sometimes points out similarities between Indian and Western music. For instance, some correspondence in scales can be cited between the A minor and Natabhairavi or between the G minor and Kalyani. Likewise, similarities in basic scales can be cited between North Indian and South Indian Ragas, like for instance the Northern Yaman and the Southern Kalyani. But stressing these similarities beyond a point will impoverish enjoyment. For structural identity in music no more determines the wonderful variety of form than the identity of skeletal structure determines the varied beauty of face and figure in human beings.

This varied beauty is created in many ways. Even when two Ragas have the same notes, they may differ in the use of the sharps and flats or the more delicately shaded microtonal variants. Some note or notes may be dropped in ascent or descent. Specific notes may be selected for accenting, as a sort of gravitational centre for the melodic elaboration. This feature is very characteristic of North Indian musical practice. Certain combinations may be built up as characteristic phrases that are signatures of the Raga. Above all, the type of movement from one note to another may differ widely. This last, known as the Gamak, is a very rich category, including shakes, trills, glides, swings, spiralling ascents and numerous other graces, as varied as the nature of the brush-stroke in painting.

The permutations possible, with all this variability, are very large. But since the selection rule that musical evolution seems to have applied is that the melodic mould should be aesthetically satisfying, the number of Ragas is about three hundred of which a hundred or so are common. Several attempts have been made to group the Ragas in a relation of primaries and derivatives. But these are still debated and in any case will be of interest only to scholars. Fascinating for the layman, however, is the tradition relating Ragas to specific seasons and even to specific periods of the day. But taken too seriously, these traditional attributions will create expectations of tonal painting of the type one gets in European programme music.

The singing or playing can be slow, medium or fast and this determines the t mpo. This is an easy concept to grasp. But one may keep in mind that North Indian music has explored the possibilities of the slow tempo perhaps more fully than the South Indian and that it accelerates in minimal gradations, while in South Indian music the medium tempo is precisely the double of the slow, and the fast precisely the double of the medium. Indian rhythms are apt to be more difficult for foreigners to grasp. This is because a single cycle of rhythm, or bar, can be built out of units of different duration, the total duration for the cycle can be divided in various ways when the cycles are repeated in the continuous singing or playing, the pattern of accenting may vary even if the total duration of two rhythm-schemes is the same, and the cycle itself may be long. But one clear punctuation for the listening ear is available in the first beat (*Sam*) which is the most emphatic of all the beats in the cycle. The variations by the singer or solo instrumentalist or the footwork of the dancer create drama, for they tax to the full the alertness and skill of the accompanying percussionist; the delay creates suspense; and the precision of the arrival at the *Sam* after extended variations provides an explosive climax which can receive a sensational response from the audience.

Equipped with melody and rhythm, music has undergone a magnificent evolution in India. In its sweep it has united earth and sky. Originating in religious worship, it has become a spiritual discipline, a path of realisation quite independent of the burden of the lyric. Singing by itself thus becomes a spiritual exploration, in addition to being an aesthetic one. The harmony of pure being and dynamic becoming, of the transcendent and the immanent, of eternity and time, is a fundamental doctrine in the Indian tradition. In the initial elaboration of the Raga as free melody, the singer contemplates the beatitude of timeless existence; in the later, rhythm-bound movements, he senses the excitement of the rhythm of cosmic evolution. Indian music has no absolute pitch. For each occasion of singing, a drone (Pl. 168) furnishes a frame, a sustained tonal centre. The tonic, heard continuously before, throughout and at the conclusion of the singing, expresses the timeless, eternal background of things. The singing itself is an interlude—like the interlude of the world in the eternal existence—which builds up tonal space through melodic elaboration spanning the lower and upper tetrachords and tonal time through the organisation of tempo and rhythm. And since each singer is in a profound sense a composer, he too becomes a creator.

This faith in their discipline as a way of realisation has been a real inspiration for all great practitioners of music in India. Yet, if this had been all, music would have remained esoteric for the common man. But right from the beginning it has made gracious the vicissitudes of ordinary living. Even in the Vedic period there were songs of the people and we find mention of categories like Grama Geya or songs sung in villages, and Aranya Geya, those sung in forests. These melodies proliferated in course of time to envelop the entire life of man, from the cradle to the grave, in an entrancing shell of musical sound, touching with poetry the sacramental moments of marriage and its fruition in the advent of progeny. They kept man in close touch

with creation, for the Baramasa songs are on the cycle of the seasons, the relief that comes with the rains after summer's long reign of implacable heat, the rejuvenation of nature in spring. They helped him to transform his work into a joy, for the ploughman and the boatman, the shepherd and the camel-driver, all have their songs that pulse to the same rhythm as their work.

Systems of Music

Though the early treatises know of no distinction between the North Indian or Hindustani and the South Indian or Karnatic systems, a divergent evolution was initiated when history began to irrigate the north with cultural streams from Persia. Amir Khusrau, the Persian aristocrat and humanist of the thirteenth century who made India his home, was a great pioneer. The cultural interaction gained momentum with the establishment of the Moghul empire and, like the architecture and painting of the north, music too has richly assimilated influences from Persian traditions (Pl. XXI). Thus today the northern and southern systems are distinct species though of the same genus. The happy effect of the divergent evolution has been a richer heritage of musical forms which one can now proceed to relish, starting first with the forms of the north.

The Dhrupad, whose form was first shaped by Raja Man Singh Tomar of Gwalior and developed by Swami Haridas and his disciple Tansen who was a luminary of Akbar's court, conserves the antique liturgical stateliness in its style. It begins with a free melodic elaboration or Alap and goes on to a rhythm-bound lyric whose first two sections traverse progressively the lower, middle and upper octaves while the last two sections can be regarded as the complex development of the same musical material. There are only a few practitioners of this style today. The Dhamar is a transitional form pointing in the direction of the further evolution. For, though it is very much like the Dhrupad, its lyrics are mostly based on the romantic episodes in the life of Krishna and this in turn has made its style more supple and sensuous, with greater use of Gamaks.

These qualities of suppleness and sensuousness, with swifter and wider appeal than the gravity, discipline and stateliness of the Dhrupad, reach their fullest expression in the Kheyal. The word itself means imagination and the elaboration of the Kheyal is decorated with all possible imaginative graces. The structure is considerably relaxed. It is rarely that the singing begins with the Alap or free melodic elaboration; more often the Alap is done in the melodic elaboration of the phrases of the composition itself. There is extensive exploration of all possible resources of Gamaks.

Germinally originated perhaps by Amir Khusrau, developed by Sultan Sharqi of the fifteenth century and stabilised as a classical style by Sadarang of the eighteenth century, the Kheyal later proliferated into many *Gharanas* or schools: those of Gwalior, Agra, Jaipur, Kirana, Patiala, etc. In aesthetic quality they range over a wide spectrum, from the stateliness of the Jaipur Gharana, nearest in musical temper to the spirit of the Dhrupad, to the sensuous sweetness of the Kirana. The

distinction of musical temperaments reflected in these styles is not difficult with some exposure in concerts or through recordings which are now plentiful. But it would be better not to try to fix features of each *Gharana* in any rigid or mechanical manner. For each school has had the vitality of growth to permit individual practitioners, generation after generation, to find a personal utterance that rings distinctive though within the frame of the broad stylistic features.

Beside the major form of the Kheyal, the North has a rich variety of light classical forms too. In Tarana, syllables which have no articulate meaning are used for tonal values and the tempo is generally fast. The Tappa, which tradition derives from the song of camel-drivers, is distinguished by quick turns of phrases with no slower elaboration. Rhythm predominates exclusively in the Tarana, accommodates a lyrical text in the Tappa, becomes full-fledged lyrical song, most often a love song, in the Thumri. The romantic love of Radha and Krishna is the basic inspiration of this form in light-weight Ragas of swift appeal. In the Thumri of Lucknow, this romanticism is often touched by over-ripe autumnal scents, for in the twilight of Moghul fortunes, Wajid Ali Shah of Lucknow composed and patronised it within the retreat of his marble palace. The Thumris of Banaras, on the other hand, have the feeling of the sunlit, wind-swept open air and have assimilated motifs from seasonal folk song like the Kajri which greets the rain. The Ghazal, a Persian lyrical form, has been completely naturalised in India and is comparable to the Elizabethan song or the German lied.

In the Sabads or sacred songs of the Sikhs, classicism refrains from too great elaboration and ornamentation so that the meaning of the hymns would be clearly communicated. Songs of this clarity, but romantic in temper, stud the folk epics of the Punjab that tell of the tragic loves of Leila and Majnun or Heer and Ranjha. Muslim and Hindu devotion is facilitated to group singing in the Quavals and the Abhangs respectively. While the Abhang is indigenous to Maharashtra, and the Kirtan to Bengal and Orissa, the Bhajan has a greater regional spread, and saintly people of all classes, from Meera who was a princess of Rajasthan to Kabir who was a weaver of Banaras, have enriched the legacy of this form. Many influences, secular and religious, Persian, Hindu and even European, came together in the creativity of Rabindranath Tagore who composed a very large number of songs that modulate the classical tradition to contemporaneity in feeling and expression.

In the Southern or Karnatic system, a basic form is the Varnam which incorporates the characteristic phrases and melodic movements of the Raga and thus corresponds to the Etude. Some Varnams have a lyric; they may have, in addition, solfeggio passages as well. This is obviously a movement towards articulate message and complex structure and reaches its fulness of development in the Kriti, moulded to perfection during the first half of the nineteenth century by Syama Sastri, Tyagaraja, Dikshita and Maharaja Swati Tirunal. The Kheyal neglected the lyric somewhat; the Kriti restores the parity and develops it through a complex, unfolding structure. The Pallavi is the opening statement in lower and middle registers, the Anupallavi is the elaboration in the middle and upper octaves. It is followed by one or more Charanams,

developmental sequences tracing complex arabesques over the whole range of registers, the Pallavi being repeated like a refrain after every Charanam. In Northern singing we get what are called Bole Tans which are phrases of the lyric sung fast and with complex rhythmic variations. But while these can be introduced anywhere in the composition, the Neraval of the South which corresponds to it is effectively used for the climax before the conclusion.

Pallavi singing—an independent form not to be confused with the Pallavi of the Kriti—is rather like the Kheyal in that there is no full-bodied lyric. A lyrical phrase or sentence is used for elaboration of melodic and rhythmic variations. After full exposition in one Raga, the phrase may be developed as a Ragamalika or garland of Ragas.

There is a great variety of instruments, though the most frequently used are relatively few. The bowed string used for solo or accompaniment is the sarangi in the north and the violin in the south. The most important plucked strings are the sitar and sarod in the north and the vina in the south. The most familiar reed instruments are the shahnai of the north and the nadaswaram of the south. The flute is used in both the regions, but the southern flute is shorter and its pitch higher. Of percussions there is a great range. But in concerts, the south uses the mridangam, and more rarely the ghatam which is an earthen pot. The north uses the tabla, though Dhrupad singing is accompanied on the pakhavaj.

While, in the south, instruments play the major forms as in vocal music, they follow a different pattern in northern concerts. The recital opens with the Alap or the elaboration of the Raga melody in slow tempo, by the solo instrument. This quickens to the Jode where intricately wrought phrases follow one another in fairly quick succession. Next comes the Jhala where the drone strings of the instrument are also used. All the three sections are free renditions without rhythmic punctuation. The recital closes with a Gat, a structured form with an opening section in the lower and middle registers and a following section that spans the middle and upper octaves. All the technical resources of the instrument are used to building the form of the Gat which is first played in a slow tempo and then builds up to a brilliant climax in the fast tempo.

Integrative Explorations

Indian music is basically melodic, Western music is basically harmonic. While complete harmonisation of Indian music will be an unsound idea doomed to failure, interesting experimentation is going on today which seeks to assimilate some features of western music without impairing the integrity of India's own tradition and without sounding alien. In the fascinating explorations of choral singing groups that have come up in Delhi, Calcutta and Madras, there is clear distinction of planes of sound, the massed voices of the men being used to deliver exhortative phrasings with authority and those of the women for soaring lyrical elaborations. Antiphonal call and response are also being used with convincing dramatic effect, recitative in speech rhythms is

interspersed with singing, and occasionally sounds other than those recognised by the classical scale are also used.

In the orchestration of Indian music that commenced some decades back, while harmonisation was rightly not attempted, part writing was developed for giving personalised roles to the various instruments, each of them "speaking the lines" best suited to it in terms of range, timbre and tone colour. This has led further to the creation of programme music of the European type, some of which is very delightful and none of which violates the tradition.

Indian music is basically improvisatory and jazz too is improvisation. Therefore there have been very pleasant experiments in the development of an Indian jazz. The deeper, meditative moods of the Indian Raga are perhaps not within the reach of the jazz treatment. But every Raga, in its lighter moments, has a relaxed profile. By selecting the features of the lighter moods, shaping them in telling phrases and making them dance to exciting rhythms, a very delightful category of light music, especially popular with the young people, has been developed.

Judiciously cautious integrative explorations of this type have been made on the high classical plane too and the cooperation of Ravi Shankar and Yehudi Menuhin has helped a lot here. Ravi Shankar's Concerto for Sitar has been performed and recorded, the orchestra being the London Philharmonic and the conductor Zubin Mehta. With a layout more like the Concerto Grosso of an earlier epoch, the composition retains the intimacy of chamber music characteristic of the Indian tradition.

There have been some outstanding achievements in this field where not only have Indian and European traditions been well integrated, but features of avantgarde music have also been assimilated and, further, the compositions given social relevance by reflecting the great upsurge of contemporary India. As an instance, the work of Vanraj Bhatia, who studied music in Europe and whose compositions have been published there, may be cited. In the Sound and Light show at Teen Murti in New Delhi, he has told in music the story of our freedom fight up to the death of Nehru, using both Indian and western idioms and instruments. Though in one sense "applied art", his compositions for India's public sector pavilions in international Expos eminently qualify as absolute music too, and of great excellence. In the Baladila Symphony he composed for the Metals and Mines Pavilion, he uses "musique concrete", actual sounds from the Baladila mines and from the ships that carry the ore to foreign countries. Instances of telling uses of natural sound are the breaking of the surf, the call of the sea gulls, ship horns many times superimposed and work-songs whose rhythms pulse through the whole musical fabric and hold it together. An impression of elemental energy is conveyed in Bhatia's score for the Bharat Electronics pavilion. The verse from the Gita where Krishna reveals that he is the energy behind all the energies of the world, and shows his cosmic form, is used in canons and variations that convey the impression of a tremendous and reiterated affirmation. The background swell is from the piano, the notes played in harmonic series at many levels. But the first explosion of the note is edited out and the reverberations are used straight or in reverse, dying away or gaining in amplitude with a liturgical impact.

Even while sustaining the classical tradition, the musicians of India are showing themselves to be splendidly responsive to the ever renewed impulses of modernity.

Classical Dance Forms

The euphoria of singing, especially rhythmic singing, leads naturally to dancing and the traditional Indian concept of *Sangeet*, though nowadays it signifies only music, was a total concept in the classical tradition integrating music, both vocal and instrumental, dance and even dance-drama. At the head of this classical tradition stands the great text *Natya Sastra*, attributed to Bharata who lived sometime between the second century B.C. and the second century A D. All the regional classical traditions claim derivation from this text. But this has not prevented the evolution of fascinating modulations of a great variety.

Classical dance includes both abstract or pure dance (*nritta*), consisting of stylised movements and poses and footwork of complex rhythms, and representational dance (*nritya*) which is suggestive, interpretative and expressive, with every movement and gesture invested with meaning. The representation (*abhinaya*) is an integrated achievement managed through appropriate costume and ornament (*aharya*); all the resources of the body (*angika abhinaya*) for expressive stance, movement and gesture; the uttered word, speech or song (*vachika abhinaya*); and above all through the capacity of the face for expressing a great range of emotions (*satvika abhinaya*). All these means converge to the expression of feeling (*bhava*) and this representation of the inward sensitivity in a sensuously palpable way enables those who witness the dance to experience pure aesthetic relish (*rasa*). It is useful to remember two more details. In terms of tempo, and thereby of its associated mood, the dance can be fast, dynamic, even turbulent (*tandava*) or delicate, graceful, exquisite (*lasya*). Broadly, these correspond to the allegro and adagio of the European tradition. Secondly, over the centuries, the gesture has been developed into a complex language, in some cases deviating far from the natural gesture to become a symbolic code.

Though, today, many from the north have learnt Bharata Natya (Pls. XXII, XXVI-XXVIII, 169-171, 173), it is a southern tradition originating in the dances of the maidens (*Devadasis*) who were traditionally attached to the temples of Tamil Nadu for ritual worship through dance. From the twenties, the lively interest of the educated upper classes led to the practice of the dance becoming a socially prestigious tradition. The poems that form the libretti are in Tamil, Telugu, Sanskrit and, less frequently, in Kannada. The music followed is the Karnatic. Drum (*mridangam*) and cymbals accompany the singer.

Bharata Natya is essentially solo for a danseuse. Her costume and make-up consist of a brief blouse and a sari of shimmering satin or brocade, sheathing the legs from the hips to the ankles and having an array of pleats in front which unfold like a fan when the knees are lowered in the basic stance. A recital opens with an invocatory sequence of pure dance (*alarippu*) and is followed by a more intricate and faster sequence (*jatiswaram*) which is also pure dance. Here the dancer's limbs create nume-

rous patterns through movement and rhythm. It is only in the next section that the transition is made to representational, interpretative and expressive dance. The poems used as texts can be homages to a god touching on his attributes and legendary exploits (*Sabdam, Kirtanam, Slokam*) or a love lyric (*Padam, Javali*). Gesture and facial expression, above all the expressive glance and movement of the eye, are fully used here. Then comes the most complex and difficult sequence, the *Varnam*, which combines both pure and interpretative dance. Usually the last item is the *Tillana,* a pure dance in different rhythms and fast tempo.

Bharata Natya developed from solo dance to group dance and from interpretative dance to dance-drama in two forms, the classical and religious Bhagavata Mela Nataka and the secular and relatively popular Kuravanji. When the Vijayanagar empire broke up, the Nayaks who were its viceroys became autonomous rulers. Achyutappa, one of the Nayaks of Tanjore, endowed a village to a group of Brahmin families for sustaining the Bhagavata Mela tradition and it is in the temple of this village, Melatur, that the tradition has mainly survived. There are over a dozen plays in the repertory, all drawn from Puranic legends. Kuravan means gypsy and the Kuravanji seems to derive its name from the fact that a gypsy woman comes along to read the palm of the lovelorn heroine and assure her that all will go well. As she is in love with a deity or a prince who does not appear on the stage, the play is very simple, but the scenes of the heroine with her friends provide occasions for songs and dances.

In the Therukkoothu (literally, street play) of Tamil Nadu we have a popular theatre of great vitality (Pl. 178). The remote origin of the form in ritual is remembered in the invocation, and the link with the classical tradition is clear in the episodic themes which are all drawn from the Puranas and the epics. There are only male actors, the make-up is elaborate, costumes gorgeous. The main character, soon after his entry, makes a circular movement around the acting space to the accompaniment of music and singing and his steps come close to those of Bharata Natya. The songs are in classical Ragas and folk tunes. The director (*Sutradhar*) later takes on the role of the Fool (*Vidushaka*) which is very important in classical Sanskrit drama and often makes hilariously ironical jokes about the contemporary social situation.

In the seventeenth century, Tirtha Narayana Yati, a Telugu Brahmin whose family had settled down in the Tanjore district of Tamil Nadu, fell so much in love with the enchantment of the Krishna story that he retold it in a long narrative poem in Sanskrit entitled *Krishna Leela Tarangini.* From the fact that he has introduced sequences of rhythmic dance syllables at the end of several cantos, it is clear that he wrote this work as a libretto for a dance-drama. Yati lived for a while at Varahur in the Tanjore district and he trained some boys and presented the dance-drama in the Tanjore temple. His disciple, Sidhyendra Yogi, followed up with another play, dealing with the story of Krishna bringing the Parijata flower plant from Indra's heaven at the behest of one of his consorts, Satyabhama. Yogi presented it in the small village of Kuchelapuram or Kuchipudi in the Krishna delta and the tradition thus initiated has been called Kuchipudi. It is very probable that the Bhagavata Mela Nataka was an offshoot of the Kuchipudi dance-drama of Andhra. Originally, only men took part in

Kuchipudi which thus involved female impersonation by males. But these days solo sequences are detached from the play for stage presentation by danseuses, like Bharata Natya. Kuchipudi, unlike the rather didactic and religious Bhagavata Mela, moves nearer to the secular temper, allows freer expression to romantic moods, permits the incorporation of improvised comic interludes not present in the original text (Pls. XXIV-XXV).

The Veethi Bhagavatam (Pl. 177) is a splinter from the Kuchipudi dance-drama that developed towards a popular type of expression and incorporated humour as well as social criticism. Since danseuses were not permitted to participate in the dance-drama, a parallel tradition arose where one danseuse could narrate a story through pure and mimetic dance. There is a multi-purpose male actor too here. He introduces the play in the beginning and also plays the role of the Fool (*Vidushaka*). In a staple sequence invariably present in these recitals, the danseuse, in the guise of a girl of the cowherd community, rather low in the caste-hierarchy, attacks the Vidushaka's claims to superiority by virtue of being a Brahmin.

Yaksha Gana (Pls. XXXIV, 188-189) is the traditional dance-drama of Karnataka. It is also called Bayalatta, literally dance in the field, because it is a night-long performance in the open air, and Dasavatara Atta because the themes are drawn from the rich legends about the ten incarnations of Vishnu. The themes have been recast in poems and there are over a hundred libretti in existence. The musician sings the poem in Ragas, basically of the Karnatic system, but in a freer style than the classical, and to the accompaniment of drums. The narration is interpreted in dance and acting by the characters who are allowed improvised prose dialogues relevant to the context. Headgear, costume and make-up are elaborate, have taken detailed cues from Hoysala sculpture and are very clearly differentiated for the various roles. Very interesting in its affinity with Wagner's use of the musical leitmotiv for characterisation is the clear distinction of the rhythm-pattern on the drums when each character makes his first entry. The themes being mostly heroic exploits, the temper of the plays is turbulent and the dance is mostly of the Tandava type, although there are also exquisitely relaxed scenes like those of young girls sporting in water.

Though the Kathakali of Kerala has by now become globally known, this state has several traditions of dance-drama and we may begin with the lighter forms before we take up Kathakali. Kerala is the only region of India where the presentation of the Sanskrit drama has continued right up to the present. Very characteristic of the temper of the Kerala people is a novel feature here. The Vidushaka has become an ironic foil to the hero. For every stanza recited by the hero, praising his beloved or expressing his romantic longing, the Vidushaka recites another, in mocking parody, creating an overall temper of piquant, Eliotian irony which has become ingrained in the people through subsequent, reinforcing developments. The tradition of sacred recitals in temples began very early. But the Chakyar, the raconteur, freely incorporated contemporary social references in his narration, and even ridiculed the various social types present in the audience right before him. In the eighteenth century, Kunchan Nambiar, a very brilliant man who had the exuberance of Rabelais, the

capacity for satire of Aristophanes and surpassed Dryden in the fluency with which he could write verse charged with irony, created a new form, the Thullal, where the tradition of satirical social criticism reaches perfection.

The Thullal (Pl. 190) is a mono-actor play where the raconteur recites the long narrative poem in a continuous dancing and also acts all the roles in the story. The costume is picturesque, the facial make-up is elaborate though not to the same extent as in Kathakali, the dance measures vary in tempi according to the mood of the narration and may have assimilated the style of the Patayani, a martial folk-dance (Pl. XXXV); the gestures do not deviate far from natural gestures though they are accented in expression for more telling impact. With a hilarious anachronism, Nambiar introduced every social type in Kerala into Puranic milieu and epoch. The Thullal libretti he wrote are literary masterpieces and can rank high in the world tradition of satirical writing. Very subtle is the aesthetic action of this art-form with its continuous interchange of the roles of the narrator and actor. In one moment the dancer brings out the comic antics of a vain fop with such a complete self-identification that it traps people in the audience also into identification, fantasy and vainglorying. But after this build-up, he switches back abruptly to the role of the ironic raconteur and, in a devastating gesture, exposes the stupid vanity and brings down the audience to the earth—with a thud which may hurt them but will do them good. The danced and acted narration thus emerges with a continuously shifting focus, the camera now quite close, penetrating the interior world of men's self-delusions, now remote, seeing things with a sane objectivity, correcting vanity with raillery and deeper fixations with a cathartic, caricaturist distortion.

Two other light forms of Kerala may be mentioned before we take up Kathakali. In the east coast, in Tamil Nadu, there was a popular form known as Dasi Attam which had little classical status though it borrowed some of the more elementary steps and gestures of Bharata Natya. This tradition seems to have spread to Kerala in the west coast but was consciously refined—by the brilliantly talented early nineteenth century ruler, Swati Tirunal, in the opinion of many researchers – by the incorporation of some Kathakali gestures though made supple and elegant, by varying the footwork and above all by accenting the lyricism. While Bharata Natya tends to be monumental and rectilinearly statuesque in its poses and dynamic in its movements, this dance—Mohini Attam—has evolved into a gracious and graceful style (Pl. 181).

The other form is Chavittu Natakam. Christianity in Kerala is as old as the faith itself and the tradition of integrated culture made it easy for this form to emerge when European contacts began in the modern period. The libretto was by Christian missionaries and their native colleagues. That is why we have dance-dramas on Christian legends about Charlemagne emerging in Kerala. While the libretto was in verse as in Kathakali, the actors sang their lines and spectacular decor was used, unlike Kathakali. A tradition of gymnastic and martial training (*Kalari Payattu*) was traditional to Kerala and the forceful rhythmic pounding of the floor of the stage by the feet of the actors is the result of the assimilation of this tradition. In its turbulent

presentations, Chavittu Natakam brings on the stage as many as forty or fifty men and alarums and excursions abound in this curious dance-drama.

Kathakali (Pls. XXXII-XXXIII, 187), as it was stabilised in the seventeenth century after a long evolution through transitional forms like Krishna Attam (Pl. XXXI) and Ramanattam, is high classical art in the sense that thought has been given to every detail. The libretto in verse is in the tradition of narrative poetry that goes back to Sanskrit literary canons. The actors confine themselves to balletic and mimetic interpretation and dramatic action, their dialogue or monologue songs being sung by attendant singers supported by drummers and cymbalists. Many of these songs are fine lyrics with exquisite imagery. Ravana, unexpectedly happening to meet the nymph Rambha, muses: "Like a flake of gold on the river bed seen through the shimmering waters of the blue Kalindi, the beauty of her golden form gleams through her fluttering garments." For giving the most appropriate melody to this lyric, Raga Nilambari has been chosen. For this sensitive integration of lyric and melody, the style of singing classical Ragas has been simplified, avoiding the technical flourishes and elaborations that will interfere with the immediate comprehension of the words.

Costume and make-up are elaborate. Many dramatic traditions in the world have used masks which can be clear and immediate differential signals of various character types. The Kathakali make-up retains this advantage because the whole face is painted over with typological differentiation. But the mask does not permit the face its expressive mobility. In the case of the Kathakali character, however, with the contour of the face clearly demarcated by a white or coloured fringe which frames it effectively, the face becomes a stage for the inner spirit. The tumult or the tranquillity within finds immediate expression in the mobile features with no mask to conceal them, but with very striking mask-like painting to accent the expression. The masterly painting of the face brings it nearer to sensory assimilation, psychologically, by focussing attention, with the same effectiveness as the close-up in a film can bring it visually, through optical means.

Years of training make the eyes unbelievably expressive here and some librettists have thought up piquant contexts challenging the actor to express one feeling with the left eye and a wholly different feeling with the right.

No decor is used, the poetry solving the problem of evoking the background at a higher level by developing a heightened colour and descriptive sensitiveness. There is no drop curtain. Just before the appearance of the actor, the stage attendants hold up a curtain-like cloth, screening the character from the view of the audience. This prop is assimilated into the dramatic expression in a unique manner. Thus, a demoniac character would seize the curtain forcibly and fling it away, while ultimately revealing himself. The "rise of the curtain" thus becomes expressive of character. Kathakali has a very complex code of gestures. The ballet element is attuned to the mood of the narrative, fast in tempo in battle scenes, relaxing into languorous slow sequences in the romantic passages.

The exalted diction, the use of similes and metaphors in the tradition of the conceits of Sanskrit poetry, the cryptic gestural code and several other features tend to

make Kathakali a classical or even neoclassical tradition. But the most extraordinary feature of this form is that it has been able to retain also the quality of ritual drama. This derives from its link in evolutionary origins with traditional ritual plays. Here, through a ritual (*Thottam*) and its hymns, goddess Kali is supposed to be induced to "possess" a dancer who thus virtually becomes the deity *Theyyam* (Pl. XXX). The ritual then develops into a representation of the goddess slaying a demon. All the details of the style of this enactment lift it far above the level of a mere dramatic presentation to the hidden dialectics of the world's unfolding, the unceasing war between good and evil. The acting area is not confined to one spot. The goddess pursues the demon all over the vast precincts of the temple, symbolically all over the world. Fistfuls of a resinous powder flung periodically into the flaming torches become incandescent clouds that illuminate the scene with an unearthly light; the blinding light lasts only for a moment, but it affords a vision deep into the drama at the heart of reality. Kathakali is not, on the surface, a ritual play or sacred drama. But almost invariably, its themes are duels and battles and these are conflicts where the gods, or the righteous, vanquish the wicked. The costumes and make-up are unearthly, escalating the enactment to the plane of the symbolic. The incandescent resinous powder is used here too. As the play moves towards its denouement, the hurling of challenges fills the stage with tremendous clamour. There is a special make-up for the demons mutilated in combat which shows them covered with blood and with entrails exposed. Even the sophisticated spectator experiences a shock of terror when he sees such an apparition. Sometimes this gruesome figure is chased by the hero right through the midst of the audience. In such moments the confrontation of conscious appraisal, habitual in the case of classical art, collapses completely and the spectator is deeply involved in a maelstrom of primitive, half-magical, half-religious emotions. In the final analysis, it is this continuous interplay of confrontation and involvement, appraisal aud identification, that makes Kathakali a unique art-form without a parallel in any other tradition in the world.

Leaving the south and turning to the east, we have, in the Odissi of Orissa (Pls. XXIX, 182-186), a dance tradition that has evolved out of the practice of attaching girls (*Maharis*) to the temple for ritual dance. An early thirteenth century inscription in the temple of Ananta Basudeva in Bhuvaneshvar states that one hundred girls were engaged in this service. The tradition is thus similar to the Bharata Natya in Tamil Nadu, but Odissi today has almost completely opted for the gentler style (*lasya*). The thrice-bent (*tribhanga*) posture, very familiar in Indian sculpture, is characteristic of Odissi. The legs are flexed at the knees, the hip deflected and the head inclined (Pl. 183). An Odissi recital begins with an invocatory section where salutations are made to mother earth, Ganesa and to the audience, passes on to sequences of pure dance and then of interpretative dances and concludes with a pure dance in fast tempo. We see the influence of sculpture in the interpretative sequences. Musicians are represented in sculpture in the great terrace of the Konarak temple and the Odissi dancer too adopts sculpturesque poses of damsels playing the lute, flute, cymbals or drums. The extended interpretative sequences mostly pertain to the Radha-Krishna theme. In

the Indian tradition, Odissi complements the dynamic style of Bharata Natya with an exceptionally lyrical and graceful one.

In the region where the borders of Orissa, Bihar and West Bengal meet, the Chau dance emerged as a generic tradition with slightly variant evolutions in Mayurbhanj in Orissa, Seraikella in Bihar and Purulia in West Bengal, masks being used in the two latter places. Only men participate. The Chau seems to have some genetic links with hunting and fighting, for the steps, movements and gymnastics have assimilated cues from the traditional training exercise of soldiers, known as the Parikhanda system (Pl. 175). Purulia Chau draws its themes almost extensively from mythology, concentrating on episodes of combats like Kathakali, without the latter's evocation of the sense of numinous dread but with more complex and spectacularly effective choreography for duels and battles. In Seraikella and Mayurbhanj, the themes have a greater range. One Seraikella dance presents a man and woman setting out on a boat, running into a storm and coming through safely. There is a faint allegorical reference to the journey of life here. Another dance represents a deer shot by a hunter and a third is a very highly stylised peacock dance.

The Yatra of Bengal began as communal worship through song and dance of devotees of the Krishna cult, became secular later, dropped the practice of men playing female roles and developed a style which is very melodramatic but also irresistible in its spell because of its sheer vitality. The songs are rather loosely based on classical Ragas. The orchestra has come to include western instruments like the clarinet and cornet also. Duet dances are a characteristic feature and provide comedy since the episodes represented are quarrels between husband and wife, scenes between an old man and his young wife, etc. Prose dialogue, originally absent, is now normal and dramatic monologues are an important feature. A popular dance-drama form with great appeal, the Yatra has responded in its themes to national and even global developments.

The Ojapali of Assam, surviving today only in the districts of Kamrup and Dastang, presents stories from Indian mythology through narrative verse, singing, dance movements and gestures. The more important tradition is that of Ankia Nat originated by the saint-poet-singer Sankara Deva (1449-1568) and followed up by his disciple Madhava Deva. They wrote many libretti, mostly based on the Krishna legend. These plays are enacted today in the numerous village prayer halls (*Naamghars*) and monastery (*Satra*) precincts. The play begins with a prolonged musical prelude, including dances also occasionally. Speech and dialogue are minimal; singing and dancing predominate. The songs are in the classical Ragas and rhythms. Performers are all men. In many of the dances the principal dancer, who also plays the lead role, makes his first appearance behind an improvised curtain or through an arch of flaming torches. The dances of Krishna and the maidens of Vraja are the most popular, though dances representing combats with bows and arrows or clubs are also present.

Contiguous to Burma, Manipur is far away from the metropolis of India, today as well as in the days of the *Mahabharata*. But there have been links with the national

tradition throughout. Arjuna, in his wanderings far from Indraprastha, won an exceptionally beautiful bride, Chitrangada, from this land. Much later came the Vaishnavite devotional movement which exerted a profound influence on the gentle and sensitive people of this land. Lai Haaroba is a dance that goes back to the earliest epochs. It is performed once a year in front of shrines to the chthonic deities. White-clad men and women (*maibas, maibis*), thought to be chosen by these deities, are the principal dancers although everybody participates. Mythic concepts of the origin of the world, memories of the Manipuri epic about the ill-starred lovers, Khamba, a poor lad, and Thoibi, a princess (Pl. 176) and folk legends are mirrored in the dance sequences which are loosely structured but have the flowing and sinuous movement characteristic of the Manipuri tradition. Krishna worship through singing and dancing, initiated by Chaitanya of Bengal, spread here and gave rise to the Sankeertan in which drummers and cymbalists give displays of spectacular dancing including leaps and spins in the air without missing a single beat. But the finest dance of Manipur is the Ras Lila (Pl. XXXVIII) which, according to legend, was taught to the eighteenth century ruler, Bhagya Chandra, by Krishna himself in a vision. This ruler started the practice of building special annexes in every temple for the Ras Lila dances which all relate to episodes from Krishna's life culminating in his dance with all the maidens of Vraja. They are danced by girls though Krishna may sometimes be impersonated by a boy. The costumes are colourful, the singing is moving and heart-felt. The face is kept rather expressionless, in a rapt musing. But perhaps far more than in any other tradition, dance has become truly a body language here and it is a very lyrical adagio.

From the north, we have the interesting Karyala of Himachal Pradesh. After the invocatory rites, it opens with a pure dance sequence by 'Chandravali' and her consort 'Chiragiya' who seem to represent the divine dancers, Parvati and Siva. In the next sequence, after a choral prelude, actors in the garbs of mendicant monks (*Sadhus*) make their entry and dance to another chorus. In unexpectedly pithy queries and answers, they bring out the deeper implications of life on earth. Puns, word-plays and humorous gestures make the didactic messages wholly enjoyable ones too. There is also a Vidushak or Fool among these Sadhus. A sequence of humorous skits follows, their order being flexible. There is lot of pungent satire here. Slapstick and acrobatics are also present in some sequences. Lastly, before the collection of money, there is a virtuoso dance by a handsome boy impersonating a girl.

Western India presents a variety of forms. The lyrics in Maharashtri Prakrit of Hala Satavahana (between 200 and 450 A.D.) are piquantly erotic and also make the first mention of Radha as the beloved of Krishna. The Lavani songs of Maharashtra evolved from these lyrics and the form known as Tamasha started as the singing of the Lavanis by boys and girls. In the course of its evolution, after a musical prelude in praise of Ganesa, the amusing scene of Krishna and his friends waylaying the maidens of Vraja and exacting toll from them in the form of milk and butter came to be enacted. After this, Lavanis are sung by the girls while performing provocative dances and there is some hilarious clowning by the jester or Songadya. A sequence called Vag follows in which a small musical play based on a mythological, historical or

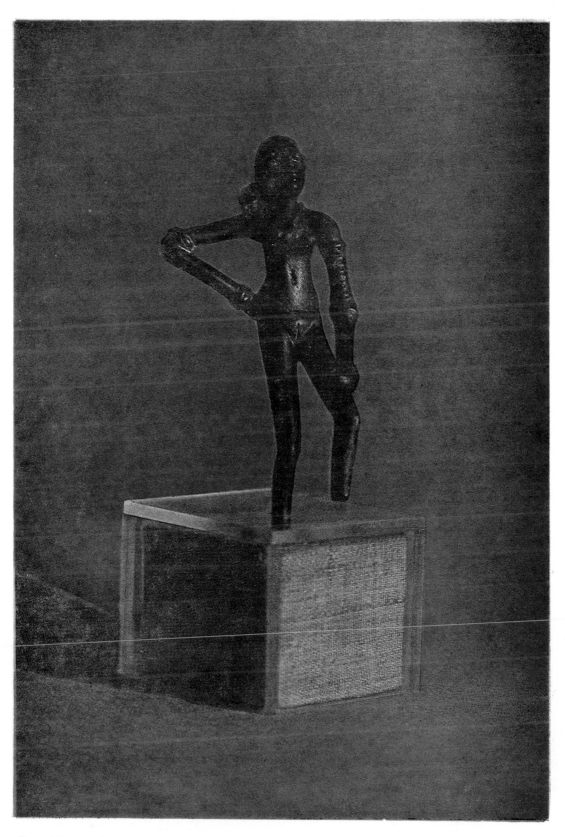

XX. Dancing girl. Bronze. Mohenjo Daro, 2500-1700 B.C.

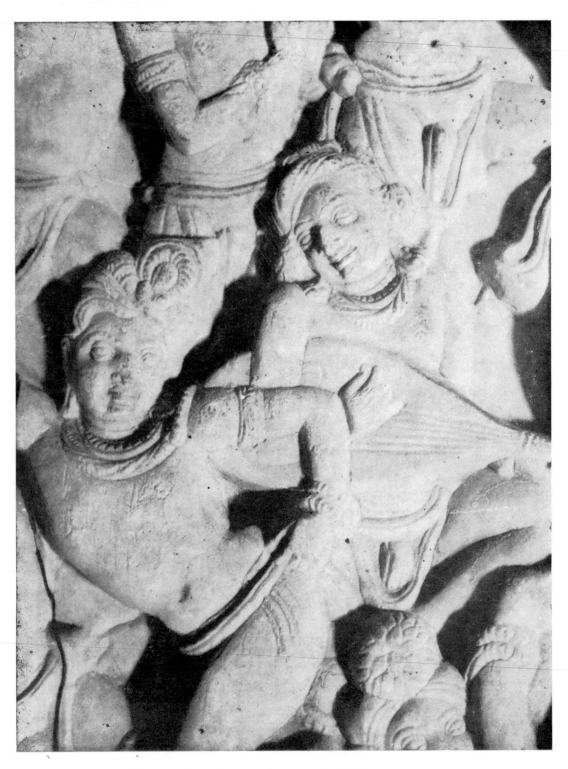

166. Musician and dancer. Nagarjunaconda, second-third century.

167. Dancer. Markanda, twelfth century.

168. Dancer with string drone. Kumbhakonam, Sixteenth century.

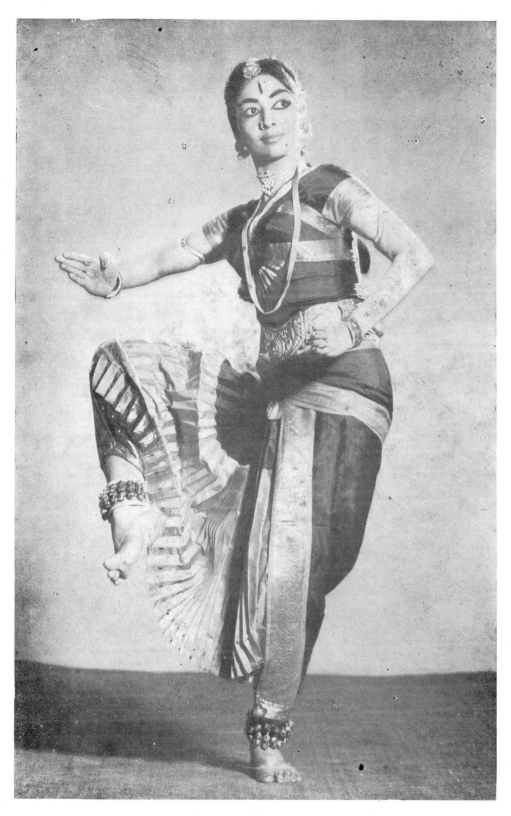

169. Yamini Krishnamurti in Bharata Natya.

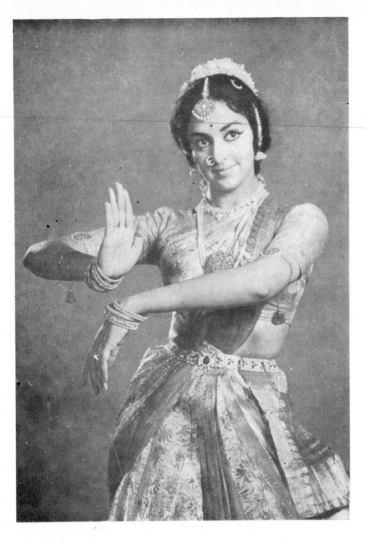

170. Hema Malini in Bharata Natya.

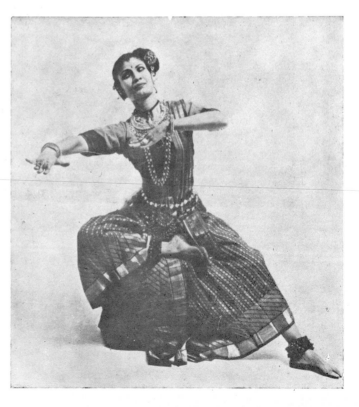

171. Santa Rao in Bharata Natya.

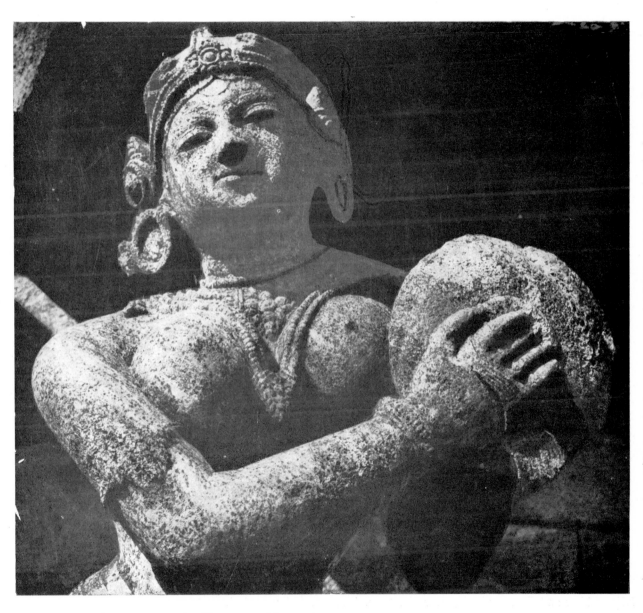

172. Cymbalist. Sun Temple, Konarak, thirteenth century.

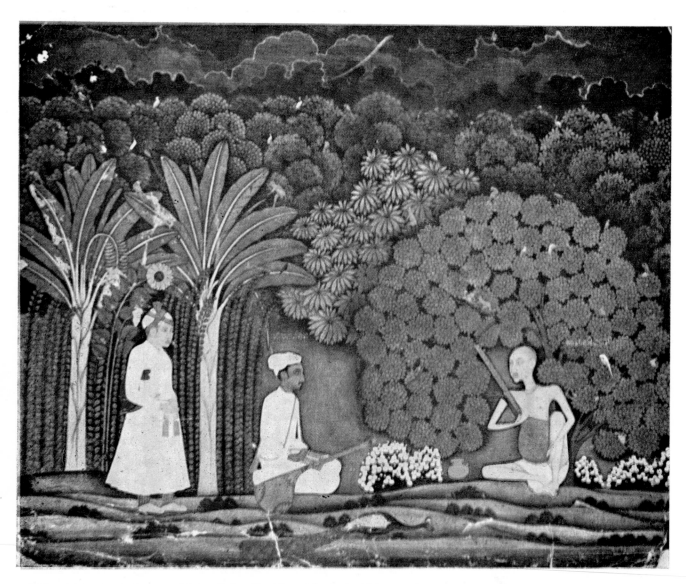

XXI. Akbar and Tansen visiting Saint Haridas. Moghul, Akbar period.

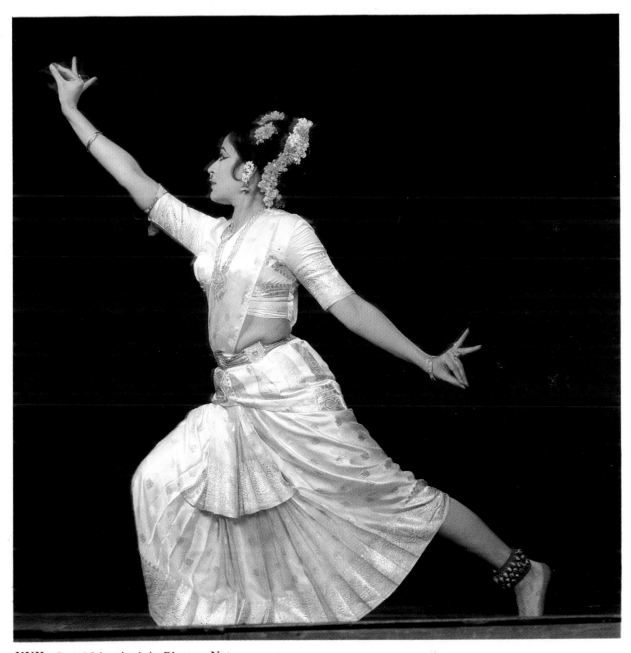

XXII. Sonal Mansingh in Bharata Natya.

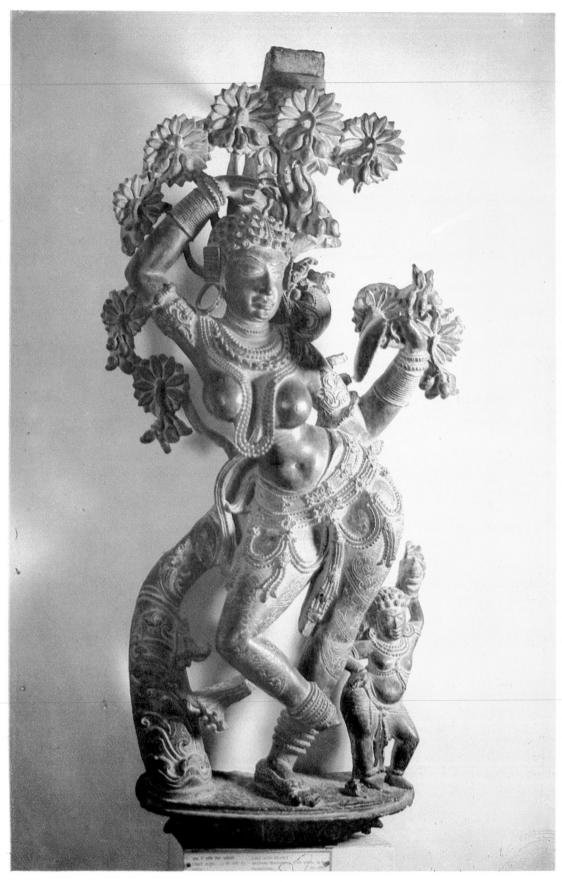

XXIII. Mohini. Bronze. Western Chalukya, twelfth century.

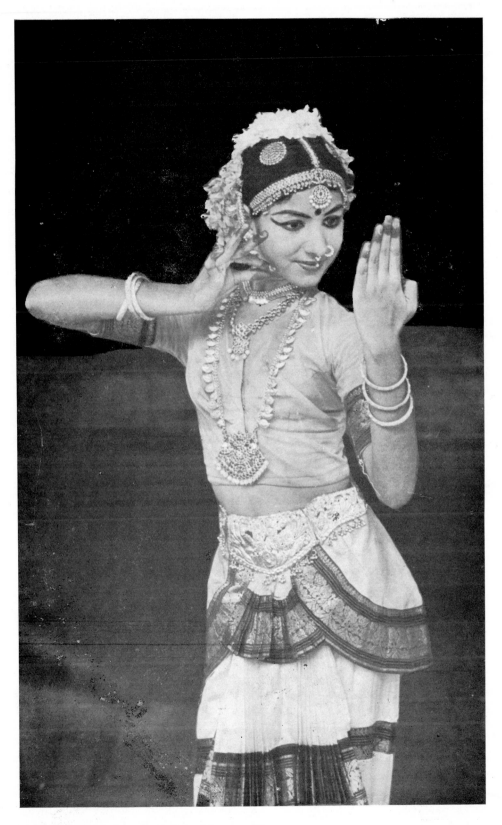

173. Vijayalakshmi Shivaji in Bharata Natya.

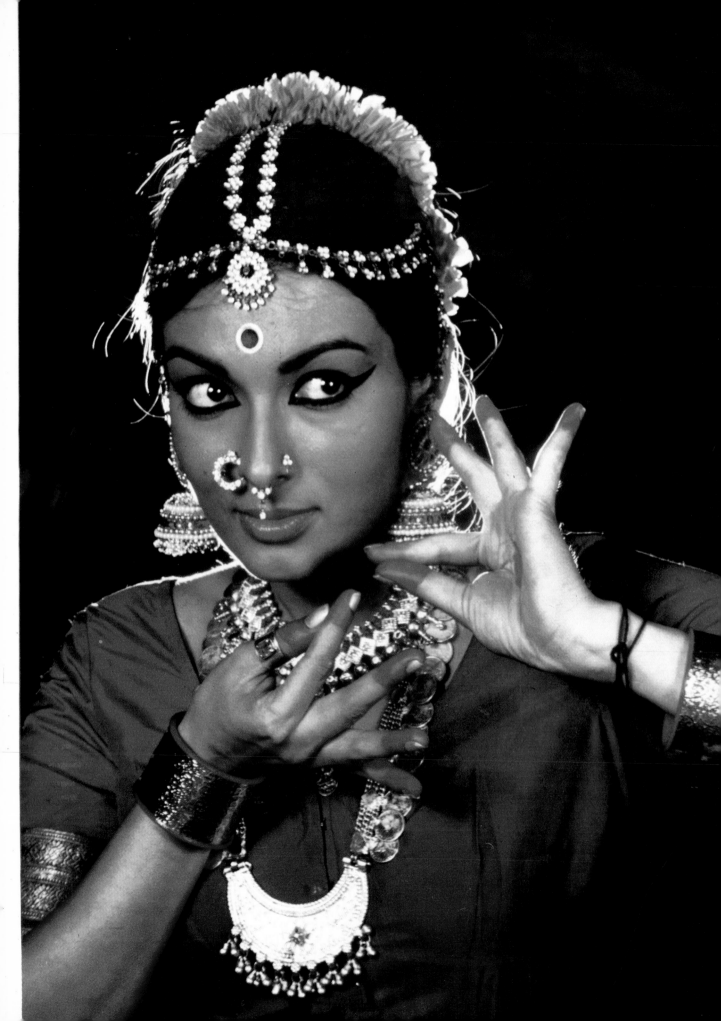

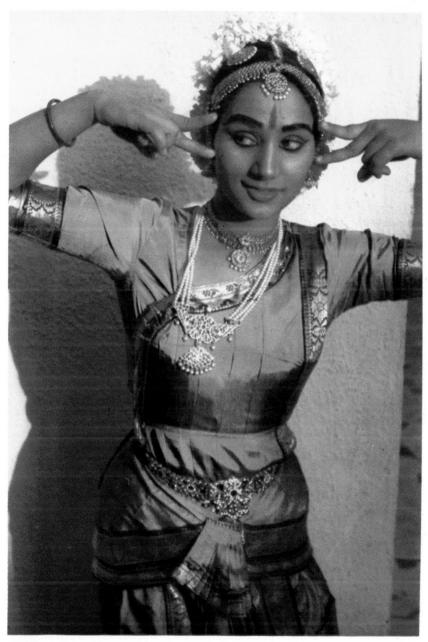

XXV. Swati Mahalaxmi in Kuchipudi.

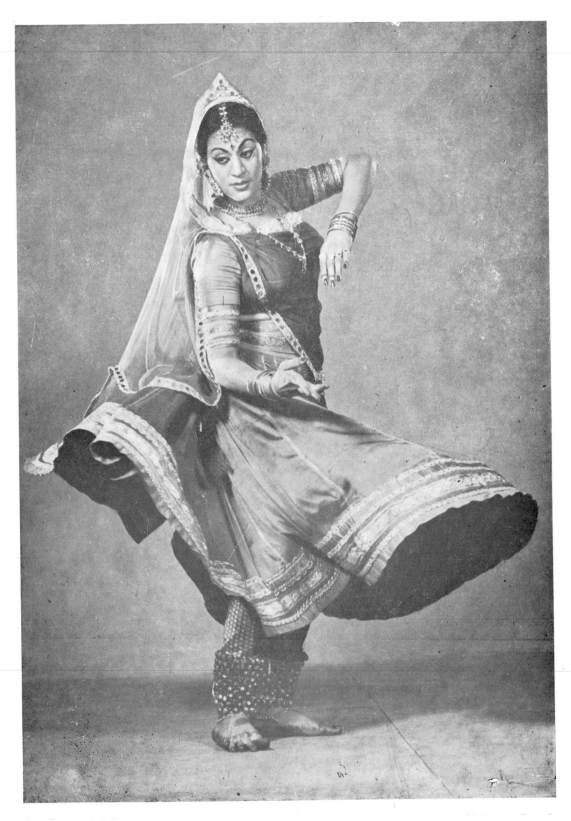

174. Alka Nupur closing a spin in Kathak.

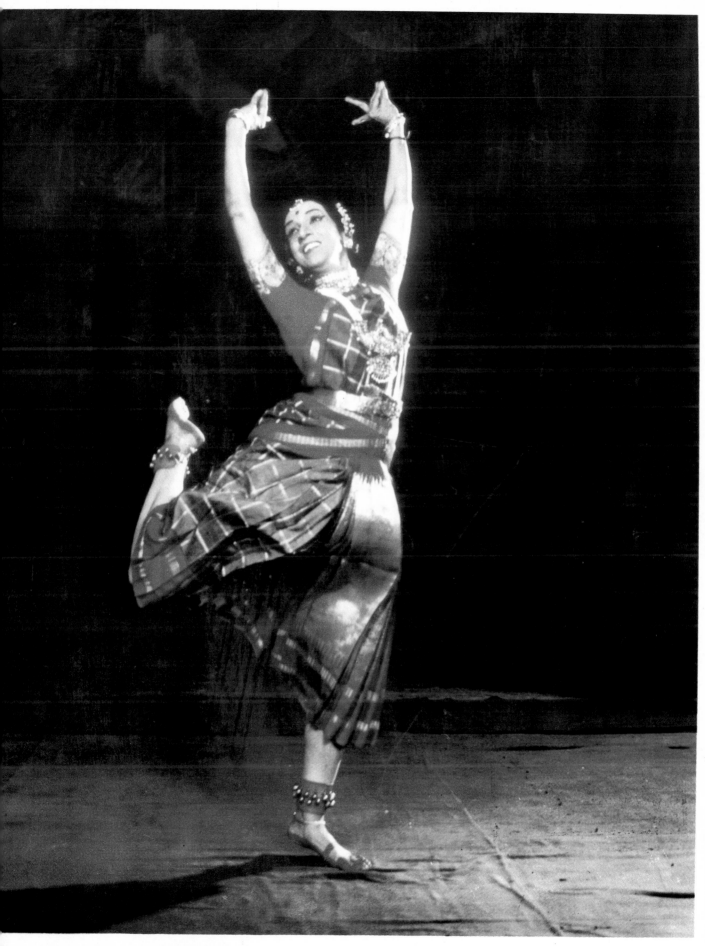

I. Mrinalini Sarabhai in Bharata Natya.

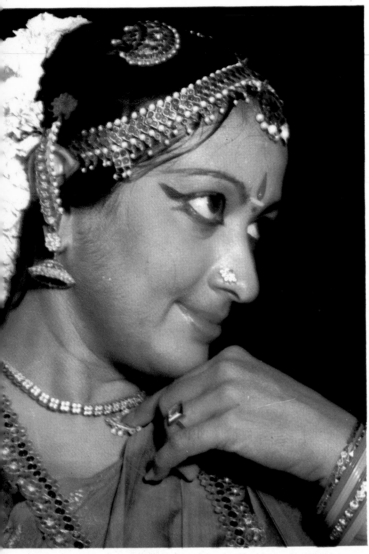

XXVII. Padma Subramanyam in Bharata Natya (expression).

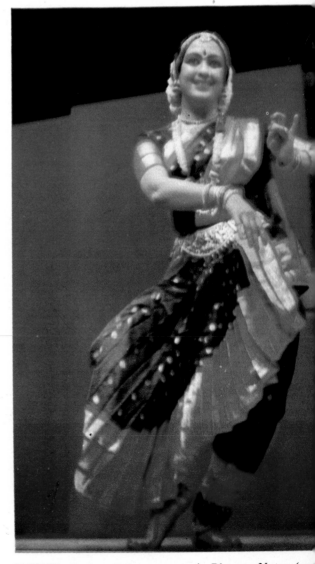

XXVIII. Padma Subramanyam in Bharata Natya (pu

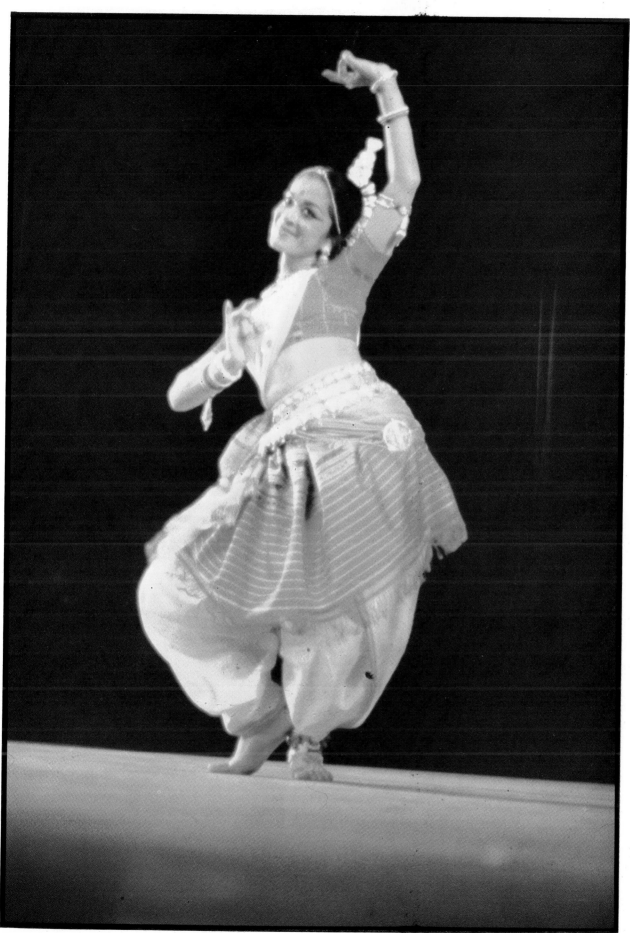

XXIX. Kiran Segal in Odissi Photo Jatin Das.

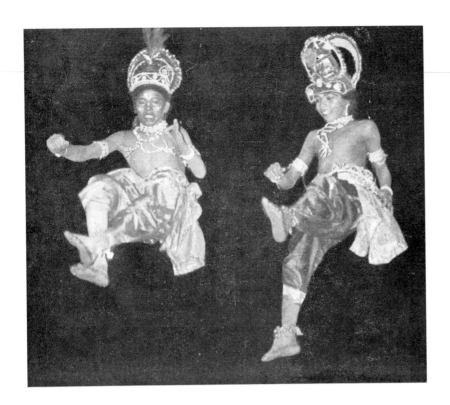

175. Mayurbhanj Chau.

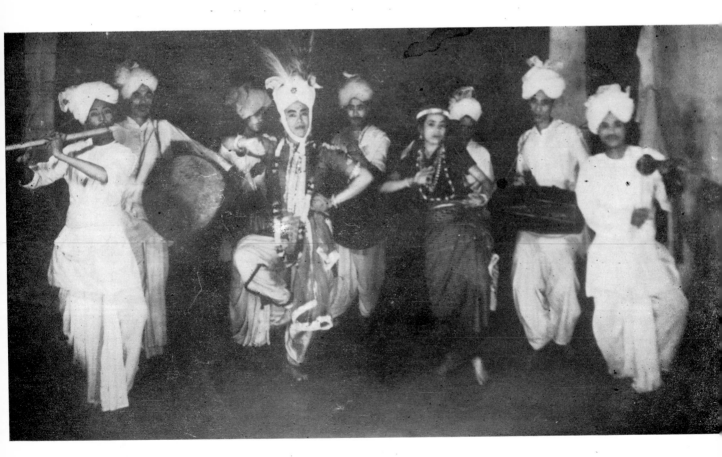

176. Khamba Thoibi of Manipur.

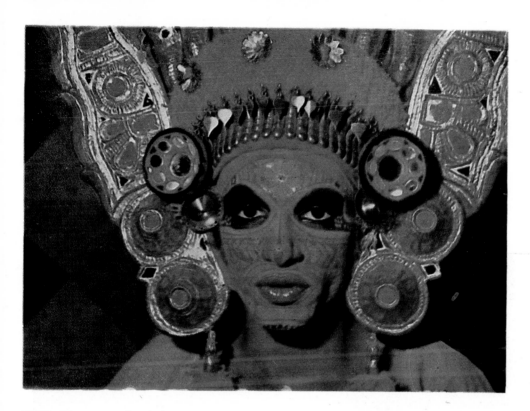

XXX. Theyyam, ritual dance of Kerala.

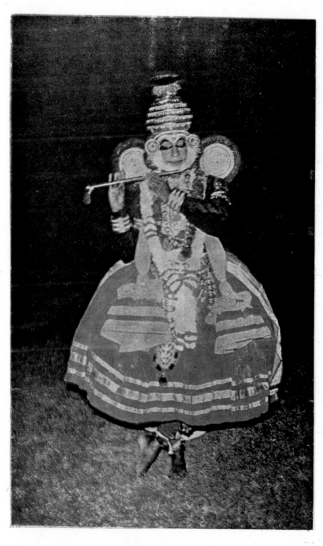

XXXI. Krishna Attam of Kerala.

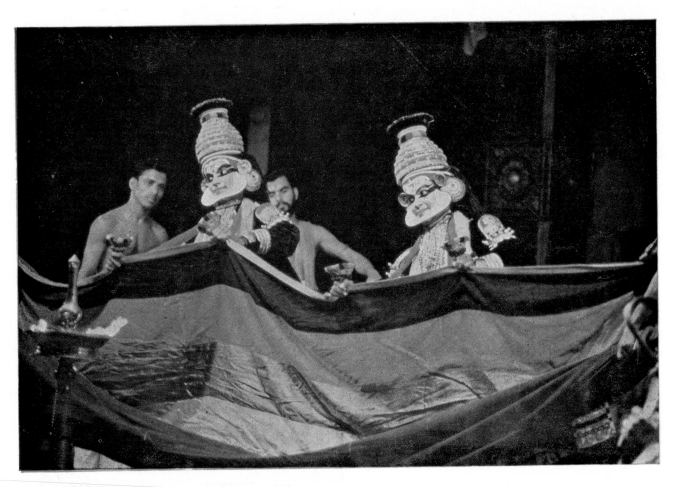

XXXII. Kathakali. Entry of characters.

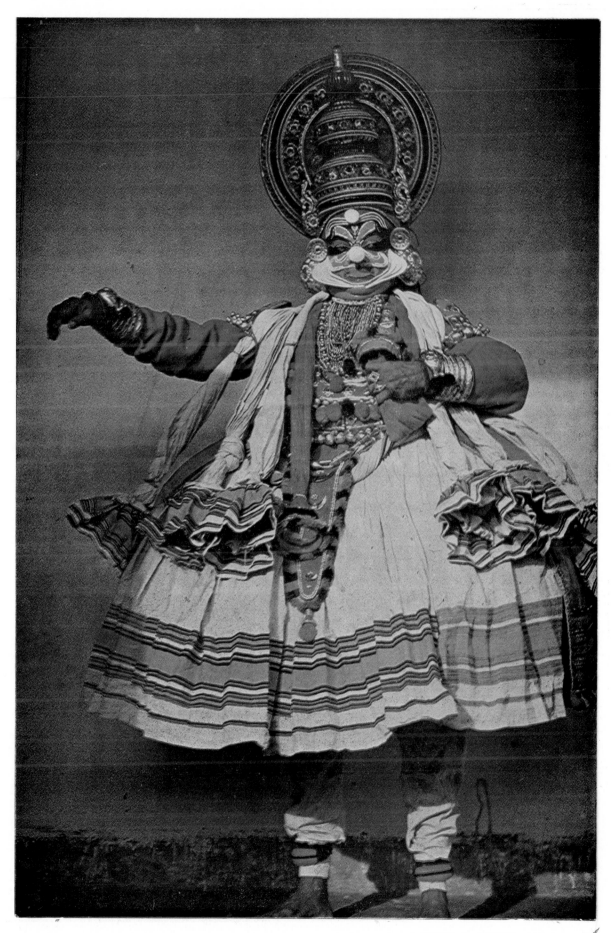

XXXIII. A Kathakali dancer in full costume and make-up.

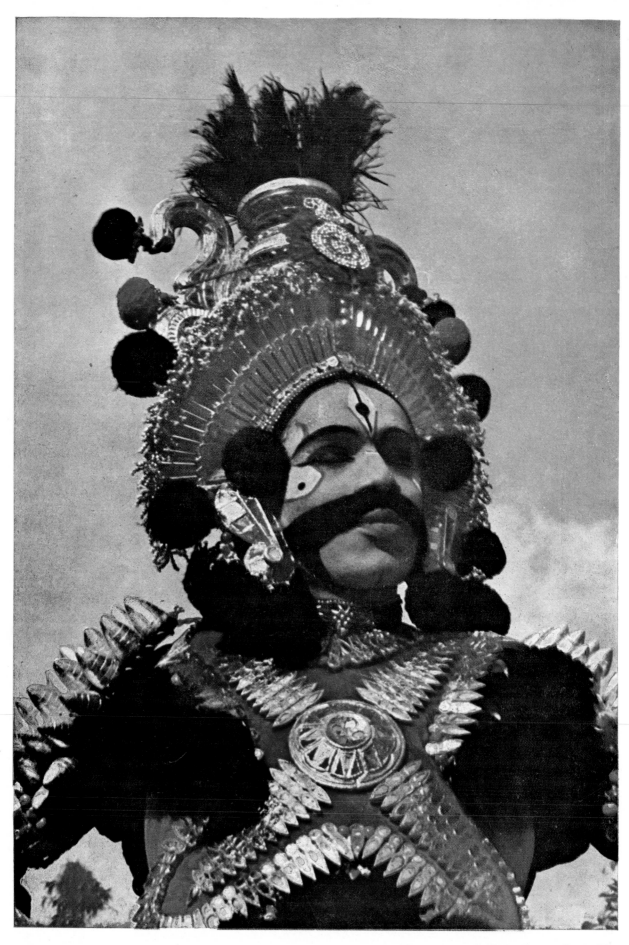

XXXIV. A Yakshagana dancer in the role of Rama.

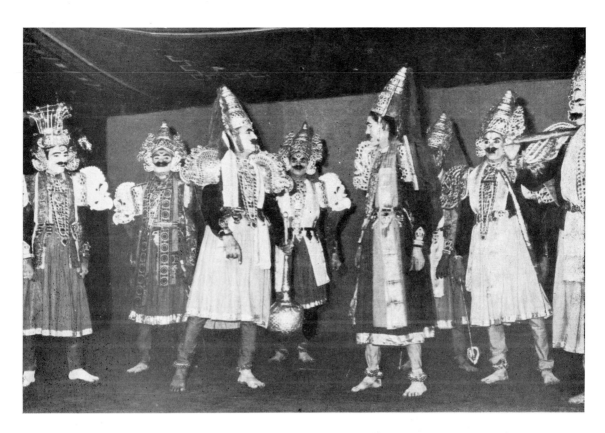

177. Veethi Bhagavatam.

178. Therukkoothu.

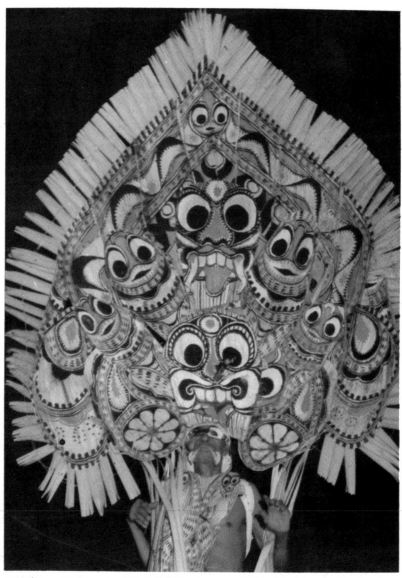

XXXV. Patayani, martial folk dance of Kerala.

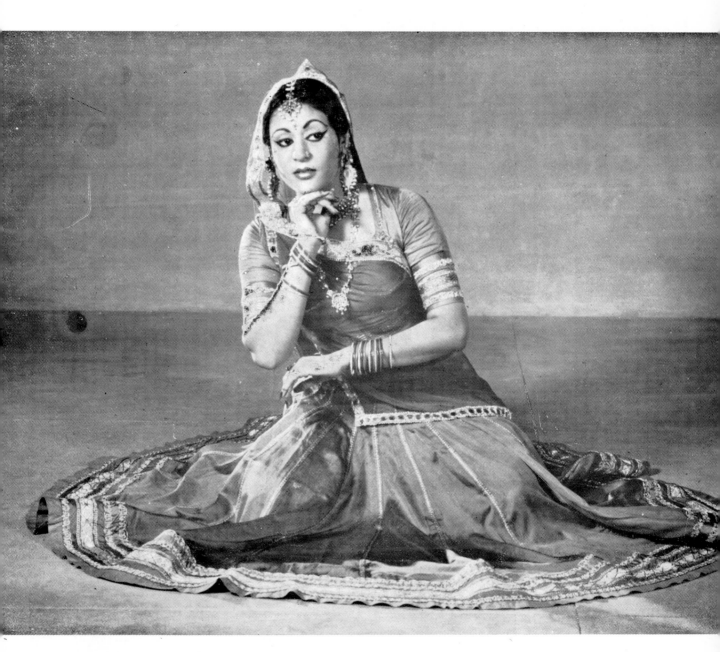

Radha awaiting Krishna, Kathak.

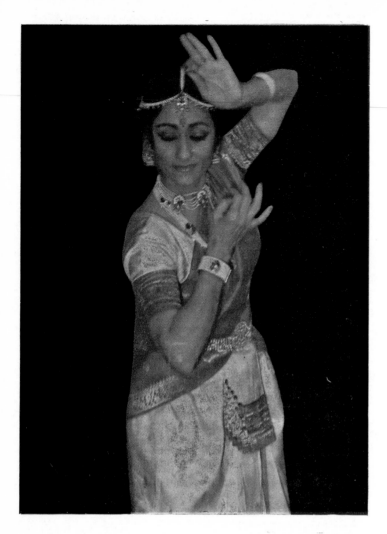

XXXVI. Rani Karna in Kathak.

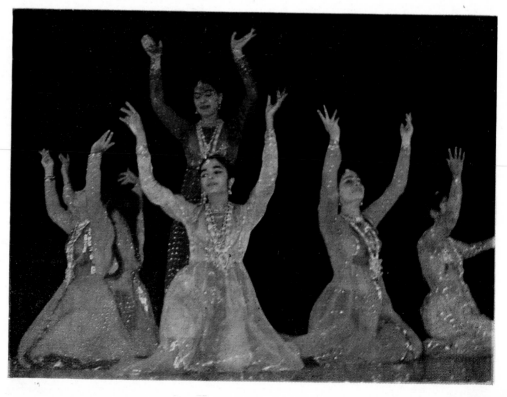

XXXVII. Uma Sharma's troupe in Kathak.

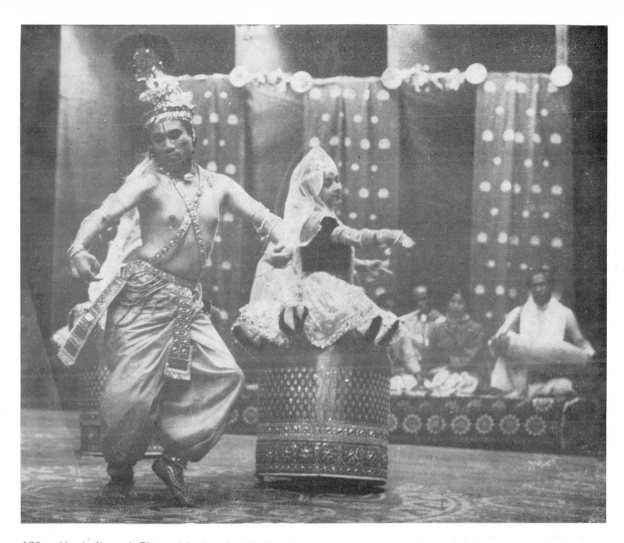

180. Singhajit and Charu Mathur in Manipuri.

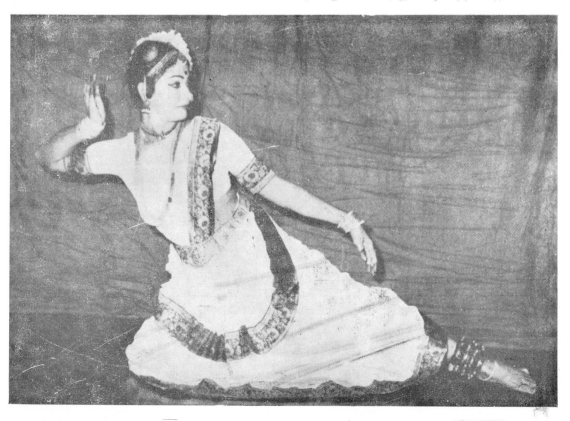

181. Mohini Attam.

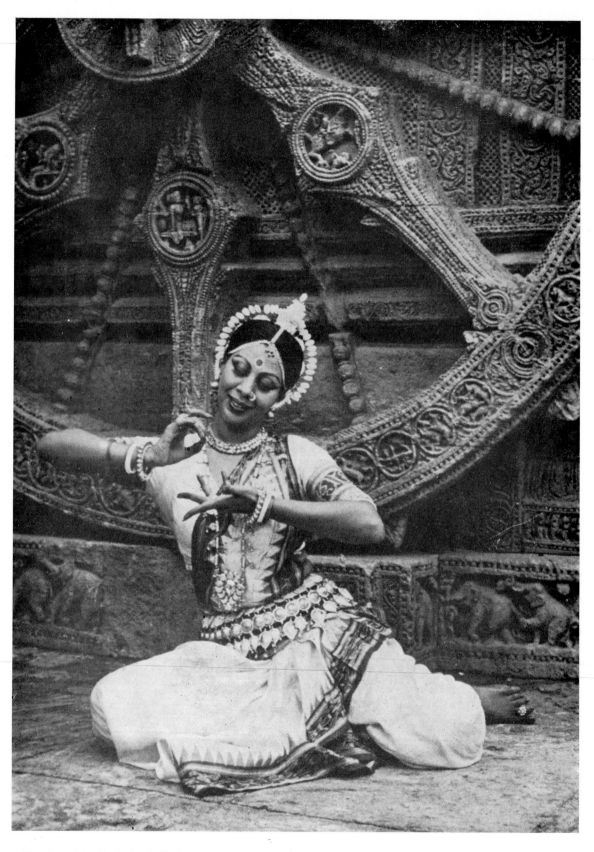

182. Protima Bedi in Odissi.

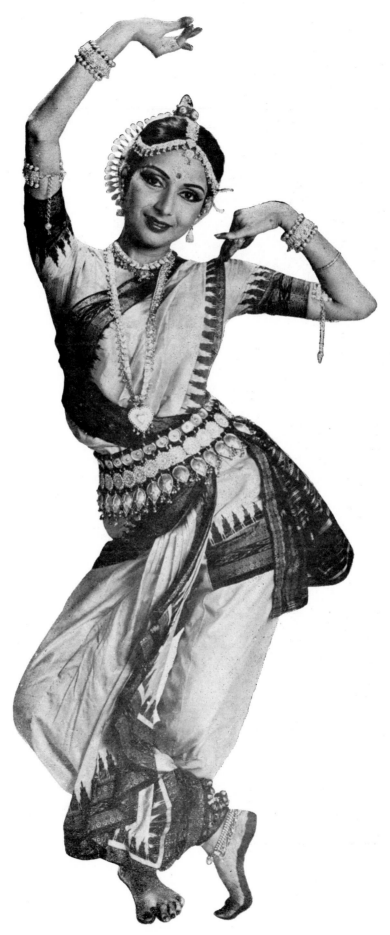

183. Sutapa Dutta Gupta in Odissi.

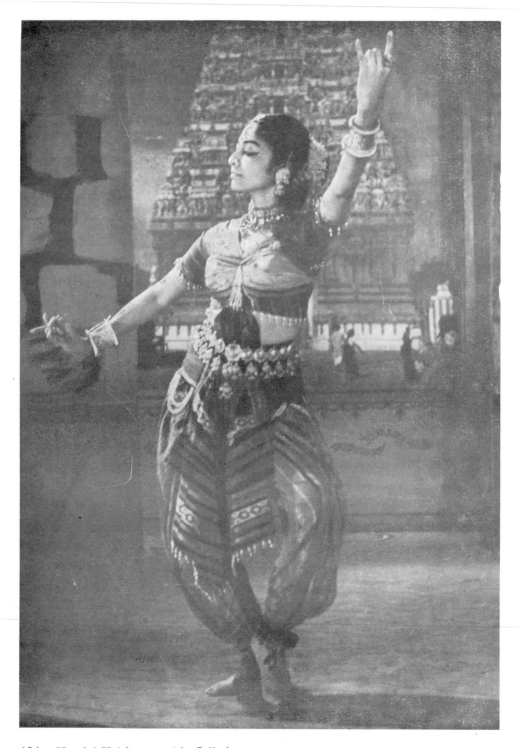

184. Yamini Krishnamurti in Odissi.

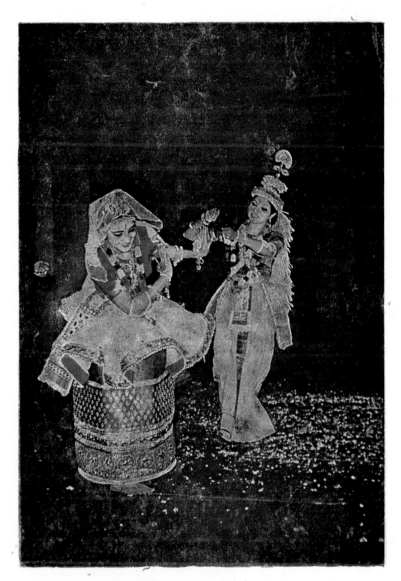

XXXVIII. Ras Lila of Manipur.

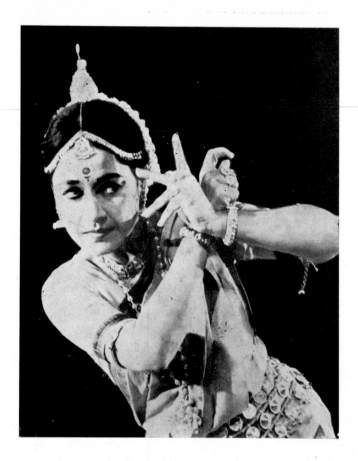

185. Kumkum Das in Odissi

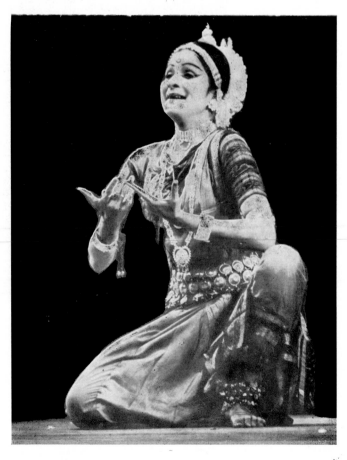

186. Sanjukta Panigrahi in Odissi

187. Episode from a Kathakali dance-drama.

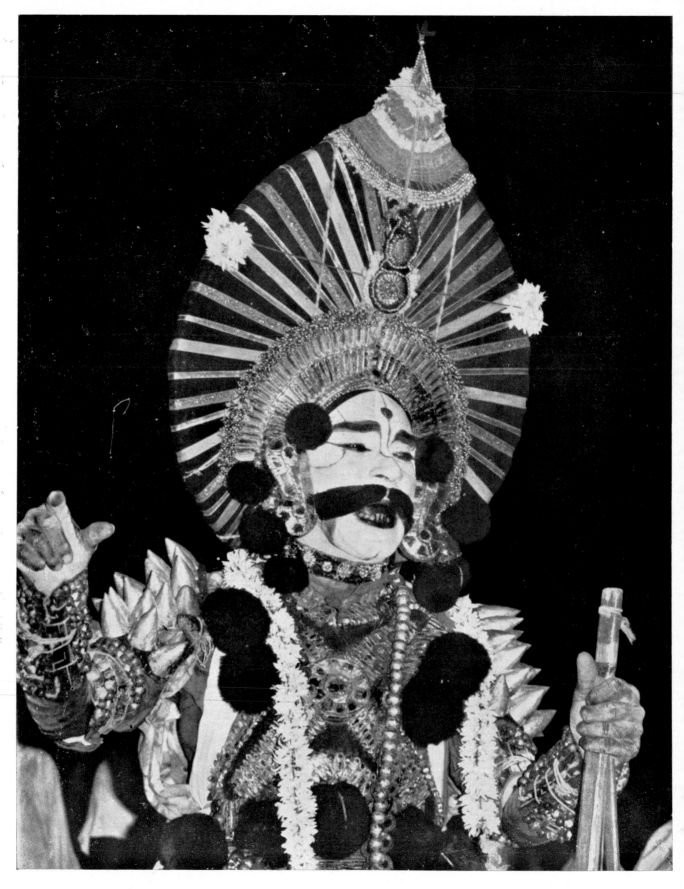

188. A Yakshagana dancer in the role of Rama.

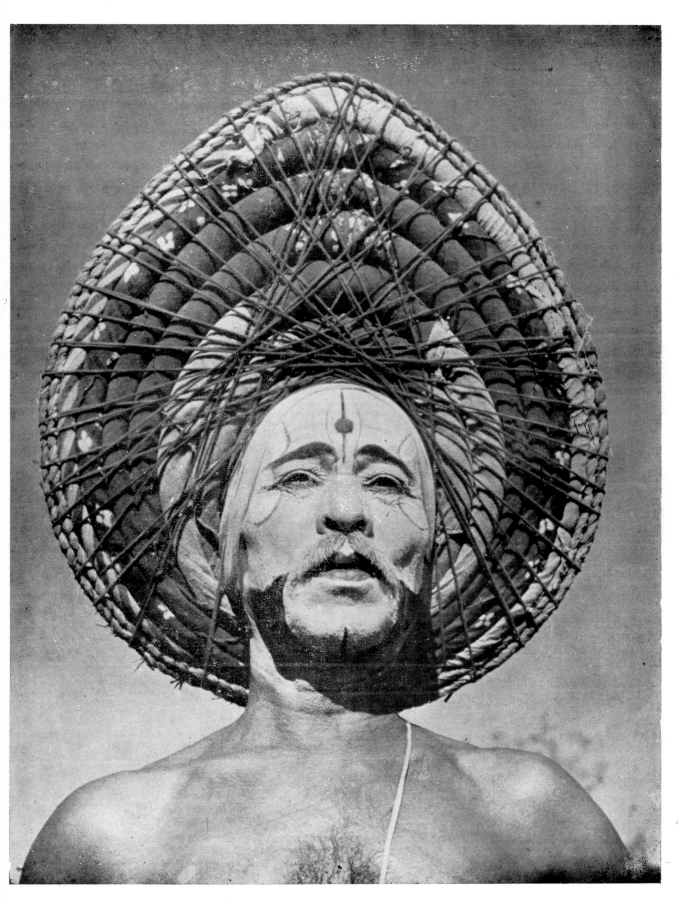

189. A stage in wrapping the head-dress of a Yakshagana dancer.

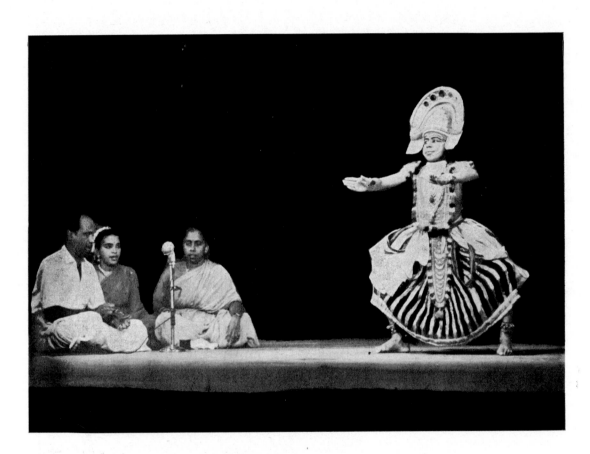

190. The dancer-raconteur of a Thullal play.

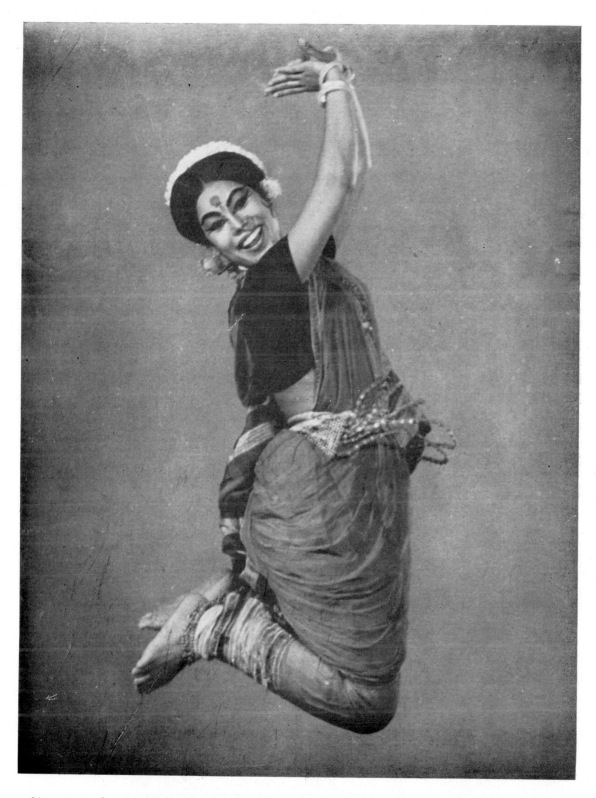

191. Folk dancer, Maharashtra.

192. Bhangra dance of Punjab.

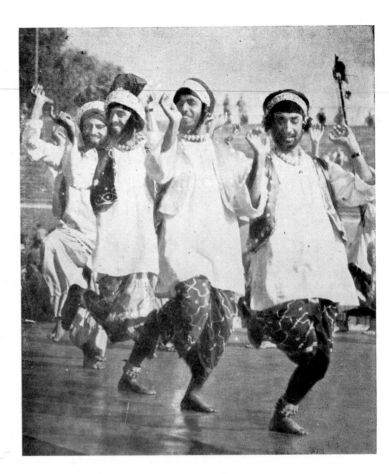

193. Folk dance of Himachal Pradesh.

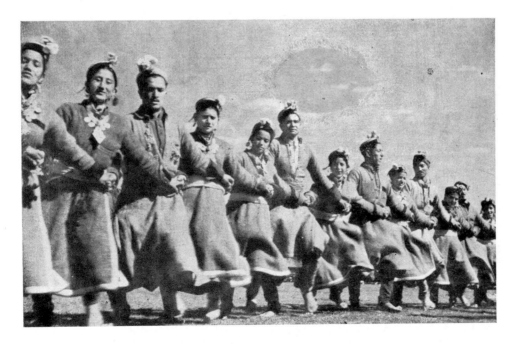

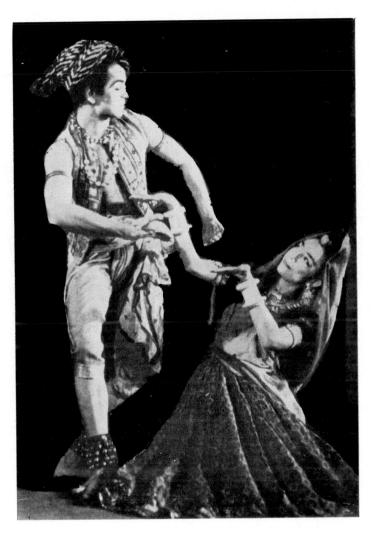

194. Zohra Segal and Kameshwar in a Marwari dance.

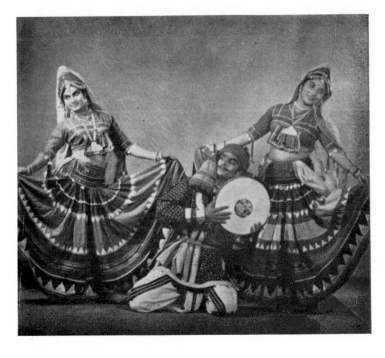

195. A Rajasthani folk dance.

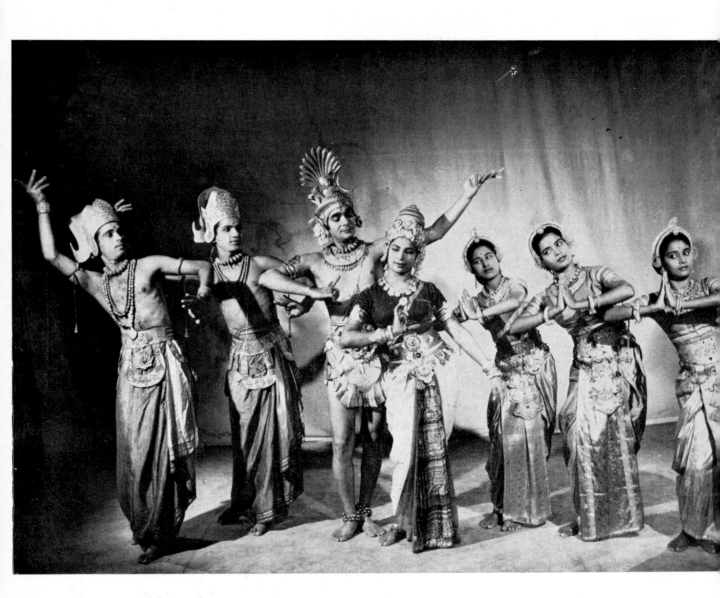

196. Uday Shankar and his troupe in "Nritya-Dwanda".

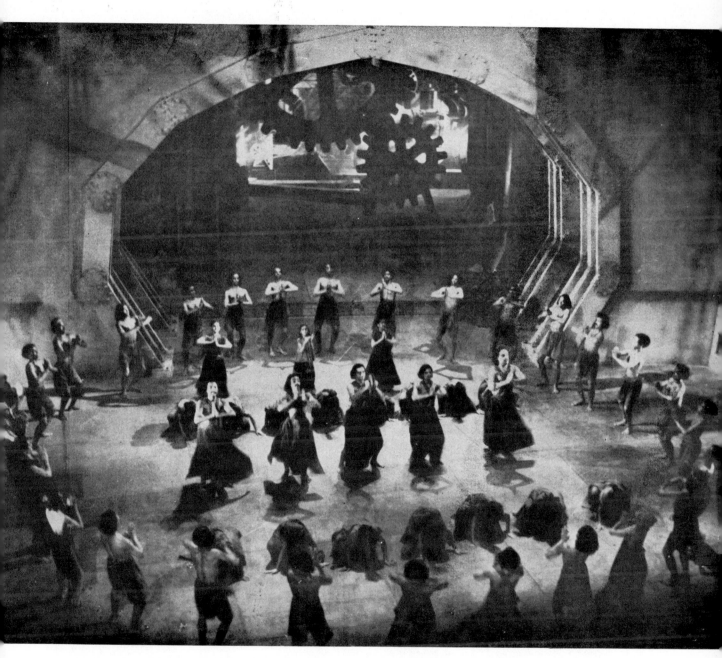

7. A scene from Uday Shankar's "Labour and Machinery".

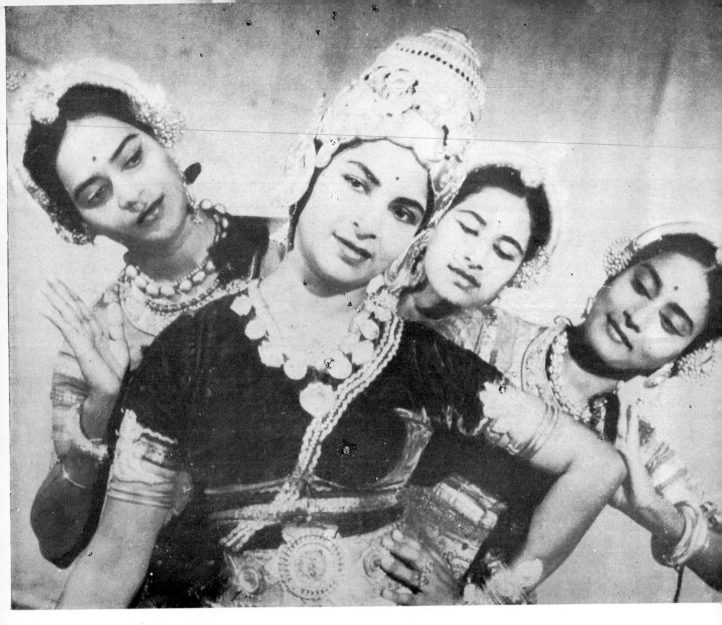

198. Amla Shankar and others in a fine choreographic grouping.

199. Fluent movement in a modern ballet.

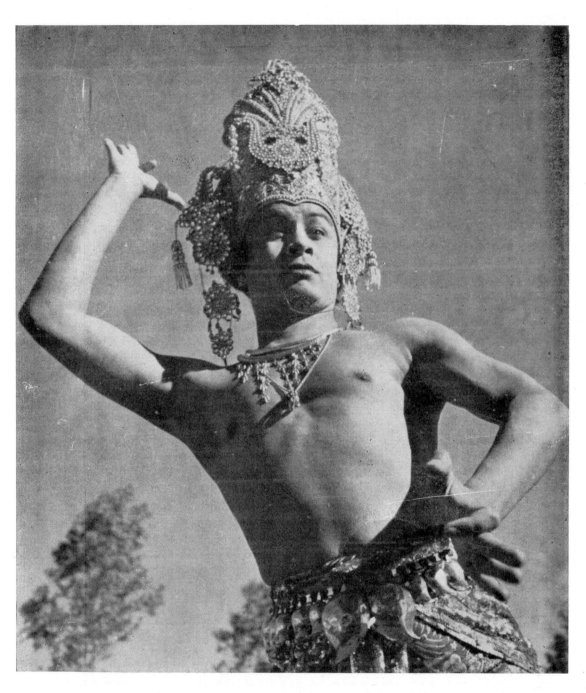

200. Ram Gopal in a stately pose.

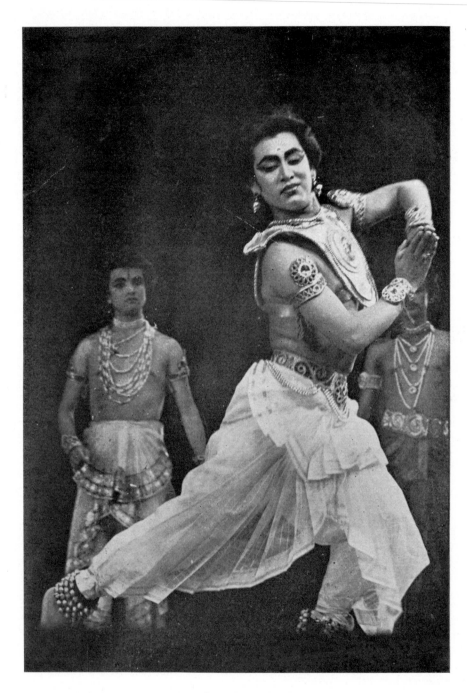

201. Bhushan Lakhandri in "Karna", ballet in Chau style.

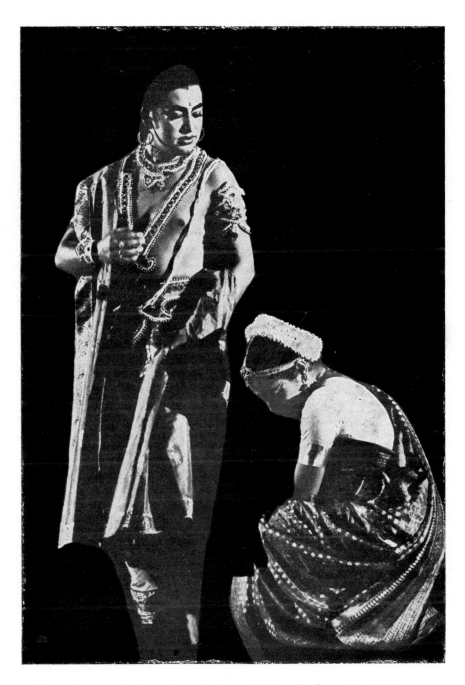

202. Bhushan Lakhandri and Baswati Misra in Ram Lila ballet.

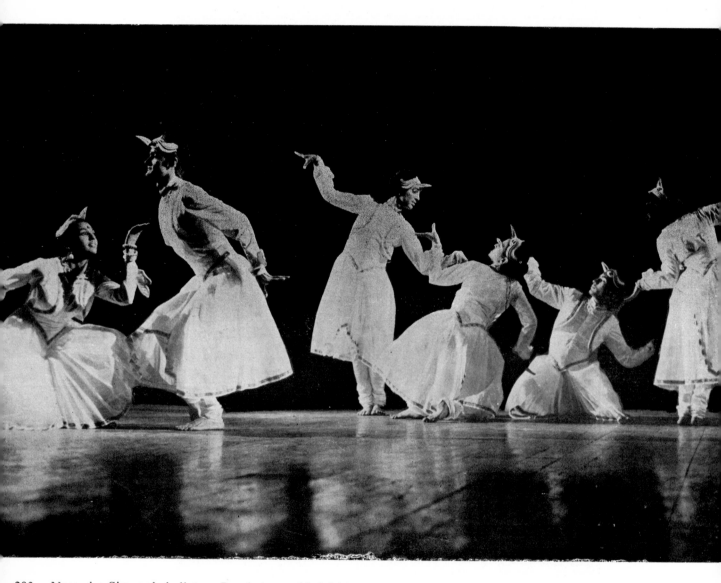

203. Narendra Sharma's ballet on Panchatantra bird-fable.

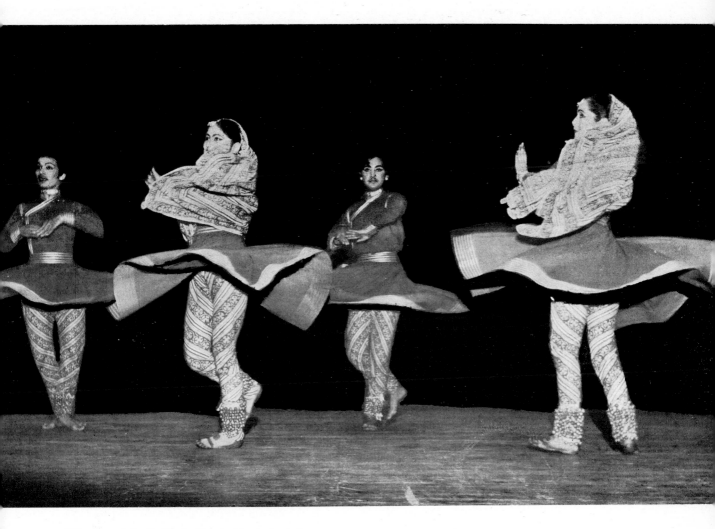

04. From "Shahn-e-Moghul", ballet in Kathak style.

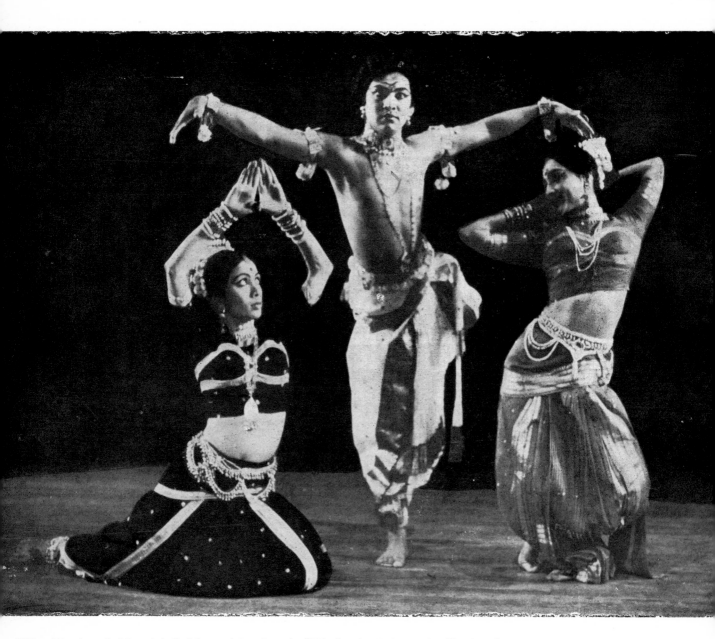

205. Bhushan Lakhandri, Rekha and Ranjana in "Khajuraho", ballet in Chau style.

social theme is presented. The tradition allowed free and hilarious comment on the current social situation and today modern playwrights are continuously refining this vital tradition.

The Bhavai of Gujarat opens with dances in the roles of Ganesa and Kali and of a priest offering them worship and then presents small, independent plays based on mythological or historical themes, with interludes of music, dance, recitations, acrobatics and magic tricks. Every play or Vesha begins with a song (*Avanu*) introducing the main character who makes a spectacular entry with fire brands in his hands which highlight his face and expressions. Bhavai performances take place in the open under a clear moonlit sky, the illumination being by flaming torches. The costumes are spectacular. The dialogue songs are based on the classical Ragas, but in a distinctive style that has absorbed influences from folk music too. As there are a number of plays with Muslim characters, some of them depicting the romances of Muslim youths and Hindu maidens, forms like the Ghazal are also found in Bhavai. The dances show traces of the influences of Kathak and of the folk dances of Gujarat like Garba. A unique feature is that the dance movements and mode of steps are stylistically specific for each of the major characters. In the Yakshagana we noted a similar use of the rhythms of the drums for specifying characters.

Khyal, the four-centuries-old dance-drama of Rajasthan, shows some regional modulations. In the Chitor region there were Siva and Sakti cults and the chief medium of their propagation was the poetic competition, known as Dangal, where followers of both sects would discuss philosophical issues through the medium of poetry. The Dangals gradually developed into stage shows called Tura Kalangi, Tura standing for Siva and Kalangi for Sakti. In the Udaipur area, the Rasdhari plays depict various episodes from the story of Krishna. Elsewhere the romantic stories of Heer and Ranjha and Dhola Maru have furnished the themes.

The Swang of Haryana is an open-air folk theatre form that narrates its stories in songs and dances. Episodes from the *Mahabharata* and heroic and romantic legends furnish the themes. The musicians sit on the stage itself and the bowed string instrument, sarangi, and drums form the orchestra. The loud singing and the vigorous dances have confined the form to participation only by men. Comic interludes are used to give variety.

As the name itself suggests, the Kathak (Pls. XXXVI, XXXVII, 174, 179) of north India originated in the simple, devotional, mimetic recitation of stories (*kathas*) by rhapsodists attached to the temples—of Vraja, the Mathura region associated with Krishna. But the vicissitudes of evolution made it a chamber form for patrician audience and the two main schools of Kathak grew up under the patronage of the princely house of Jaipur and the Nawabs of Oudh who had their court in Lucknow. Sarangi, the bowed string instrument and the tabla and pakhawaj, percussions, are the traditional accompaniments. But perhaps even more important than these are the anklets of the dancer with their two hundred odd tiny bells which translate the brilliant visual rhythm of the footwork into an exciting aural rhythm too. Though Kathak has expressive narrative sequences, the accent is mainly on pure dance. Under the secular, and to some degree

sensual, patronage of the princes, the opening sequence (*amad*) has been transformed from a devout invocation to an elaborately courtly salutation. The dance unfolds further in a series of intricate and complex steps (*torhas*). The sequence includes provocatively expressive movements of the head, beautiful arabesques of body patterns, lightning footwork, tantalizing arrested pauses (Pl. 174). Using a technique somewhat like the European rubato (robbing one note fractionally of time and paying it back later), the dancer makes brilliant variations in the rhythm schemes but manages to conclude precisely on the accented opening beat (*Sam*) of the cycle, along with the percussionists in bouts of sportive rivalry. The Gat Bhavas are the narrative and representational sequences interspersed between the sequences of pure dance and they relate the amorous episodes of the Krishna story (Pl. 179) or illustrate lyrical songs (Thumris) which are equally sensuous.

Nautanki is the folk theatre of Uttar Pradesh, with two main traditions, that of Hathras laying the stress on the lyrics and the singing and that of Kanpur emphasising dialogue and acting. The oldest story of the tradition, to which all Nautanki plays almost invariably refer, is about a boy who won princess Nautanki by gaining admittance to her apartments in the guise of a girl who was expert in making garlands with flowers. This love of romance has characterised the tradition, though there are also some plays about the heroes of olden times. The dialogue is in a flamboyant idiom but has an irresistible verve and some Nautanki players are capable of brilliant coloratura singing though the style is not that of pure classicism.

Folk Dances

While there are many forms where the dilution of the classical tradition has developed into relaxed, popular styles, folk dances (Pls. 191-195) are a distinct category. They emerged in immemorial times, when the simpler style of life ensured a closer alignment between the rhythms of the ambient world, its cycle of seasons which was also a cycle of the productivity of the fields and orchards, and the rhythms of living, of work and relaxation. The larger movements in the ambient nature of their milieu have insensibly flowed into these dances. In some of the dances of Himachal Pradesh, especially from the valleys under the shelter of mountain ranges that are not forbiddingly jagged in their contours but undulate in gentle curves, one can easily see the reflection of the milieu in the slow swaying of the dancers who plait themselves into long lines with cross-linkage of arms. The leisurely build-up of form by the sea-wave, the clearer definition gained when the roller moves with increasing speed and the turbulent drama of its crash are, similarly, seen in stylised simulation in the dances of fisher folk from many coastal regions of India. The folk dance tradition is vigorously maintained by communities that have continued in their simple life-style. This can be seen in the case of the Santhals who are the largest of the Indian tribes and are found in three states— Bihar, West Bengal and Orissa. They have evolved quite a complex vocabulary of percussion rhythms and the torso and the limbs sway sensuously to these rhythms in the dances. These are performed at the beginning of agricultural operations like tilling

of the land and sowing of seeds and when the harvest is over. The dance movements are often stylised and rhythmic simulations of the action of the limbs in work. While praying for rain, the alliteration of the song, the drum beat and the footwork of the dancers, all blend to imitate the steady rhythm of falling rain.

The simplicity of these dances can sometimes be deceptive. While it remains true that tribal dance is dramatically effective because the dancer wholly identifies himself with his role, this identification is not always unconscious. The dancer has to stand apart from himself and evaluate his interpretation of the role. This comes out very clearly in some Naga dances where the same dancer has to change roles swiftly and many times, as the hunter and also as the hunted quarry.

Other remarkable features of the folk dance tradition can be brought out by referring to the Bhangra dance (Pl. 192) of the Punjab. It is truly an expression of the psyche of the community as a whole and therefore it can obliterate the separation of audience and performers which has become an extreme polarisation in the case of classical forms. In the Bhangra, young men come together in a clearing in the field after the harvest and begin to move in a circle which continues to swell by drawing more and more people. When the circle has stabilised its form, pairs move from it into the centre, dance in the central area and sink back into the circle, and this is repeated many times by many pairs. Everybody thus becomes a participant. Apart from the fact that the dance idiom is vigorous, with jerky movements of the shoulders and hop-steps, there is no rigidly prescribed measure or sequence. This allows considerable improvisation by individual participants, another characteristic of the folk dance tradition.

All the regions of India have dances exclusively for women too. The Garba dance of Gujarat is one of the finest of this category. It is a graceful and lyrical dance by women around a lamp in an earthen pot with perforations in it to let the light shine through. The women clad in yellow and red garments move in rhythmical circular motion, singing melodious songs, clapping hands, bending forwards and sideways and weaving numerous patterns.

The surplus of energy, not exhausted by the demands of life as survival, flows out to make life a celebration and it has an endlessly expansive urge. The surging joy of the heart finds progressive expression in the metrical beat and cadence of poetry, the percussive rhythm and soaring melody of music, the lyrical language of the body in dance, the enactment of the joys, and the sorrows that too were joys in some mysterious manner, of men and women of the storied past in dance-drama. It is in the festival that retains all these artistic features and is participated in by the entire community that this more than vital elan culminates. The Durga Puja of Bengal and the Ram Lila of many regions of the north are festivals of this kind. To illustrate the category, the Ram Lila of Ramnagar may be mentioned. About twenty kilometres from Banaras across the Ganga, Ramnagar was once a princely state and the Ram Lila was such an important festival of the state that when it was merged into Uttar Pradesh, one clause of the agreement provided that the Uttar Pradesh government would set aside a sum of one hundred thousand rupees every year for celebrating it.

The Ram Lila opens with the birth of Rama, lasts thirty days and concludes with Rama's coronation. It is comparable to the Passion Play of Oberammergau in its scale and total participation by the community. The acting area covers several square kilometres, all the temples and gardens in the area being temporarily designated as the various locales of the episodes of the *Ramayana*. The dance-drama becomes large scale spectacle and pageant. When Rama breaks the great bow in the test to win Sita, a cannon is fired. Sita's marriage is solemnly celebrated in the Vedic tradition. When Rama and Sita are exiled, the crossing of the Ganga is enacted over a rivulet. The Lanka of Ravana is set on fire in truly fiery splendour. And the coronation takes place in the palace of the Maharaja who too becomes a humble subject, like the people of the entire community, before this prince who was a divine incarnation.

Modern Ballet

This account of the Ram Lila enables a smooth transition to the contemporary experiments in evolving a modern ballet, for there have been several productions of the Rama story in innovative styles.

It was the chance encounter of Uday Shankar with Anna Pavlova that inspired him to experiment, during the thirties, in the balletic treatment of Indian dance with streamlined choreography, decor and orchestral music (Pls. 196-199). The perennial attraction of the Rama story can be seen in the fact that the theme of one of his earliest ballets was the burning of Lanka by Hanuman, emissary of Rama; later he created a complete Ram Lila ballet. Ram Gopal (Pl. 200), younger to Shankar by eighteen years, is another dancer who modernised Indian dance and presented it in many countries of the west.

The emergence of groups like the Indian People's Theatre Association and the Indian National Theatre was a fillip to the movement. In the main, the song has not been discarded and in many cases it is sung by the dancers themselves, instead of by accompanying musicians. Thus the creations are not completely identical with European ballet which relies, though not without some exceptions, only on instrumental music.

In the general pattern of evolution, choreographers of each tradition tried to create ballets conforming to their particular styles though paying greater attention to patterns of grouping (Pl. 198) and fluid transitions (Pl. 199) and developing the story line without repetition and stagnation. Thus Rukmini Devi of Kalakshetra in Madras used the Bharata Natya style to create many ballets including those based on the *Ramayana*, Kalidasa's narrative poem, *Kumara Sambhava* and play, *Shakuntalam*. The *Kumara Sambhava*, which narrates the story of the love of Siva and Parvati and its fruition in the birth of their son, Kumara, has been done in Kathak style by Birju Maharaj, and the Triveni ballet of Delhi has presented the *Shakuntalam* in Manipuri style. Shanti Bardhan created a *Ramayana* ballet in which the dancers used the stylised movements of Indian puppets. Stories from the *Pancha Tantra*, the famous animal fables of India that have been translated into numerous languages, have also been balletised innovatively, with the help of striking masks and costume (Pl. 203).

In the USA, Matteo and Carola Goya have produced Tchaikovsky's ballet, *Swan Lake*, with the sinister sorcerer modelled after the demoniac characters of Kathakali and the dances in Bharata Natya style. While not attempting cross fertilisations of this range, Indian choreographers have explored along eclectic lines. In some of her creations, Mrinalini Sarabhai has used Kathakali style for men, Bharata Natya for women and Manipuri for composing groups.

Unwearying in its appeal, a theme like that of the Rama story has been inspiring ever fresh choreographic presentations. The Shriram Bharatiya Kala Kendra has been producing a new Ram Lila (Pl. 202) almost every year and it has been handled by different choreographers. Many of them integrate not only different classical styles, but also incorporate folk dances. This latter has helped greatly in enlarging the textural variety of the productions, for folk dances have a whole repertory of movements—high jumps of great elevation (Pl. 191) and turns in the air, jumps that finish with falls on knees, travelling pirouettes on knees, crawls on the ground—which are not permitted in the pure classical styles.

If the epoch of the Rama story and other legends goes back to remote times, their meaning will always be contemporary. Nevertheless, there is need for artistic creations that speak to modern man in terms of his vicissitudes, in his specific frame of historical experience. One fine feature of the modern Indian ballet is that it has moved in the direction of this contemporaneity of reference. Uday Shankar himself created a ballet entitled "Labour and Machinery" (Pl. 197). Sadhana Bose, in 1941, produced a ballet called "Hunger" based on the Bengal famine; Zohra Sehgal created one on the divide-and-rule policy of the colonial power. Prabhat Ganguli, in Gwalior, based a ballet on Jawaharlal Nehru's *Discovery of India*. Mrinalini Sarabhai, Uma Sharma and Kumudini Lakhia have produced ballets on complex social themes like the position of woman in Indian society. New Kathakali plays have been produced on the great Indian revolt of 1857 and the tragic death of the Rani of Jhansi. And a young Catholic priest, Bombay's Francis Barboza, has been interpreting Christian themes in Bharata Natya, incidentally enriching its gestural code.

Classical Indian dance is a great tradition but it seems to be a very conservative one too. European ballet too was an immensely prestigious tradition, but Isadora Duncan was able to stir up a great wind of change and creative personalities like Martha Graham and Mary Wigman who came after her were able to stabilise modern dance; today classical ballet itself is increasingly assimilating its liberated movements and modalities of expression. A similar sea-change is yet to take place in India. But innovative impulses are alive below the surface. If Uday Shankar did not bring in radical innovations, his streamlined and fluid choreography was itself subtly innovative and Agnes de Mille, who is a great choreographer, dancer and ballet historian, has stated that the only great ballets produced by Anna Pavlova's company after she broke with Diaghilev were "Radha-Krishna" and "A Hindu Wedding"; these were Uday Shankar's creations. Choreographer Chandralekha's tirade against classicism is full of flamboyantly polemical rhetoric and her balletising of the movements of indigenous martial traditions is not sensationally innovative. In the west, Glen Tetley has

balletised the movements of a Chinese martial tradition and superbly balletised duels are found in Yuri Grigorovich's "Spartacus" with sensational attack by Maris Leipa, in William Dollar's "Combat" and many other ballets. In India too, duels are balletised with remarkable vigour in Kathakali which in fact has links in its origin with the martial tradition of Kerala. Nevertheless, Chandralekha is essentially right in protesting against the continued preoccupation with sentimentally romantic episodes with the dancing obliged to be a literal mimesis of the literary text, and in calling for a more liberated body language of the kind seen in the modern dance of the west.

Modern dance of this type too is emerging in India. Here the pioneer is Astad Deboo. As in the west, his modernism too absorbs elements from tradition in a new synthesis. In "Ritual", to music by Vangelis, something of the intense absorption of Martha Graham's "Adorations" has been managed, with impressive use of a miniature Stonehenge of candles and some acrobatics in air, suspended on ropes, a feature adapted from some traditional South Indian rituals. In "Duel", to Moussorgsky's music of the revel of demoniac spirits on Walpurgis night, Deboo plays both roles in the conflict of Good and Evil, moving through the heavy shadows between spotlit areas for the transitions. Bathed in red light, Evil is a truly demoniac character and Deboo brilliantly integrates Kathakali including even the terrible sequence in the "Slaying of Dussasana" where Bhima tears open the chest of Dussasana and drinks his blood. Deboo has been commissioned to choreograph a dance for Maya Plisetskaya, a Prima Ballerina Assoluta of Russian ballet. For an Indian pioneer in modern dance, this is high recognition from abroad. One hopes that the classical tradition in India too takes notice of this achievement and begins to incorporate the expressive modalities of modern dance.

Art of the Artisan

It is not elitist art that makes gracious the daily living of the masses, but the art of the craftsman who transforms the humble articles of daily use into objects that are beautiful too. The artisan also works under greater constraints, compared to the artist. The latter can take considerable liberties with his forms and in modern times the liberty has been so libertine that there are no norms left against which performance can be checked. But the artisan has to streamline functional shape into lovely form. A handle for a pitcher may look graceful if made very slender; but it may break when the filled pitcher is lifted. It is because beauty is thus realised even under great constraints that craft forms endure with only minor modulations, no radical change, over the epochs.

The craft tradition in India is very old and very rich. Figurines from the epoch of the Indus valley civilization are often represented as clad in handloom cloth with beautiful designs (Pl. 52). Much later, Megasthenes, Greek ambassador to the court of Chandragupta Maurya, noted that the commoner wore fine flowered muslins. Products from India were valued all over the ancient world. Aurel Stein came across ancient printed cottons of India in many places of Central Asia. Pliny of the first century once voiced a strong protest against the extravagance of his fellow citizens which sent an enormous amount of money every year from Rome to India for her silks, brocades, muslins and cloths of gold. In the *Ramayana* we read that among the citizens who went into the forest with Bharata in search of Rama were gem-cutters, potters, weavers, ivory-carvers and goldsmiths. The list of gifts received by Yudhishtira when he performed the imperial sacrifice, in the *Mahabharata*, is a very important source material for any one who wants to know the incredible variety of craft products in ancient India. In the description of preparations for a tourney in the *Harivamsa*, we get an idea of the prosperity of the craftsmen. "The pavilions of the different guilds, vast as mountains, were decorated with banners, bearing upon them the emblems and implements of different crafts." In the *Harsha Charita*, the fictionalised biography of Emperor Harsha by Bana of the seventh century, we get an idea of the respect enjoyed by the artisan classes. "Carpenters, presented with white flowers, unguents and cloths, planned out the marriage altar." In Bana's other romance, *Kadambari*, we read about the soft silken garments "white as the foam of ambrosia with pairs of swans embroidered in their hems". This is the famous Hamsa Lakshana sari which figures in Ajantan paintings as well.

Pottery

Food and clothing being primary needs, we may begin with the crafts that were closely related to their satisfaction. Pottery (Pls. 206-211) is an ancient tradition. Though it is mostly thrown on the wheel, it is interesting to note that in some areas of Assam and of Manipur, shaping of the clay is managed without the help of the wheel. The same sureness and sensitivity which enable peasant women to make free-hand drawings of the most intricate geometric designs for decorating the walls and floors of their dwellings (Pl. 255) are seen in the flawlessness of the forms created by patting and beating the clay. Through the light or pronounced swell of the belly of the vessel, the varying proportions of the neck and the slow or sharp flaring of the rim or mouth, modulations of the basic shapes of a very great variety are obtained. The surface is decorated with incised, pellet, applique and painted designs. The decoration is usually rich. But occasionally we find a water-pot or cooking vessel attaining aristocratic distinction through a minimal use of motifs, a garland in delicate relief around the neck of the vessel or a girdle around its waist. Sago starch in Orissa and the fruit of a wild creeper in Manipur are used to rub terracotta pottery to a glossy finish.

The discussion of pottery, as it is practised at the level of the artisan communities in the villages, will be seriously incomplete without a reference to the objects made for religious worship and ritual. While homage is paid to the deities of the classical pantheon, it is very clear that dearer to the artisans and the community are the village deities. Aiyanar is the guardian deity of the village in the Tamil region. In Orissa, it is to the goddess, Thakurani, that the villagers look for protection, and the ancient mother goddess lives on, under many names, in the entire stretch from Gujarat to West Bengal. The favourite votive offerings are terracotta images of these deities, in the full round or in plaques, and also images of animals, usually elephants, horses and bulls. The variety of stylisation of these animal figurines, from the fluently streamlined horse of Bankura to the life-size forms, decorated with gay trappings and garlands of bells, of Tamil Nadu, can by itself yield a rich book of designs. Ritual lamps, lit with oil and wicks, used in the worship of these deities, are of a shapely form, like garden fountains in miniature, the receptacle for oil unfolding like a flower from a pedestal with mouldings and decorative designs of a considerable variety.

Though there has always been a wide difference in economic status between artisan and affluent communities, patronage by the latter has helped the former in their livelihood. Pottery made for the more affluent stratum has evolved in numerous traditions only some of which can be mentioned here. The blue pottery of Delhi and Jaipur is distinctive in that it is not made of clay but of ground felspar mixed with starch or gum. Hence the vessel cannot be shaped on the wheel but has to be moulded by hand though the neck and lip are fashioned on the wheel. The ware is coloured by dipping it into copper oxide or by painting it on the surface. For the decorative work, in Jaipur, the pot is put on the wheel and rotated and the ornamentation is done with a fine brush made of squirrel's hair. There is only a single firing. This blue pottery has a Persian flavour (Pl. XLIII). The pottery made in Azamgarh (Pl. 206) in Uttar

oil. The surface is then incised and mercury is rubbed into the incisions, creating patterns that look like those made with silver wire inlaid on oxidised gun metal in the Bidri ware of Andhra Pradesh. Alwar in Rajasthan is famous for its paper-thin (*kagazi*) pottery. The double-walled surface is cut into different attractive patterns, which helps to circulate the air and keep the water cool. In the pottery of Khurja in Uttar Pradesh, the decorative pattern is raised into a light relief with the use of thick slips and the colour-palette is of warm hues. In South Arcot, intricate forms are built up by making the components separately and then joining them together. Designs are stamped in on the raw ware which is fired, glazed and given the final firing. The shapes are elegant and the glazes bright. Ash trays and flower vases decorated with figures and floral designs, and paperweights shaped like animal figurines are also now being made in this style.

Handloom Cloth

Clothing is second in importance only to food and the Indian tradition is rich in handloom cloth where the design is either woven in or printed after the weaving. Taking up the first category, the cotton muslins of India were so fine that the Romans called the material *textalis ventalis* or 'woven air'. The cloth earned other names too, like Evening Dew because it became indistinguishable when spread on the grass, Running Water because it became invisible when dipped in water, Sherbati because of its cool feel on the skin. Such fine muslin continues to be produced today in places like Ponduru in Andhra Pradesh and Madhubani in Bihar. The colours have clear associations with the highlights of the natural cycle and the life cycle. Yellow is the colour of spring drapery; crimson is for the bride, ochre is for the man who withdraws from routine preoccupations of living for himself for serving others.

Though design elements can appear all over the Indian sari, the more important areas are the border and the *pallu* or the sari end which falls over the shoulder at the back. Aristocratically reticent in its elegance is the Kerala sari which is plain white with a gold band for border and a wider gold band for the *pallu*. Maheshwar in Madhya Pradesh produces saris in midnight blue and dark purple with moon and star designs, a reversible border which can be worn either side and a *pallu* of white and coloured stripes alternating. Shahpur in Karnataka also produces a similar sari, but in soft pastel shades.

In the Jamdani cottons made in Tanda in Uttar Pradesh, the weaving is somewhat like that in tapestry. Here the patterns are worked in white on a white background. The extra weft threads which create the patterns - floral sprays either scattered over the surface or arranged in diagonal rows - are of the same fineness as those used in the fabric. They are thus absorbed into the fabric and the design can be discerned only when it is held against the light. In a fabric called *Panna Hazara* (Thousand Emeralds), the floral design is made to stand out with flowers in gold or silver shimmering like precious stones.

In the Himroo of Hyderabad and Aurangabad made with cotton in the warp and

art silk in the weft, the weaving consists in the interlacing of the weft yarn with the warp yarn at right angles. The designs are either geometrical, like circles, ovals, diamonds and hexagons, or fruits and flowers. While Himroo is a kind of brocade, the real brocade or Kinkhab is the traditional product of Banaras. Silk threads and gold wires of extreme fineness are interwoven in beautiful colours and floral designs to yield gorgeous saris which usually have gold *pollus* and borders. The hunting scene design is typical of Banaras brocade. The Baluchar sari of West Bengal comes in dark rich shades, particularly red, purple and chocolate, is brocaded with untwisted silk thread and has a *pallu* with mangoes in the centre bordered by lively genre images like travel scenes with horse riders and palanquins, royal courts, etc. (Pl. 212).

The Patola, the preferred wedding sari of Gujarat, is a marvel of weaving skill. The whole design is borne in mind when the threads of the warp and the weft are separately coloured by tie-dyeing according to pre-calculated measurements and markings and arranged on the loom so that, as weaving progresses with little bundles of warp and weft, the design appears on both sides of the material. The process is most laborious, but it yields radiant results. There are two principal styles: the Cambay pattern with a diaper that forms meshes within which occur white flowers borne on dark green stems; and the Patan pattern without diapers, in which the border strips carried within the field picture a serious of elephants, flowering shrubs, birds, and human figures including dancing maidens.

Fabrics of silk are produced in Kashmir and Assam, but the most famous of this category is the Kanchipuram sari. Very intricate designs are woven into the body of this heavy silk sari in gold thread, of human and animal figures and geometrical patterns, with temple towers along the borders. A feature which lends great distinction to the Kanchipuram sari is the wide, contrasting borders in different designs and colours. The *pallu* is often separately woven and joined very delicately and may have figures and flowers independently worked in with gold lace or silk yarn.

The most highly-prized woollen fabric is *Pashmina*, made out of the under-belly of a Himalayan goat that lives at an altitude of about 4000 metres above sea level. The shawl is the favourite item produced from wool and Kashmir, Mandi, Kulu and Chamba are important shawl-producing areas. The Jamavar shawl is woven rather like a tapestry, as numerous shuttles loaded with richly coloured threads are moved around even in a single weft line because of the constant and almost fantastic change of colours which can be as many as fifty in a single piece. In the old days, about three hundred vegetable dyes were used in shawl-weaving.

Decorated Fabrics

The tradition of printed textiles is of great antiquity in India and the printing is done in many ways: by using wooden blocks (Pl. 214); by covering portions of the cloth intended to be kept in the background colour with wax, clay, gum, resin or other resist so that when the cloth is subsequently dyed the colour does not penetrate the masked areas; by treating portions of the cloth with mordants which produce colours

through chemical reaction with the subsequently used dyes; by the application of thick pigment which creates patterns that appear to be encrusted on the fabric; by the modern discharge process where designs printed with chemicals discharge the ground colour.

The most famous printed fabric of India is the Kalamkari of Andhra Pradesh (Pl. XXXIX). 'Kalam' refers to the brush used in this technique. It is devised by sharpening a bamboo piece to taper to a point like a skewer which is split at the point for about an inch. A sponge made of rag, hair or wool is tied an inch below the point in the shape of a ball and the fingers manipulate this ball soaked in the required colour. But the use of the brush does not exhaust the great variety of techniques used here. Block printing for black colour; printing of alum as a mordant, dyeing and boiling for red colour; waxing as a resist with a brush before indigo blue dyeing; dyeing in indigo vat in cold for blue colour; removing of wax by boiling, painting with brush for yellow on white ground and for green on blue ground: these are the important techniques used in Kalamkari.

The Kalamkaris of Kalahasti are painted with mythological scenes, mostly from the two great Indian epics, the *Ramayana* and the *Mahabharata*. The flowered chintzes made in Machillipattanam are used as curtains, bed-sheets, table cloths, etc. A favourite motif is the tree of life with birds perching on the branches and animals resting in the shade below.

Printed cloth is made also in many other regions like Gujarat and Rajasthan. Kutch uses a soft local satin. In Tanda in Uttar Pradesh, two blocks with the same design are used, one perforated and stuffed with cotton to a saturation of colour, the other plain. These are then printed and reprinted and juxtaposed in the process, developing a dark red colour for printing of motifs.

Fabrics are decorated not only with woven and printed designs but also with embroidery and applique (Pls. 216-217). Gujarat probably has the richest tradition here. Embroidered panels with flaps and longer end pieces hang over doorways to welcome the guest. Embroidered pieces representing Ganesa, called *Sthapanas*, are housed in niches in the wall and serve as icons. Embroidered hangings decorate the walls and smaller pieces cover the furniture. There are embroidered pieces for the back of bullocks, gay tasselled covers for the horns and adornments for forehead, face and muzzle. Small inset mirrors are components of floral designs and add their luminosity. The elite people have started using such cloth as table linen for candle light dinners. Beads are also used in embroidered motifs in Saurashtra and Kutch. The motifs are very rich. The figuration of Ganesa is found in numerous stylisations, some of them having an astonishingly modern feeling. Genre scenes abound and the figures of men and animals are represented in lively movement. Applique is an integral part of this decorative tradition. Rajasthan also has a characteristic embroidery. The Bengal Kantha is made of old saris and sheets piled up according to the required thickness and sewn together using the darning stitch in white thread, to cover the entire surface. The threads are drawn so close across the surface in one direction that the edges of the several pieces are imperceptible and the surface gains a wavy, rippled look. The motifs include fauna, flora, articles of daily use, even lines of verse.

In the old days, the Punjabi maiden started working at an early age on the embroidered cloth known as Phulkari which would later be a part of her trousseau. The word has associations with the garden and in one variety the embroidery stitch covers the entire area so closely and completely that it becomes the fabric itself. Madder brown and rust-red indigo are the usual background colours and the stitches are mainly in golden yellow or white or green, though a few bright colours are introduced in the borders.

The Chikan embroidery of Lucknow is made with a very delicate stitch, patterned on lace, in white thread on white cloth. This is sophisticated art in its play with fine tonal distinctions and exquisite art in its miniature craft. One type of design is worked on the right side with minute stitches, the thread accumulating on the reverse producing a shadow effect on the surface. Kashmir embroidery has drawn on the natural milieu for its favourite motifs of the lotus, the *chenar* (plane tree) leaf, almond and cypress. Chamba is famous for its large embroidered scarves (*Rumals*) where the romantic episodes of the Krishna story, especially his dance with a ring of maidens, provide the motifs (Pl. 215). Embroidery with gold or silver wire (*zari*) is practised in many places in India, the more important centres being Delhi, Agra, Lucknow, Bhopal, Ajmer and Srinagar (Pl. 219).

Floor Coverings

From textiles we can move on to floor coverings like carpets which also involve the techniques of weaving and dyeing. Emperor Akbar must be given the credit for starting the making of pile carpets in India. As in the case of miniature painting, he brought Persian masters to give the initial impetus. But again, as in painting, the indigenous craftsmen were able to bring about great modulations. Abul Fazl, in his chronicle of the Akbar epoch (*Ain-i-Akbari*), wrote that "the carpets of Iran and Turan are no more thought of". Perhaps there are elements of pardonable pride and exaggeration here for Kashmir still continues to make carpets that are modulations on those made in Persia and Central Asia.

The decoration is rich in Indian carpets (Pl. XL) but is always subordinated to the surface which is not only a flat one but must also visually strengthen the sensation of flatness as the feet will feel uncertain in treading on seemingly uneven surfaces. Thus represented objects are shown without cast shadows that may suggest relief effects and an uneven plane. Leaves and flowers are stylised, avoiding the extreme naturalism which may make one hesitate to tread on a flower; the motifs are arranged in symmetrical manner. And there is the further advantage of handicraft that no motif is repeated with a dead, mechanical exactness.

Carpets are now being made in many parts of India besides Kashmir. In fact the largest concentration of carpet-weaving is in Uttar Pradesh. Mostly pastel shades are used here, though mingled with bright colours. Short clippings of the yarn around the contours of the patterns bring them out vividly. The Taj Mahal is a favourite motif. The Himalayan region produces carpets with mainly geometrical designs, using blocks

of colour to build up a pattern. Carpets are made in wool alone, wool and cotton mixed or cotton alone. A relatively inexpensive floor covering made with cotton is the *durree*. The main designs are geometrical, but with the outlines in delicate tracery and with floral motifs in the cross borders.

The *namda* (Pl. 218) and the *gabba* are two interesting species of floor coverings made in Kashmir. The tradition seems to be an ancient one. For a wooden tablet excavated by Aurel Stein in Eastern Turkestan records a commercial transaction by one Buddhaghosha attached to a Buddhist monk, Anandasena, and it mentions the *namda*. It has felt for its background. Applique decoration is made on it, sometimes by laying dyed wool and pressing it and sometimes with a crochet needle with a hooked end. *Gabba* is a rug made from old woollens on which assorted coloured pieces in various shapes are chain-stitched. The body and the border are embroidered with gay decorative motifs.

Kerala, for many decades now, has been making coir mattings very suitable for continuously covering very long corridors. Door-mats are also made, covered with tufts of coir yarn. Recently carpets are also being made of this material. In one variety, the weft is made of alternate rows of tuft with very decorative designs.

Mat-weaving and Basketry

We stay essentially with the technique of weaving when we move on to mat-making and basketry in which bamboo, grasses and reeds as well as the leaf of palms have been used from time immemorial.

For sitting at ease or lying down after the day's work, mats are being made all over India in a variety of materials. *Sitalpatti* is a variety of mat made in Assam and Bengal. The name itself is an invitation to relax as it means 'cool spread'. It is woven with slivers of cane in their natural golden colour and also dyed deep maroon, designs of animals, birds and stylised human forms enclosed within squares being created by plaiting slivers of contrasting colours. Orissa produces mats of a soft warm glow from what is usually called golden grass though it is really the spliced stem of the *khuskhus* plant which has a shining golden colour. Mats of Kora grass are made in Kerala, the favourite colours used in designs being red, black and white. A special kind of Kora grass that grows wild on river banks in the Tirunelveli district of Tamil Nadu yields very fine mats of this type. Soft-textured mats are also made from the leaves of the screwpine, though in smaller quantities, in Kerala. Some mats are made in enormous lengths to seat rows of guests at wedding feasts. But the tissue is relatively so thin and light that they take up very little space when rolled up for storage.

Baskets are made with a variety of fibres (Pls. 220-221, 225) and in a variety of techniques like wrapping, twining and plaiting that yield fascinating designs of weaving, quite apart from the designs created by the use of colour. Punjab makes sturdy, spirally built baskets with a wild grass growing in swamps stitched with dyed date palm leaves which are worked in patterns that recall the geometric designs of Phulkari. In Kashmir, the young fresh twigs of the willow tree are woven in intricate designs to

make a variety of baskets. Karnataka uses cane to make strong baskets as well as boxes, edged with metal and with lids and metal hinges. The leaf of the palmyra and coconut palms is used for making baskets practically all over south India.

The poetry of traditional living is conserved in these humble creations. Baskets are made of the golden coloured Sikki grass in Bihar. But, in addition, the peasant women here make three-dimensional figurines of horses and elephants, piquantly stylised in form, attractively coloured, for presenting to the bride at the time of marriage. In the old days, elephants and horses were part of the dowry of brides from the rich land-owning families and the women of the poorer classes wanted their daughters also to feel rich on the greatest occasion of their life. The Tharus, a semi-tribal community of Bihar, make special baskets decorated with tassels made out of shells for presentation to brides. The girl, now become a wife, uses the basket to carry lunch to her husband while he works in the field and the tinkling of the tassels in the breeze heralds her arrival.

The lowliest utensils are transformed into objects of beautiful form. Winnowing pans of Assam and fish traps made of bamboo and cane splits in Manipur are exquisitely fashioned. The tea garden workers of Assam have a decorative headgear made with bamboo strips. Nagore makes folding fans with tender palm leaves dried and painted with floral designs. Bamboo and reed are used to make inexpensive and beautifully shaped garden chairs and stools (Pls. XLII, 223, 226), while cane is fabricated in drawing-room furniture that is now responding to the demand for sophisticated modern designs (Pls. 222, 224).

Woodcraft

The mention of furniture leads us from weaving to carving, for carved wood has been far more important than plaited bamboo, cane or reed in the tradition of indigenous furniture. The *Matsya Purana* says that every home should have a beautifully carved door-frame in wood as a sign of welcome to visitors and carved lintels, brackets and balconies are found in traditional homes in many parts of the country. But here we are not concerned so much with the use of wood in architecture as its use in the making of furniture and utensils.

In Himachal Pradesh, where wood is plentiful, shapely pitchers for carrying water and bowls for eating are made out of wood. Kashmir uses the elegant, soft-toned walnut wood to make trays, fruit bowls and other ware for the table (Pl. 232). Paper-thin bowls of wood are made in the Pali district of Rajasthan. The shaping of the vessel in the form of a lotus flower or the leaf of the lotus or of the *chenar* and minimal but elegant decoration in the form of carving along the rim lend great distinction to such creations. Bear-mugs and even tea-sets are being made in Tripura with bamboo, fitted with handles and ornamented with incised and coloured decorative motifs.

Storage receptacles are made in wood in many regions. Assam makes finely-carved chests for storing everything from jewels to vessels, small seats to sit on and small low tables to go with them. Gujarat has a very rich tradition of wood carving

and makes, in addition to small chairs and tables, the swing (*jhoola*) without which no traditional home is complete. Typical of this region is the beautifully carved stand for the water pot. Gujarat is rich in decorative designs and one can find forty to fifty variations in the same motif, like the lotus or the peacock. Madurai in Tamil Nadu has a flamboyant though delightful style. The table-top may rest on elephants carved in the round and tiny elephants may run round its edge to form a decorative rim. Rare woods have special uses. Ebony and rosewood are carved into toilet and trinket boxes in Uttar Pradesh and the fans made in Karnataka from thin slivers of sandal-wood can waft the fresh breeze from a virgin rain forest right into a modern drawing room, the delicate fragrance of the wood blending with that of the cosmetics used by elegant women.

While the natural tones of the rarer woods are cherished, the cheaper woods are decorated in many ways. The surface may be painted as in the Nirmal ware of Andhra Pradesh or plated with metal in attractive designs. Lacquering of articles while rotating their component parts on the lathe is now done in many regions, though Kashmir and Rajasthan produce the best work of this kind. The graffito technique is skilfully practised in lacquering. Several layers of lacquer, of different colours, are applied one over the other and the final design is built up by scraping through to the various layers to expose their colours. Kashmir makes large-sized lamps, big flower-pots and fire-screens with rich patterns of birds and flowers in this manner.

In Karnataka, rosewood and ebony are inlaid with ivory. Less expensive articles of this kind are made by using woods of different tones and grain for inlay. Landscapes and genre scenes are created as decorations in this manner on the surface of many articles like plates, boxes, teapoys and table-tops. In the marquetry of Gujarat, known locally as *sadeli*, inlay has become applique work and mosaic designs are built up from strips of different kinds of woods first glued together and then sliced into thin laminae.

Stonecraft

The use of stone in architecture and sculpture has already been noticed, but a brief mention of some aspects may be made here. Small scale sculptures of deities, modelled on the classical prototypes, continue to be made in many regions of India, for installation in small new shrines that are always coming up, as icons for domestic worship and as ornamental pieces for a much larger number of people for whom the spell of their beauty is still strong even if the hold of traditional faith may have weakened. At Mahabalipuram in Tamil Nadu, such sculpture is made in granite. At Devanhalli in Karnataka, figures are carved in relief in black stone and details are engraved in fine lines which come out in greyish-white against the black. Orissa uses a soft stone which is light in weight and easy to carve. The small dryads and dancing figures go well with the elegant decor of modern drawing rooms.

In Rajasthan, where wood is expensive, door frames are often built with red stone. Only the actual door is made out of wood and the hinges are so designed as to fit

into the sockets carved in the frame. The windows are also carved in stone trellis work. An extension of this particular technique is seen in stone pedestal lamps where the light filters out in delightful patterns through a stone shade worked in trellis in a variety of designs.

Blocks of stone, hollowed out, are used as cooking vessels in Kerala and some dishes attain their finest flavour only when cooked in such vessels. The Hamirpur region of Uttar Pradesh has a soft stone which is carved into plates, bowls and other table ware. Since the stone is many-coloured though with predominance of a lovely red shade, each item is shot through by several shades which adds to the allure.

But marble is the most extensively used stone for a variety of useful and ornamental articles for the home. At Agra, the marble is most often inlaid with semi-precious stones in floral motifs and shaped into table-tops, boxes, plates, plaques, mirror-frames with lace-like fringes, basins with filigree rims to float flowers (Pl. 228).

Other Carved Ware

Ivory-carving (Pls. 229-231) is a very old tradition, for there is a Vedic reference to it as one of the noblest of crafts. We saw earlier that the marvellous skill of the stone-carvers of Sanchi was derived from that of ivory-carving. That skill is alive even today and can be seen in the magic balls, sets of five to nine spheres, one within the other but completely detached, carved from a single block, or the elephant with rider and canopy and ornaments made, again, from a single piece, or the lace-like fans. Figurines of deities, heroines of Puranic romances, representations of woman in all her moods, are the favourite themes of ivory carving. But many other items are also made like chess sets, scent bottles, compact cases, salt-pepper cellars, paper-knives. The tapering end of the tusk is sectioned to yield bangles which are decorated with carved motifs. Etched designs are also used to decorate ivory ware. In Delhi, Agra and Jaipur, small thin pieces of ivory are used for miniature painting.

Several other materials are also used for carving. Orissa makes bone carvings of compositions of amorous couples (*Mithuna*) and animals. Buffalo horn is fashioned into a variety of bird and animal figurines in Kerala, and combs and hairpins of horn are made in several places, sometimes with mother-of-pearl inlay. A curiosity is the hollow comb that can carry hair oil which perfumes the hair through tiny holes. Visakhapatanam in Andhra Pradesh makes trinket-boxes out of tortoise shell inlaid with ivory. West Bengal makes bangles out of sections of the conch shell and, more recently, is using it to carve mythological and other compositions in low relief. Here the intact shell preserves its form; the relief composition is made by carving away the shell surface in a small area to leave the design in relief. From the hard shell of the coconut, Kerala produces attractive bowls, vases, rosewater-sprinklers and teapots.

Shola is a herbaceous plant growing wild in marshy and water-logged areas. Its soft pith is easy to carve but consummate skill is required to carve it into the magnificent and intricate coronets and jewellery that decorate the icons of Siva and Parvati (Pl. 235) or of Durga during the Durga Puja festival in Bengal. In Tiruchirapalli in

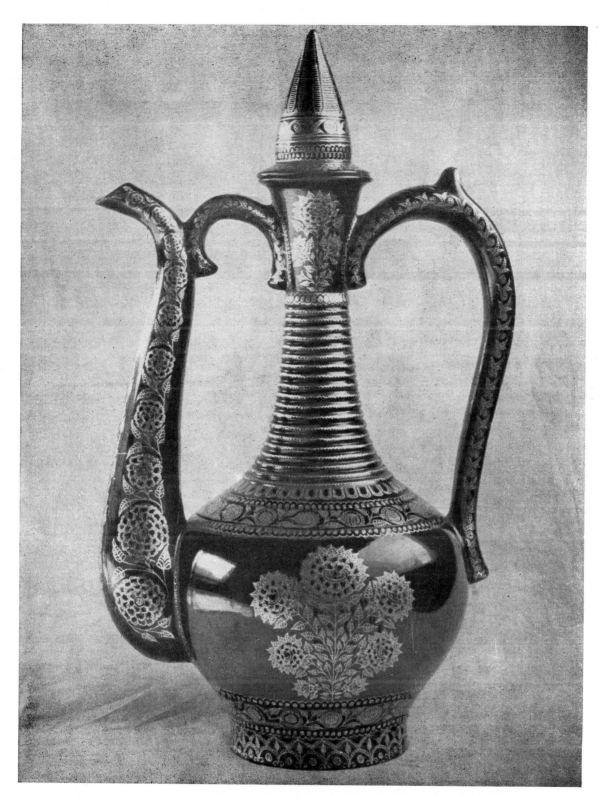

206. Water pot, Azamgarh.

207. Perforated pot from Suratgarh.

208. Moulded pot from Kumharka, Ch

209. Engraved pot from Nohar, Ganganagar.

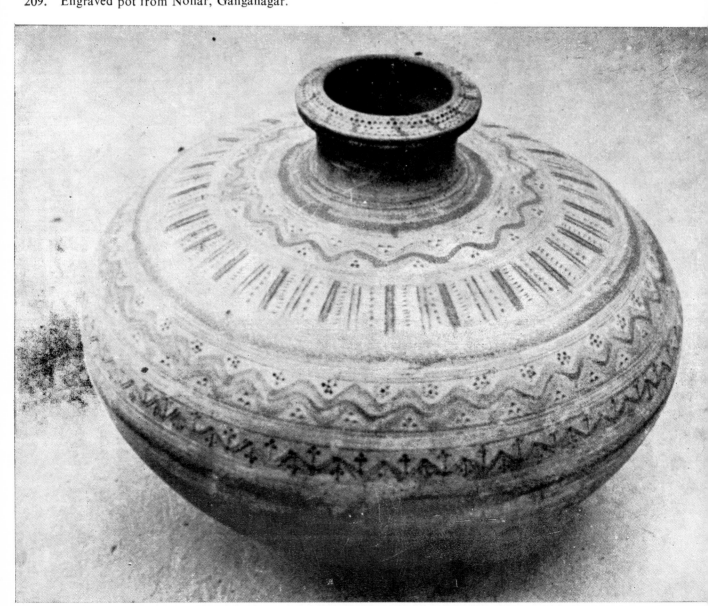

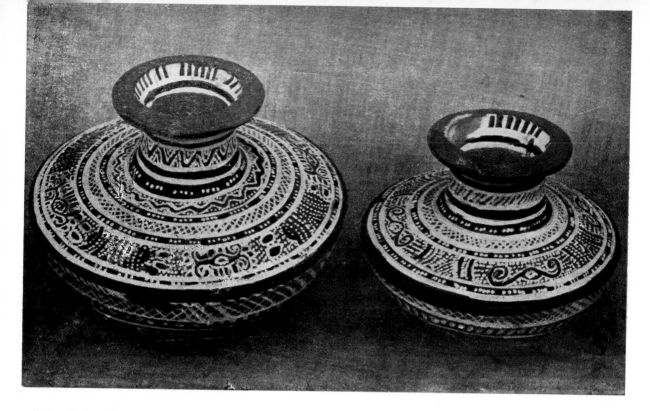

210. Painted pots from Bihar.

211. Painted pot from Nohar, Ganganagar.

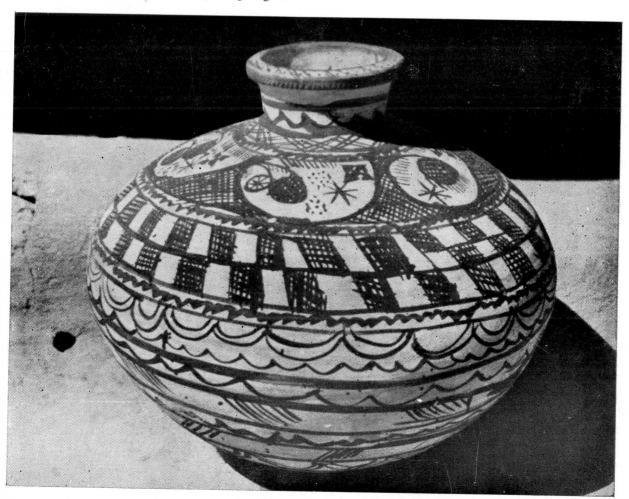

212. Border of Baluchar sari from Bengal.

214. Design unit from a single block used in printed handlooms.

213. Embroidered cotton piece with figure of Ganesa.

215. Chamba Rumal with Ras Lila motif.

216. Embroidered piece, Kashmir.

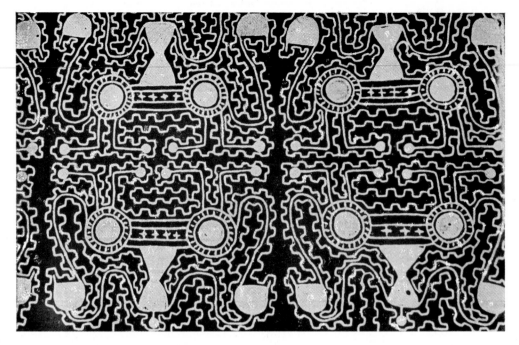

217. Applique and embroidery, Bihar.

218. Namda, Kashmir.

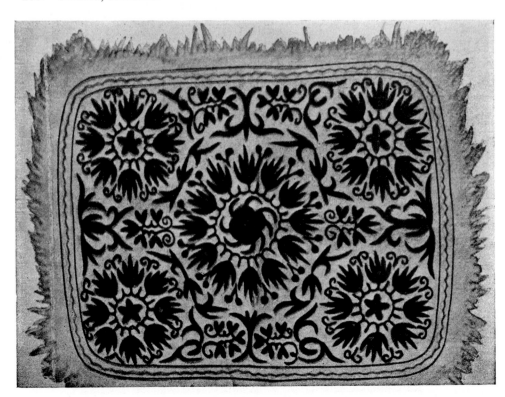

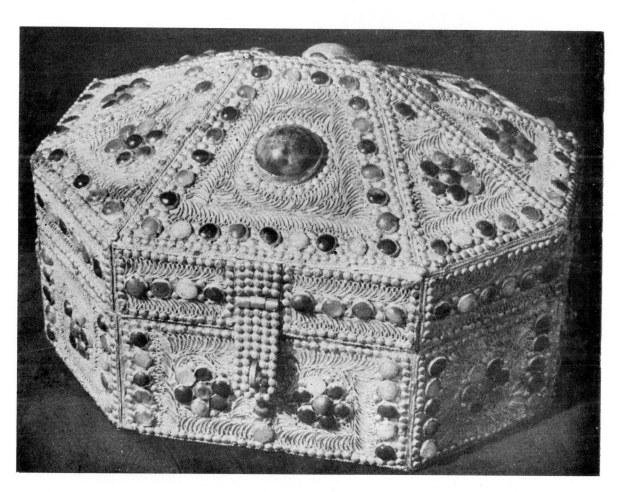

219. Jewel box of gold thread and semi-precious stones, Gujarat.

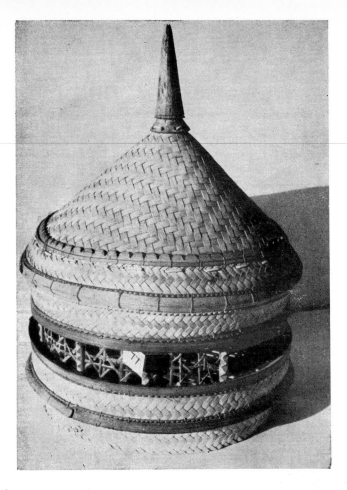

220. Covered basket, Nagaland.

221. Hunter's basket of Siadi fibre, Bastar.

222. Lamp-shade of cane and bamboo, Agartala.

223. Garden seat of cane, Arunachal Pradesh.

224. Table mat of reed, Bihar.

225. Cane basket with lid, Andaman and Nicobar islands.

226. Garden seat of raffia and palm leaf.

228. Marble tray with inlay, Agra.

229. Table top with ivory inlay, Agra.

230. Ivory carving, Karnataka.

231. Ivory carving of miniature palanquin, Rajasthan.

232. Carved walnut wood trays, Kashmir.

233. Carved wood plaque, Karnataka.

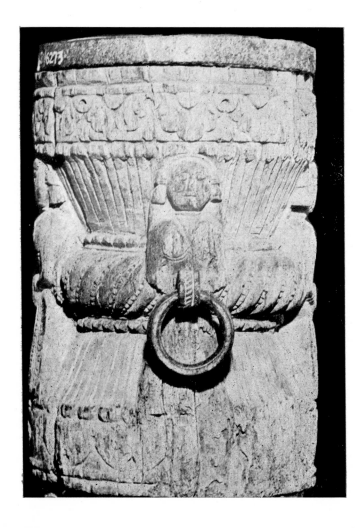

234. Wooden mortar for pounding grain, Rajasthan.

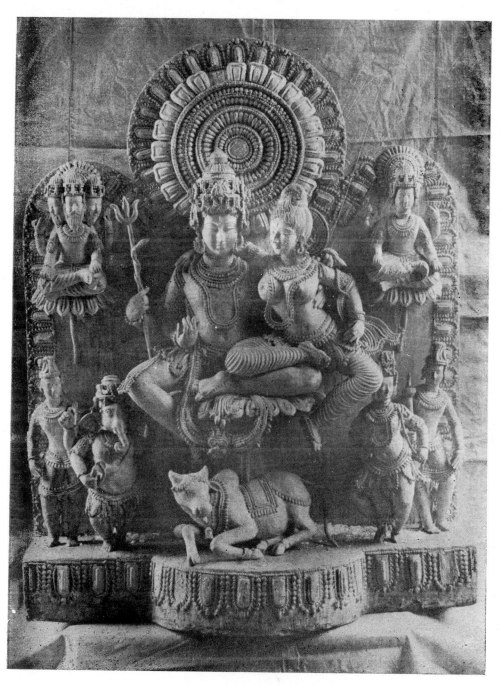

235. Siva-Parvati carved in shola pith, Bengal.

236. Papier-mache, Kashmir.

237. Plate made of iron, Rajasthan.

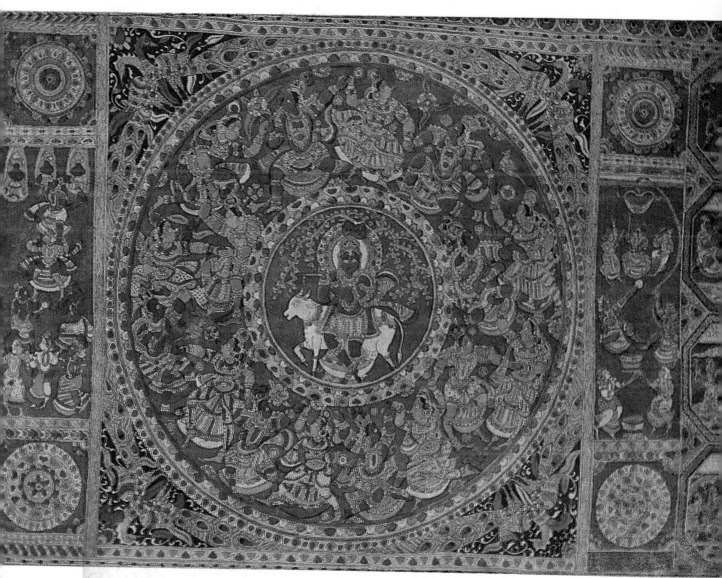

IX. Kalamkari temple wall-hanging showing Ras Lila.

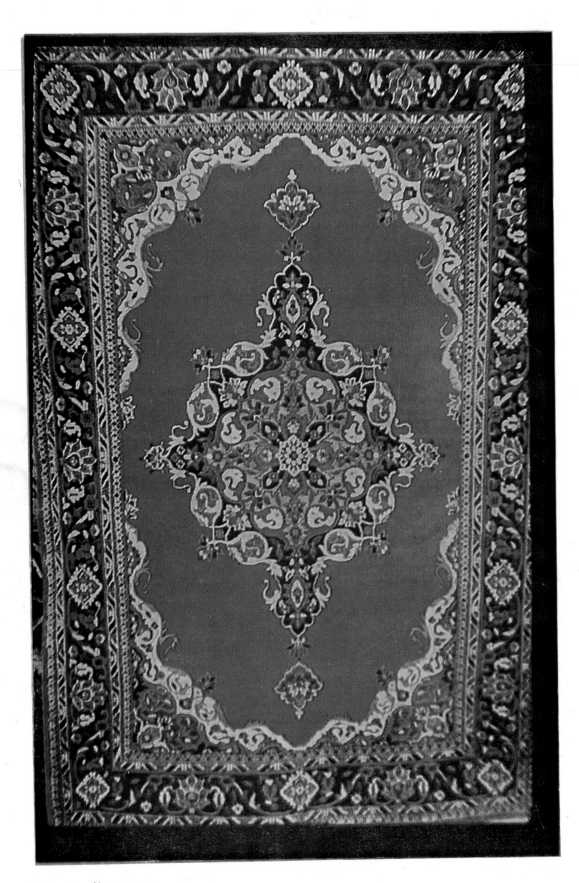

XL. Gwalior carpet.

238. Pot of copper and silver,
 South India.

239. Enamelled brass bowl, Gujarat.

240. Bidri jar with line inlay, Hyderabad.

241. Silverware, Kashmir.

242. Bidri jar with sheet inlay, Andhra Pradesh.

243. Silver filigree work, Orissa.

244. Ink-well in brass, Rajasthan.

245. Brass sandals, Rajasthan.

246. Toy owl in wood, Bengal.

247. Doll showing a Rajasthani peasant girl.

248. Clay lamp, Cuttack.

249. Brass hanging lamp.

250. Tribal lamp of metal, Bastar.

251. Pots decorated for ritual worship of Manasa, Barisal.

252. Paper-cut, Mathura.

253. Tribal memorial tablet, Betul.

254. Wooden mask of a demon.

255. Painting on wall of nuptial chamber, Madhuban, Bihar.

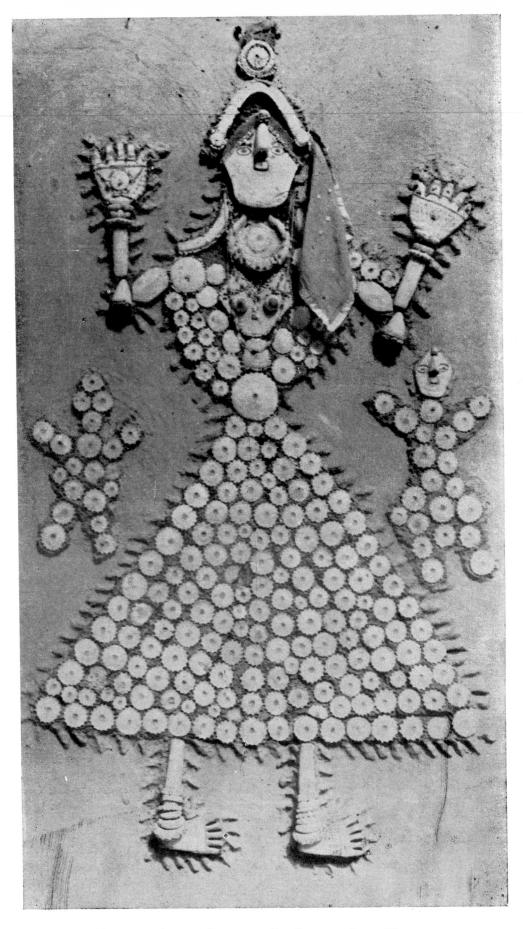

256. Devi in clay and metal discs on walls of peasant huts, Harya a.

XLI. Painted teapoy, Gujarat.

XLII. Garden seat of Sikki grass, Bihar.

XLIII. Blue pottery of Jaipur.

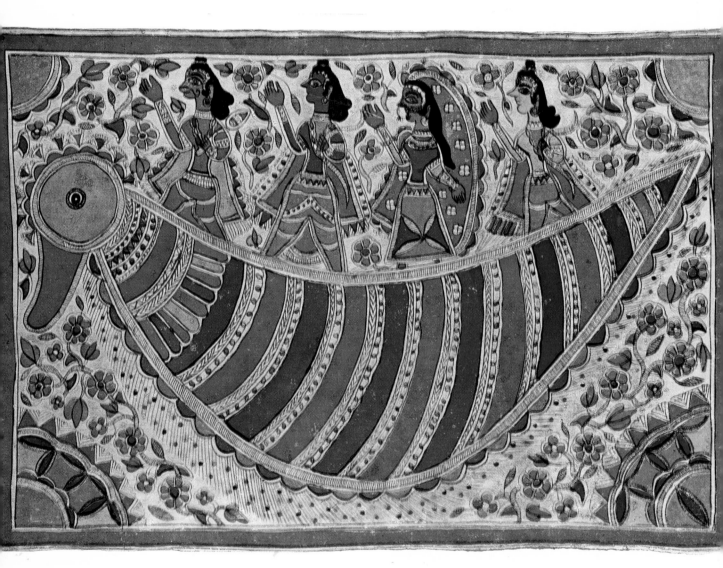

LIV. Madhubani painting showing Guha ferrying Rama, Sita and Lakshmana.

Tamil Nadu, pith is used to make models of the local temple. Flowers and garlands of pith are made in many parts of India.

Two relatively minor craft traditions may also be mentioned here before we pass on to a major one like metal ware. Comfortable and informal footwear is the major product of leather-work in India. In the slippers made in Rajasthan, the leather is surfaced with silk or velvet and decorated with designs done in applique with thin leather pieces of different colours. Bikaner produces a unique water bottle in different designs from camel hide. The leather is first softened and then stretched over a clay mould of the desired shape. When hardened thus, the leather retains the shape and the clay is washed away. The decorative pattern is first drawn on the leather; then the portion to be ornamented is raised in relief by applying a mixture of shell powder, glue and the pulp of a species of wood apple. The raised surface is painted in gold and other colours while the base is coloured black or red to show up the colours at the top by vivid contrast. Papier-mache is a relatively new craft; but several regions, and especially Kashmir, produce a variety of articles like vases, bowls, cosmetic and trinket boxes, gaily decorated with designs of rose, iris, tulip, hyacinth, the *chenar* leaf and cherry and almond blossom.

Metalcraft

The figurine of the dancing girl (Pl. XX) from the epoch of the Indus valley civilisation and the fourth century iron pillar which still stands unrusted near the Qutb Minar in Delhi show that metalcraft is an old tradition in India. The metals used most are copper, brass (alloy of copper and zinc) and bell-metal (alloy of copper and tin). Moulds are used in the lost-wax process for making icons, but we have already noticed metal sculpture. Utility and decorative articles are mostly made by hammering, turning on the lathe, soldering of separately made components. There is a great variety of techniques for the further ornamentation.

Traditional metalware has become an indissoluble part of the rhythm as well as poetry of Indian life. The living tissue is mostly water, life is impossible without water. The containers for the precious fluid have incarnated beauty besides realising functional utility. Walk along any of the ancient straw-littered lanes of the rural areas that meander past fields and orchards to a well, pool or stream and you will encounter the unforgettable and characteristically Indian silhouette: women returning from the watering place, the swelling body of the pitcher of shining brass or copper snugly fitting into the curve of the waist, its base resting on the hip, its mouth close to the swell of the torso, and the feminine figure itself in a variant of the *Tribhanga* (thrice-bent) posture of classical sculpture and dance to balance the weight. The large pitchers and the miniature ones known as *lotas* occur with fine modulations of shape, all equally functional but variedly beautiful, in the far-flung parts of the country. Over the sun-flooded sands of Rajasthan, the advent of a cloud that yields the precious water is an event. Therefore, the pitcher is called *badla* (cloud) and it is often covered with cotton, woollen cloth or felt decorated with metal-engraved designs of flowers, birds and animals.

A pudding made with rice and milk is a ritual offering in many temples and is invariably made for birthday and wedding feasts. The *Uruli*, the bell-metal vessel in which this is made in Kerala, is as basic an element of the culture of that region as the Grecian urn was of the Hellenic epoch. It has a soft or bright gold sheen, comes in a range of sizes and the basic shape shows infinite modulations through decorative mouldings.

The lamp lit with wick and oil radiantly lights up many facets of traditional living (Pls. 248-250). Fire, a god who has graciously agreed to dwell with men, abide in their domestic hearth, is the messenger who mediates between men and the gods on high. Temples, especially in Kerala, usually have a lamp-tower in front, like a coniferous tree in form with circular tiers of numerous lamps whose radius diminishes with the rising height. The outer walls of the temples often carry row after row, in neat align- ments, of small lamps fixed in a wooden framework over the masonry base. During the night, these myriad lamps gleam like precious stones against the velvet dark and people afar can see them through the lush landscape. Agni, the god of fire, is priest and with certain communities like the Nairs of Kerala, marriages are solemnised in the presence of the lamp and do not need any other priest to officiate. The bell-metal lamp used for such rituals has a classic form with a pedestal shaft rising from a circular base, expanding into a basin for holding the oil and wicks and continuing as a tapering finial. Subtle variations in the ratio of the height of the level of the basin to the total height, in the extent and design of the decorative mouldings on base and shaft, in the plain or petalled shaping of the rim of the basin, and the decorative treatment of the finial, create a great range of modulations of the basic form.

The older generations, from time immemorial, chewed the betel leaf with arecanut and spices while the jeans-clad younger generation uses chewing gum. Perhaps the traditional variant is better, for it gives fragrance to the mouth and a lovely red to the lips. Anyway, the tradition has yielded lovely metal boxes, nut-crackers and containers in many regions of India, those from Kerala and Manipur being particularly attractive in design.

Vessels, teapoy and table-tops, plates and plaques are all decorated, with land- scapes, temples, deities, dancing figures, court and battle scenes, floral motifs. In Jaipur and many other places, the designs are raised in relief in repousse, by hammering the reverse surface. Chasing with a blunt chisel creates relatively lightly imprinted designs on the surface. Engraving creates deeper lines and, when done in tracery, gives a finely granulated surface to the metal, the technique being called frost work. Dama- scening is an ancient art in which one metal is encrusted on to another either in the form of wires or small pieces. *Koftagiri* was originally done with silver and gold wire on iron or steel meant for swords, daggers and even guns. Today this art exists only in Kerala, where a number of objects decorated with designs in silver wire are produced. The *Bidri* technique derives its name from Bidar in Karnataka where it originated though today it is practised in many places. Here silver is damascened on oxidised black vessels made of copper and zinc and the contrast of black and silver is striking in effect (Pls. 240, 242). In one technique, which may be in high relief

(*zarbuland*) or low relief (*zarnishan*) silver pieces are first engraved with patterns and then inlaid. In *tarkashi,* the inlay consists of wire patterns. This technique is being used for decorating furniture too. Tanjore plate-work is also a kind of damascening. Here, silver medallions carrying repousse designs of deities, and sometimes brass decorative rosettes as well, are attached to a copper base, in large plates, pitchers and bowls. Enamelled decoration is done in two ways. In one, the base metal surface is heated and colours made out of glaze are applied. In the other, metal is engraved so as to provide depressions in which different colours are heated and fixed to create a surface of variegated colours. Enamelling is done on silver and gold jewellery too, besides on copper and brass ware.

A rather unique tradition is the silver filigree work done in Orissa (Pl. 243). Silver is drawn out into very thin wires. These are wound and flattened again into wires, which now acquire granular edges on either side. Boxes, trays, bowls, spoons, etc., are made as combinations of component parts. The space within the frame is filled with the main ribs of the design which are usually creepers, leaves, flowers etc. The most important part of the technique is the filling of the interspaces with the delicately bent pieces which gives filigree its character.

Jewellery

Metalcraft attains the greatest delicacy and the finest decorative effect in the creation of jewellery. This is a rich and old tradition, and probably the one which has received the best documentation, for both painting and sculpture have represented the jewels of past epochs in meticulous detail. If the jewellery meant for the affluent was made of gold and precious gems, the humbler strata of traditional society also fashioned for themselves jewellery that was equally decorative—in silver, brass and lac, often using coral and semi-precious stones.

A pleasant literary convention found in classical Sanskrit poetry is the systematic, head-to-foot (*kesadipada*) description of the heroines. The approach can be conveniently adopted for an account of Indian jewellery, for we have ornaments for every part of the human figure from head to foot. But each basic category shows design variations, within the same region, and between the various regions. The repertoire thus is enormously rich and only an outline is possible here.

The *chak,* made of silver and used by the women of Himachal Pradesh, is basically a round boss worn in the hair above the forehead. But it has many variations, each so distinct that it has a separate name. The boss may be smooth, hemispherical and set with a stone; it may be cut or indented so as to resemble a chrysanthemum; variations in the degree of convexity yield distinctively different forms. Blue or green enamelling may be done on the boss. Two bosses may be added, one on either side of the central boss. Round beads may be hung at the edge of the boss with silver chains. The women of Ladakh wear a head jewel (*perak*), reaching right down to the ankles at the back, closely studded with turquoise, coral and other stones, the largest being

at the top. Plate ornaments worn over the plaited hair are traditional in Tamil Nadu at the other end of India from Ladakh.

Ornamentation descends from the black tresses of the head to embellish the fair or brown forehead. The *bindli*, common among tribals, is a head ornament having a central pendant which hangs from the parting of the hair to the forehead, and from which intricately worked chains with silver globules extend on both sides up to the ear, thus framing the face of the wearer. In some tribal communities, small star-shaped ornaments are worn over the eyebrows.

Nose ornaments have many forms. The simplest is the small stud, generally of gold, though in the south the stud may have an inset ruby, diamond or pearl. The *nath* is a large nose-ring often supported by a chain attached to the hair by an ornamental hook. It may be decorated with pearls or suspended gold spangles or one or more pendants. In the case of the ear ornament also there is great variety. It may be a large star-shaped jewelled stud, a heavy-fringed ear-ring, a bell-shaped ornament with a fringe of pearls or metal suspended from the ear by a flower-shaped stud. Sometimes a set of rings may be worn all round the edge of the ear. Or the ornament may be shaped like the ear itself; it is worn covering the ear and has attached rings.

It is practically impossible to do justice to the variety of neck ornament in the short space available. It may be a plain or jewelled gold collar. The collar may be shaped to be thick in the middle with a heavy encrustation of stones and tapering at the ends. The longer necklace may be plain or built up of a number of chains, usually five or seven. The unit design out of which the chain is built up is in a great variety of shapes, some of them simulating grains like paddy or wheat, the bamboo stem or fish. The strings are often decorated with pendants all along their length. In one well-known design these pendants are often rubies or emeralds set in gold to look like tiny mangoes. Most often there is a single large pendant intricately wrought in gold and set with precious stones.

As ornaments for the arms, we have wristlets, series of bangles for the hand and armlets for the upper arm, wrought with gold or silver in many patterns, occasionally set with stones. Women of Sambalpur wear brass bangles which they polish every day to a golden brightness. Bangles of enamelled metal or lac are popular in many parts of the country. Enamelling creates the impression that the jewellery is closely encrusted with precious stones. There are girdles of plain gold bands or bands decorated with many rows of gold beads or of clusters of chains. Anklets are often embellished with jingles. A ring is sometimes worn on the toe. The anklet and the toe-ring may be linked by chains decorated with pendants which lie flat around the ankle.

Crafts and the Great Tradition

Fashions change with elitist art and when life becomes mechanised, when nature ceases to be the ambience and backdrop of daily living and becomes a remote wilderness, when there is no loving contact between the shaping hand and shaped material

because the latter is left to the machine, when the memory of the poetry of tradition becomes faint in the blood, art can practically cease to be the fine flowering of the deep creativity latent in man. The present is a dismembered epoch of this type. And that is why unpretentious craft gives a more authentic assurance than the various styles of elitist art that the old vision of beauty, and the sense of fulfilment in its creation, are not wholly lost.

It is the surplus of man's energy, not exhausted by the tasks of survival, that finds creative outlet in play, and in art which is an equally joyous but higher form of play. This euphoria, today, is retained far more by the crafts than salon art. And this justifies some concluding words on the specific traditions where it is seen most clearly.

The making of playthings and toys began with the Indus valley epoch and continues to flourish today (Pls. 246-247). The clay toys of Krishnanagar in Bengal are exquisitely shaped by artisans who start as children and do not mind spending ten to fifteen years in perfecting their skill in hand modelling. The same is true of the artisans of Kondapalli in Andhra Pradesh who make toys in carved and painted wood. Deities, rural types and genre scenes are the themes in both regions. Chennapatana in Karnataka makes attractive miniature sets in lacquer of cooking vessels and kitchenware with the help of which little girls develop the joy in managing the house that will remain as an abiding asset when they grow up and have little children of their own. Gujarat makes splendid animal toys out of embroidered or appliqued fabrics. Perhaps some of these toys are really something far greater. A familiar sight in southern households is that of an infant lying in its reed crib and looking up wonderingly at the painted clay figure of another infant like itself, suspended from the rafter right above. The toy child is Krishna, shown most often as asleep on a peepul leaf floating on a vast spread of waters. This latter is one of the most poetic and profound visions of the *Bhagavata*, a great poem which saw the creation of the world as the sport of a deity who could be as joyous as a child.

Toy figurines come to life in the puppet theatre, and in folk theatre human actors move in to extend the spirit of play into the represented vicissitudes of living even though the original episodes may have been tinged with tragedy. It is stated in the *Natya Sastra* that articles fabricated for the theatre should be light in weight. From clay, cloth, bamboo strip and light wood, the craftsmen build architectural sets of Ravana's Lanka, and the throne of Rama. They fabricate out of inexpensive material splendid costumes, the gorgeous crowns of Yakshagana and Kathakali characters, the masks of Purulia and Seraikella folk dances, puppets of wood and leather.

Elitist art often moves away with aristocratic hauteur from the dailiness of living; the art of the artisan infuses it with grace and thereby it ceases to be something special, becomes a way of regarding the world and living in it. This outlook is not insensible of the dark forces active in the world. The wooden masks of demons (Pl. 254) intuit the ominous. But, if the war of good and evil has to be renewed by every generation, the latter can rely for help on the living shades of the dead ancestors, depicted as heroes in memorial stones and tablets (Pl. 253), and the undying deities whose iconic

forms are moulded in clay reliefs on the walls of huts (Pl. 256) or drawn on the pottery used in their ritual worship (Pl. 251) or painted on walls or paper (Pl. XLIV) or re-created in relatively new media, like the paper-cuts of a pilgrim centre like Mathura (Pl. 252). The humble hut becomes a place of rich remembrance through the tradition of painting with which peasant women decorate the floors and walls of their huts. This is very widespread, being known as *alpana* in Bengal, *aripana* in Bihar, *mandana* in Rajasthan and Madhya Pradesh, *rangoli* in Gujarat and Maharashtra and *kolam* in the south. Rice paste, wheat flour, earths and vegetable dyes are used for colours. The most complicated geometrical designs and the most elaborate floral motifs are done in free hand with precision and elegance. The hand itself most often serves as brush, fingertips, closed fist and open palm substituting for a whole range of brushes. The auspicious moments of life are given a sacramental halo by this decoration. In Madhuban in Bihar, the most elaborate painting is done in the Khobar Ghar or nuptial chamber (Pl. 255).

Designs that look like imprints of feet very frequently occur in floor painting, shown as progressing in the direction of entry into the house. It is in this way that the simple women of traditional India invite their unseen deities to enter their abodes and abide with them. And it is because the faith too abides that the appeal will be heeded that what never claimed to be anything more than humble craft still retains the power to commune with invisible but deeply sensed verities, a power which art once had in the days when it grew around the interior vicissitudes of the Buddha's life and the inner meaning of the Krishna story.

Index